He Cheated, :
We Cheated

He Cheated, She Cheated, We Cheated

Women Speak About Infidelity

Ebony A. Utley

McFarland & Company, Inc., Publishers
Jefferson, North Carolina

Earlier versions of excerpts from sections two and six originally appeared in Ebony A. Utley, "Infidelity's Coexistence with Intimate Partner Violence: An Interpretive Description of Women Who Survived a Partner's Sexual Affair." *Western Journal of Communication* 81, no. 4 (2017): 426–445. Copyright Taylor and Francis.

Earlier version of excerpts from section four originally appeared in Ebony A. Utley, "Rethinking the Other Woman: Exploring Power in Intimate Heterosexual Triangular Relationships." *Women's Studies in Communication* 39, no. 2 (2016): 177–192. Copyright Taylor and Francis.

ISBN (print) 978-1-4766-7577-0
ISBN (ebook) 978-1-4766-3750-1

LIBRARY OF CONGRESS AND BRITISH LIBRARY
CATALOGUING DATA ARE AVAILABLE

Library of Congress Control Number: 2019942898

Front cover photograph by Roberto Pangiarella (Shutterstock)

Printed in the United States of America

McFarland & Company, Inc., Publishers
Box 611, Jefferson, North Carolina 28640
www.mcfarlandpub.com

To the women who share their stories

Table of Contents

Acknowledgments

I owe a debt of gratitude to each woman who shared her infidelity story with me. Even if your story did not make these pages, it influenced the way I think and teach and talk and write about infidelity. Because of all of you, I am a more mature, open-minded, and worldly woman. Thank you for your vulnerability, honesty, and transparency. I apologize for the length of time it has taken me to produce this book. I had several unanticipated life lessons to learn before *He Cheated, She Cheated, We Cheated* could take the shape it has taken today.

Thank you to countless colleagues, friends, and strangers who supported the other projects inspired by my interviews—the articles, blog posts, and relationship lectures, not to mention the Oprah Winfrey Network *Stories of Betrayal* team, Infidelity Counseling Network and the online game formerly known as Love Lines. I earnestly tried to make your experiences accessible to as many audiences as possible.

To my editor, Charlie Perdue, thank you for your confidence in the manuscript and your patience while awaiting its delivery.

Thank you to my former research assistants who would probably be grateful to never have to use Google Drive again: Raisa Alvarado, Eternity Bruce, Sandra Garcia, Vivanna Goh, Eric Kim, Barry Lyrse, and Sia Turay.

Thank you to my intellectual comrades—always down to read a draft or debate an infidelity issue: Tommy Curry, Marcia Dawkins, Brandon Gamble, Amy Heyse, David Leonard, Nneka Ofulue, Shira Tarrant, Monique Wells, and Christina Ying.

Bless up to my spiritual guides: Lionel Mandy and Jacquelyn Courtrell-Washington who repeatedly reminded me that everything happens in its perfect time including publication of this book.

Props to my personal support system: Laura Garris, Christopher Peterson, Alia Shah, Shandra Summerville, Anthony Utley, Ava Utley, Chery Utley,

Christin Utley, O'Shea "Kid" Utley, and Zoe Utley. Verlan W. Grant III, thank you for being my person. Armyn Grant, thank you for the quiet time. May you never have to have another quiet summer.

Special thanks to my girls: Rachel N. Hastings and Katrina Taylor. May we writing retreat around the world from now into eternity. Here's to the genius we have yet to create. The aliens are counting on us.

And even though I stopped officially collecting interviews a while ago, I appreciate every single call, electronic message, or face-to-face communication with someone who wants to share an infidelity story with me because they feel like I "get it." I do. I see you.

Introduction

My husband impregnated a waitress while he was serving as a chaplain in the Air Force. The baby had already been born when he told me. He confessed because she served him papers, not just for child support but also for chaplain misconduct, which meant he was under investigation. He had to tell me before the Air Force did. One minute, I was a regular wife finishing her first year as an assistant professor of communication studies. The next, I was a subject for my newest research study on black wives' experiences with their husbands' infidelity.

While my husband was busy hiding his affair, I was regularly brainstorming with him about a potential infidelity project. I was writing my first book, *Rap and Religion*, and reading rapper (auto)biographies. Many of them had concurrent families—children with a wife and children with an Other Woman. Oftentimes, the children were around the same age. I really wanted to ask: How do wives feel about the Other Woman (or Women)? How did they decide whether to end or mend the relationship? How did they deal with children born as a consequence of their husband's affair? How often did they have revenge affairs? Since I was already committed to writing a book, I tried to give the project away to colleagues and graduate students. No one was interested. When I decided to fully commit to the project, my husband encouraged me. He thought it was a great idea. Unbeknownst to me, he was working on an infidelity project of his own.

The night he told me, I was watching *The Young and the Restless*. My husband and I both watched the stories and the rule was no talking while they were on. Commercials only. I was serious about it. I didn't want to miss anything especially in that episode because one of the characters had been unfaithful and it was a baby daddy reveal. I was 100 percent focused on the stories when my life became one.

Out of nowhere, my husband said, "I may have a child." The first thing

1

I did was pause the stories. The second thing I did was assume one of his former women just told him he had a seven-year-old or something. Then he said, "When I was in Montana." That's when I freaked out because we were married then. He tried to explain. It sounded like one bad lie. Then I got mad because I knew he was lying, and he had more than a year to get the story straight and it was still shoddy. He didn't even care enough to lie good. I put him out of the house. Once I was alone, I turned off the stories. The baby daddy reveal in all of its real-life irony was going to have to wait. I cried myself to sleep.

The next morning, I went to Pilates crafting an email in my head. I came home, banged it out, and sent it to everyone we had ever known. I waited. Within 15 minutes, I got my first email responses, then the phone started to ring. It became clear who was going to be my support system and who was not. Most of the women were like, "Go, girl, I wish I would've had the guts to do that." Some of his male friends and one of mine were like, "Don't be angry and bitter. Don't do anything you'll regret." But that was bullshit. They were trying to protect male ego. The email was just the facts: he cheated on me, supposedly had a child, and doesn't live here anymore. I didn't pass judgment. I never called him out of his name.

Sending that email was the best thing I could have done. I was instantly not alone. Telling the story freed me. I refused to be shamed by something he did, but when the calls stopped at night, and I was alone, I was devastated. I felt so betrayed. I thought I was physically going to die my heart hurt so bad. I called the nurse hotline, and the nurse I spoke to told me it was a panic attack. I later learned that's what it feels like when your heart breaks.

Despite my well-meaning friends' advice that I pause my project, I took my personal experience as a sign that I had to continue. I was now both intellectually and personally invested in the answers to my research questions. The project was going to be part of my processing. The first step was completing was my own interview. I could not ask another woman to answer those questions for me until I answered them for myself. My interview questions were open-ended. I asked interviewees to define love and infidelity, describe their experience(s) with infidelity, offer advice to other women based on their experience(s), and explain their motivation for participating in the study.

My self-interview was grueling. I typed my responses without editing. I put all my profanity-laced anger and frustration on the page until I created enough space among my own pain to make room for the pain of other women. After Institutional Review Board approval, I recruited a sample of 20 ever-married African American women via email and word of mouth. My first interviewees were older black women whose husbands cheated on them.

During my interviews, I did not disclose my personal experiences unless

someone asked. I did not want to bias my interviewees, but I like to think that strangers could feel my familiarity, and that it made them comfortable enough to share their intimate lives with me. I always clarified that I was not a therapist. My communication background made me interested in *how* they told their stories and made meaning out of their experiences. I was neither qualified to help them heal nor interested in passing moral judgment. I just wanted the women to share.

Sitting with them was like having a bunch of big sisters. Sometimes, we ate together. Other times we cried together. I learned a lot about infidelity in particular and life in general. I published my first infidelity essay, "When Better Becomes Worse: Black Wives Describe Their Experiences with Infidelity," from these initial interviews.[1]

It was well received, but I knew I wasn't finished. The more interviews I conducted, the more questions I had. What makes a woman become an Other Woman? How do Other Women really feel about wives? Why do women cheat? Does infidelity in a relationship that ends lead to more infidelity in future relationships? Does infidelity differ in opposite and same-sex relationships?

I had to expand my sample. This time, I recruited women of all races who had been cheated on, the cheater, the Other Woman, or some combination of the three. As I interviewed more women, they recommended their friends and the sample snowballed. I told everyone what I was up to, and a few of my close friends surprised me. I was staying with a friend while traveling for interviews, and she randomly said to me, "Are you going to ask me?"

"Ask you what?" I said.

"If I want to tell you my story." She wasn't the only one. Women I had known for more than ten years were telling me infidelity stories that I'd never heard. I dutifully left my friends' stories in the interview. We talked about it when the recorder was on and never spoke of it again. Ultimately, between the first and second set of participants, I personally interviewed 110 women around the United States either face to face or via phone.

One interviewee, Raven, asserted, "Cheating always involves four sides: the truth, the husband's side, the wife's side, and the mistress' side. You'll never have all four of those sides together, but I think you might get part of those sides in your book." Similarly, psychotherapist and author Esther Perel describes an affair as "one story that is experienced by two (or more) people in completely different ways."[2]

He Cheated, She Cheated, We Cheated is necessarily one-sided. Each narrative focuses on one woman's perspective. Taken together, however, the 57 narratives in the pages that follow comprise a unique, introspective, and more complete picture of women's experiences with various aspects of infidelity. I omitted narratives that were confusing, repeated similar patterns as other

stories, and were solely about emotional infidelity defined as a secretive, sexually-charged, psychological bond between individuals, at least one of whom (if not both) are committed to other partners.

The focus on sexual infidelity or betraying the sexual trust of a committed partner is intentional. Quite frankly, the sexual narratives were more dramatic, and everyone likes a page turner. Secondarily, nonsexual infidelity is generally considered a lesser infraction. Most importantly, I want to challenge evolutionary psychology studies on sex differences and infidelity that report men are more upset by sexual (physical) infidelity for paternity reasons and women are more upset by emotional (falling in love) infidelity for resource and fear of single parenting reasons.[3]

Current data does not always bear out this social expectation.[4] Women are sexual beings with sexual desires and, in some studies, are shown to be equally upset by sexual infidelity. Furthermore, Perel notes that women's "sexual needs have not been culturally sanctioned, but their emotional needs are well acknowledged. Perhaps hidden in women's pursuit of love lies a host of physical yearnings that can be justified only when wrapped in an emotional package."[5] My intention is to consistently convey that women are sexual and emotional beings.

Here is a demographic snapshot of the interviewees. Ages ranged from 21 to 64. The women's average age at the time of the interview was 38. The racial breakdown was as follows: 33 blacks, 18 whites, two Latinas, one Asian, and three biracial individuals (two white and Latina, one black and white). The majority were Christian (28), heterosexual (44), and had graduated from college (17) or earned a graduate degree (25). By no means do I make grand claims about the diversity of this sample.

Because interviewees were recruited via my friends and family, my social media, a talk I gave at an urban megachurch women's meeting, and an urban talk radio show, the high numbers of African Americans, Christians, heterosexuals and advanced degrees are reflective of my personal network. At the same time, my sample of first-person narratives is more diverse than most infidelity research articles or books that I've ever read and, well, I've read quite a few.

However, these stories are not driven by demographics. In fact, the women rarely mention them. Instead, their stories of discovery, decisions, and determination resonate across boundaries. From surviving a partner's serial affairs, to discovering sexually transmitted infections, falling in love with a stripper, negotiating workplace romances, being charged with premeditated attempted murder, and experiencing the best sex of their lives, these women lay their lives bare, hoping, as the majority of them told me, to help someone else.

Although I've abstracted my questions from the narratives, my subjec-

tivity shapes this book. The women responded the way they did because they were talking to me—a woman with her own personal infidelity experience who spent several years collecting, writing, and thinking about other women's experiences. My interviewees' conversations with girlfriends who had never experienced infidelity were not the same conversations they had with a stranger and a researcher who had.

Because an hour-long open-ended interview rarely produces a neat narrative, I heavily edited for clarity and consistency. I created transitions, omitted nonessential details, and redacted identifying information like names and professions unless the profession was integral to the narrative. Specific locations have been replaced with generic places. The women chose pseudonyms to protect their anonymity. Partner names are single letters ordered loosely alphabetically. Any correlation to actual names is purely coincidental. I take responsibility for any inaccuracies resulting from my misunderstanding of the transcripts.

While I believe the women were honest about their stories, I cannot know for sure. As I noted in a previous infidelity article, "the majority of these women shared a post-relationship perspective that would have been impossible to obtain while in the midst of a potentially tumultuous affair."[6] The version I received more than likely minimized cognitive dissonance and the interviewees painted themselves in a more positive picture to "maintain consistency between how they view themselves and what their behaviors suggest."[7] But I am more interested in the narratives' viability rather than their veracity. As a communication scholar, my goal in prioritizing these narratives is to humanize infidelity—to understand how women choose to share their infidelity stories, why women say that they make the decisions that they did, and what meanings women make about love, life, and themselves through the process.

This book is an alternative to the sensationalized, commercialized, voyeuristic infidelity—soap opera and daytime talk show "baby daddy" reveals, the "men are cheaters" Lifetime movie plots, "how to keep your man from cheating" online clickbait, and "fight for your man" reality television shows with love or wives in the title. These common androcentric infidelity perspectives privilege men's sexuality over women's. Prioritizing narrative as an epistemological research strategy spotlights women's decision-making and amplifies women's agency by offering explanations in the women's own words of how they come to know what they know about infidelity, intimacy, and themselves.

The narratives are organized into six sections. In Section One, "I Was the Last to Know That My Partner Cheated on Me," women describe discovering their partner's infidelity through a third party or parties. Section Two, "I Experienced 'Infidelity Plus,'" includes the compounding violations that accompany

a betrayal experience. In Section Three, "I Cheated on My Partner," women justify being unfaithful for reasons that pushed them away from their partners and pulled them toward fulfilling their personal desires with someone else. Section Four, "I Was the Other Woman," explores how Other Women achieve the feminist principle of agency through triangular relationships.

Section Five is "We Cheated on Each Other; It's Complicated." As women in sexually nonexclusive relationships re-evaluate their investment in and commitment to the relationship, they interpret and send messages through infidelity behaviors. Women in Section Six, "I've Experienced Multiple Aspects of Infidelity in Multiple Relationships," integrate their infidelity experiences and explain how past experiences shaped their future partnerships. The conclusion, "Infidelity's Secrets," revisits the social and interpersonal code of secrecy necessary for infidelity to thrive. While I have admittedly made these sections very neat, there is crossover. In some instances, a woman may have experienced multiple forms of infidelity. I used my best judgment to determine placement in one section instead of another.

I should also clarify my use of terms. I consciously avoid the term adultery which emphasizes moral and legal infractions.[8] Instead, I use the generic terms infidelity, affair, unfaithful, and cheat interchangeably depending on the requisite grammar. Following Sharpe, Walters, and Goren's clarifications, "cheating experience [occurs] if he or she has committed infidelity, betrayal experience if he or she has been a victim of infidelity, and infidelity experience if he or she has cheating and/or betrayal experience."[9] Finally, the adjective extramarital refers to an outside relationship, partner, or sexual activity when the unfaithful person is married; the adjective extradyadic refers to an outside relationship, partner, or sexual activity when the unfaithful partner is in a committed relationship but not married.

While written accessibly for a lay reader, *He Cheated, She Cheated, We Cheated* is also a pedagogical text useful in courses on interpersonal and family communication, marriage and family therapy, and psychology of women as well as gender studies. Theories are applied directly to the narratives in ways that students can easily understand. Infidelity rates are high among dating college students. If other professors have students anything like mine, the class conversations are never more lively than when we discuss infidelity.

In fact, studies estimate that sexual infidelity rates within dating relationships are as high as 49 percent for men and 31 percent for women.[10] The 2010–2016 General Social Survey (GSS) reported infidelity rates in the ranges of 20 percent for men and 13 percent for women among married couples.[11] These statistics have remained relatively consistent over the past 40 years although accurate infidelity rates are difficult to estimate because people lie about infidelity. Very few people desire to relive the pain or shame of infidelity.

Very few people desire to be stereotyped as the type of person who was cheated on, cheats, or is an Other Woman.

Society tends to demonize women in all aspects of infidelity. Women who were cheated on are sexually frigid wives. Mothers who cheat destroy families and abandon their children. Other Women are home-wrecking sluts and whores. My aspiration with this book is to challenge the stereotypes and humanize these women. These women are wives, mothers, grandmothers, sisters, daughters, students, professors, writers, businesswomen, scientists, nurses, counselors, journalists, ex-military, construction workers, and real estate brokers to name a few of the recurring roles. Infidelity is something that happened in their lives. Infidelity did not define them, although, sometimes, infidelity did refine them.

For example, when I decided to leave my ex-husband, my financial distress was as weighty as my emotional distress. I was still paying for our cross-country move and the entire divorce as well as a massive tax bill. I complained to a girlfriend about the cost of divorce and she said, "You know, slaves had to pay for their own freedom papers." She put it all into perspective for me. Slaves had no choices. I had lots of options available to me. I could stay or go. I could tolerate the blame or not. I could pay the bills or let them go into collection.

I was not being oppressed by his infidelity. It was just the opposite. I had more choices after than I had before. I just had to decide to own them and take full responsibility for what I wanted and who I wanted to be. My experience with infidelity turned into a series of blogs and articles, paid relationship lectures, a television appearance on the Oprah Winfrey Network, a board position with Infidelity Counseling Network, an online relationship game, a consulting gig for a dating app, and most importantly, this book.

I personally learned from sending my email that telling one's infidelity story can be liberating. I also discovered that listening, editing, and analyzing women's infidelity stories can be equal parts dispiriting and uplifting. I hope that your experience reading these women's infidelity narratives is as diverse as the content. They might leave you furious, melancholy, dumbfounded, and/or empowered, but I hope most of all they are revelatory. My goal is for readers to find moments in these accounts, contextualized by the most current and impactful relationship research, where they can see themselves or someone that they know and come to understand infidelity, its causes, and its effects as much more complex than they did before.

I Was the Last to Know That My Partner Cheated on Me

Infidelity betrayal experiences are devastating. This devastation is compounded when a partner feels like she is the last to know. This section details public confirmations of a partner's infidelity delivered via Other Women, another third party, the birth of a partner's baby by an Other Woman, and/or technology. Not only is the affair public for a woman whose coworkers, neighbors, friends, family, and children know about her partner's infidelity, but her decision-making process is often public as well.

Public infidelity can be characterized as a humiliating marital event (HME) defined as "life events that devalue the individual in relation to the self or others."[1] HMEs are often followed by an onset of depression in women. More research must be done on the relationship between types of infidelity discovery and depression, but some research hypothesizes that public discovery "would be more strongly associated with depression because this type of discovery would involve more humiliation than other types of discovery."[2] This section considers how a woman publicly and personally responds to infidelity when everyone knows her business and is watching as she decides what to do.

These seven heterosexual women are all mothers. Five of them were wives when they discovered their husband's infidelity. Danielle and Janet's infidelity stories are with men to whom they were not married and were not the fathers of their children. At the time of the interview, their ages ranged from 35 to 49 with an average age of 41. Six are black and one is biracial black and white. One earned a high school diploma, two spent some time in college, one had a college diploma and two earned professional or graduate degrees. Besides her race and sexual orientation, Willa declined to provide demographic data.

This is the most homogenous sample in the book, making the narratives less generalizable across populations but instructive for thinking about how black women respond to their private lives being made public by a partner they loved and trusted. Post-public infidelity, there are no easy decisions about the future of the relationship. At the time of the interview, the two unmarried couples were still together, two were divorced, and three were separated.

Danielle

"It took several fights for him to understand the terrible position that he put me in."

I guess it was kinda a power thing because I was his supervisor. Then there was the thrill of us sneaking around. It started around Thanksgiving. It was physical at first. At some point, it turned from just strictly sex to hot feelings. Three months into it, we became something more. It evolved for the both of us from a physical thing to a committed relationship.

It was office place craziness for about six months because of our affair. People at work kind of had their suspicions and were whispering about it. He wanted to keep us a secret, and because of that we never went out. There was always an excuse why we couldn't go out somewhere in town. It started becoming an issue between us when I kept complaining about why we had to keep each other in the closet. I had never even been to his house. We were supposed to be in a committed relationship. Whenever I'd press him with that point, he'd always come back with, "We know too many people. Somebody might see us." We could go to City A or City B and be seen in those cities, but in hindsight we couldn't go out in the city where we lived because he had too many chicks.

In the beginning, I didn't question him, but in the back of my mind I'm thinking, "What's the problem?" I didn't assume he was cheating or with somebody else. I'm thinking, "He doesn't want to be seen with me" because of me. He was married when he was younger and admitted that he had a cheating issue back then, but I assumed he grew out of it. I didn't want to rock the boat with him. He was the one guy that everybody wanted. I didn't want to lose what I thought I had that nobody else did.

Our relationship was more public than we thought because coworkers would conveniently gossip within earshot. People would say that he was sleeping with this person, or talking to this person, and that someone had seen him over at another woman's house. I questioned him, and everybody that I accused him of he swore he wasn't with. In the meantime, at my business I

had to lay off employees. One of the women who I was about to lay off sent out a picture to all of my staff of her and my boyfriend lying in bed. That's how he was outed. It was hell.

When the picture went out, everybody knew that he was sleeping with several employees including myself. There was no denying at that point. Half of the staff were supportive. Nobody ever said anything directly to me about it, but their reactions were enough. Half of them were coming to me as if somebody died. It was like, "Oh, hey, how are you doing today? Are you okay?" That's how they would be talking to me. Then the other half were smirking because, despite the chaos, he was still sleeping with women from work. These women knew what he was doing with me, and they knew what he was doing with them. I was concerned for my sexual health, and when I went for my annual gynecological appointment I had an abnormal test result. I had to have a biopsy because he gave me HPV, and now I have to go every year for pre-cancer screening.

It was very hard. I don't even know how I did it. It was very difficult to come to work every day, having to deal with the aftermath and the backlash. I had to keep my head up knowing that I put myself in a situation where everyone at work knows my business, and that I shouldn't have gotten involved with an employee in the first place. I had employees purposely getting involved with him knowing what was already going on, but it worked out because I needed to downsize. The women at work who I had suspicions about, even before the picture came out, I ended up laying off anyway. The employee that sent the picture out, she actually quit the day after. I guess that was her way of keeping him or getting him, but he got fired and started a new business. So she actually pushed him away by doing that.

It took several fights for him to understand the terrible position that he put me in. It took me really drilling the impact of what he had done into his head. I think that was what made him realize the magnitude of what he did, but at first, he didn't get it because he's a guy, he's a man, and it didn't affect him the way it affected me. You know, all the guys were like, "Oh, you're the dude! You're with the boss." Not only was he sleeping with the boss, but he got all these chicks, and he was able to be the big man on campus.

He begged me to stay, but we broke up for about three months, and during that time he actually did seek some help. So he gets help, and then we get back together. I took him back because I do love and care about him. I do feel that he does care about me and has the potential to be something great. He is a great person aside from the infidelity issue. He now tries to make it right and be with me and only me. He's going to church and seeking out a mentor and counseling.

Since we've been back together, I haven't caught him in any lies that I know of. He's more open with me, talks to me more, and calls me more. We

don't live together, but we check in with one another. No one in my life has given me a hard time about taking him back. However, I'm also selective on who I tell certain bits to. You do have those naysayers and negative people who, it doesn't matter what you say, you know, they're just not going to be happy for you. So I don't tell every little thing, but for the most part, everybody likes him because as a person he's okay. He's a good guy, and because of that, I'm willing to give it a chance, but I'm not confident that it's not going to happen again. I'm still guarded.

It's too soon for me, and I'm very insecure about it. Although I'm not naïve and passive like I was before, I don't take everything that he says as truth. If something doesn't sound right, I question him when I feel I need to. For example, if he tells me that he's going to the gym or a spin class. I don't just let that go like before. I don't just say, "Oh, okay, you're going to do a spin class. Let me know how that goes." Now it's like, "No, you're lying. You're not doing no spin class, I'm going to go to that spin class" or "I'll believe it when I see you in that dance class." I will be there as soon as that dance class starts and the moment he gets on that bike. So he can't pull anything past me anymore.

My experience with infidelity has been physical and emotional. For a woman that finds herself in my situation, first, don't get involved with your employees. Second, don't be naïve. Don't take what someone is saying for gold. Have more value in yourself. I think people that know my story are kind of shocked that something like this could happen, and I don't want to be stupid like that again. I need to keep reminding myself of it because he is still here in my life. I wanted to work this out 100 percent because he is a great guy aside from his infidelity issues. We actually are starting a business together, so I really do want it to work out, and I hope that it does because if it doesn't that might be another catastrophe.

Janet

"You know about me and you're okay with him having sex with both of us?"

A_____ was eight years younger than me, 21 to be exact, and I was living with someone at the time. The person I was living with started messing around with a few women at his job. A_____ let me know he had some type of attraction to me so once I ended the relationship with my live-in boyfriend, I finally gave A_____ a chance. Even though A_____ had chicks that he was still talking to, I couldn't really say anything because I still lived with my ex-boyfriend. I wasn't sleeping with him. We were just sharing bills and rent. We communicated on matters of the house, but I hated him, and we pretty much knew it was over.

Once he finally moved out, A____ and I got serious. A____ went to jail for eight months. I wrote him every single day no matter where was I at. When he was released from jail, that's when the infidelity started with this particular chick. He was acting different, and I started figuring things out. He stopped answering text messages and calls, and also didn't invite me over to his place as much. There were a lot of new things around the house, like a new TV, bedroom set, and PlayStation 3.

He had a neighbor that didn't know that we were together. One day she took me aside to gossip. "Oh, it's some weird looking girl that A____ has coming over all the time," she said. "She's light skinned and has a funny looking haircut."

"That's funny. I've never seen her," I said.

"You don't get to see her because you're at work. She only comes over during the day." We were together for about three years before I finally confronted him. I went to his place, and I confronted them both. I'm outside at this point. She's inside the house and A____ won't let her come out. He's telling me I'm acting crazy, and I'm just spazzing out. I feel like I'm outside of my body because that's not me. You can ask my friends or family, I'm not an aggressive person unless you push me to that point.

I yelled to the window, "Oh, you guys are just going to have sex? You're not going to come out and face me?"

"Get a hold of yourself, Janet," A____ begged.

"I just want to talk to her." I somehow got around him and got inside the house. I'm calling her name, and I can't find her. When I tried to go to the room he stopped me. He drug me back outside. He held me back and she finally came outside. When she saw me she just looked at me crazy. "Do you have anything to say to me?" I asked. She didn't say anything. She just left. After she left, I threw my keys at A____ and then I left as well.

Then I began to stalk her on social media. You would think she was a superstar by the way she'd post stuff on Twitter, Facebook, and Instagram. Everything was me, me, me! I know this because I'm kind of like a low-key stalker. I think I've gotten better because I can go like days, even weeks, without wondering what she was doing or checking to see if they're together. It got to the point where I knew all of her physical flaws. I saw that she was knock-kneed, there was something wrong with her eye, and I noticed she was a mixed chick but she didn't have nice hair. It got really bad. I was looking for any subliminal she might be sending towards me. I even used other people's accounts to try to talk to her. Sometimes I'd talk to her as another person, and she'd give me so much information without even knowing it was me.

I saw on Twitter that she was over his house because she posted a picture of herself drinking coffee in his bedroom. Everything was a picture. That's how he would always get busted because with her everything was a picture.

She had on tights and a shirt and you can tell she spent the night. She had no makeup on and you can tell it was just one of those early mornings. I decided I was going to confront them again. I came home and took off my work clothes. I changed clothes just in case I was going to fight her. I didn't want my work clothes to get ripped. Whenever I see girls fight, clothes are hanging. I didn't want that. Then I packed all of his things in a bag and went to his house.

When I got there the two of them were in the garage sitting, chatting, or whatever. When they saw me both of them had a look on their face like, "Holy shit." The first thing I said to her was, "You know about me and you're okay with him having sex with both of us?" She didn't say anything at first so I continued, "That's nasty, and you're okay with this?"

"Yeah, I'm okay with that," she said. "I know what he tells me about you."

I stood at the edge of the driveway and yelled, "Come out here and talk to me or take this ass whooping like a woman. You can put that on Twitter since you like to put stuff up."

She wouldn't meet me in the driveway so we didn't fight. I wanted to beat her up so bad. She just seemed a little too comfortable and cocky at that point. The whole time he just stood there in silence. "Give me my house key," I said to him. "Here's your crap." I threw the bag at him. As I was going to my car he followed me, and I hit him on the back of his head. When I left I got maybe not even a block away and I called him. "I really need to fight her," I said. "I can't let this go." I turned around and went back to his house, but by the time I got there she was gone.

After that A____ and I didn't talk for at least a month. Once we did talk it was the same old routine. "I love you," he said to me. "I want to be with you. She doesn't mean anything to me." I wanted to believe that they didn't see each other anymore, so I decided to take him back. For that brief period, she really wasn't around, and she wasn't posting anything about him on social media. They were doing a good job at keeping their relationship under wraps.

Then there was one day he went to a baseball game with his friends. He wasn't very clear about who he was going with, but he was adamant that I wasn't invited. When he left for the game, I had a suspicion that he was going to take her. When I went on her Twitter, I found out that those two went to the baseball game together. I confronted him again. "Is there something that keeps you guys talking? Why do you keep lying about seeing her?"

There was a funeral for one of his family members and a couple of days before he tried to pick a fight. I don't know if that was to get me to not come because he knew she was going to attend. On our way to the service he told me, "Oh, there's a few people at the funeral that you might not want to see." He named a couple of exes and then he named her, but I sat there and didn't argue. I didn't get disrespectful. I'm not that cold-hearted a person to act like

that. This was a funeral for someone that he was very close to. If I had known prior to getting in the car I probably wouldn't have went.

When I saw her, she briefly hugged A____ and gave her condolences to the family. When it came to the actual service I sat in the front with the family and she sat in the back. It was very clear who was the main girlfriend. His family knew about her. I know that his sister and his daughter liked her, but when it came to any important events like funerals, graduations, or family events, I was the one that always came to the rescue. When his daughter needed help picking out a dress for her birthday, he called me. No matter who came over to his house, everyone knew that I was his main woman.

He was supposed to take his daughter to this wedding. I wasn't invited, and I really wasn't tripping because he does a lot of things with his child. Then two weeks before the wedding he told me that his child couldn't attend. I didn't say anything then about going or being asked to go, but then a friend told me, "I think he's taking you-know-who to the wedding."

"Why do you think that?"

"Use my Instagram and go look." I go on Instagram and she's posted three pictures with the caption, "Shopping for a wedding dress." I couldn't believe that we were going through this again. I wanted to have a conversation about the meaning of their relationship so I told him that I needed to talk to him. I couldn't do it over the phone. I needed to talk to him in person. When he came over the next day I asked, "Are you embarrassed by how I look? Are you ashamed of me?"

"No," he said. "What are you talking about? I always tell you that you're pretty and that you're beautiful."

"But you didn't ask me to go to the wedding with you."

"It's not like that," he said. "You should be secure in your position. You're number one. You're the main girlfriend."

"Why does there have to be other women?"

"There may be other women," he said. "But if we're together, we're together. My phone doesn't go off. No one calls me, and no one disrespects you."

"That's not good enough," I said to him, "because you're not a main boyfriend for me. You're not my main dude. You're the only dude." I was tired of the lies, the cheating, and the excuses. He said there were other women, but he kept going back to *her*. It's only her that he sees when he's not with me. He didn't have anything to say when I pointed this out. I asked him, "Are you in love with her?"

"No," he said. "If I was in love with her, I would've left you a long time ago. I don't want to be with her. I want to be with you." I'll never know what the attraction was between them because he's never going to be honest about it. With her there is something that he can't let go. I just don't know what it is.

If it were a one-time infidelity, I could look past it, but because it was the same chick over and over, I started to question myself. I've been on this emotional roller coaster for ten-plus years. Eventually, I started to question how I looked, how I dressed, my age, just everything in general. I know I'm not a bad-looking person. I'm not no beauty queen, but I'm not a bad-looking person. He knows when I clean up, I look good. He doesn't like that so we hardly ever go out anywhere.

He now tries to accuse me of cheating. He has an imaginary boyfriend for me named Juju. "I know you have it with Juju. I'm gonna find out who he is." He says he's waiting to catch me with someone so he can act literally a fool, but there's nothing for him to find out. I don't want to go through all that, the whole lying. That's how me and him got together so I don't want to go through the lying and being deceitful and sneaking around. There have been periods where I have been by myself, but I'm not one for dating several guys at a time. I like to be in something serious and when it's you and me that's how it's going to be.

If I tell him, "Let's break up. Do you want me to let you go?" I never get an answer from him. I never get a straight answer, or I never get an answer at all. Whenever I ask him, "Why do you want to stay with me?" He just says, "Because I love you."

Kathy

"When you're married and you love someone you do not stop loving them because you find out today what they did yesterday."

His father was his best man at our wedding. He had terminal cancer when we met and died a few months after we married. From there, it was a downward spiral. My husband was very, very depressed and grief struck to a point where I had to get him psychiatric help. He cut everybody off except for his mother and me. Based on his behavior, I knew that he would probably cut me off too. I owned a house when we got married and when he said he was never coming back to that house I knew this was all a part of his depression. I made him an ultimatum.

"You know what?" I said to him. "I'm going to get an In and Out burger. If you can't get it together then just leave the keys to the house on the table. If you're gone when I get back, I'll understand what's up." When I got back from In and Out the keys were on the table. I was expecting it, but it broke my heart.

He disappeared for a few weeks but while he was on the road he called me every night. From then on he would come back to my house once in a

while and we would have relations. He was trying to figure if he could still be in the relationship, so instead of living together we talked on the phone every night. Then he told me he found a place, and I would love the house. It was two stories, had a fireplace—all these things that I've wanted.

While we were still figuring things out, a woman came to my house completely drunk and intoxicated with this guy who was supposed to be her backup. The two of them just stood at my door and you could smell the alcohol reeking through them. When she came to my door, I was talking to a church friend. I told my girlfriend not to hang up. I wanted her to just listen.

The drunk woman claimed that she had a relationship with my husband and that their affair was very complicated because it involved multiple people. She was angry because my husband had recently started having a relationship with her best friend, but that best friend used to be in a relationship with my husband's best friend. I let this woman stand at my door for three hours as she explained her anger towards my husband. I didn't react or get mad. I listened to her and when she was finally done I gave her my opinion.

"I appreciate you coming and everything, but it doesn't matter because me and B____ are not together anyway. I could care less."

"I just thought you should know."

"That's fine. Have a good night," I said. That's all I could say because I knew that she wanted to hurt him. She thought she could hurt B____ by hurting me, but I wasn't going to give her that satisfaction. After she left, my church girlfriend on the phone asked if I was okay. "Yeah, I'll be okay." Then she asked one more time and then I started spiraling on the phone. I couldn't hold it in anymore. I just started breaking down.

"I'm on my way there," she said.

"Don't come. I'm okay."

"No, I'm coming."

"I won't be here when you get here."

"Well, call me if you need anything."

After she hung up, the hurt in me was just rising. I laid there on the floor till three o'clock in the morning with a with a magnum .38 gun. All of those nights on the phone, B___ led me on to believe that we were still in a relationship, but he was living with this woman, and he was calling me from their house every night. This drunk woman had the gall, the nerve, and the audacity to come to my house while I was there alone. She could have come with a gun and easily took me out.

It's not just about B____ running into the arms of someone else. It's the lies and the deceit that hurt me the most. The fact that he looked me in my face and literally lied is what made me lose rationality. The hurt that he caused left me so emotionally devastated and then to have some woman come and

give you information like that just sent me over the edge. I prayed and prayed, but I cannot tell you how God got that gun out of my hands. I never wanted to kill anybody, but I seriously thought about hurting B____.

I then received a voicemail from a random woman. She started calling me all kinds of names and told me that my husband was her man. Not only was he her man, but the two of them had been living together for months. The woman told me her name and it was a very odd black woman's name. I had never even heard that name before in my life, so I had a suspicion that this was the drunk woman's best friend. When he came home, I confronted him and played the message over and over for him.

"That message is from my daughter," he said.

"Your daughter?"

"She was at a sleepover and that was her and her girlfriends playing on the phone." His daughter from his previous relationship was about 14 years old. I couldn't eliminate the possibility because I was never around his kids that much.

"If this is your daughter," I said, "you better have a talk with her mom, because I will go over there, and I will shut it down."

"It won't ever happen again."

After that incident, I still played that message over and over trying to figure it out because it couldn't be his daughter's voice. After many listens I knew that the name on the tape was the scorned woman's best friend. He'd been living with her while lying to me. When I put it all together my mind went red, black, ballistic. I pulled up in front of his house blowing the horn. I started blowing the horn and screaming his name like bloody murder. It was four in the morning. He finally came out of his house and when he saw me he knew what was coming.

"You've been lying to me," I said to him. "That woman came to my house, and she could've killed my son and me."

"I told you I was sorry."

"Now your girlfriend is calling me. I have to sleep with a gun now."

"I wish you would take that gun and kill me. Just put me out of my misery." When he said this, I knew that it was depression from his father's death coming through, but after standing by him throughout that pain, I hated him for treating me like mine didn't matter.

"I'm glad I didn't bring my gun tonight because you're not worth it. You live with it."

Throughout his depression my husband had a habit of coming back to me. After that confrontation he would show up at my job unannounced and call my house at all hours until I picked up. The thing I tell people is when you're married and you love someone you do not stop loving them because you find out today what they did yesterday. You do not stop loving that per-

son. You try to understand what happened and find something salvageable in your relationship. He wanted to be with me, so I decided to give it another shot.

There was one day he took me out to lunch and said, "I still want to be married to you. I love you and I want us to get back together. I'm gonna find a place for us."

"You're telling me that you love me, but you don't want to come back to our house."

"I can't go back to that house."

"So you're gonna live with this woman until you find a place for us."

"Well, she's going to need some time to find a place of her own."

"You need to make a decision because you cannot look at me and tell me you're not sleeping with her. Tell me you're not sleeping with her." He couldn't do it. He just sat there silent and looked down at his plate.

"She's pregnant, Kathy. I can't leave her now." I had a rage in me and he could see it on my face. I started to get up from my seat. "Please sit down, Kathy," he pleaded.

"No, I'm about to throw something." He got up from his seat and tried to sit me back down forcibly. "Let me go before I tear this restaurant up." Once he finally let me go I walked out of the restaurant.

I drove my car to their house. When she opened the door I said to her, "I know what kind of woman you are, but let me tell you what kind of woman I am. You need to understand that he's a man and he has a problem. There are three victims here—me, you, and your baby. You need to get it together because you're a victim and your child is now a victim."

Things became complicated because even though he had another family, we were in major debt and I needed help with our bills.

"I can't help you with bills if I can't be there," he said.

"If you come back here, it's only to help us financially."

"That's fine. Where am I going to sleep?"

There was nowhere else for him to sleep except for on the couch. I let him sleep in our bed, but he wasn't allowed to touch me. It didn't take very long for him to make physical advances in bed so I just gave in. I laid there and just let him do his thing because I didn't want to fight him.

He had children with two different women. He had four kids when we got married from his previous relationship and two with woman he cheated on me with. I try to be a moral person. When he and his baby mamas weren't being good parents, I decided to take in all of his kids. They were good and smart kids. I took them to church, did homework with them, read to them every night, and I forced myself not to be the evil stepmother. I was very angry about the whole situation inside. It would've been real easy to mistreat and abuse these kids emotionally.

I decided to get a divorce because these mothers wouldn't see their kids for months. I needed to separate myself from this mess because it was completely bringing my life down spiritually, financially, and just morally. When I first proposed a divorce to him he thought it was a good idea. We even held hands that night and made love, but when I told him that I would get a lawyer on Monday his anger started escalating while we were driving on the freeway. By the time we got back to the house he had started getting anxious and violent. I should've called the police, but I didn't because I didn't want the situation to get worse. Once things finally calmed down I packed my bag and left the house.

I had to move on because he wasn't a good person anymore. I shouldn't have let him back into my house to help me with the bills. I should've been able to stand on my own. Letting him come back didn't pay off because it cost me $75,000 to divorce him. Women need to be economically stable and economically viable because we make our decisions based on emotional economics. We sleep with this person who's throwing us some little pennies. I also stayed in this relationship the whole time because I'm committed and loyal.

There's nothing I can do differently. I didn't do any of this. I walked where God wanted me to walk. I'm totally committed to me. It's a struggle I go through every day because I'm extremely lonely. I miss my husband and I still love the things I loved about him. However, I would never go back to that relationship because those flaws are still a part of him. My husband did a lot of unforgivable things and the two years it took to get through the divorce were very difficult, stressful, and emotional. I've learned that you can't walk and deal with major stress every day, so I put it in a little box in a place inside of me.

Willa

"I've had more STDs than Carter's got pills and
I have been with no one other than him."

I've been legally married to my husband for 26 years although we've been living in separate counties for the last six years. I really loved my husband at first. It's like he just wanted to tear it down block by block until there was nothing left. I don't forget anything. I'll forgive you, sort of, but forget the forgetting part. Each thing in life is cataloged in my mind.

I first found out about his infidelities maybe two years in. Infidelity is his M.O. My husband felt that he wasn't happy so anything he could do to bring happiness into his life was his to have. It's just ridiculous, but it's his

lifestyle. Sometimes I blatantly looked for evidence. Sometimes his patterns changed, and I knew something had caused that pattern to change so I would look for evidence. Then there was always somebody that managed to tell on him whether that was the intent or not. A coworker would approach me, "Willa, I saw you your car last night. I was trying to wave to you."

"You saw my car where?"

"City C."

"Ah. It was my husband, most likely."

I didn't tell people my business, but I was not one to try to hide it if it came up.

My mother used to have an old cliché: what goes on in the dark always comes out in the light. So unless you just want to have blinders on there's always something. I knew that I needed to know as much about his extracurricular activities as I could possibly know because I would not know from one day to the next when some idiot would be coming after me behind his foolishness. Women coming and attacking my car because of his foolishness. I said to myself, "Don't be naïve and unaware or you're going to pay an even bigger price."

And I've paid some pretty steep prices. I've had more STDs than Carter's got pills and I have been with no one other than him. Nine times out of ten, I wouldn't even know until he came in to give me something that the doctors had given him. He didn't even conversate; he just put it there. "You need to take these." And I would be livid, but I didn't want to start World War Three around the kids. We each have outside kids but none together.

In fact, he got a young lady pregnant which, I told him, was because God doesn't like ugly. He actually thought he couldn't have any more children because he had an accident at work as a crane operator. He fell and burst his scrotum wide open. I found it quite amusing that after the accident, sperm was going through where there weren't any before. Anyway, his sister refers to this girl as a hoodrat. I like to call her his albatross.

We had quite of bit of fun playing games with each other because she expected me to be this traumatized wife. No, darling. That which you have is your problem and his, not mine, and that will be hanging around your neck the rest of your life, not mine. It has no direct relationship to me ... sorry. That's something you have to deal with all the days of your life, not mine. I can walk out the door today and see nothing, no effect whatsoever. He knows better than to come to me about child support. He made more money than I did. In the early 90s, he was making $70–$80,000 a year. Because of his income, he was paying some thousand dollars a month for one child. It's not like he was a pauper, just an idiot.

I think I had slipped into another role entirely where I had adopted another child (him, not his child), so to speak. When you have a child, you're trying

to teach them something. You don't always just knock them upside the head. Sometimes you're going to maneuver things so that they can get another outcome, so they perceive it a little differently. It created a lot of stress, but I lived with it because I don't like to fail. That's my own shortcomings. I have to try every angle before I decide it's futile. I'm thinking, "Well, perhaps if I do this, he'll perceive it a little differently or perhaps if I do that." Meanwhile, it simply gives him an advantage because it looks like I'm not going to do anything.

I'm not argumentative and not interested in taking the hysterics approach so he could never read me. He didn't understand; he had a lot of misconceptions about my actions and reactions because it wasn't what he understood. One time, he actually made a statement to me, "Well, that's the problem. You never say anything." I asked him, "Do you think I should be running up and fighting these women? If that's what you're looking for then you have wasted a lot of time, fella. And I do tell you things. You just want to make pretend that it's all a part of my imagination. I'm not going to stand there and argue with you. What for?"

When I tell him exactly what he's done without leaving out any detail and he stares me in the face, denies it, and expects me to believe it, I'm going to assume I'm dealing with a pure idiot and there is no sense in taking this conversation further because it's going nowhere. I'm just going to accept this and for so many years I did. A lot of family and friends that knew me didn't understand why I stayed. I was hoping that maybe this idiot would get a clue.

Church is part of the reason I wanted to make it work. To be honest, part of it is old-school black culture. I'm born and raised on the east coast. I can remember the things my grandmother said or other older people in the communities said when I was growing up. Marriage was forever. If you complained that he was doing this or that, the older women would say, "It don't matter, baby, that's what they do. That's just what the men do."

Eventually, I had enough. I was going to file for divorce I would say maybe eight or nine years ago. I went to the lawyer. I was ready to move on, and I was told at that time because I was the reliable person in our partnership that nine times out of ten I would suffer greatly, and I would wind up paying spousal support even if he did make more money than I did because he was a freaking idiot with money. Because I was the responsible party all of this time we had been together, it would become my responsibility by the rules of the state to support his smart ass. The lawyer said, "I wouldn't even want to file these papers for you because your lifestyle would go downhill so dramatically." Pissed me off. I went on a shopping spree that was ungodly. I was devastated. My attitude was fuck you too. But here's the last straw that made me separate.

He wanted one more chance. I gave it to him, but I told him, "*We* is doing

nothing. I'm the one who's married, you're not. Let's be real here. If you wanna work at marriage then it's going to be you and I'll be watching you like a hawk."

It took him maybe two months until he started his old habits again. Christmas Day our extended family were all meeting over at my girlfriend's house. He got up in front of the entire family, said, "I'm gonna go see my sister," and strolled out the door. I was standing in her hallway, cause it's a long hallway, watching him walk out the door and my mind said, "The time has come to do something about this." I began to do everything necessary to put the house on the market. My daughter kept asking me, "Mom, where are you going to live?" I said, "I don't know but I've gotta get out of this house because he views it as a cash cow."

He was already moving out of the house slowly because he had met a young lady. I guess I wasn't supposed to be aware of it, but he's taking his clothes out in pillow cases. How can you not miss a matched set of linen? All the while, I'm thinking, please, hurry up and take more! The lawyer suggested maybe he'd be so in love that he'd ask me for a divorce and we could get him to sign all kinds of waivers. He never did. He moved in with her but was still in a state of denial. I waited until the tenth hour to get him to sign the trust stating that it was mine and mine alone. Without it, I know that I would have a hellified fight on my hands.

Now I wonder since we've been apart six years and he's had to depend upon himself, can I finally get a divorce? I guess he's been really sick. He asked me recently if I were ready for him to come back. He must be joking. He's cost me an arm and a leg. Why would I welcome him back into my haven? I learned I have no control over nothing but myself and the only thing that I can change is myself because I can't change anything else.

Stacey

"I always thought he would change, but being with him changed me."

I'm currently separated but not officially divorced yet. I filed it a few months ago. I just haven't served the papers because I know it's going to get ugly. I know it's going to be a fight, and I don't want to do it. I recently had a heart attack. All of the tests were normal and the only thing that led to the attack, according to the doctors, had to be stress. I've been married for 23 years, and my husband has had several affairs. We got married when I was almost 21. I was initially drawn to my husband because he was attractive to me, but that was the bad part because he was attractive to everybody. We got married because we loved each other, and we did want a family. We thought

we loved each other. Right now, I love him, and I hate him. I love him because he'll still call and check in on me, and once in awhile I'll still do things for him, but I can never go back to that situation because he'll probably cheat again.

I didn't see the affairs first hand, but I could always tell the difference in his behavior. He wasn't at home like he used to be, and he'd pick at little things about me. People liked to let me know that they heard something about him. The first time he had an affair, it was easy to tell. His baby's mom was pregnant with their second child, but the thing was, I was pregnant too. I wanted to break it off, but I didn't want to bring this child into this world without a father. I didn't want my unborn baby to be without a family. So I decided to make the best of it. He said he wasn't with her, and that it wasn't supposed to happen. She meant nothing to him. He told me he'd only go over there to see his son.

My pregnancy wasn't a good pregnancy. As a matter of fact, none of our three children that we have together were easy pregnancies. While I was in labor, he'd gone out. So that wasn't a pleasant way to bring a baby into this world. When our baby was born, he didn't end things with her. When I was pregnant with our second child, things weren't getting better. There was one day a woman called the house. I realized it was one of his girlfriends, so I told her, "You know, his affairs only last three months." I heard nothing on the other line. Just a click.

I would still have unprotected sex with him, even though I knew he was sleeping around. He wanted it that way. It's not something I wanted to do all the time. But how do you tell your husband that you don't want to have sex with him? I'm pretty sure there were times where I enjoyed sex with him like the times when he was nice or when he was on a hiatus from his affairs. When I was pregnant with my second child, he told me we needed to go to the doctor because he ended up having herpes, but luckily it wasn't passed on to the baby.

Our second child was born a preemie which the doctor said was due to stress. I had her at six months, and when I gave birth, she had to live in the hospital for three months. I went back to work because she was in the hospital so there was no reason for me to stay home without the baby. Every day after work I would go to the hospital and spend the evening with her. I don't remember him going with me once. Not once. He's never participated in family activities. He would go to all their functions like graduations, performances and all those kinds of things, but fun stuff, he wouldn't do.

I ended up raising both of his children. In total, we had five children, our three, and his two. It was the kids and me most of the time. I was able to love those two kids as if they were my own, and you wouldn't know that they weren't mine until strangers would ask me why my children were calling me by my name. I'm still close to them even now that they're adults.

Once, I wanted to take the kids to the snow, and he knew that I was afraid to drive, but he insisted that he didn't want to go. When we came back, he wasn't home, and the house was the same way we left it on Friday night. I called and called and called; he didn't answer. Finally, he came in the house. He said that he just went to the club, and I'm assuming whatever girl he was with dropped him off, but something still wasn't right. I had a suspicion that he wasn't home all weekend, so I searched and searched for proof but couldn't find anything.

As I was putting away our boogie boards in storage behind our garage, I noticed that his car was very dry, and it had rained that weekend. He never pulled his car out, so that proved that somebody dropped him off at home. Then I saw his overnight bag with his jacket, everything, hidden in storage. I took it out and put it on the bed in front of him, and he said, "Thank you for bringing my stuff." He was gone that whole weekend. I looked at his credit card saw that he had gone to Vegas. I didn't ask him directly if he went to Vegas with a woman. I didn't ask him who she was. I know it was a she because he doesn't hang out with guys. He never confessed he went with a girl to Vegas.

There was one time I decided to move the bedroom around just to change it up to a different style. When I moved the dresser, I saw a picture. It wasn't a nice picture of me with him. It was a picture of a woman giving him head in our van that we had just bought a couple of months before. Oral sex was always an issue with us. I refused to give him head, and we'd always argue about it.

"I have a wife who doesn't want to give me head," he said. "I don't want that."

"Well, I don't know where that's been," I quipped. "So I'm not comfortable with that anymore."

I threw the picture away. When he found out, he went inside the trash can looking for it. He tore that room apart looking for that picture, demolishing until he found it. Then I put the picture on the stove and burnt it. I'm a clean person, but I didn't clean that stove for a long time.

My relatives would tell me stuff with the intention of breaking us up. Not only would it be good for me, but they wanted us to break up to hurt him. I mentioned to them that he'd just confessed that he'd been seeing a woman on and off for 14 years. They turned to me in shock. "You just found out?" they said. The woman was regularly calling his cell phone, and even though it was going on for 14 years, I was the last to know because I didn't go out.

"You're at home with all these babies," they'd say, "while he's out there having fun with her."

One of the funny things is that I've had that girl's phone number for

years. I saved her number from when she first called my husband, but I've never used it. I have a small business. Once I sent out a mass text including her saying that I'm offering these services now. She responded back with, "What's your address?" I knew it was her because her name popped up. So I gave her the office address.

Then she texted back and said, "Do you know who this is?" Of course, I knew. I've always wanted to ask her why she did it. I can never see myself messing with a married man, and I want to sit down and have dinner with her or lunch just to ask, "Why did you do this?" But I've never had the nerve.

After I knew for sure about her, I couldn't take it anymore. Before his pattern of affairs only lasted three months, and they'd be gone, but this woman was different. I stopped being a wife. I stopped washing his clothes. I would still cook his meals, but not lovingly anymore. I would feel bad. This is my husband, and I'm washing everybody else's clothes except for his.

There were times when I did try to reignite our bond, like when the kids weren't home, but then a couple of hours later he would get dressed.

"Where are you going?" I asked. "The kids aren't here."

"You should have told me. I can't change my plans now."

"Have fun with your girlfriend number whatever."

"You're not doing anything for me anymore," he said. "You're boring, and you don't want to go anywhere."

"It's because of the things you do."

"You don't act like you love me, that's why I left."

"Should I lock the door or put chains on the door so that you won't go?"

"You just like to stay in your corner and be quiet."

"What am I supposed to do?" I asked. "Tear off your clothes for you to stay home? You should want to stay here."

I don't think that fighting him on it, calling him out, going all the way to the left would have made any difference at all for either of us. He probably would have gone ahead and seen someone on the next night or later on. He kept saying he had the affairs because he started to resent me for not paying enough attention to the things that he was doing, and I didn't show him that I loved him, but I don't believe that.

One day, I got a phone call from the police department saying that my husband had been arrested, and I needed to pick up my child from school. "What are the charges?" I asked.

"Sexual harassment," the officer said. I immediately went into action. I was ready to put up the house, find a bail bondsman, the whole nine yards. I went through that whole process, get to court, and I found out real charge was rape. They threw the case out because he kept his recorded messages from the girl who said, "If it's the last thing I'll do, I'll ruin your life." They dropped the charges, and he was released. That was on a Thursday. Friday, he came

to my job. He bought me lunch, which never happened in twenty-something years. Never once. But I enjoyed it, I enjoyed our lunch. I felt like something was odd, but I left it at that.

Then he announced, "I have a new girlfriend. She's from out of the country. She's coming tonight."

"That was the purpose of us having lunch together?"

"I thought I should tell you before the kids did. She's young, so I figured you wouldn't like that."

"It wasn't to say thank you for what happened? It was just to tell me that?"

"Go ahead and get divorce papers," he said. "Because we ain't getting back together. My girl told me she prayed for me. What have you done?"

"You're telling me after all these years, all I had to say was I prayed for you and it would be okay?"

"Maybe."

"That's all she needed to tell you? After all we've been through, after all the struggles, that was all I needed to say?"

I just lost it. I haven't spoken to him since. I mean, we have to converse because of the kids and our assets, but beyond that, we haven't spoken.

When I'm throwing out papers, I'll find proof of his affairs like credit card statements. I look at them, and I'll feel sad. It ruins my whole day when I look at them. Whatever I'm doing, it just stops, and I don't want to be bothered. But I still can't throw those things away.

My husband has now found a young lady that he brought into the country. He said that I made him bring her into the country because I acted like I didn't want him, but he wanted to spend Christmas with his family, so I told him, "Why don't you do Christmas this year? You get a Christmas tree, and the kids will go to your house for Christmas this year." So he and his girlfriend bought a Christmas tree, and for the first time in his life, he had to buy decorations. They had a wonderful Christmas, and it hurt me because he had never gone with me and the kids to get the Christmas tree. Never in all these years. He's never participated in decorating the Christmas tree with the kids, never, and then he turns around and gets a Christmas tree with another young lady.

I've gone back to school to study sociology and psychology. Based on what I learned in class, he had a lot of characteristics of emotional abuse. My husband will always claim that I cheated on him with school. When we first got married, and we had our first child, I was still in college. Then I dropped out. My brother suddenly died, and he was the one that was helping me pick up our child from school. After my brother died, there was nobody to do it. My husband wouldn't help. So I ended up dropping out of school. When I went back to school later as an adult, he threatened me that if I didn't quit

school that he wouldn't pay our daughter's rent. She'd just started college, so I withdrew from the classes, and that was it. So now he doesn't know why I'm in school, but he can't tell me anything. He can't do anything about it anymore.

People always ask me why I stayed. I grew up with only a mom. I didn't see my dad because he lived out of state. I didn't want that for my kids. I wanted to be a family. Imagine, with five kids. There was always a lot to do. In addition to working full time, we had to get ready in the mornings, the kids' homework in the evenings, and then dinner to prepare. Then the weekends were always filled because Saturdays were the kids' functions, whether it be football or cheerleading. He complained that I spent all my time with the kids, but he could have joined us. I always asked him to come, and he would say no. I put the kids before him. Mind you, they were our kids, his kids.

Leaving him was the best thing I ever did for myself. I think if I hadn't left, he might've killed me. Not in a literal sense, but when I had the heart attack I had the symptoms for a whole week, and he didn't know. I find myself laughing and talking with the kids more, and I'm not as stressed. I always thought he would change but being with him changed me. I don't trust any man. I've tried having a relationship, but I find myself being mean and accusing. I just can't seem to move forward. There are things I want to do, but I find myself stagnant. I don't have that willpower, that energy that drives anymore. He's taken all my spirits away. It's like I'm here, but I'm not here. I regret that I took so long. I regret that I had so many kids, but I don't regret having his kids. There were times when I was overwhelmed with all the things I had to do for them when he was in the streets. But they weren't the problem. He was.

India

"A person who constantly accuses you is reflecting their guilt."

C____ and I were young when we got married. During the entire course of our relationship, I suspect that C____ was seeing multiple women, but I could only confirm three. I had my first suspicions when he was in Thailand for four and a half months for a special mission. All of the military guys had apartments with a Thai girlfriend living with them. C____ wouldn't call me from Thailand, so I suspect he had a Thai girlfriend too. In a way, the military encouraged infidelity. There used to be Christmas parties at the first base we lived at. If you were an enlisted officer at one of these Christmas parties and you came with your spouse, you had a bowl that you dropped your keys into. At the end of the night whoever's keys you picked up from the bowl was the

wife you were taking home. I told my husband, "If you put our keys in there I'm not going home with somebody and for damn sure nobody's coming to my house."

Because of his job in the military, he was gone probably 300 days of the year, so I didn't see him much during the beginning of our marriage. He had to leave for Germany when our son was nine months old. Usually when troops come home families go to meet them at the plane runway. When you get to the base, there are busses that take all the women down to the runway where they go screaming and running for their men. When my husband landed back from Germany, I was there on the runway with those women, my baby on my hip. I went to greet my husband, and in the corner of my eye, I could see somebody stop. I had that woman's intuition that told me to look in that direction. The person who stopped was a woman watching my husband. As much as I tried to fight it, I had to look in my husband's direction as well. My husband was looking back at her, and there was this exchange between the two of them that told me everything I needed to know.

I knew something had gone on in Germany for the four or five months he had been there. Two months later, we were at the grocery store, and she was in our aisle. There was that same suspicious glance between them, and that's when he saw me looking at her too. When I turned my eyes back to him, I didn't say anything. There was another day when we were driving and I saw that her car was coming in the opposite direction. When we stopped at a red light I saw him from his side kind of wave to her.

Later that night I asked him, "Do you remember that woman from the supermarket with the blue dress?"

"No, I don't."

"I swear she looked at you like you knew her."

"I don't remember."

"We've seen her a few times. I think she lives on the base." He stayed silent for a second. When he caught me looking at him he finally replied.

"I don't know the woman you're talking about," he said. "I think that you see something that's not there."

I didn't have any proof that anything was going on between them, so from then on I decided to ignore it. I was only 23 years old and not mature enough to even know how to handle an infidelity. I was at a base without family and friends so I told myself that maybe my suspicious feelings about C____ would go away.

After suffering a miscarriage, C____ and I separated for a short time, and I had my own apartment for a year. He convinced me that I needed to give our marriage a second try, so when he got orders to move south, I decided to move there with him. We bought a house, and for a short period of time, everything was stable.

Within a month or two I started to get that feeling again. I could never put my finger on it, and that intuition slowly slid into what it was before. The feeling just kept getting worse, and I started to notice that he was distancing himself from me. We had a big, oversized sofa and a loveseat. There was one day I went to the kitchen to get something to drink, and when I came back to sit next to him, he got up to do something else. It was always this way. He never wanted to be close, and he didn't want to look at me. We were still intimate, but he was clearly avoiding me.

Whenever I would be out with my friends, he would always accuse me of cheating on him. My mom was at our house one day, and she could hear us arguing. When she heard him making accusations towards me she said, "A person who constantly accuses you is reflecting their guilt." I told my mom, "There's just no way he's cheating on me. He's too much of a square." Then I had a flashback to when we were younger, and I thought about that one girl at the other base. I started to wonder if I was actually paying attention to everything that was going on.

I had planned a trip and on the day that we were supposed to leave, he called my work and canceled it. "My grandma needs me," he said. I started to play connect the dots, and there were a whole lot of things that didn't add up. After some research and snooping I saw that he was, in fact, seeing someone where his grandmother lived, so I decided to move out. I told him that I was not going to the next base with him and that I already called the real estate agent to put the house on the market.

After we divorced, I moved to an entirely different state. A few months later a woman knocked on my door. My mom was living with me at the time, and when she answered the door, she came into the living room with a look on her face.

"What's wrong? Who is it?"

"Remember when I told you that one day a woman would come knock on your door?" she said.

"I don't get it. What are you talking about?"

"There's a woman at the door, India."

"Is she trying to sell something?"

"No, she says she knows your husband."

When I got to the door the woman showed me the pictures of her and C___.

She introduced herself and explained that she had been seeing my husband for three years. She had known him from high school and they would rendezvous in the town where his grandmother lived.

All that time I was unknowingly helping C____ pay for her rent and car payment. Half of his paycheck was going to a secret account, and because we lacked in funds I would work extra hours to make up for it. I was wondering

why he wasn't getting any raises. He's a military member; he was supposed to have an x-amount of money. It all worked to his convenience because we had separate accounts when we briefly separated. It was my fault that I didn't merge the accounts again. It wasn't until three years after we divorced that I found out about the secret account during a custody hearing in court.

When their affair started, he had two cell phones. The base had horrible reception, so he told me he needed the phone because he was an instructor, and the students needed to get a hold of him. His Other Woman knew everything about me. She knew my favorite foods, the car that I drove, where I worked, and where I loved to shop. While we were still married, he kept leading her on. He told her, "You can be the next her. If you stick around and you're faithful to me, you can slide into India's spot when she leaves because she's going to leave." When I think about that time, I remember that I wanted to leave because he was pushing me away.

She told me that she had a child with him and that he was born around the same time I was moving out of our house. He couldn't help me move that weekend because he said he had to see his grandmother again. That was the same weekend that her son was born. "I named my baby Luke Brian," she said. My face froze when I realized that she named her son the reverse name of my son, Brian Luke. "I thought it would be cool for C____ to have two sons with the same name." What she didn't realize was that she would soon be in my position, but not in the way that she expected. Two weeks after I left my husband he met somebody on the Internet, so his other baby mama got kicked to the side. He's married to that woman now, and she wasn't too happy about that.

After I had a two-hour conversation with her, she wanted to be friends with me, but it was because she wanted to team up with me against C____'s new wife. I told her, "Good luck with that." I wanted no part of his life. I guess the saving grace for my heart was that I had already left him when she came to my house. What I learned from that experience is to trust that instinct because I never pinpointed anything in regards to his cheating. It was always just a feeling. When I look back on my marriage, I realize that we as women fight over these scraps of men. We fight over them, and we allow them to be scraps. You then have four or five of these desperate women trying to take care of these scraps when we should instead try to take care of ourselves.

I mean, not everybody cheats, but a woman will usually let you know that she's seeing your man. The look on her face will be territorial. As soon as you suspect something don't turn a blind eye. I'm not saying to doubt everything, but pay attention because what is meant to come out will come out. If he takes his phone in the bathroom, adds a second phone line, he's playing tricks. If you're in a long relationship, and you don't see that your

man is cheating, it's because you're choosing not to see it. There's usually enough evidence. You just have to see what you don't want to see.

Dee

"I can't be a wife that allows my husband to openly have an affair."

I got married very young to my high school boyfriend when I was 20 years old. Even though I was young, it was a decision that I made for life, and I knew that I would be staying in this marriage forever. We started dating when I was in the military right after high school. After we got married, we moved to a few places, and then I was eventually stationed in Japan. The moving brought us closer because we were away from our family and friends, and we didn't have anyone except each other. That really helped our relationship and gave us a more solid marriage.

When we were living in Japan, my husband had some legal issues. He was told to appear in court and needed to come back to the States. While he was there, I received an email from one of my old sergeants who coincidentally had been living in the same place with his wife and family. The email said, "I want you to know I respect you, I've always looked up to you, and you've always been a wonderful person. You've always been good to my family and me, always taken care of us. When we lived in Japan, you were an anchor, but I need to let you know that your husband and my wife are having an affair."

As I read through the entire email, my sergeant revealed that his wife had been pregnant. He went on to say, "Dee, the son that I think is mine is actually your husband's, and he's here right now because he's claiming rights to his woman and his son."

When I contacted my husband, he immediately denied it. "I don't know what he's talking about."

"Why would he send this to me, D____? I haven't talked to him since he moved back to the States."

"It's all lies. He's one of those haters that try to break people up."

"I'm not buying it. Tell me the real reason why you're there."

"For court."

"You need to just come out and just admit it," I said to him.

He broke down. "It's true. It's all true."

"Is that baby yours?"

"Yes," he said.

"We have benefits, you have a good job and security," I said to him. "Are you sure that she is not using you?"

He said, "Nope, I love her."

I've known this woman and her husband for years. The two of them eventually moved back to the States, but for the time that they lived in Japan, I told them, "If you guys need anything, we can help you." I offered to help because we were an older couple, and we knew living in a foreign country could be difficult.

There were always trust issues with them. The sergeant confided in me that he doubted his daughter's paternity but vowed that he would raise the little girl as his own. I assured him that moving to Japan helped my marriage and that this move could be a new start for him and his wife.

"Is there any way that your husband can get my wife a job at his work?"

I said, "Sure, no problem." So, of course, I talked to my husband, and he was happy to comply.

"Tell her to put in an application," he said. "I'll see what I can do."

My husband started his affair with the sergeant's wife when I was stationed in City D for nine months. While I was gone, my husband hosted a Christmas party; she made an advance on him after a year of working with him.

When I talked to him later that night, he told me a random woman had come onto him, but he didn't say who.

"You know people are kind of funny," he said.

"Why do you say that?"

"There was a lady there tonight. As we were talking she said to me, you know my husband's gone, your wife's gone—technically, we're both single. Why don't we get together and take care of each other while our spouses are gone? I know you're a man, I know you have needs. I've always been attracted to you and, you know, if you're game, I'm game."

"Wow, people are bold," I said.

Never in a million years did I suspect that it was the sergeant's wife he was talking about. I dismissed the whole interaction, because if you had asked me a day before I found out my husband was cheating, I would have told you that I had a good marriage and that my relationship was strong. I did not find out that my husband was cheating on me until we were 16 years into our marriage. I'm not going to say I didn't have any idea that he was capable of cheating, but I wasn't looking for signs. To an extent, I didn't care because he was doing what he needed to do within the household. He was also good father and provider for our kids. I probably did let a lot of things slide because I trusted him.

The affair with the sergeant's wife was one of multiple infidelities. According to my husband, he's had over 40 affairs during our 16-year marriage. That's like two and a half affairs a year. Before Japan, we lived in other countries. He had women on the side in every place we've ever lived. He said

the first time he ever cheated on me was three months after we got married. He started getting into swinging when he started his affair with the sergeant's wife. They were into a lot of sexual stuff that I would never do. She liked adding other women and sometimes men into the bedroom, although he wanted to make it certain to me that he was not gay.

Most of his affairs were with women from his job. I hated visiting him at lunch or calling him at work. His coworkers looked at me funny, and even rolled their eyes when I walked in. Now I know why they looked at me funny. Because the women there were screwing my husband. Some tried to give me clues. There was one woman who answered the phone, and when I told her that it was his wife calling for him, she said to me, "Well, there are so many women that call here for him that I didn't know who this was." I never picked up on it. I never thought, "Well, why are so many women calling my dang husband?" The same woman answered when I called another day and she said to me, "Girl, you need to open your eyes cause your husband got women calling here all freaking day and night for him."

"Oh, they just jealous of you," my husband would say. "You know how pretty women are always intimidated by other pretty women."

Despite the multiple affairs that he was having at work, he was committed to the relationship with the sergeant's wife. While he was still in the States to declare paternity of her son, I asked him, "What are you gonna do? You're in the States. I'm in Japan. Are you coming home? Are we trying to work this out?"

"I don't want to give up my family, but I don't want to give her up either," he said.

"Well, I can't be a wife that allows my husband to openly have an affair."

In reaction to my ultimatum, my husband and his mistress decided that they were going to go back to their spouses, but they didn't come back to reconcile—they did it to torture us so we would divorce them.

As soon as we got to the house, he got on the phone to call her. I snatched the phone.

"You are not just going to disrespect me," I said to him.

"She needs to know that I made it home OK."

"I'm done with this crap. You're not going to use my phone."

We were tussling with the phone. When I grabbed his shirt, it lifted upwards and exposed hickeys all over his body. He had probably over 25 hickeys from head to toe and between his thighs. It was just nasty. He even had hickeys on his d-i-c-k. Before he came back home, she told him, "If you're gonna go home to your wife I'm going to let her know that you're sleeping with another woman."

She'd call my house and say, "Let me talk to my man."

Most of the time I would just hang up, but when I would come home from work, my husband would be laying on my bed on the phone. "Yep, she

just got home from work," he'd say out loud. "Uh huh ... she knows I don't want to be here. She knows I'm in love with you. I don't know why she won't leave me. I don't know why she won't kick me out."

Sometimes she would call to try to negotiate terms of our relationship. "I want to make you a deal," she said. "I'm okay with D____ being with you. But every three or four months, he should fly home and spends two weeks with me and my son."

"Okay, look, I don't know what kind of marriage or world you live in, but I'm not into sharing," I said to her. "I'm not allowing my husband every three or four months to go with his little whore and then come home and pretend like nothing's going on."

"Well I think it's going to be the best solution for everyone," she said. "Because I'll be honest with you. I don't think D____'s ever going to give me up, and I know I'll never give him up. You and I know that he doesn't want a divorce."

They had rationalized in their minds that if their spouses divorced them and then they got married, then God would be okay with that. Because God will understand their spouses left them, so what they were doing was the right thing to do.

My kids were teenagers totally in tune with what was going on. They asked him, "How could you disrespect my mom like this?" I was trying to work things out because we have a family. We'd grown up together. I thought we were friends.

I told him that he couldn't have the best of both worlds. It doesn't work like this, either you divorce me and pursue a life with her or let her go and do right by my kids and me. "I just need some time to think," he said. "It's not fair to her that I'm here with you. I can't decide what I want when I'm living with you."

"I'm done," I told him.

"I don't appreciate how you handled this whole situation. You need to figure out if you want your man because you need to fight for me. She is willing to fight for me. And if you're not prepared to fight for me then guess who's gonna win?"

"I'm not going to fight for my husband," I told him. "If you want to be with her then that's the decision, but I'm not going to fight. Fighting over a man is high school crap. You are my husband, not my boyfriend."

"Well, that's the problem, Dee. I know that she wants me, and I don't know where you stand."

"We have three kids, and we've built a whole life together," I told him. "I've always been an anchor for you. I've been with you through thick and thin. I could have killed you. I could've literally lost my dang mind and killed you, but I'm still here trying to figure this whole thing out."

"Well I'm going to give it to the end of the month," he said. "To see how you're acting, then I'll make a decision. If I decide that I want to be with her, I'm leaving. If I want to be with you, then I'm going to give her up."

"Okay, I'm gonna take the kids to the States to be with my family. You've got two weeks to stay here in Japan and get your head together. When I come back, you figure out what you want to do." I felt like I was a stronger woman by giving him the option to think about it.

When I got to the States, I called my husband multiple times to no answer. Then I get a call from the sergeant. When I answer, the sergeant says to me, "Did you know that your husband is with my wife?"

"There's absolutely no way. I'm in the States—how on earth is he here too?"

"He's here, Dee. He threw a rock and busted my car window. I expect the both of you to pay for the damages."

I found out that as soon as he dropped me off at the airport, he bought himself a ticket. When I confronted him about lying to me, he said that it was because I didn't want to be with him on Christmas, and therefore he went to a woman who appreciated him.

While the kids and I were with my family, my daughter got sick so my husband came to stay with us. During that weekend, my husband couldn't get a hold of his mistress. He was staying with us and going crazy crying to me. When I checked our phone bill from that day it showed he called her 51 times. "I can't get a hold of her," he said. "What if something's wrong?"

"I'm going to bed," I told him.

"She's really weak, she may have committed suicide."

"I can't stay up all night and watch you cry over her, D_____."

"What if she did something to her or my son?"

When my daughter came home from a sleepover, she was feeling worse. We thought it might've been food poisoning, and I assured her that she would be okay. She was my straight A student, but also my drama queen and, despite her concern, I told her to lay down on her bed and that she would be all right. I went about the day running errands, but something told me that I needed to go and check on her. When I got home, I touched her head, and her fever was high. Her eyes were rolled back. She stopped breathing.

"Oh my God, D_____, she's not breathing!" I screamed.

My husband ran down the stairs and did mouth to mouth to her as I called the ambulance.

My daughter had diabetes and had a heart attack. Her blood sugar and blood pressure were astronomically high.

She stabilized at the hospital, but the neurologist told us that she had no brain activity. If she survived, she would have limited mental capacity

because she had no oxygen to her brain for such a long time. She had three heart attacks throughout the day, and the last one took her life.

My husband just killed my daughter, I thought. We lost her. For one second, I thought my husband would do the right thing, but the very next day his mistress called my house over and over. His sister finally picked up our phone and said, "Have you lost your damn mind? Dee just lost her daughter. You need to back off." I think she thought he was gonna do the right thing and leave her. She felt like she was going to lose her man.

I finally picked up the phone and said to her, "I have been patient with you since I found out about this affair. I've never attacked you. My daughter just died. I can't take this anymore. I'm going to bury my child, and then I'm driving out to your house to whoop your ass 'cause I'm done."

"You know what, Dee," she said. "Don't nobody feel sorry for you because you lost your child. I'm still going to take your man, and me and D_____ are still going to be together."

"That's fine that you're gonna to be together, but I'm still going to whoop your ass," I said.

She was like, "Oh, well, bring it on, bitch. Because I've been waiting to kick your ass for a long time."

On the night of my daughter's funeral, my husband decided to stay with his mistress. He didn't care. He didn't care at all. He didn't care about my kids or me.

His mother was sick, so when she got the news about my daughter, it put her in ICU, and she couldn't come to the funeral. His mother begged him, "Please stop, please stop, your child is dead. You need to be there for your wife and kids." After the funeral, we went back to see his mother because she was not going to make it. He and I weren't talking, but on that night he asked me for money. "Why do you want money?" I asked.

"I just need it."

"No, you can fuck yourself."

"You know what? I'll just take it." He went upstairs and came back downstairs with my purse. "You're a bitch," he said to me in front my whole family. "You don't have a husband 'cause you don't know how to treat a man. You don't know your place as a woman, and that's why I found a woman that knows how to treat her man."

My husband's a big man—he's like 6'1". I'm 4'10", and for the first time, I tried to knock his fucking head off. I swung at him with all my might. My family did the best that they could to pull us apart. They held him down until he calmed down and they told him to leave. Since the day he abandoned his family at my sister's house, he's been gone from our lives ever since.

My husband and I separated the day after we buried our daughter, and

he went to go live with his mistress. The illegitimate son that he thought was his belonged to another man. She had been sleeping with other men the whole time she'd been with him, but then she got pregnant again. Since the second baby was his for sure, he stayed with her. He's too prideful to say I messed up, I left a good woman. I left an educated, independent, hard-working black woman for this hoe that doesn't work, sits on her butt, takes all of my money and doesn't do anything. Instead, he'll tell people that leaving me was the best decision he's ever made, and that he finally found a woman who loves him the way he wants to be loved. The truth is I believe he's miserable, but he's too prideful to say it.

I went to an attorney, got divorced papers signed, and when I gave them to him he said, "I'm never going to divorce you."

"D_____, in God's mind you're an adulterous dude, and you're going to have to be held accountable, and you're going to have to answer for this. You don't want to be with me. You're treating me like shit. You left me and my kids. Why won't you get a divorce? Why?"

"God has not put that in my heart."

I don't think that he gets that he destroyed a family. I don't talk to him too often, but when I do talk to my spouse, I do tell him that you didn't just leave me, you left your kids. Your son is now another black man raised in a home with a black mother with no father. If I'd known that my son would be raised without a father, I would have never had a son. I know how hard it is for our black men just to grow up in this world period and to grow up without a father is way worse.

He had left us emotionally, financially, physically and he's with her physically, financially. If I were a weaker woman, I would blame myself. Right now, I'm abstinent. I don't want to date and start over, I'm too old. I am at a place in my life where I'm very spiritual. When I look at the apostle Paul, the Bible says he was single and that it was better for him to remain single because he could do his work with the Lord and not be distracted. For married people you do have a distraction because if you really love your spouse, you put your spouse ahead of you and that can be a distraction in your relationship with God. I don't want those distractions.

I've decided what I want to do with the rest of my life. I want to be a servant. I just want to help people and serve people and minister. I want to introduce people to Jesus. My standards are so high that if I ever dated or found another man, God would have to be first in his life. I don't think that this man exists. God knows my heart, and he knows the hurt I have been through. Love doesn't mean sex to me. I don't need to have sex in order to be whole in this world. What I went through with my daughter made me realize that life is so precious. We never know when it's going to end. If I were to die tomorrow, the world can say I was complete.

Understanding Public Infidelity Betrayal

Unsolicited third-party disclosures surprise the primary partner with public news about her private life that failed to come from her partner. Public infidelity confirmations require self and social management, as women must decide how to handle themselves, their partner, his concurrent relationship, potential children from that relationship, and everyone else who now knows and has an opinion about her and what she should do next. Use of the word public includes anyone other than the two relationship partners. This group may include complete strangers, but more than likely is limited to the couple and the affair partner's personal and professional communities.

Learning that a partner has been unfaithful through an unsolicited third party is a devastating discovery method. A woman is likely to be very embarrassed if not humiliated because she was "unaware of the violation and abiding by the relational rules despite her partner's failure to do so."[3] Put another way, it will be difficult for a woman who discovers infidelity through an unsolicited third party to save face because she may feel like the last to know. Facework is a concept that describes the desired image individuals wish to convey to others.

Facework threats to one's identity as a dutiful wife in a happy marriage are incredibly high when a husband's Other Woman shows up at a wife's door to tell her that he's been unfaithful, like what happened to Kathy and India. In "When Better Becomes Worse Black Wives Describe their Experiences with Infidelity," Other Women frequently made front porch appearances.[4] The fact that India's mother forewarned her that "one day a woman would come knock on her door" confirms its commonality. Other Women also communicate via voicemails, direct messages online, and subs, short for a subliminal "underhanded comment directed at a specific person meant to insult/embarrass them publicly on a social networking site."[5]

The face-to-face confrontation, however, is the most difficult to navigate. First, it could be dangerous. As Kathy told her husband, "That woman came to my house, and she could've killed my son and me." Second, if a primary woman shows any emotion like surprise, hurt, anger, or fear, the Other Woman would gain the upper hand. Most women like Kathy refuse "to give her that satisfaction" and wait for a private space to break down.

India's situation differs in that she was already divorced when a woman came to her door, but she was shocked to learn that (a) she had essentially been financing this woman's affair with her ex and (b) this woman birthed a son by her ex-husband whose name was the reverse of India's son's because she "thought it would be cool to have two sons with the same name." Pregnancies and babies are also recurring third-party disclosures. Dee's initial

information about her husband's affair came from the husband of the wife who was allegedly having Dee's husband's baby.

Children born as a result of a betrayal experience are an irrefutable discovery. Wives must determine the type of relationship they will have with that child and his or her mother. All of the adults involved must determine how to protect children from their own third-party discoveries about a parent's infidelity either from other family, peers, or the Internet. Children who are aware of their parent's infidelities must be taught to distinguish between family secrets (to be avoided) and family privacy (to be respected).[6]

When wives have children of their own who are the same age as children born of the betrayal experience, they must also create infidelity narratives appropriate for the siblings. No one discusses how they integrated their children, but Kathy and Stacey both took in the outside children. Kathy contained her anger and forced herself "not to be the evil stepmother" for as long as she could. Stacey loved the children as her own. Willa drew firm line and told her husband's Other Woman that their child and his child support were not her issue. In these complex circumstances, wives must negotiate family relationships with both guilty (Other Women) and innocent (babies born of an affair) parties.

The prevalence of pregnancies in betrayal experiences is not just about the babies. The unprotected sex that conceived them transmitted STIs. Further devastating are unsolicited doctor disclosures that a faithful wife or girlfriend has contracted an STI. Danielle found out from abnormal lab results. Stacey's husband told her he had herpes because she was pregnant. Willa's husband gave her pills the doctor gave to him. Even though Willa was livid, she "didn't want to start World War Three around the kids." This recurring emotional suppression characterizes the facework adopted by wives who did not want to draw any more attention to the fact that their husband was having an affair. Similar sexual violations will recur throughout this book's narratives.

Unsolicited disclosures are not limited to Other Women, their children, and medical professionals. Sometimes the admissions were unintentional. An unwitting disclosure includes Willa's coworker who said she saw Willa's car when Willa knew she had not been driving it. Or Janet's boyfriend's neighbor who didn't know they were together as she gossiped about the girl with the funny-looking haircut who came over when Janet was at work. Or India's attention to furtive glances between her husband and women around town. Intentional disclosures include Stacey's relatives who shared information hoping she would finally leave her husband, and the woman who answered the phone at Dee's husband's job and said, "Girl, you need to open your eyes cause your husband got women calling here all freaking day and night for him." Third parties are bevvies of information, and so is the Internet.

Danielle describes the hellish experience of herself and her entire company discovering her partner's sexual misdeeds via technology. Danielle's identity as the boss was certainly undermined when an employee emailed a picture of her and Danielle's man lying in bed to her entire staff. In addition to the public nature of Danielle's discovery, the third party's identity as a subordinate was additionally compromising.

For anyone who knew Janet was faithful to her boyfriend, social media publicly confirmed that he was also seeing someone else. Janet used this publicity to her advantage as she gathered tangible evidence of her boyfriend's relational transgressions. Technology is increasingly becoming the common way infidelity is facilitated and discovered. When a partner's infidelity is outed via email or social media, it is akin to an unsolicited third-party discovery. Digital indiscretions, however, differ in their permanence and their reach. Emails and screenshots can be saved and shared indefinitely to an unknowable number of people.

Whether the betrayal experience is broadcast widely or contained among a knowable number of individuals, when losing face in a very public and sometimes permanent way, the injured partner usually desires verification or an explanation which necessitates a solicited confirmation. An additional reason that unsolicited third-party discoveries are so devastating is because the partner is not present to clarify the message or help the betrayed partner save face. In the absence of immediate confirmation, the injured party ruminates on "the veracity of the information, rather than the betrayal and its implications."[7] This can lead to negative mental health stress or positive thoughts about the partner and the relationship as a form of refutation.

According to relational communication researchers Afifi, Falato, and Weiner, when the transgressor's infraction is verified, "the partner's need for consistency makes it very difficult to disregard the positive qualities upon which she was ruminating. Instead, the reality of the betrayal hurts tremendously, leading to a relative unwillingness to forgive, but the relationship survives."[8] The researchers identify an interesting pattern. Unsolicited third-party disclosures are incredibly damaging to the relationship, highly unlikely to be forgiven, and yet unlikely to lead to dissolution.

Correspondingly, despite what many would consider the epitome of relational adversity, none of these African American women immediately left their partners. Perhaps they did experience cognitive dissonance between their partner's egregiously embarrassing actions and his positive qualities. Perhaps a closer look at positive facework may further explain their decisions. In order to maintain an image others would perceive as positive, these women may have elevated their family over themselves. Despite pubic embarrassment, saving their families, i.e., keeping them intact, was more important than saving face as individuals.

Research on African American relationships emphasizes an infamous imbalanced sex ratio where more black women are available than black men within the ages of greatest marriageability. Marriageability is defined as exhibiting characteristics of economic security and emotional maturity. The imbalance was documented as early as 1850.[9] The continuously high contemporary black male mortality rates, the disproportionate numbers of black men in prison, on probation, or on parole as well as those who marry interracially contribute to an imbalance today. The actual ratio, however, has fluctuated throughout African American relational history and is contingent upon demographics. Nevertheless, the perception of a black sex ratio crisis, bolstered by media and pop culture, creates the belief that a good black man is hard to find.

As a result, black women frequently compete for black men and rates of partner sharing, infidelity, divorce, and STI transmission are higher among African Americans than other cultures.[10] The "stand by your man" and "ride or die" maxims in the black community are a form of cultural facework that resist an even broader public's pathologies about broken black families.

Willa describes the moral and cultural imperative that marriage is forever as "old-school black culture." She was willing to follow the prescription and remain with her husband without completely forgiving him. Dee, too, was very willing to work on her marriage despite her husband's multiple affairs. Her nonnegotiable request was that he give up his main Other Woman. She wanted to save her family so much that she said, "If I'd known that my son would be raised without a father, I would have never had a son."

As much as facework theories help rationalize a why a woman would stay after a public infidelity betrayal, it seems the most common reason women stay is love. Danielle, Kathy, and Stacy name it explicitly. Janet seems to be persuaded by her partner's declarations of love despite his actions. Robert J. Sternberg's triangular theory of love includes the multifaceted combination of intimacy (closeness and connectedness), passion (attraction and arousal), and commitment (a cognitive decision to remain in a relationship).[11] Each of the women could have maintained a different mix of the three components and still sustained their love. Love is the intangible bond, but that bond is not immutable. None of the women in this sample left immediately, but with the exception of Danielle and Janet (the two dating relationships), the wives eventually did leave.

At their turning point, the decisions were no longer based on others—community impressions, family desires, or love for him. Instead, they were inwardly focused on the self's needs. In fact, Stacy is clear that although her love for him remains, her love for self supersedes it. This generally positive shift to self sometimes results in a potentially negative extreme social with-

drawal. A woman may withdraw from social spaces because of public judgment, perceived disapproval of her decision-making, and/or pain.

She may also withdraw from future intimate relationships. After experiencing her husband's multiple affairs, his blatant disrespect in front of her family compounded by the agonizing loss of her daughter, Dee decided upon the ultimate intimacy withdrawal where she will remain single and never date again. Stacy also declared that she could not date because her husband has taken all her spirits away and left her unable to trust and move forward. Public infidelity betrayal has its share of private implications. An introspective shift may be wise for one's decision-making, but it also may be unnecessarily isolating when it comes to finding love again.

I Experienced
"Infidelity Plus"

Recovering from an infidelity betrayal experience takes as long as it takes. Word on the street (and the Internet) suggests it often takes half the amount of time one spent in a relationship to heal.[1] While some people remain in search of formulas and deadlines, there is no universal prescription for how long it takes to rebound from an infidelity betrayal experience whether one mends or ends the relationship.

This section, however, proposes that a woman's adaptability period or recovery time may be impacted by "infidelity plus"—the coexistence of infidelity and other forms of intimate partner aggression. Infidelity is often presented as an isolated transgression, but when it accompanies other forms of aggression, it can compound the pain of a woman's experience and either accelerate her decision-making by providing additional reasons for relationship termination or delay her decision-making by compromising her social support, financial resources, and mental and/or physical health.

These women's ages ranged from 34 to 61 with an average age of 46 at the time of the interview. Five are black, three are white, and one is biracial (white and Latina). One spent some time in college but did not graduate, two were college graduates, and six had professional or graduate degrees. The relationships described in this section are heterosexual with the exception of Dot (bisexual), Sam (lesbian), and Forsythia who identifies as heteroflexible. Heteroflexible is generally understood as a primarily heterosexual orientation that is inclusive of minimal homosexual activity. All of the heterosexual/heteroflexible women were wives when they discovered their husband's infidelity. Of these nine women, Elizabeth's relationship was the only one to survive.

Elizabeth

"Affairs don't happen to nice middle-class Jewish girls!"

It was a classic mid-life crisis. He was struggling at work. We were having struggles in our marriage. He was having some kind of personal mid-life career struggles—not sure he wanted to do the thing he was always doing, so he went back to school. One of his peers was the person he made the connection with. He told me he was very attracted to someone in his class and had feelings for her. I asked if anything happened. He kind of alluded to maybe there had been a kiss.

We have since talked, my husband and I, over the past few years, and it's a he said, she said. He is pretty clear that he told me that there was something sexual going on. I'm pretty clear that he didn't say that. He may have said it, and I didn't get it. He may not have said it and thinks he did. I have no idea, but he was honest over the entire thing. He told me about her. I didn't believe him. I didn't get it. I didn't pay attention. I was in denial until I wasn't.

I was very, very angry, but I couldn't really grasp specifically what it might have meant. No one in my family had ever had an affair, and, as far as I know, that's still true. No one I had ever known had an affair; I never even knew what that was. There's no one divorced in my family. There's only one person divorced in my husband's family. In our contacts, the idea of divorcing, it doesn't exist. Everyone stays together forever. As I famously said to my rabbi, "Affairs don't happen to nice middle-class Jewish girls!" Infidelity was just so foreign to me that I didn't accept it because I didn't really know what that meant. It was naïve, but I was living in a very naïve world.

We were arguing for weeks and weeks about him not being sure he loved me and whether he wanted to stay in the marriage. So we went to a counselor. She prodded and asked him if he were physically involved with his Other Woman, and he said no. I've known this guy for 28 years. We'd been married for 21 years. He's not capable of lying. I looked at him and thought, "Oh shit, he is having an affair, and he's lying to the therapist." He later admitted that he was lying because he's a terrible liar. At that point, my naiveté left. I had to really see it in the therapist's office, but I still didn't see it. I just said, "Oh my God, he's having an affair. He really is. Not 'Elizabeth, he told you a month ago. What took you so long?'" I didn't see it myself, I was just too mad at him.

Then I wanted to know who she was, how they met, whether he brought her to the house. I wanted to talk to the bitch. E_____ and I had switched cell phones. He was getting a new one, and I got his old one. And there's her

number. I told myself I shouldn't call, but I called her anyways, and it totally freaked her out. It was at a period when I wasn't sure the affair was over or not so I asked, "Are you still seeing my husband? She said yes, and I'm sure I said nasty, bitchy things. I don't remember. Then I called my husband and I said, 'She said you're still seeing each other. I thought you were done. When I come home tomorrow, you're going to get the fuck out of the house.'" My husband is a strong, tough, fearless guy. Nothing fazes him, but when I got home that next day, he was like frantically getting his crap together and getting out of the house. I just had some hell in me, like, "If you don't get out of the house, I'm going to come kill you."

We were still having sex until he moved out. My husband was my only partner; we got married soon after college. I heard single friends talk about AIDS and STDs, but it didn't really register until a girlfriend suggested that I get tested. I told E_____ that we should go get the AIDS test, and he agreed. He claimed that this other woman was fine because she'd only been with one person. I thought that was bullshit. How can you know for sure? I'm not that naïve. He never admitted to having unprotected sex with her, but I got the test and was fine.

I was still anxious every day, thinking, "When is this over? When is this over?" It was September or October when it happened, and I kept writing April on my checks or calendar or anything that I had to write, because someone told me just to wait it out for six months and see what happens. I had in my mind, "If I can just get to April, I'll be fine." It was a disassociation of the present. Of course, it wasn't April, but I wanted to leave and get divorced right away. I was throwing crockery and my vases, all sorts of dishes. I was a screaming, angry, in-pain woman. Infidelity is such a profound, profound, profound, painful trauma that changed my entire life. I thought I would commit suicide. It brings you to your knees. It completely shatters who you think you are and what you think your marriage was. It's a deep wound.

From that point on, I started telling everyone, and I mean everyone, that I could think of. I told for two reasons. One, I told everyone because it was really the only thing I knew how to do. I was in so much pain, I thought if I don't tell someone, I'm just going to die. I have a really good, super network of amazing friends and family. I'd been through other things in life and gotten their support, so I knew that talking to people was the only way in hell I was going to make it. So I just told everyone. I told his parents, a few of his coworkers, my entire family, all my doctors, my therapist, my internist, and my gynecologist. I told from anger, for revenge, for support. I didn't really think it through. I just told. I don't think there's a person in my circle who doesn't know, and I wish some didn't know, but there it is. As soon as I started telling people, I realized how naïve I was because it happens all the time in all kinds of circles.

The second reason I told everyone was because I wanted to shame him. People would know our marriage was crumbling, and it was his fault. I was so angry, I thought if I tell people, then they'll know it's not my fault. I didn't think it was my personal fault, like I had driven him to this, but I definitely felt like, okay, our marriage is in trouble, and it's been in trouble for a while, we just need some counseling, but my heart wasn't in it. I had gotten to a point where I knew it wasn't like it used to be, but I could live with it. I settled for it. I didn't realize we were really growing apart. Then he went back to school, had this whole other world that I wasn't a part of, and started this affair with this person he met there. I don't remember a lot of the emotional resonance. I just know I was very angry. I was in a lot of pain, and I was outraged that the world had brought this to me. I don't remember thinking this was my fault, but I remember feeling ugly, unsexy, unlovable, and old, which is different than thinking it was my fault.

No one said anything or suggested anything, like, maybe you didn't take care of the marriage or maybe you weren't good in bed or maybe this was inevitable. If they thought it, they didn't say it. Actually, my mother-in-law hinted at one thing like that, and our relationship has not been the same. My girlfriends all said they would support me whatever happened if we got divorced or stayed married. From when he told me about the affair to its end was about five months.

During that period of time, we separated for a few months until he ended his affair and said he wanted to try to rebuild. I didn't want to rebuild for a long time. It took a long time. E_____ worked far harder than I did. He had come to his senses, like, "Oh my God, what the hell. I almost ruined this. I almost blew it," and he did, because I wasn't sure that we were going to rebuild. I think a person who has an affair has been abducted by an alien. It's like they're somebody else for a while, and they either come out of it or they don't come out of it or they come out of it too late and the marriage is over. He came to himself, or the aliens returned him, but a part of me was really looking forward to being single, because I've never been single in my life.

I've never, ever been single. I met E_____ when I was 21, and I was excited about dating because I'd never done it. Maybe the universe brought me a new life. I started dating, which was way too soon to be doing anything being that raw. But I wanted to reassure my sexuality and reassure that at 45 I was still dateable even though I didn't know how to date and I'd never been online. I thought it was prudent to prove to myself that I could do it. I clearly know now that I was having revenge relationships.

E_____ was determined, though. He really wanted us to go to this couples' weekend. I agreed and it was a really informative jump-start to our relationship. After that I agreed to seriously go to couples' counseling. We went to individual therapy. Our daughter had a therapist because although she didn't

know about the infidelity, she knew that mommy and daddy were separated, and we had talked about potential divorce. We all had a lot of therapy. We read websites. We read books. He was very forthcoming about when she would call or email, or he would run into her at Trader Joe's. We talked and talked and talked all the time. We rebuilt our marriage. It took us a full year of solid work to really rebuild the marriage and rebuild trust. Since then the marriage has been great.

Talking is key. I'd tell any wife going through infidelity, if your husband isn't ready to talk to you, then tell clergy or a professional therapist or a peer-support network or girlfriends or family or anyone you think will understand because you can't keep it all inside of you, you'll just explode. It's too big to hold. It's too painful and too dangerous. It's like holding something really hot. The more people help you to hold it, then the heat is released in your little area. Be active in telling people but be a little passive in what you do because you don't want to make a mistake you can't undo. Don't make any sudden decisions. Take a deep breath and try to go day by day and see how long you can wait before you decide what to do.

A husband's affair is one of these things that, if the woman can get to the point of understanding that her husband is doing it to escape his own emotional crisis, then it's not her fault anymore, it's his. It's on him; it's his choice. All you can do is work on your own healing. A therapist gave me this great sentence that really helped me. He said you have to rephrase it from "Why did it happen to me?" to "Why did it happen?" When you make that switch, you're suddenly far more powerful. You're not a victim anymore. As soon as you start believing it's not your fault, then everyone around you will follow suit, except for maybe your mother-in-law, but everyone else will get that energy; it's not your fault.

Sam

"It was very frustrating to feel like I had paid for the
social activities that led to her cheating on me."

Years ago my partner and I met at work. At the time, I was working at a lot of sporting and music events. She and I worked for the same company and we got drawn into working together. From there we started talking, friendly texting, and then eventually invited each other to go out to do stuff. The way our relationship started was more organic than picking someone up at a bar. We were kind of interested in the same thing, and for the first time in a long time I was with someone that was stable and down to Earth.

I have never been a suspicious person, but I noticed a change in her per-

sonality. During the last six months of our relationship, she started texting someone all the time. It wasn't anything that I was really concerned about. She expressed a desire to spend more time with friends from her hometown, and I was very supportive. I even gave her money for spending and gas. Whenever she would come back from seeing her friends, she would do this self-imposed weird exile. All she wanted to do was sit on the couch, play video games, and text. She lost the motivation to participate with me or any of our mutual friends in the things we used to enjoy. Whenever I would walk into a room, all of a sudden, she'd put her phone down. Whenever she would do that I would say, "What's the big deal? I don't care what you're doing." In retrospect, I should've cared, but it's not natural for me to get paranoid just because my partner is texting someone on her phone.

On Thanksgiving morning, we were in the car trying to arrange plans with her family. Within 15 minutes into our drive she dropped a bomb on me.

"I've been cheating on you."

I was silent for a moment because I thought it was a joke.

"It's with someone that you know," she said.

"You gotta be kidding me. Who is it?"

"F_____."

"From work?"

"Yes." She went on to tell me that she had been seeing this woman behind my back for months. "I didn't want to lie to you anymore."

"Did you fuck her?" I asked. She didn't answer.

I didn't need to know if she slept with her because I was threatened. My attitude towards sex is different from most lesbians. Sex and relationships are two different things for me. I can get more of an emotional life out of a lot more things than sex, but my girlfriend went out of her way to see this woman, and I wanted to know why.

"F_____ is picking me up later. I'm done with us, Sam," she said. "When she picks me up, I'm going home with her."

I really thought that she was just pulling my leg, but when we pulled into the driveway she threw the keys in my lap and walked into the house. I just sat in the car, and I realized that it was actually real. This was really happening, and it was happening right then. I got out of the car and followed her into the room. I hopped online into our joint account together, and I transferred those funds into my personal account. I don't even know why I did it. It was kind of a very autopilot thing. Once I realized that this was real, my mind automatically shifted into crisis mode.

F_____ was somebody who was very dramatic and enjoyed entanglement. She worked with my girlfriend and me. When it came to drama, F_____ loved stirring the pot. I clashed with her personality. I would never have this

woman in my social circle, but it's not for me to dictate to my partner who she can and cannot be friends with as much as I would've loved to have put my foot down and said, "Do not hang out with F_____. She's just bad news." I don't regret not saying anything. If you have to dictate who your partner can and cannot spend time with then that's not a healthy relationship. I certainly wouldn't want anyone telling me who I could spend time with, but the fact that she never admitted to spending time with this person was lies by omission.

If I had to say that there was one thing in the relationship that wasn't working for me it was the sex, but I wouldn't have cheated. I never really put this emotional attachment towards sex. It's just fun and feels good. I was pretty promiscuous in my 20s, so it wasn't a big deal. The trust between my girlfriend and I was more intimate, and that support doesn't have anything to do with sex. We're adults and everyone has gone through break-ups, but my anger was more from losing my best friend.

When F_____ showed up to take her and all her stuff, I was too much in disbelief to allow myself to be in a full rage. I watched them leave, and that was it. I kind of sat there perplexed and had a cigarette. After I told my roommates what happened, I went to go grab some beers from 7-Eleven, drank until I fell asleep, and called it a day.

Since her confession about her affair with F_____, she's admitted to lying about other things. Those lies were probably the most out of character thing about it. I thought I was in a very comfortable and settled relationship. When this whole other person emerged, I was all of a sudden dealing with a stranger who I'd never met before. She clarified an event that happened last year. There was one time she said she had to go visit her family because someone was sick. A few days after she left, I called her family. I wanted to give my regards, but I found out that she hadn't been down there to visit them. I called her. "Where the hell are you?"

"I had to stop at a hotel halfway because my car broke down. I had to stay here for another day because the mechanic had to order the part."

"Okay," I said. "I just wanted to make sure you're okay. Your family was worried." I accepted that as her explanation. I'm just not the type that automatically jumps to the worst possible conclusion or scenario. I know now that she was with F_____, but I don't think I was being naïve. I was sincerely worried about her and she took that for granted.

Then one day she came to the house unannounced with an itemized list of what was hers but ignored the fact she still owed me money for bills. We lived in a house together with some close friends. Before she left, she never had a conversation with the rest of the housemates about settling her financial affairs. She left it up to me to deal with the fallout of making sure that the finances were all in order.

When she demanded that I give her the items on her list, I threw the gauntlet down. "You can't forgo your bills." I told her. "We won't make it. They'll evict us." "I'll get to it when I get my next check," she said. I didn't believe it. Getting her to finally pay took more communication than I wanted, but she finally folded and gave me the money.

She still owes me a significant amount of money. While I was doing little audits of my accounts, I saw all of these purchases that were clearly part of this affair. I got parking tickets on my truck while she was seeing F_____. After we broke up, I had to pay those fines. The times I had given her gas money or let her take my car while she was with F_____ was a form of financial infidelity. It was very frustrating to feel like I had paid for the social activities that led to her cheating on me.

We still have a few joint accounts that haven't been separated yet, but neither of us want to deal with it. I get the sense that she's mad at me, but I can't put together why. I think maybe it's because there is a mirror now that's held up. She's always prided herself on being someone who is honest, dependable, reliable, and loyal and every time she has to communicate with me it's a reminder that she's not any of those things. We have these very short and unhappy communications, because she still owes one of our roommates money from some random loan that she took out without my knowledge.

Dealing with the financial crisis helped me ignore the emotional part of our break-up, but once I got the finances sorted out, I had to face it. I think my mind couldn't wrap itself around shedding a tear for someone who had been so dishonest and insensitive about the whole situation. I would've never imagined that I was in a relationship with a pathological liar. To me she was the most stable person I ever knew. I went through a lot of feelings of anger and disbelief because the whole lying thing threw me for a loop. If you asked me before this to give you three adjectives that describe my partner they would be honest, dependable, and loyal. Hands down. That just would've been it. If you asked me after to give you three adjectives, they would be dishonest, disloyal, and manipulative. I want her as far away from me as possible once we get our financial matters resolved.

After our break-up, I expected a month of sobbing in the corner and that completely didn't happen. Instead it was like a month of me going out and meeting a ton of new people, having a blast, and really enjoying myself. If your partner cheats on you, it's definitely an indication that your relationship has failed. The second you turn the spotlight back on yourself is when just everything gets better. It can take days, weeks, months, but I guarantee if you put that spotlight back on yourself, it will open up doors.

Teah

"He was playing Russian roulette with his health and mine."

We had just gotten engaged. We were supposed to go to a friend's barbeque, and I saw him walking down the street holding hands with a female that I had never seen before. I just froze and didn't say anything to him. He happened to look up, saw me, and came running across the street trying to explain. I don't even remember what he said exactly. She completely disappeared.

Now, that's debatable to some people on whether or not that was infidelity, but it certainly, certainly bothered the hell out of me because I had no idea that he was that willing to just be out in the public doing something that clearly wouldn't be acceptable or that would hurt me. It was painful. I don't think I felt more shocked and hurt by him than I did at that point. It was just like, "You're doing this around a bunch of people that we know." He was at a barbeque with our friends, his best friend, and his best friend's fiancée. My immediate thought was, "If you can do this with people that we know in an environment that I was supposed to be at, what else have you done?"

Later I realized there were a bunch of people there that knew he was there and that I wasn't there and that he left with a woman. It made me look at his friends and the friends that we had in common. Were they really my friends or were they really just his friends? Were they our friends? The fact that nobody told me was just as crushing. Not like I expected the relationship police but just having the assumption that some people would have my back or at least would be honest enough to say, "I don't know what this is, but this is what I saw."

I had a whole lot more doubt, and a whole lot more questions. It just made absolutely no sense to me. I was confused as hell, but I didn't take that as a reason to end the relationship right then and there. I asked him if he wanted the ring back because I was trying to figure out if he still wanted to get married. He said he didn't want it back. I thought that he was still an amazing black man with so many better qualities than my abusive childhood sweetheart. For one, he didn't whoop my ass. He didn't threaten my safety.

We did lots of things together. We traveled, dined, danced, talked, visited. We just hung out and had conversations about things that had nothing directly to do with us. I appreciated how his brain worked. He was sexy, and the sex was good. So I just figured, "You know what? Could be worse. He's still a good guy who wants to marry me." I went for the "at least" approach. I went on willfully ignoring many obvious red flags that came to my attention.

For instance, the sex was fantastic, but by that time he had already given me an STD. I figured it was him because that never happened before, but then I told myself that I probably had it all along and never knew. I got treated. When the STD went away, my concerns about how I contracted it did too. Besides, the sex was great, but then it started to slow down to a point where I used to keep track of it on a calendar because it was so infrequent. I would try to start something and he would politely tell me no or move my hand away if I touched him in a certain way or in a certain area. Sex wasn't initiated nowhere as much as it used to be.

We started off with a very regular sex life and then somewhere down the line it got to be irregular and then irregular became the norm. I never really questioned it. I never said anything about it. I wanted to keep the peace. Keeping the peace meant I kept him, so he wouldn't see me as a nag, so he wouldn't see me as someone that wasn't supportive, or so he would know I could roll with the punches. Not nagging was keeping the peace, keeping him there, keeping him from going someplace else.

The intimacy still wasn't spectacular. It wasn't happening more frequently. It wasn't happening more regularly. There just seemed to be more distance, yet I contracted another STD from him. There was no explanation, no answer. The first one they treated, but this one was for life. Our sex practices didn't change. I didn't demand condoms. I felt guilt, fear, embarrassment. Maybe it was something that I had all along and didn't know about. I just couldn't believe that he would be that sinister and would be leading a double life. Then I got to a point where I thought, "I have to marry him because no one else is going to want me." That was probably more the motivation than anything else outside of love and the fact of the abusive ex.

Seven years after we started dating, we got married. I was never one of those girls who really wanted to get married. I was surprised when he proposed to me, but I can't say that I walked around dreaming of that. It wasn't an issue for me, but I desperately wanted to keep him. I didn't want to be without him. I felt like there was someone in my life who wanted to be with me just the way I was, where I was. I valued that so much, and, to be honest, I didn't have much else of a reference. He was my second adult relationship. The abusive one didn't end so great. He was just so different. I took different to be better as opposed to just different. That was my mistake. Grossly my mistake because after we married, things got worse.

Two months after the wedding, I moved in with him and started watching his old videos. There were videos of him with some woman he had dated in the past. No big deal. I kept watching, but there were so many videos with so many women. He had some amazing extracurricular activity! I saw cash exchanged on one of the videos. He was sleeping with prostitutes, not just random chicks. Then I saw a video that clearly showed me that he was with

someone while we were together—the length of his hair, some of the things in the apartment were mine. He left these videos in the house. I think he wanted me to find them because he was so tired of living with the guilt that he needed the secret to be out so that he could be free. If he were that concerned about me finding out, he would have done something with them or thrown them away.

I called him and told him what I saw (after I transferred $10,000 from the joint account). He rushed home. He seemed upset, but there was no begging, no pleading, and no trying to get my understanding or forgiveness. The reaction that I was expecting was more fear, nervousness, and embarrassment and just some "Baby, baby, please" but it didn't happen. I didn't see remorse. I didn't feel like I was worth fighting for. I felt devalued. He was playing Russian roulette with his health and mine, but he's not a reckless person. He's very calculating, a planner, a strategist, one of the smartest people that I know. I guess he did it because he could. He had the spoil of the land even though he could have gotten in trouble, gotten arrested, gotten fired. He brought these women to the house. He didn't care about safety. There were so many things that made me realize he cared so little. He couldn't even fake giving a damn. That probably hurt just as much as just finding out. He's never apologized to me to this day.

After that, I still stayed, but I moved out and got my own apartment about two or three months later. He even moved in with me and we tried to work it out until I realized that there was nothing to save because he wasn't a fighter—for me. He wasn't a fighter for the relationship. There was nothing I could do by myself that would make up for what we needed to do together. That's when I realized I had to go. There was nothing left for me to do. I did think about revenge, though. I had dreams of sending those sex tapes to his mama, his family, and friends. I was going to call it "our special day," and it was going to be him fucking a whore in his car or something like that. I spent so much time at one point thinking about it, it consumed me and made me feel worse. I never did it.

I was glad to get the divorce but I'm never going to be free of him. With almost every single person except one, I've felt like I've been harboring the deep dark secret that if they found out about the STD, I'd be untouchable, unlovable, unwhatever, and I don't think I've been able to be as free or uninhibited or comfortable. I always felt like I was waiting for my cover to be blown, or I was always waiting for them find out something horrible and ugly about me. After the divorce, I'm mid–30s, single, with zero to low dating etiquette because of this. I was at a big disadvantage for any relationship going forward. I quickly latched on and embraced risky relationships that weren't best for me.

I'm walking around thinking I have this plague, this disease and that's

such a defeating way to go about your life and relationships with people. When I get to a point where I really care about somebody, guilt sets in, and it's like I've got to leave because I can't do this anymore. I haven't been forthcoming. I didn't get a full disclosure. Blah blah blah blah blah. And now I have to either self-sabotage or I've got to run away or continue living a lie or not disclose it. I made it like leprosy in my mind, and it's far from it, but I think in my mind I made it so bad that I even made it seem like I was unlovable because of it, on more than one occasion.

I had a relationship with one person, only one person, that I told beforehand, and it didn't change him, and it didn't change me, and it didn't change how he interacted with me, and it was the most amazing response I could have ever gotten from someone. He could not have come at a better time. It was reaffirming and reminding me that I am a human being and kinda a victim of circumstances. Somebody did this to me, I didn't do this to myself. I've got to make peace with it and sometimes that means making peace without totally understanding. It's a process. This kind of thing is a lot more frequent than we want to admit. When it happens to you, you feel so alone and so isolated and you think that nobody could understand, let alone attempt to comfort you, and that's not the case. That's not the case at all.

CeCe

"He had no control. He threw away everything for sex."

I married a man that I went to junior high with. His family and my family come from the same neighborhood. When I used to fantasize about my marriage as a little girl, I visualized a house with a white picket fence. My husband and I dated for six years before my mother became insistent that I get married and aggressively looked for a church on our behalf. Once the wedding plans were made for us, we got married. I was in my late 20s and still pretty innocent. I didn't speak up for myself as much as I do now.

I had a feeling within the first six months that something wasn't right. His mother moved in with us early in our marriage, and within a few months he started staying out every night till 2 a.m. One night I asked her if she knew what was going on. "You know what's going on," she said. "Men will be men." His father used to beat her so I understood that it was just easier for her to accept what you can't change. I remember my husband used to say that he could do whatever he wanted to me. I'm sure he learned that behavior from his father. My mother-in-law and I were used to being in a world of dominance. Like her, I was used to laying low. My mother was the complete

opposite. I came from a mother who wouldn't let me talk. She controlled everything including the men that she was with.

I knew for sure he was cheating when he started bringing new things into the bedroom. While we were having sex, he made a move I hadn't seen before. I knew everything about him including what he liked in bed. When I asked him, he just said he wanted to try something new, and that I was making a big deal out of nothing. I was young. I was soft back then. Since he would never admit that he was cheating, I knew I had to prove it.

As I mentioned before, I have a mother who's aggressive and manipulative. She's somewhat of a busybody. If I couldn't get to the bottom of his behavior, she was going to do it for me. She took on the investigation. When we went on vacation, she decided to go into his office and take the answering machine tapes. She played back all these messages from women telling him how much they miss him. When I got back into town my mother told me what she had found so I began to snoop around as well.

I found love letters from different women in his briefcase. One of them said, "That was really hot what we did the other night at the motel." Another said, "I miss you so much. I can't wait to get you alone." I was so disgusted when I found all of these letters. I had my proof, but I couldn't do anything at the time. I didn't have any money, and I couldn't afford to leave him. I decided to work on the marriage.

About two years later he came into the kitchen and told me to sit down. "What's wrong?" I asked him.

"I just want you to know that you need to get yourself checked."

"Checked for what?"

"I may have chlamydia."

"What? Who did you get chlamydia from?"

"From the mail lady that comes into where I work. It's not my fault she just kept pestering me to go with her." He was a real estate broker so he could always make excuses about his whereabouts. If he were going out he'd just say, "I have a client tonight." There was nothing to stop him from doing whatever he wanted to do. I think he preyed upon weak women. He would figure out who he could control and who he could talk into doing the things he wanted to do.

There was one night I happened to be over at his friend's house, and I talked to his wife. When we started talking about our men, she mentioned she thought her husband was cheating too. She'd confronted him about it. He said it wasn't him that was doing the cheating, it was my husband. He told her that my husband liked to go to the track with the guys and brag to everyone about how he always had more than one woman. She and her husband thought it was disgusting. I did too, but I couldn't afford to leave.

In addition to everything else, he'd taken no interest in the children. Even when I was sick he would find a reason not to take care of them. There

was one time I had a fever of about 104 degrees. He told me he was going to the gym and then he would be back. He never came back. He treated our children like how you would treat a dog. You give them play time and a treat and then you're done.

During the rare times my children were with him, they would call me, hungry, because he wouldn't feed them. He wasn't a great parent, but I still couldn't leave him yet. I had a few surgeries that I was still recovering from. I waited seven years for him to grow up, wanting to leave every day. I was going to stay for the kids because they were still young. If I had to do more of the work to take care of them that was a deal that I willing to make for myself.

Things just started getting out of control. On Christmas Eve I said something to him that wasn't anything really serious. Out of the blue he got really angry and he decided to hit me in my head three times. After that, the abuse became more habitual. He started to hit me in front of the kids. He would put me in like a chokehold and drag me backward across the room.

My children would be screaming at the top of their lungs, trying to jump on him. They were little babies at the time and they were trying to get him off of me. Instead of snapping out of it, he would laugh hysterically. That's when I realized that he was becoming a crazy person. When it came to sex, he would just force himself on me. Looking back, I think he was a sex addict because he would be out with all of these women all night and then still come home to me. He had no control. He threw away everything for sex.

I grew up with a dominant mother. I realized that I married the same type of person. I found a husband that was just like her. I didn't know how devious my mother was until I was in my 30s. If I could turn back time I would not have let her encourage me to marry him. I married him at her insistence. I loved him, but I never had a good feeling about marrying him. I would've moved on. She insisted that everything I knew in the world had to be from her, so I learned not to talk to people about my problems which made me into a loner.

I tried to reach out to some friends when things got really bad, but because my husband and I were successful, some of my friends were haters. The friends that were not that successful didn't want to help. I think they enjoyed that we were going through problems. Some would be judgmental about why I wasn't leaving, and after hearing the same lectures over and over again I just didn't want to hear it from anyone.

Once my surgeries were healed, I practically left without him knowing because he was so preoccupied by his womanizing life. I finally had enough money to devise a plan, and I was able to secure a lease on an apartment right under his nose. While he was out all night, I was packing boxes. He never noticed that I was moving all of these boxes into my car. He was so full of himself. It never crossed his mind that I would leave him.

When I finally left, I rented an apartment and put together my children's

bedrooms. Everything in my new place was arranged and organized from the kitchen to the bathrooms when I went to go pick up the kids from school and move in. I had a few things to get from the house that I shared with my husband. He wasn't happy with us leaving, so as I was packing stuff, he called the police. A few minutes later we had seven police cars outside of our house and a helicopter above us. He told them that I was robbing the house. When the police found that he lied they held him in the house for 30 minutes so that we can finish moving and leave.

He would never have left me because, in his eyes, he had the ultimate life. He had a wife who made a decent salary, took care of his kids, cooked dinner every night, and didn't waste money. We had a pretty stable income and a secure home. When we first got married he wasn't very successful, but as he became more successful, he became more emotionally unstable. He could run around with women, and the home that we built would be waiting for him once he was done. When I left him things started to fall apart.

Since our divorce, he's done everything in his power to destroy me. He feels that I spent all my time trying to bring him down, but I didn't have to bring him down. He's always doing something that's stupid. When we were dividing our properties, I found out that he had stolen money out of the bank, and I pretty much had the judge on my side after that. We used to manage multiple properties, but because of his negligence I decided to sell them all. I made about $100,000 in capital gains. I would've made more money if I kept them, but it was easier for me mentally to just get rid of them. He was a slum lord for those properties so once they were gone he had to figure out other means for money. I exist in his world every single day and every second because he's lost everything. He no longer exists in my world.

Despite his faults, my children are doing great. One is finishing college and the other is going to Stanford for computer camp. He thought that I would put up with anything he did to me. I think age determines how you react to these types of situations. I was still in the little girl mode back when I was trying to make my marriage work. I was still trying to please my parents, my husband, my coworkers, and my supervisor. Now, at 52, I'm not trying to please anyone.

Faye

"I was already suffering from his cheating, so I couldn't imagine how bad it would be if I were cheating too."

I was in a mutually exclusive relationship in college. It was my first serious relationship, and at the time I thought he was the love of my life. One

day I was driving around, and I spotted his van in our local supermarket parking lot. I was worried that he was stranded so I pulled up next to him and saw that he had another woman in his van. I had seen her before but didn't know her. When my boyfriend saw me, he and the woman got out from the back as she was still putting clothes on. It was the first time that I understood what seeing red meant. I was trembling and angry. My vision actually went red around the edges, and I didn't have control of myself or my emotions. I started the car and left. I quit dating him after that.

My next experience with infidelity was with my first husband. When I was young, I believed marriage would be Camelot. When it came to my husband, I believed that it would all work somehow. As more time passed in our marriage, it was like the castle collapsed. In most of the seven years that we were married, we were not together. As soon as the wedding was over, he immediately took an overseas job. He would be gone for three to six months at a time. I would see him maybe for a week or two, and then he would be gone again for three to six months. It was weird for me because I'd never considered that my husband would not want to live with me. When he took the job that was going to take him overseas, I was like, "Why?"

Our sex life was very odd. It was very infrequent with no communication at all. He would get angry if I participated in sex. He didn't want me to show emotion or move at all. "Just stay still until I'm done," he'd say. "Don't talk, don't kiss me, don't—just lay there."

We still did married couple things. We bought a house. We had a son. When he was maybe a few months old, I picked my son up from daycare, arrived home, entered my living room, and witnessed my husband having sex on the floor with some guy. The two of them stopped as soon we walked in. I swear the boy my husband was having sex with was not older than 12. That was the second time I saw red.

"Faye, it's not what it looks like," he said. As I watched the two of them scramble for their clothes, I picked up my son and left the house. Just like the first infidelity, I didn't stick around to face it. I went to my parents' condo. I didn't know what to do. I was crying and shaking and thinking about that scene in the living room. I knew that he was gay, but I never wanted to confirm. I knew that he was unfaithful, but I didn't want to see it.

I knew both of those things. It was clear to me from the beginning, and in some ways, I think he even tried to tell me. I think he thought I knew he was gay. There was one day we got into a big argument, and I was outraged about everything.

"I don't care if you have girlfriends. I don't care about what you do anymore."

"What about a boyfriend?" he said.

"Are you out of your mind?"

"I'm just trying to get you to stop yelling at me."

"Can I have a boyfriend?" I asked. "How would you feel if I had a guy on the side?

"Absolutely not."

In his mind, his homosexuality and infidelity were completely separate and different issues. In retrospect I think he married me because it looked good. It made him look more professional to have a wife. He was a pilot and was not out of the closet at all, so the marriage put another level of buffer on his secret. I think it would have destroyed his mother had she known. He was a good-looking, heavily-decorated Vietnam vet. He was a man's guy, and I think that he could never face the truth about his sexual orientation.

He actually wanted a lot more children. I had several miscarriages before I had my son, and he almost divorced me because of that. "If I had known you were defective, I wouldn't have married you," he said. Now, he never raised our child. He was full of contradictions. He was gay but wanted to be married to me. He wanted a family but didn't want to be a father. He wasn't even there when I was pregnant or when the baby was born. He wasn't there at all. I had to take the baby to him when he was four months old, which is about as early as you can get them on an airplane.

He didn't want to live with us. He just wanted to have the stuff. We were his insurance that he was having a normal life. Having us assured him that he wasn't really gay. I tried to negotiate with him. As long as he was providing, I tried to turn a blind eye. Then it just got bizarre, because he was just bringing guys to the house without any regard for us. That was my tipping point, and that's when I decided that I couldn't do this.

My second marriage was with G_____, someone who I loved more than anything on the planet, but he was a huge womanizer. There was about a year and a half between my first and second husband. I met G_____ when he literally walked through the door. I had some stuff from my first husband that I wanted to put into storage and was trying to get anything that was of value out of the house. He was working for an auction company, and he showed up to my house with the estimate. He asked me out that day and we were inseparable from then on. He was a Southern guy, really good with the sweet talk. I'd never had that experience before.

I was pretty sure that he was still seeing his ex-girlfriend from time to time. There was one day he had gone boating with somebody. I knew when they were coming back, so I drove by the house and I saw his ex-girlfriend get off the boat with him. Then there was another time his car was parked in front of her house. I was following him quite a bit. I didn't make these discoveries till it was close to our wedding date. I didn't want to back out of it because people were coming in and the plans were all done. I just hoped that it would all work itself out. It never occurred to me that he would continue the behavior.

Throughout our marriage, I confronted him many times about his cheating. His response was always to mind my own business. He was very unemotional about it and said, "There's no such thing as a faithful man. It's something that women made up and put into movies. I've never known any man that was faithful, and you probably don't either."

"To the best of my knowledge, my father's been faithful to my mother," I said.

"I doubt it."

I had a really good relationship with my father at that point. Before my first husband and I got married my father tried to warn me about his sexuality. "He's a playboy, Faye," he said. Hugh Hefner was what I considered to be a big playboy at the time, so I didn't know what he meant. I never considered "playboy" to mean that my fiancé was gay. Homosexuality wasn't something that I was exposed to, so I did not see the signs until I saw them all. It was several days before we were getting married so I just blew it off and continued with the wedding plans. I rarely solicited my father's advice after that, but when G_____ tried to put it in my head that my dad was probably a cheater too I had to ask.

"Dad, you can say that it's none of my business, but have you ever cheated on Mom?"

I could've sworn I'd told him my son died by the way he looked at me. "Why are you asking me that?" he said.

"I just need to know. You don't have to tell me if you don't want to."

"No, I've never cheated on your mother. What kind of man do you think I am?"

I sunk in my seat. My dad has known my whole romantic history, so he knew there was trouble by the look on my face. "G_____ and I were having a discussion about boundaries in our marriage," I said, "because he dates other people."

"Dates other people? What the hell do you mean he dates other people?" My dad was so sad for me, but he didn't suggest that I get divorced since I'd already been. I had a small child and the thought of going through another divorce devastated him. I was terrified to leave my second husband.

G_____ accused me of cheating constantly. I was already suffering from his cheating, so I couldn't imagine how bad it would be if I were cheating too. I wasn't allowed to have friends. I was an estate broker doing a big property management job. I couldn't even walk into a tenant's office because if G_____ saw me he would accuse me of having an affair with the tenant. Any time that anybody called, he assumed it was someone that I was cheating on him with. He had completely isolated me away from everyone, including my family. He couldn't stand anyone that was close to me.

G_____ broke into my office on a regular basis and went through the

phone bills. He went through my correspondence, my desk, my computer, and he went through the trash. He was always looking for something I had done, but G_____ had actually given me a few STDs throughout our marriage. There was one time I had to get six different prescriptions to treat one infection. "You got a lot of nerve to accuse me of cheating. Look at yourself. You're the one that gave me some nasty disease," I said.

"It's none of your damn business what I do," he said. "Your job is to take care of the house and the finances. If you have to take pills, take those, and get over it."

He took our son's college fund that required double signatures to get it out of the bank. He ran up the credit line on the house so that there was beyond no equity. G_____ ran up every card we had, and he took out more cards, then maxed those out. When the dust settled, collectors told me I owed about $100,000 on his behalf. I spent the next eight years paying it off. His most extravagant adventure was when he picked up a couple of girls from a strip bar, took them to Hawaii, and spent $10,000 in five days. I didn't find out till later because he burned the credit card statements. I found out he was in Hawaii because a traffic ticket came in the mail. He had gotten a ticket in Maui while he was driving with two girls in the car. He never fessed up to it. He never said he was in Hawaii.

I worked like a maniac to pay all of that back. I had to borrow money to get an apartment because I sold everything that we owned. He even tried to sell my car in front of the office. I happened to look out the window and saw him out there. I went out of my office and said, "What the hell are you doing?"

The guy who G_____ was talking to said, "I'm buying a car."

"Oh, no, you're not." I went and sold the car to another buyer that day and bought another one that only had my name on it.

In addition to stealing from me, G_____ became increasingly more violent. When I took our son and his kids to the lake for the weekend, G_____ didn't come because he was in another one of his disappearing phases. For some reason, he thought that I was on this trip with a lover. He went into a jealous rage, and when he found our hotel room he broke down the door.

"Who the fuck is here?" he screamed. "Tell your boyfriend to come out so I can kill him." I told the kids to hide in the bathroom until I could calm him down. It was brutal when he would get like this, but then there would be periods when he'd be so sweet I could barely stand it. The final straw was when he pulled a gun on me. I was sleeping and in the middle of the night, he touched my foot. When I woke up he was standing at the foot of the bed with a gun pointed at me. He hit me a few times. I could deal with that, but now there was a gun to my face, and I had to figure out what to do. "I can just leave, G_____," I told him. "I can leave, and I won't bother you anymore. You can do whatever you want."

"I'll bury you if you try to leave."

I was scared out of my mind, but I was able to get him to put the gun down and leave. I moved out of the house shortly after that.

When we finally were done, he moved back to the South. I was afraid every time the phone rang or every time a door knocked. Since our divorce, G_____ has been married like a dozen times. As soon as he wiped me out, he conned two or three other women into draining themselves financially. He's made a decent living out of being a con artist. For ten years I was dealing with a financial mess. I was ashamed. I'd blown through two marriages.

I'm not 100 percent healed. It will still bring tears to my eyes if G_____ calls. Every year or two he calls, and it upsets my world for days. He'll call to say I'm sorry or to tell me how much he misses me. "I love you," he'll say. "We should get back together." It's always a backhanded sorry. Like, he knows that he did me dirty, but he also wants to remind me that it wasn't all bad. "Wasn't it good?" he said. "Didn't we have a good time, Faye?" I've changed numbers a couple of times, but he always found a way to get to me. I have to live with that.

I blamed myself for allowing this to happen. Others blamed me as well for choosing these men. I was told that if I had kept these men satisfied, they wouldn't have gone elsewhere. It took me a long time to realize that's not so. Their secrets and wrongdoings were not my fault. I ended up getting involved with some spiritual studies. I started to get involved with Buddhism a little bit and some New Age. I think once I started those practices, I began to think that I would finally be okay. I was never the one that was defective. People have always tried to tell me that I was a horrible person. I know in my heart that I'm a growing and evolving human being. I just had rotten husbands.

Marie

"I became a mad woman on this hell-bent quest to find out everything."

For a brief moment, my ex-husband gave the appearance of a committed person. We used to do everything together. We were very close, like, best friends to the point that one of our dearest friends told me he envied our marriage. He was great around the house, very neat. He washed his own dishes and clothes and was a very attentive father. We were a cohesive family unit. We always did things with our boys.

When we were first dating, I liked that H_____ was ambitious. He always thought that I could do better for myself. He didn't like my career when we were dating. I was a flight attendant, but once that company was sold, I was laid off. I knew on some level that he was dissatisfied with me when I wasn't

working. One of the things he wanted to do was to buy a home. Because things were stagnant in my career, he didn't want to purchase a house with me. We broke up for a little bit, and he ended up buying this house.

I found out I was pregnant with our first son, but at the time H_____ was seeing another woman, so I gave him his time and space to do what he needed to do. When I finally got a chance to talk to him, I announced that I was six months pregnant. We moved in together, and I would say that things were really good. It was the happiest I'd ever been with him. Things were so good that I became pregnant with our second child. At that point, I started to put a little pressure on him to get married because I didn't want to be a baby mama. My parents were married for 60 years, so that's kind of subconsciously what informed my value system. When we got married, I was a big pregnant bride. It was a really good period of my life after I had the second baby. Work was going well for him, he was making money, and we were surrounded by family and friends.

A year and a half into the marriage, I remember looking at myself and wondering why he wasn't so into me. H_____ always had a critical nature, and when he was mad he would say just really mean and terrible things. I had a hunch that he was seeing somebody because of the new condoms in our bedroom. It initially wasn't a huge deal because he had an STD, so we sometimes used condoms. However, at one point, there were some unfamiliar condoms in the nightstand drawer so I started to take inventory. I noticed that the numbers were diminishing every week. One day I confronted him, and he reluctantly admitted to sleeping with someone else. I remember him saying it was just sex and didn't mean anything. We managed to put that behind us rather quickly, and we got on with our lives.

H_____ and I shared a single email address because I wasn't on the computer much back in those days. While he was out of town for work, I went into his office in the garage. His work took him mostly to west and central Africa. I decided to go through his computer while he was gone. As I was going through this email there was one that caught my eye. It wasn't anything alarming, but it was just something for me to look at. I opened it and saw there was a lot of back and forth with this African woman who could barely write in English. When I read his last correspondence to her, I was heartbroken. "I wanna make love to you," he said to her. "I don't know when I'll be back, but maybe you should think about coming to the United States and learn English."

This email sent me into a blind rage, and I became a mad woman on this hell-bent quest to find out everything. I printed every single email correspondence between him and this African woman. I went through his wallet, computer files, restaurant receipts, and phone bills for evidence. When I was finally ready, I confronted him in middle of the night and threw all the emails in his face.

"I found out about your African girlfriend!" I screamed. "You're a liar."

"Come on, Marie."

"How could you do this to me?"

"You know she's 10,000 miles away. How serious can it be?"

The email incident was my first breakdown, and things started to crack at this point. For some years, I lost my mind. After the African woman incident, I found out H_____ acquired a post office box. When I asked him about it he said, "Well, I need it for this contract, and I don't need all of that correspondence coming to the house." I was determined to find this PO box. I would switch cars so I had an excuse to use his keys. I became a super detective, literally driving around the city matching up the numbers to different PO boxes. I finally figured out which post office had his secret mailbox, and from then on, I would check it often.

There was one post office trip when I saw that he had gotten a card from someone I recognized. The card was from a woman who was married to a mutual friend. We just recently went to their house for a party. I opened the card and it said, "I'm sorry I couldn't meet you for your birthday, but I just want to let you know that I feel you and I love you. I miss you most of all. I love you."

I sat on that card for a long time trying to figure out if I was wrong about it. The more I sat on it, I realized that I needed to talk to the woman who wrote it in person, so I went over to her job. She came outside and was surprised to see me.

"What are you doing here, Marie? Is everything okay?"

"I would like to know about your relationship with my husband." She became very flustered.

"Well, we're just friends."

"Are you sure about that?" I asked.

"We once went to get something to eat. It was very casual. You know? It wasn't a big deal."

"I read your birthday card."

"I don't know what you're talking about."

I caught her lying through her teeth, and all she could do was turn away and walk back to her work. To make my point clear, I called her at work about eight or nine times that day. I don't think she ever heard any of the messages, but I'm sure other people did, and that was enough vengeance for me. A mutual friend later told me that I rattled her. I believe that my husband loved her, and it was not just a flame. To this day they still keep in touch, but she ended the affair because she had too much to lose. She has a wealthy husband who's older, and she can't afford to be humiliated. I can't tell you the number of times I thought about calling her husband.

There were other women too. Looking back on this, I think he was losing

his mind or having some sort of mid-life crisis. There was another woman he was seeing who I considered sort of a friend. We weren't close at all, but our sons went to school together. The relationship was friendly enough to invite one another to each other's birthday parties. One day I went through his phone book. H_____ would write notes in his phone book of every single call that he received that day. Sometimes he would just have the phone number and the address, but not the name. With this other woman, the friend in question, I noticed her address in his phone book.

"Why do you have her address?" I asked him.

"I don't have her address."

"It's here in your notes. You talked to her."

"I don't need her address, why would I need to talk to her?"

We had separate phones in this house with separate landlines. One was used for the family, and the other was primarily used for business. I rarely answered the business phone. At some point I got the code and checked his messages. He had a message from the woman from our child's school.

"I can't wait to see you. Call me when Marie leaves."

I called her back and left a message. "This is Marie. My husband is never seeing you again. If you continue to call our house, I'm going to let the whole PTA know that they can't trust their husbands around you."

My tipping point came when I went to my OB/GYN and found out I had an STD. I had enough and told him I was leaving. After everything we'd been through, he still would never admit to any of the affairs. I could never get the kind of admission that I needed from him. He was never genuinely remorseful about the things that he did. Instead, he would just kind of write it off like, "Hey, you know everybody does it, ain't no big thang."

During the early years before I was married, I was one of those women that said, "If my man ever cheats I'm gone," but when you're in a marriage and you take that that vow seriously it's not something that you just walk away from, especially if you have children. After the divorce we still stayed involved with each other, and we kept trying to reconcile. I think we loved each other more after breaking apart, because he realized what was lost.

He's always been a real Jekyll and Hyde. During our separations, he'd claim that he left me because I didn't keep the house clean. He'd tell you that our house was always a nightmare, and that he couldn't stand to be there. Then sometimes he could be so incredible, thoughtful, and generous. Just last week he bought my mom and me tickets to see *Wicked*. He brought dinner over, drove us to and from the theater, and stayed at my house to baby-sit our sons. He just took care of everything without me having to ask.

If I have any regrets in my life it would have been the amount of energy that I put into his affairs. I always wanted him to admit it. Always wanting to know the truth made me partially insane during those years. When I used

to do crazy stuff like going through the trash can and piecing things together, I wonder if there was something for me to learn in all that madness. When I look back, I do wish I put that energy toward constructive things like getting myself together.

I never imagined that my marriage would fall apart, and that I would be a middle-aged woman without a pension or an IRA. I should've established a solid career path because here I am at fifty-something trying to get back into the workforce. I regret not stepping up more financially in our marriage because I expected my husband to be some kind of superman. During our marriage he needed a lot more help, and he felt that I wasn't there for him. I enjoyed being a mother for all of those years, but if I had it to do again I wouldn't put all of the financial responsibility on him. When I think about it, if we were in a better financial place at the time maybe that would have shifted our other marital problems.

Forsythia

"His violation of trust hindered my ability to trust my world."

I leaned against him on the sofa while watching TV. When I got close enough to cuddle, I smelled his t-shirt. "That's not my laundry soap," I said to him.

"What do you mean?"

"Your shirt doesn't smell like the laundry soap we use."

"Oh, well, I spilled something on it while I was at my brother's house, so I just washed it there," he said.

My husband and I both worked at the university, but he was on the other side of campus. One morning a coworker came into my office and she said to me, "Oh, I just saw your husband and your daughter walking across campus." My daughter worked 30 miles away from us so I asked him about it later.

"Who was that woman you were walking with today?"

"That's J_____. She's one of my employees."

"You guys were walking kind of close, practically touching."

"We're good friends."

"How old is she?"

"She's 23," he said.

He started going to a tanning salon with J_____ and the other young employees. He was tanning to the point where he was turning orange. He was also super bleaching his teeth, so he had white teeth with an orange hue. I remember saying to him, "This is inappropriate. Why are you going to a tanning salon with them?"

"It's not a big deal" he'd say. "You're overreacting."

The upkeep of his appearance was out of character for my husband who was always "Mr. Punk-Rocker." He started to work out more, and he updated his style to a more younger look. Usually he would call me as soon as he was off of work to let me know that he was on his way home. As time went on, it was increasingly harder to get a hold of him on the phone.

One day I finally confronted him about not answering the phone. His voice was constricted as he got defensive and angry. "Well, I took a day for myself and went to Guitar Center."

"I was worried because you didn't answer."

"I was playing with the guitars. I couldn't hear you."

"You couldn't even take a moment to text me?"

"Can you back off? I just had a 'me' day."

One day after work that I got home before him, I locked every door in the house, and then I went into his computer. I've never gone through his email. I didn't even know his password. It was like I was able to channel it, though, because with just a few attempts, I was in his email. From what I saw, everything was cleaned. There was nothing in the inbox, but after a bit more searching, I saw that there was an email in the outbox. It was from J_____, his 23-year-old employee.

When I opened the email, it was a photo of him and J_____ stretched out on a bed. He was tenderly holding the back of her neck and leaning in for a kiss. I realized that maybe a week before this photo he and I were having sex, but he didn't touch me in that same way that he was touching her. It was a very subtle thing, but it showed me exactly what we were missing. We were missing intimacy from our marriage. This whole time he was giving it to her.

When he finally got home, he came into the room. I turned from the computer and asked, "Do you love me?"

He looked at the computer and then back at me. "What's going on?"

"Do you love me? I asked you a question."

"Not when you're like this."

When I walked out of his office, he followed me to the kitchen.

"You weren't supposed to see that," he said. "I'm sorry."

I just took whatever I could grab and left. I didn't even pack a toothbrush. I want to say that he did an excellent job of hiding it. That's the mindfuck of it all because for so many months he came home and ate dinner together with me without ever letting on. His violation of trust hindered my ability to trust my world.

I didn't come home that night. I went to my office at work. It was the one place where he wouldn't have access to me. I do not believe that he had an affair because our relationship was bad. Even if it was bad. I also don't believe

in giving people an out for that reason. If you're not happy then you should say something, but to abdicate yourself of responsibility by saying, "Well, I wasn't happy" is just not going to cut it.

He's got a long criminal record. One of his arrests was for attempted assault with a deadly weapon, which took place way before he met me. His past didn't align with the person I married. I told him if he ever acted that way with me we would be over. Throughout our relationship he didn't show any violent behavior, but while I was in my office I got text messages from him throughout the night. He said things to me like, "Would you throw yourself in front of a train track for your daughter?"

"In a second, without hesitation," I texted back.

"Would you do that for me?"

"I don't think I can answer that."

"Well, see, this is why I don't know if I can be with you because you wouldn't die for me."

He had lost control to the point where he threatened to kill me. I didn't feel safe at all. I was getting scared. He then began to say things like, "I'm going to kill you. I'm going to commit suicide."

After the night in my office, I went to my cousin's house, and I stayed there for a few days. It was a very bold move for me because I've put up with a lot of shit, but I always came home. There was something about this infidelity that was a danger to me because his mental health was an issue. It was a combination of blinding rage, drug addiction, crazy, and massive self-destruction. It was to the point where my colleagues were put on notice. "If you see him on this floor, do not do anything. Call the police immediately."

He was still staying at our house, and I told him, "You need to go."

"I have nowhere to stay."

"You can live with your girlfriend."

"I've been living in my car. That's why I came home."

"Well, I found a charge for $1,200 to Bed Bath & Beyond," I said. "So that must be some decked out car that you're living in."

He wanted to come home and work things out, but we had a family plan for the phones, and he didn't realize that I could go online and see all of the text messages between him and J_____. He was still very much in a relationship with her even though he was telling me that he wasn't. He would try to send me friendly text messages, but then he would become violently compulsive. One time he sent me 300 text messages over a three-day period. I installed an alarm for my house; my dad wanted me to get a gun. This was a big deal because my dad regularly testifies to state legislation about gun control. He's seen a bunch of kids get shot, so he's very anti-handgun.

People were mad at me because I wouldn't file a restraining order. I knew that using that route would escalate things in ways that were very dangerous for me. He was a two-strike felon, and he would take the restraining order as a personal assault. In the divorce papers, I had my lawyer write in a clause that says that he cannot have any direct contact with me. If he wanted any communication, it must go through my lawyer. It gave me some measure of protection and it worked. I really had to be strategic in that way. He was really dangerous. There's infidelity and there's something else wrapped up in it that I think it makes it infidelity plus.

It took a long time to finalize our divorce. He blamed me for dragging it out, but his lack of communication stalled the process. My lawyer would constantly ask him, "What do you want? What furniture? What pots and pans? Do you want the dog and cat? No, you can't have pet visitation." He created all of these control issues to keep me engaged with him. At some point I just straight up asked him, "What will it cost to make you go away?" He wanted half of my retirement, half of the proceeds for all my future royalties, and half the advance for the future book. In the end I retained it all because I'll be damned if he's getting half of any of those things. It cost me at least $200,000 to be freed from that marriage.

I really understand infidelity as abuse and that's the awful part to me. What helped get me through it was a really good therapist. I assembled my support team. In addition to working out, I started to look on domestic abuse forums. There were cycles of addiction and abuse that were relevant to my marriage. Having that new information was very helpful for me. I remember I did a talk about this experience, and this young girl said to me, "I was in a relationship like this when I was 18. Do you think that when people get older then they see the signs?"

"I don't know if I get what you're asking."

"When I'm your age will I see the signs so that this doesn't happen to me?"

"None of us are immune to any of these things," I said to her. "It's sort of like an oncologist could know everything about cancer, but it doesn't mean they're immune to it."

My ex-husband and J_____ are married now. I heard that they bought a house together. He was even elected to their neighborhood council. Now he's pursuing a master's degree. Perhaps this whole experience changed him for the better. I wish I could say I will never experience something like this ever again. Perhaps I can spot the signs better, but I've always prided myself for having great intuition. Knowing the signs won't necessarily change the outcome of infidelity. The truth was, I didn't have a good answer for this girl, because no one is immune to infidelity no matter how old you are.

Seville

"As soon as I left, he was trying to get on top of her."

In the beginning, I was attracted to the fact that he was a family guy, had a great work ethic, and was a man of God. He wasn't this type of person that was just so Christian it would scare you away, but he was charming, and we had a lot in common. He was smart, athletic, outgoing, and fun to hang around. He was filled with potential, but that fell through.

While I was pregnant with my twins, my ex-husband had an affair with someone. He claimed it was just a one-night stand and did it because I was not meeting his needs. I was in the hospital going through pre-term labor with our twins. I was not in a position to provide him with any physical intimacy, and because I wasn't able to meet his sexual needs, he went and had an affair. Going through pre-term labor was intensely emotional and filled with physical pain. He begged me to have kids, and he didn't support me through that pregnancy.

I found out about his infidelity through a phone call. Some Latina woman from his job called the house and asked to speak to him. I thought that it was somebody from HR, so I started questioning her about the purpose of the call.

"What message would you like me to convey to him?" I asked her.

"I just want to talk to him."

Someone from HR wouldn't say that so I was suspicious. "Don't call my house anymore." After I said that, she hung up the phone. I confronted him about the call, and he confirmed it was the woman he slept with from work.

"I thought you were going to leave me," he said. "You were ignoring me the whole time you were pregnant."

I was outdone and displeased. "If you have a problem with me, or want to step outside of this marriage, do it in a way that's mature."

It was this vicious cycle of the honeymoon phase, the tension phase, and then just crazy domestic violence. He didn't want to work sometimes and had an issue with me going to school because he was afraid that I would meet someone from school and leave him. He was doing some drugs then, but I didn't know the signs of crack cocaine. I just thought he was smoking weed and drinking. He was hanging out with a drug-using crowd and wasn't as responsible or dependable as he used to be.

I was slowly getting worn out because we had other issues as well. I'm at home with our kids, working, going to school, and taking care of this household. I'm doing everything with backward flips to be this wife to him. I was young when I got married, so I was used to doing everything that I could to be the perfect wife. His mother had a Southern background, so I made

beans, I cooked fish on Fridays, and his other favorite Southern dishes. I was a wife to him in and outside of the bedroom. I did everything I could to make sure that he was pleased at home. Even though I gave all that, he could not appreciate it, because he was too busy doing drugs. I told him, "I can't compete with cocaine. I can never give you what cocaine is giving you."

He had another affair with a lady who owned a daycare. He was friends with her husband; they all partied together. My twins were at this daycare across the street from their house. I wasn't pleased with my kids' daycare, so he suggested I bring the twins to this lady instead. When I saw her in public, my husband introduced me to her. When she said hello back, there was something that was odd. I could tell she didn't want to say hello. I just felt her staring at me. I told my husband that something wasn't right about her; our few interactions were neither healthy nor positive. Normally when you meet someone, you can afford a candid or courteous hello. Then he confessed that he had been sleeping with her; the affair began when he started to buy drugs from her husband.

I finally left him, and while we were separated he moved over to the trailer park. One day I went to his place to drop off our kids. I saw her car and I figured that her husband was with her as well. I called my husband and I said, "Maybe I should take the kids with me. You seem to have a lot of guests."

"Oh, no, she's just here visiting."

"Without her husband?"

"Well, this bitch is trying to bribe me to be with her. She threw money all over the bed, and said that it could be all mine...."

"I don't want to hear about your back-alley affairs," I told him. "I don't want you talking to me as if we're close friends."

"But you are my best friend."

"No, you don't treat best friends like this."

"Well, you know, she's trying to get me to stay with her."

"I don't want to hear this."

"I'm going to be with her. She told me she's pregnant."

"This woman's telling you that she's pregnant when she's married to somebody else?"

"I need you to listen and support me."

"Nope. Gotta go." I was really burned out by that time. She would also talk to my kids, and I would have to confront her.

"You're overstepping your boundaries," I told her. "That's disrespectful."

"I'm just saying hi," she said.

She did not have any kids, so she wanted to buy my kids stuff. I told my husband I wouldn't take anything from her, and if she wanted to purchase my kids anything, he had to keep it at his place. It will not come into my house.

In addition to the infidelities, my two older daughters knew about some of the domestic violence. He would get loud in front of them, so they knew. What I didn't know was that my husband was abusing his kids as well. While I was attending a conference, I got a phone call from the sheriff's department. My second oldest daughter confided to her friend. The friend took my daughter to her mom who was a counselor. She told her that my husband had been habitually molesting her from ages seven to 12. As soon as I left, he was trying to get on top of her. She was afraid of what he would do because I wasn't coming back for a few days. My whole life was shattered.

The counselor reported the incident to the authorities. We were thrust into the child services system. We were involved in counseling, DCSS, and just a conglomerate of all these services and different entities. My daughter's stories were consistent with times and dates when I wasn't at home. Her dates were so specific that when the authorities checked my background, they were able to confirm that I was at work and school during the molestations.

When she was a little girl, my husband used to play and joke with her. "Mama, Daddy keeps messing with me," she'd say. She was obviously upset and stressed, but she wasn't specific about what my husband was doing to her. To be honest, I wasn't concerned about the people in my household. When I think of child molesters, it's always strangers, not people in your family. Now I know that most of the perpetrators are people that your kids know, and they groom them into the molestation. If you're in an abusive relationship, it's most likely that your children are being abused in some form or fashion.

The police system is horrible, and, unfortunately, our criminal justice system just is not set up to protect children. Because my daughter didn't want to testify—which, according to the counselor at victim services and assistant D.A., is normal because children tend to not want to feel like they're destroying the family—we didn't press charges. At that time, when she said she didn't want to do it on more than one occasion, my concern was, "Let's just go to counseling and help her through this process." He moved out of the city, but I still have to deal with him at times because we have five kids together and the other kids wanted to see him even though we had an order of protection against him.

I talk about this because it's important just to get a black perspective. Black women get a bad rap in society. My husband was abused when he was younger. I understand as a male, he didn't want to want to talk about it. There was no outlet for him to express himself because our families, society, and community have judgments about people who are weak. When we talk about incest and rape, we just assume that our young black girls are being fast. We're not thinking about these uncles, grandfathers, or brothers that are doing these things.

We only think that sexual assault takes place in a white community and not within our families. Our community shies away from counseling. Teach your kids about safety measures and have them learn to say, "I don't like to get touched there." Guide them to their intuition to spot inappropriate behavior and unhealthy relationships. Encourage them to speak up and speak out.

As for adults, think of yourself first. People tend to treat you the way you treat yourself. So if you shrink for that man, he's going to walk all over you. When you're in love, sometimes you just don't pay attention. You don't see the flags, or you see them, but they're not red, they're some other color.

The irony of this whole thing is that he always wanted to get married, and I was always skeptical. If you really want to be with someone, there should not be any skepticism. We can't always control who we love. I took my vows very seriously. I knew that there were going to be ups and downs, but I didn't realize we would have more downs than ups. I was quite committed and submissive to the man who was my husband, the father of my children, and, once upon a time, my best friend.

Dot
"I fucked up my whole life over a person."

When I was 19, I met a female, and she and I engaged in a relationship until we were 22. I was already living on my own and going to school. She had just moved out of her home and was living with friends. It's funny because we met through a personal ad in the paper, which is what people did back in the old, ancient days before dating sites. During that time, we moved in together, and we were a very out couple considering it was the early '90s. She was butch, or the boy in our relationship. She dressed masculine and got mistaken for a guy a lot which was always kind of funny. We were each other's first love and lived in this sort of idyllic space where I thought we were going to be together forever. We looked at people around us who were breaking up and making up and then sleeping with each other's friends. It was all so messy; that wasn't us. We were the stable couple. We were like an old married couple and we enjoyed that.

We moved in together. She had a day job working at a little mom-and-pop store downtown, but she also sold drugs, so I had a good life. Her mother did not care for me at all. She was just finding out her daughter was a lesbian, and she was still working through that. I just sort of accepted it because my mom wasn't all that happy with the fact that I was in a lesbian relationship. But my mother loved those lesbian dollars because my girlfriend would buy her stuff and lend her money, things like that.

My girlfriend didn't want me to work. At the time that we met, I was going to junior college, taking classes, and I didn't have to want for anything. At some point, I stopped going to school and became a housewife. I knew when she was coming home. I had dinner timed within five minutes of her walking in the door. Every day as she entered the apartment, her plate was getting put on the table. Food is a hot plate of love. When I cook food for somebody, I think about what they like and what they don't like. I think about the person I'm cooking for. I put my heart and my soul and my spirit into it because I enjoy cooking, and, for me, one way of showing love to someone is by providing them with emotional nourishment, spiritual nourishment, and nourishment for their body. Because a good meal to me is a hug in a bowl.

Sometimes while we ate, I'd ask her about getting a job, but it caused huge arguments. "Why do you need to work?" she'd say.

"I'm bored. I need to interact with other people."

"I do what I do so that you don't have to work. You working is a slap in the face to me. It means I'm not taking care of you."

So while she was at work all day, I'd get bored and go shopping. She didn't want me to drive. She was very protective of me and very protective of what I did. I always had to tell her where I went and who I was with. Because of her, I was one of the first people who had a cell phone, and she also bought me a pager for when I was in school. It was kind of weird to have a cell phone and a pager, because in the 90s only doctors and actual real important people with jobs and drug dealers had cell phones and pagers. Every day after class she'd want me to call her. So I'd call her and say, "Hi, honey, I'm out of class."

"Okay, what are you doing next?" she'd ask.

"I'm going to lunch."

"Who are you going to eat with?"

"I'm going to eat lunch with Joe, Bob, and Mary."

"Oh, okay, call me when you're done eating lunch and before you go back to class."

It didn't occur to me at any point in time that these conversations were odd because I knew that she loved me, and her main concern was keeping me safe. She even arranged for a black car service anytime I wanted to go somewhere. If I wanted to go shopping and the car service wasn't available, I would ride a bike or take a bus, but if there were anywhere that she considered far, she would want me to take the black car service. I'd be shopping with her stacks of money, the car would wait for me, and then I'd go back home. From the exterior, I could see that I had a great life because I could buy whatever I wanted. We lived in a nice condo. I had nice stuff.

She spent a lot of time keeping me occupied. We had none of the same interests. If I read a book and told her about the book, she would have no interest in it. If I wanted to see a certain film, she'd always shut it down. If I

wanted to go to a museum, forget about it, that was the last place she'd ever go. So she would pay for me to do it with somebody else. I wanted to take tennis lessons, so she bought me all of these cute tennis outfits and a great racket and paid for my friend and me to have lessons. Then I told her I wanted to take ballet classes, so she bought me some cute outfits and sent me to take lessons with my own personal teacher.

But when I continued going to school to be a pharmacy technologist, she wasn't happy with that at all. I couldn't understand why, because when she wanted to go to bartending school, I was supportive. When she completed the program, she started bartending at a local gay bar that we used to go to. People asked me, "How do you think it's going to be with her working at the club with all those girls?" It didn't occur to me that we would have any issues because she loved me. She still had her day job and then on certain nights during the week she would bartend.

She was getting a lot of attention from women, and initially, I didn't take it personal because I understood that she was working at a club. Her job was to be surrounded by beautiful strippers. We were each other's first lesbian relationship, and with this new job she was suddenly exposed to all kinds of different girls with all these ethnicities. She was the fat kid in a candy store, and I was willing to kind of turn a blind eye to that because she still came home, she still took care of home, and there were no visible signs.

I remember one night she came back and showed me her cash. "This girl gave me a $100 tip," she said.

"Oh, well, tell her thank you." I took the bill and put it my purse. "Tell her your wife appreciates it." I brushed it off and went shopping the next day.

One night she didn't come home. I called one of her friends because she wasn't answering her phone. I didn't know if she was hurt or something. The friend called my girlfriend and then called me back saying that she was okay.

"So is she not coming home?"

"I don't know," her friend said. "But she's fine."

When she came home the next morning, we started arguing and then it got physical. We made up, but then her disappearance became a regular thing. When she stopped coming home at night, I got used to it. I think part of me thought, "Well, maybe she just needs to get this out of her system." I didn't address it when I first had the suspicion that she was cheating. We were each other's first female relationship so I could understand how you might be interested in people. I got that because my understanding of her sexual history is that she didn't have any, so it didn't bother me if she wanted to see other women. I've always given my partners a freebie because I understand that, at times, things might get stale. I understand a person's need to wander. I don't necessarily associate sex with intimacy.

She'd never had sex with a man, and one of the things that she would

give me a hard time about was the fact that I had relationships with men. For me, it was kind of a no-brainer, because I had a baby, but being very young, naïve, and in love, I felt like you should be 100 percent honest with the person that you're with. So I told her who I had slept with and how many. Those admissions would come back to me because in arguments she'd tell me I'm a whore and remind me of all of the people that I'd slept with. In addition to her attacking me for the fact that I'd been with men, she had gotten on me about my weight. She made this comment once, "I can't date a girl who wears bigger panties than me." At the time, I was a size 14 which wasn't big at all. She sent me to this expensive place to lose weight, but she wasn't happy because I didn't lose enough weight for her. Mind you, she was Japanese, Samoan, black, and easily close to 250 to 300 pounds.

When she came home less, I started to drink more. At this point we were mostly cohabiting. I knew that we were breaking up and us breaking up would have left me technically homeless, jobless, and everything-less. I was trying to figure out what was wrong with me. Why wasn't I good enough? I had been everything that I thought she wanted me to be and everything that I thought a good wife, a good spouse, and a good mate was supposed to be. I couldn't understand what about me was so broken. In my heart, I knew that she was cheating because there would be no other reason why she wouldn't come home.

There was one night I called my brother, the one person who always saved me. If anybody upset me, my brother would beat them up. I wasn't feeling suicidal, but I was feeling despondent, and he was worried, so he sent over his wife and my best friend. They were there with me through the night, even though I had gotten pretty drunk and broke a lot of stuff around the house. It felt good to destroy everything because I was just broken up over this relationship. My sister-in-law and my best friend cleaned up the mess that I had made. In the morning the house was probably the cleanest it had been in, like, I don't know, since we started breaking up.

Of course, she came home the following morning. She went to go do her normal stuff, like go fucking take a shower, fucking change her clothes, and that same shit that'd been going on for months. When she got into the shower, I decided to ambush her. "Why the fuck are you even bothering to come home if you're just coming home to shower?"

"I don't want to be with you anymore."

"That doesn't sound like you. Who told you to say that to me?"

"No one."

"Is there somebody else?"

"No."

"Why don't you just stay where you're at?" She didn't say anything. She just looked at me. "Who's telling you to leave me?"

"I don't need anybody to tell me to leave you."

Something inside of me just snapped. She was a much larger girl than me, but I snatched her out of the shower. She pushed me and couldn't hold me down. Things escalated so bad we were fighting and tussling in the bathroom.

After the fight, I took her car keys while she got dressed. My intent was to move her car a couple of blocks away to where she couldn't leave. Therefore, she'd have to stay and talk to me so we could figure out what the hell was going on. I hadn't been to the car in a couple of weeks, but when I went inside it was startling. She'd always been the driver. My side of the car had little stickers, little books, and just little things, but the passenger side was completely cleaned out. It looked as if I'd never been in that car before. None of my stuff was in there; nothing of me was in the car.

I sat there for a minute behind the driver's seat, and something told me to pop the trunk. When I opened it, the back was full of bags of clothes for somebody else that's not me, who's several sizes smaller than me. I opened a different bag, and all of these cards and letters spilled out. They were love letters from various girls, saying, "I love you" and "Happy six months anniversary." That was the one that I think did it. There was a picture of a topless girl, and she was a very pretty girl. After that, it was a black rage.

I don't remember closing the car, getting into the elevator, and going up the three flights to our condo. I don't remember going into the house. It's a blank space of time from seeing that card to standing in front of her with this picture.

I shoved the picture in her face. "Who the fuck is this?"

"Oh, that's just my friend."

"No, bitch, who the fuck is this?"

"That's my friend."

"Friends don't give each other naked pictures of themselves. I have lots of friends, and I have never once felt the urge to give them a naked picture of myself. Especially inside of a card that says happy six-month anniversary."

We were arguing, and as I was getting madder and madder, all of a sudden the last little thing inside me shattered. The feeling was like jumping into an ice cold pool on a very hot day. It's a shock that takes your breath away. You come up for air, and you're gasping for breath because all of your cells have just, have just been juxtaposed against themselves and all these little tumblers just clicked into place. Wait a minute, you didn't want me to drive because you didn't want me out in the streets? Wait a minute, you had the black car service so the driver can tell you everything I do, everywhere I go? Wait a minute, you kept me closed here inside the house so that I couldn't see or hear what you were doing out in the streets?

I grabbed a knife out of the butcher's block because at one point I wanted

to be a chef, so she bought me a whole set of knives. It was the butcher's knife, which is the biggest one in the set. I stabbed her once in the chest in one arced motion.

She looked at me, then back to her bleeding chest, without saying a word.

When I pulled the knife out, blood splattered everywhere, which snapped me back into real-time consciousness. I was instantly horrified by what I had done. "I'm sorry about that," I said to her. "I love you. I didn't mean to do this to you!"

The blood was so hot. That's not something you think about. Your body is 98.6 degrees, and you don't think about that until somebody else's blood sprays in your face. It was all pandemonium when my sister-in-law and my best friend came into the room. They took one look at my girlfriend before they started screaming at me. "Oh shit, oh shit! What did you do?" My sister-in-law frantically called 911.

A different tumbler shifted in my brain, and I told myself that I couldn't go to jail. I couldn't live with the fact that I tried to kill the person that I love. So I stabbed myself in the chest.

My girlfriend freaked out. "Dot, stop! What are you doing?"

There were some pills on the counter, three different kinds. I emptied all the pills into my mouth, while swallowing a large amount of Jack Daniels. Everyone freaked out even more, and before I could stab myself again, my girlfriend grabbed the knife from me.

There were at least 40 cops outside with their hands on their guns, and they see that she's obviously wounded because she's bleeding through her white shirt. When we came outside, they ordered us to sit down, so I sat down next to her, and she scooted over. Then I scooted over next to her again, and she scooted over more. I tried again, and she moved away.

"Why do you keep moving away from me?"

She looked at me. "Are you serious?"

The police cuffed me up. As they were checking my wounds, I fainted. I vaguely remember that I had on a purple robe, and I could feel the back of my robe flap up, and I'm like. "Oh man, now everybody can see my butt." That was my last conscious thought. Someone did cover my butt at some point before they stuck me in the back of the police car and read me my rights.

The police took me to a hospital. At the hospital, I was feeling the effects of the pills I'd swallowed. I remember the doctor sewing me up. It was a black doctor, and in my drunkenness, I started singing a Sam Cooke song. The doctor sang with me and we had a Sam Cooke duet as he sewed me up. He was very nice to me.

I had nine charges against me. During my first arraignment, I was charged

with premeditated attempted murder, assault with a deadly weapon, and corporal injury which is like felony domestic violence.

My lawyer said to me, "You're looking at anywhere from two years to life with your bail at a million dollars."

I looked at him. "Did you say life?"

I was still in a daze. I was like, "Oh shit, you mean the rest of my life, like the rest of my life?" I mean, I didn't say that out loud, but in my head, I'm thinking, "Why do I have to go to jail for the rest of my life? She's not even dead. She's sitting over there."

I took a plea deal for two years in a state prison. It killed me to have to go to my court dates and see her sitting in the back of the courtroom. There were a couple of times I wrote her apology letters covered with tears. I only served 13 months out of my two-year sentence. I didn't have any problems in prison. To be honest, prison wasn't a big deal. It helped that I looked young, and I was only 22, and I had glasses and a mouth full of braces. I could've passed as somebody's little sister. I think when I came home, I was just so sad and so broken. I can't get certain jobs and do certain things. I'm the last person somebody would think of as a convicted felon, but I am. I can't even volunteer at my kid's school because I can't pass the background check. I fucked up my whole life over a person. Everyone always asks me why I did it, but I think the person who was maddest at me was my brother. He asked me, "Why didn't you tell me you were having problems? I would have taken care of her for you."

I've heard through mutual friends that on the night of my arrest, the person that she technically left me for showed up at our home while my best friend and sister-in-law were still there. The woman asked my best friend what happened. My best friend told the woman, "All we know is there was a picture of a naked girl."

The woman looked at my girlfriend, confused. "What picture? What naked girl?" The two of them started fighting. My girlfriend had to defend herself again while I was in jail. That story brought me a tiny bit of joy.

She is on Facebook; I saw a picture of her. It's just that middle-of-the-night curiosity where you're looking up different people that you might have known in a past life. It didn't evoke any particular feelings in me, but she hasn't aged nearly as much as I have. I wasn't angry. I wasn't sad. Sometimes I wonder if she was ever in another relationship and missed me. I hope she's happy and that she finds someone in her life who can give her the things that I wasn't able to give her.

I think your gut is your true heart. Your heart can lead you into so many situations. I'm not saying don't trust it. I'm just saying your heart helps you make excuses. It's like in those Greek tragedies, where something ridiculous would be going on, and the character can't get out of trouble. Then the hand

of God comes down and plucks you out of the situation. I feel like that's been me on more than one occasion, so I feel like somebody is looking out for me. If I could go back in time, would I change it? No, I wouldn't, but I'm glad she's alive.

Understanding "Infidelity Plus"

Infidelity betrayal experiences are common. Less common is identifying how compounding violations impact a woman's mental and physical adaptability. This section unpacks the stressor of private infidelity discoveries plus social, economic, emotional, psychological, physical, and sexual aggression. These are six intimate partner violations that often coexist with infidelity and compound the betrayal experience.

Certain types of infidelity discovery are more damaging to a woman's mental adaptability than others. Confessions through unsolicited partner disclosures are generally considered less face threatening because the infidelity did not have to be discovered and the partner confessed (usually very apologetically) in private. Relationships are most likely to survive when discoveries were made through unsolicited confessions.[2] Although sometimes a partner does confess as an exit strategy like Sam's girlfriend did, Elizabeth's story is a prime example of relational recovery.

Other discovery methods like Faye's first two relationships where she caught her partners *in flagrante delicto* can be traumatic. While the affair may or may not be public, the infidelity partner's presence while caught in the act is face threatening to the discoverer. Discovery through being caught in act frequently leads to relationship termination. Afifi, Falato, and Weiner suggest "the carelessness reflected by being discovered in such a fashion may reflect a desire (either conscious or unconscious) to be caught, thus ending the relationship."[3]

Solicited discovery occurs when a partner directly confronts her allegedly cheating partner with her suspicions. Solicited discoveries are opportunities for the couple to discuss the infidelity in private. The turmoil, however, is less in the confrontation and more in the prior evidence-gathering. The period between suspicion and solicited confirmation is often characterized by rumination—"repetitive intrusive thoughts about negative emotional experiences."[4] Rumination is frequently triggered by a hurtful event that creates uncertainty and has been linked to negative mental health outcomes like "hypervigilance and digging for details, accusatory suffering and flashbacks."[5]

A woman obsessively seeking concrete evidence of how and why her partner would have an affair is ruminating. Marie is the best example. She describes being partially insane as she searched for more and more evidence

of infidelity that her husband refused to acknowledge in a way that satisfied her. Dot details how she started becoming despondent and drinking more as she ruminated on what was wrong with her as her girlfriend created more distance between them. Dot's violent reaction to confirmation was a culmination of her frustration. Teah dismissed her doubt and ignored questions about her relationship until she found her husband's sex tapes. She confronted him immediately, but when he refused to fight for her, she was consumed with ruminative thoughts of sending those tapes to his mother as revenge.

Even when confronted with reams of evidence, with the exception of Elizabeth, none of the unfaithful partners explained or elicited what their betrayed partners thought were appropriate amounts of contrition. Although they avoided losing face in public via their discoveries, their private emotional stability was ransacked by partners who failed to immediately apologize and provide assurances that they valued their relationships. When finally confronted during a solicited discovery, the offending partner has an opportunity to explain, but when those explanations include more lies and gaslighting—attempts to make a woman question what she knows to be true—it is additionally hurtful to the individual and harmful to the relationship.

Mental stress increases and mental health often decreases when women do not receive validation for their outrage. Health compromises do not end with rumination and gaslighting. Stefano and Oala note that "an affair's discovery results in a host of problems including posttraumatic stress-like symptoms of shock, confusion, and anger, depression, damaged self-esteem and decreased personal and sexual confidence. Also, the marital crisis following the discovery of an affair has been associated with subjective experiences of poorer health and well-being as well as with functional impairment in occupational, professional, and parenting roles."[6]

Ortman has extensively compared PTSD to infidelity discovery and coined post-infidelity stress disorder (PISD) to uniquely identify the phenomenon. Ortman argues that "individuals who have dependent personalities and find their identities in love are the most vulnerable to PISD."[7] Other vulnerable populations include victims of childhood physical and sexual abuse as well as individuals "who have long-established patterns of abusive relationships with significant people in their lives."[8] Elizabeth is a prime example of a woman in Ortman's first population who met her husband at 21, had never been single, and had no inclination that affairs could happen to nice Jewish girls.

No one mentions childhood abuse in these narratives, but the odds are greater that Seville's daughter who was molested by her father may be more susceptible to PISD in her future. That said, everyone's betrayal experience with the exception of Elizabeth's included at least one additional violation that may have made them more susceptible to PISD, or, at the very least,

followed a blueprint for an unhealthy relationship and resulted in relational termination.

"I can trust you" and "I am safe in this relationship" are two foundational beliefs annihilated by a betrayed partner prior to experiencing infidelity plus aggressive behavior. Safety eradication is a serious relational defection that cannot always be forgiven. For many women, "infidelity is not just a loss of love; it is a loss of self" as well as safety.[9] This overview provides brief examples of each violation in terms of one of the six aforementioned aggressive behaviors.

Infidelity in relationship to social aggression is imposed isolation like Faye's husband who isolated her from everyone. It also includes the moment Dot realized her girlfriend's insistence that she use the black car service was more control than convenience. And when Teah realized several of her friends knew her partner was with someone else, no one told her, and she felt like an outcast among their mutual friends. Teah also described feeling alone and isolated when she contracted an STI. Social aggression isolation also works through public embarrassment which includes "acting in ways that discredited the joint identity of the couple (e.g. explicit sexual advances in public, openly flirting with other people, intentional inattentiveness)."[10] CeCe and Faye's husbands as well as Stacey and Dee's from the previous section made it impossible for their wives to be comfortable in public because they left so many witnesses in the wake of their disrespectfulness.

Economic aggression coincides with infidelity when the betrayed party tallies the resources expended on a partner's affair. Sam recounted the moments she realized she had been unwittingly paying for her girlfriend's affair. Even after transferring money from their joint account, Sam's ex's lack of financial accountability continued to impact her negatively. CeCe and Faye's husbands stole money from their bank accounts. Faye and Forsythia tallied the cost of being free as $100,000 and $200,000, respectively.

Mental aggression includes emotional and psychological aggression. Emotional aggression "involves comments and actions intended to undermine the victim's self-respect and sense of worth."[11] Dot's girlfriend attacked her for having sex with men and complained about her weight. Psychological aggression differs from emotional aggression in its ability to undermine a victim's sense of safety and security. Psychological aggression and infidelity manifests when an unfaithful partner tries to control, threaten, and/or manipulate the other partner. Faye's husband threatened her with a gun. Forsythia's husband threatened her by suggesting suicide. The previous gaslighting examples are manipulative forms of psychological aggression.

Physical aggression is "the intentional use of physical force with the potential for causing death, disability, injury, or harm."[12] CeCe, Faye, and Seville described physical violence that was the catalyst for leaving their

relationships. While sexual aggression is also a form of physical aggression, its characteristics are unique enough to form a separate category. Sexual aggression in relationship to infidelity includes nonconsensual sex and/or the nonconsensual transmission of STIs. Teah, CeCe, Marie, and Faye all contracted STIs from their husbands. CeCe described marital rape when her husband forced himself on her. Additionally, Seville endured the terrifying circumstances of an unfaithful husband who habitually molested their daughter.

This section's narratives reflect the variability in betrayal experiences. How women handle the stressors of discovery and various aggressions varies but can be partially understood via the ABC-X model of family stress and coping.[13] Within the model, A is a stressor, a betrayal event that demands a shift in family functioning. Stressors include discovery and violations. How a woman responds to her stressor is represented by B, her resources, and C, her perspective.

Resources include friends, family, therapy, faith, high self-esteem, education, economic independence—anyone or anything that can be activated for support. For example, when it comes to economic aggression, having money in the bank and a well-paying career are resources that may be exploited by a partner but make it easier for a woman to avoid emotional economic decisions after discovering infidelity. A friend living with an STI or access to rape crisis counseling are examples of resources for women experiencing infidelity and sexual aggression.

C represents perspective including personality, socio-cultural experiences, perspectives on committed relationships, attitudes towards infidelity, previous infidelity histories, length of time with her partner, relational satisfaction, partner intention, and so on. For example, a woman with a negative disposition and a history of trust issues who interprets her partner's actions as intentionally hurtful is more likely to see the situation more abysmally than a woman who is generally optimistic and less dependent on her partner. Sometimes the additional aggression becomes the catalyst that shifts a woman's perspective and influences her decision to leave the relationship.

The outcome X of the model is an integration of the stressor, a woman's resources, and perception. X may result in manageable stress or an overwhelming crisis. Women with high adaptability manage the stress through their resources and perception. They are able to move on and seem more whole like Sam, who spent a month after the break-up "going out and meeting a ton of new people, having a blast." Despite all the terror at home, CeCe via high adaptability was able to work daily towards creating a new life for herself and her children—both of whom are doing well. Women with high adaptability may also enter therapy, take responsibility for their roles, assign responsibility to their partner for their roles, find forgiveness, and realize a stronger relationship like Elizabeth.

Women in crisis are not functioning normally. Those who demonstrate low adaptability are more likely to feel fraught. Dot's violent response is an example of crisis and low adaptability. Marie's distracting pursuit of evidence instead of preparing herself to be independent is another example of low adaptability. Teah also represents some low adaptability in her inability to share her STI status with future partners and thinking she has a plague.

There is no one-size-fits-all prescription for dealing with infidelity. If high adaptability is the objective, that might mean leaving in some situations and staying in others. The goal of this section was to unpack how discovery and violations create what Forsythia calls "infidelity plus"—an acknowledgment that infidelity can be devastating for a plethora of reasons beyond a beloved partner having sex with someone else.

I Cheated on My Partner

Consequences are uniquely high for women who cheat in heterosexual relationships. Women are denied the sexual curiosity and experimentation encouraged in men.[1] There is a social stigma for mothers who run off with their lovers. Husbands are less likely to forgive and remain in a marriage with a wife who has been unfaithful. Vengeful male partners are more likely to inflict physical, psychological, or sexual harm when they suspect or can prove their girlfriend or wife has committed infidelity.[2] An unfaithful woman may also be unsure about her child's paternity. Average nonpaternity rates in modern Western industrialized nations are approximately 2–3 percent. This means that approximately 2–3 percent of the children in the United States are born to social (alleged) and not biological (actual) fathers.[3] And, of course, anyone of any sexual orientation who cheats on a partner risks losing that relationship upon partner discovery.

Despite these risks, women are still unfaithful. Some of the women in this section received rewards from their cheating experiences that were greater than the risks. Others did not. They all reminisce on their experiences and justify being unfaithful for reasons that include either their partner's deficiencies, their personal desires, or a combination of the two. Their average age was 32 at the time of the interview. Six were married when they committed their indiscretions. Three are mothers. Six racially identify as white, six as black, and one as Asian. Ten are heterosexual. The remaining three identify as lesbian, bisexual, or pansexual. One woman attended some college, six graduated from college, and six earned professional or graduate degrees.

This section explores the varied circumstances and consequences for women who cheat. At the time of the interview, seven women were caught or confessed whereas six kept their secret. In the relationships where truth came to light, four couples remained together, one relationship was still to be determined, and two relationships ended, suggesting that there is no

prescription for how a relationship must proceed when a woman has been unfaithful to her partner.

Frances

"I know it's weird to say that I was in love with her
and slept with someone else at the same time."

I was freaking out because I'd never dated a girl before. But it had been a few weeks, and I was super into this girl. We started seeing each other, just having fun. We never talked about exclusivity. We never specifically said, "I'm not going to be with anyone else," but there was a certain level of emotional intimacy that we'd reached where we both realized that the other person would be hurt if one of us fooled around. Being with her was awesome and confusing for me. I was home schooled and raised Baptist, Christian in a way where being a lesbian wasn't even part of my vocabulary. To meet this girl and to have her be so amazing, to realize suddenly that we weren't just really good friends, that I was flirting with her and she was flirting back and to recognize a spark when she looked at me.... I was obsessing over her and simultaneously freaking out.

One night, I was talking to a really good guy friend about my concerns. We'd had a couple beers, and he's one of those terrible people who says everything that he's thinking all the time and you can either take it or not. He's incredibly arrogant and really just an in-your-face, too-smart-for-his-own-good guy who's always out to get laid. It was understood that we were never going to sleep together because he was kind of an asshole, but he was a fun friend to hang out with. I still don't know if he said it as a joke, if he'd always been a little bit interested, or if I was just the nearest vagina, but when I told him I wasn't sure I was totally into girls, he was like, "Well, you can make sure if you want."

At first, I was like, "That's stupid. I would never do that. I really care about this person," but I guess I wanted to prove something to myself. I had slept with guys before and enjoyed it. I didn't think I was gay. I wasn't sure that this is what I wanted to do with my life, so I slept with him. I was a cheater-pants all the way. It was terrible. There was no longing built up over seven years like in the movies or anything; it was not hot. And he was really awful at sex. I felt sick afterwards. We used a condom, but I felt dirty. Ironically, I also felt like I had proven something to myself. I was in love with this person and falling for her kind of hard. I know it's weird to say that I was in love with her and slept with someone else at the same time, but it gave me a sense of clarity that I hadn't had before.

So I confessed. I've always thought that the important things shouldn't be said over text message or phone because that's the coward's way out. That way, you don't have to look at the person's face. I was really tempted to do it over the phone, but we live in the same city, so there was no excuse. I sat her down, like, "I have to talk to you, and it's really awful." I nearly started crying. And she was like, "Okay." I mean, when someone sits down and says that to you and then starts crying, you probably have an idea that your partner did something terrible. I said, "I was hanging out with J_____, and I've been really confused and I...." I stumbled over it. I think I made her say it. I was like, "Uh, uh...," and she said, "You slept with him?" "Yes." I was crying. She was crying, and then she asked me, "Why?"

"I've been confused and because I didn't understand what, what this is or what we're doing.... I feel terrible. I feel sick. I'm so sorry. I've never been so sorry for anything that I've done. Ever." She was crying, but not sobbing, just sitting there very quiet and very pale. She looked so stricken. Oh, it just hurt. I've never had a physical manifestation of an emotional pain before. It just hurt to see her hurt that way. I told her, "You mean so much to me, and I want you to forgive me. I didn't want to lie to you. I wanted to give you the option of letting me touch you again before I took those kinds of liberties with you."

Her personal space is very important to her. Her bubble and who she allows into it and the fact that she even let me touch her in the first place, like even holding hands or eventually sexually, that was a huge deal for her. I knew right away that I couldn't touch her with dirty hands. I couldn't hold her in that way, knowing that I just let someone else touch me and sweat on top of me. I tried to be as honest as I could be after basically lying with my body with somebody else. She said, "The only reason that I'm not kicking you out right now is because I fully believe that this was a complete result of you freaking out. I've seen it before. I've seen girls not able to deal with their emotions for another girl or girls who aren't sure and try it out and then are like, 'Ewww' or 'I don't know why I ever dated boys.' I've seen girls who are like, 'I like this one chick but then find out that maybe they're more fluid, maybe they're queer.' But I really trusted you, and we're going to have to rebuild that."

She uses a lot of metaphors when she talks and she said, "I'm not like a flower because that's too pretty and too fragile. Our relationship is very much like some kind of weed or tomato plant. It still needs things to grow. It grows harder; it grows stronger than a flower would, but it still needs sun. I feel like you just cut off my sun."

It still makes me cry. It was the saddest thing anyone's ever said to me. I made an idiot of myself just groveling, just flat-out groveling. No pride, no nothing, because it wasn't worth it. It wasn't worth it to be more dignified about it.

"I don't know if we'll be able to be together anymore," she said, "but I do forgive you and I think that we should talk about it and still be in each other's lives and see what happens."

Women do a lot of processing anyway, and then when you're in a relationship together, it's just exponentially more every day, all the time, which I like. I was grateful that she also understood that it was me trying to figure out whether this was a lifestyle that I could talk to my family about or deal with on a daily basis. I'm from a conservative Christian background with parents who flipped out when I told them. Parents who still won't let me tell my grandparents because they don't want them to die mourning me.

She comes from a family that's known since she was five years old, and they always just assumed as she grew up. They asked her about the girls in her class that she was seeing. They're completely supportive. Even her 85-year-old grandma's super excited when I come to visit. It's a different support system, a different way of being. She couldn't really understand why I would be so terrified. There's a level at which you feel empathy for other people and you're like, "That would be really awful, I'm really sorry, that's really scary," but if you have never been there, it's almost impossible to fully understand.

We are empathetic to each other, but we are lesbian in our bodies differently. For example, her hair is just really short. She has really great androgynous features so she has different challenges. Like, people "dude" her all the time. They're "Hey, dude," and she's wearing a T-shirt, like my boobs are right here. I don't have short hair. I like to wear heels; I wear lipstick. I'm not a dyke. I'm not a person who you would look at and be like, "That girl's gay." It took a while to get over that concept, to get over the idea of the label and move on to being a person who's in love with another person.

Before I got to that point, though, I didn't know what to do. I didn't want to hurt her. I didn't want to say, "You're terrifying, and I don't want to tell people about you because it's going to reflect badly on me." That's a selfish, horrible thing to say, but I'm sure it's what everybody feels when they're coming out of the closet. It's a very selfish thing to have to go through because you're either hurting the people that you love because you won't tell anybody about them and you're keeping them a secret. Or you're hurting the other people that you love because you're taking away all their dreams that they had for you. Especially with my parents, they had dreams for my life, and they're having to rebuild those now. I had to ask myself, "Is this person worth destroying a different part of my life?"

About three weeks after my confession, we were out on this hill where people go sometimes to make out, and she said, "You know those movies where two best friends go out and are staring at the sky and then one of them howls at the moon?"

"Yeah."

"I'm going to do that."

"What?"

"And you should too."

So we did, and she kissed me and told me, "Now I love you again."

It was still a while, probably three more weeks, before we had sex again. Sex for us isn't a Band-Aid you can put on something. You have to be in a place of trust with each other to make it happen. I didn't want to hurt her any further by talking to him anymore or having her see his name pop up on my phone, so I told him, "Hey, that was a really terrible mistake. I don't hate you, but let's not hang out anymore." And he was like, "I understand. I broke the bro code." She asked me to get tested. It didn't help that he was a notorious man-whore, so I agreed. It came back clean. Then I waited for her to initiate sex. Once she did, our sex was awesome. We've been together a year and a half. She's—I sound cliché—legitimate. She's the love of my life and we're moving in a few months to start our life together. I'm really excited.

Infidelity expedited my clarity, but our trust had to be rebuilt. In a way, we might be stronger for it, because we've overcome it, but I still wish that it had never happened and that I didn't have to hurt her the way that I did. I also think that if it happened now, it would completely destroy us. Because I did it in the beginning of our relationship when we had those undefined lines, we were able to overcome it early and set rules. Now, we know this is never okay—ever again. Yes, there's people that you admire, people that you find yourself flirting with sometimes when you're hanging out with them because it's an ego boost. It makes you feel good, makes them feel good, and then you both go home. But there's no one or nothing that's worth hurting someone that you love that much on purpose for. Doing something like that when you know that it will devastate another human being is cruel.

Assata

"But I knew after I cheated on him that we would have to break up because I'm not really a cheater like that."

I used to go to parties when I was 19, 20. That's how I met him. We were at a house party, and he kept trying to talk to me. Everyone kept telling me that he really likes me and that I should talk to him, but I would say no and kind of shoo him away. I just didn't really care. He was really cute, but it wasn't like I was immediately head over heels for him. He was good looking, but I just didn't care. Then I saw him at the club, and he approached me again. My friends were like, "Oh my God, it's him again! He really likes you!" Everyone was clowning because it was really clear that I just didn't care. Then he

tried to talk to me again. The third time I saw him somewhere else, I finally gave him my number. I mean, he was really cute and every time he saw me he tried to talk to me, so I gave in.

We started talking on the phone and I kind of pressured him to be in a relationship. I was trying to figure out what we were. I would say to him, "If we're not going to be together, then I don't want to do this." So then he was like, "Okay, we're together." In retrospect, that was the first problem. He chased me really hard and once I showed legitimate interest, he was kind of like, "Whatever." He felt like he already had it at that point.

At first, he was really, really sweet and he had a job. Within six months of dating, he didn't have a job anymore. He got really controlling. If we went to a restaurant he would say, "You can't eat that, or I won't kiss you." He would try and control what I ate. He started to try and change how I dressed because he wanted me to be plainer and blend in. We would get in real fights about clothes. One fight we had was about this Dereon jacket by Beyoncé that he wanted me to wear, but I didn't. I wanted to wear this pea coat. And he said, "That's so 90s, why do you want to wear that?" And I would say, "Well, this is cool, nobody has this pea coat." He would really try to battle me on wearing the cheap-looking Dereon hoodie. It was ridiculous because he was adamant about it. Every time I wore the coat, he would try to embarrass me in front of people.

I started to notice that his exes were, I don't want to say plain Jane girls, but they would have just worn the Dereon hoodie and thought it was a great jacket. That wasn't a great jacket to me. He would always try to compare me to his exes. He would say, "Oh, well, my ex used to do this, or my ex used to do that." And I would say, "Why are you trying to compare me to your ex?" It was like he had some sort of preoccupation with proving that I wasn't that great. Always trying to pull me down.

He would say things like, "You don't have any friends; you have fans and people just tell you yes to everything. I tell you what's real." And I would say, "What? You're mean. What are you talking about?" I felt like he was just mean and justified it by being real. He would tell me that any dude that didn't tell me what's real was just lying. It started to get mentally abusive to the point where I would get physically violent with him because I was sick of it. He never put his hands on me, but I hit him. He was trying to keep me under his thumb. I felt caged and unhappy, but then I felt like I loved him too. I just wouldn't leave.

I didn't want to waste the time I put into him. He would always make it seem like he's as good as it's going to get because "I keep it real and these other dudes lie. I'm a nice dude, I don't cheat." Like, I was lucky because he didn't cheat. He would always make it seem like he wanted a family and a future with me. Once I commit to something, I try to see it all the way through.

I was trying to see us through. I felt like I loved him and that we had fun together. I didn't want to just leave.

Still, he tried to patrol everything I was doing. He didn't want me to have attention. He was jealous if his family members were fond of me. Like, we had a MySpace and his cousins would have me on their Top 8 and he would be mad that I was above him on the Top 8. It was crazy stuff. It just became a competition that I don't understand how it got that way. His family, like his mom, would even say, "I don't know why you like him." She would give me hints that I'm better than him. His dad did it once and that was kind of the last straw. It was just like, "Wait a second. I think I need to leave you because now your dad is saying something. Your mom could just be talking, but your dad saying it to me, and I'm a girl, that's weird." Then his brother said something to me too, like, "Why do you want him?" By that time, he was being mentally abusive and controlling. We had been together for a year. I started to be disgusted with him. It was just ridiculous. I couldn't take it anymore.

I had an ex-girlfriend from high school that would always tell people I was her first love, but she was never mine. We weren't good friends. I would rarely talk to her, but I always knew I could call her, ask her to come over or come hang out, and she would run over. So one day, I called her to come over with the intention to cheat, and I did. It was whatever. It reminded me that the thing with her had passed. We weren't in high school anymore where it was fun. I didn't walk away feeling like that was great, but I didn't have any regrets. To this day, I think, "Ha. He doesn't know that I did that." I never said anything. I never told him. But I knew after I cheated on him that we would have to break up because I'm not really a cheater like that. Within the next two months after I cheated, I tried to kind of work it out with him, but I just ended up dumping him.

At the exact time that I cheated I wasn't sure what I was going to do about my relationship with him. I was just going to do what I wanted to do. I knew that I wanted to feel good for myself. I was always worried about him and what does he like and what does he want me to wear and what does he think? My ex liked me for who I was. She would do whatever I wanted. I got my way when I was around her, where it was always his way if I was with him. I cheated kind of like for revenge. I need to be a winner, to win. I'm not like other cheaters who just cheat with whoever for no reason. People who say, "Oh, I like that person, and I'm going to cheat. I'm cheating with this person and this person. I'm doing this, this, and this." I don't like cheaters; my dad is a big cheater.

In my future relationships, if the person thinks that I'm monogamous to them, then I'm monogamous. I don't really like to lie and sneak and do stuff like that. I guess that's why I say I'm not a cheater because I wouldn't even want to live that way. I don't regret cheating on him, but I do regret being in

a relationship with him. If my mom hadn't been sick at the time, I probably wouldn't have been so clingy. Before him, I thought I was clear on who I was. I was doing certain things, and as soon as he got in the mix, it started to just change. By the time I realized I was chasing his dreams, it was almost too late. That time between 21 and 22 are important to a woman. I'm irritated that I lost it.

But I'm definitely more self-aware now. I know what I want and what I don't want. Don't ever change who you fundamentally are to try to make something work with someone else. They should already align with you. If you do, that's settling. Settling got me into a situation of not being happy, cheating, and then eventually leaving anyways which I just should have done in the first place when I realized it wasn't working.

Sue

"Once my husband caught me cheating, all of these complaints
came out and there was no taking them back."

I was married when I was looking at doctorate programs. Since I knew some big life changes were ahead, I wanted to do something fun and artistic so I auditioned and was cast in a romantic musical. My opposite lead was a guy named K_____ who wasn't exactly a dreamboat, but we spent a lot of time together so we developed a pretty tight rapport. The character he played was this passionate and take-charge type of guy. As the production progressed, I started falling for the character he was playing. It sort of played with my head because I started to get really drawn to K_____.

There was some backstage flirtation that definitely transitioned into onstage sexual chemistry. During one rehearsal, me and K_____ were passionately kissing on stage and as the scene got racier it got to the point where it didn't feel like acting anymore. We're on this bed making out and he's grabbing intimate parts of my body. All of these actions were in the script, so it wasn't technically cheating. However, I was totally in that moment with K_____ and not with his character. That was the moment the infidelity started.

After the dress rehearsal party, K_____ and I got drunk and started making out in his car. All of the sexual tension we'd built up during the play started to implode from the moment we got into the car. I came home with a really big hickey. I told my husband that I ran into some furniture. It was a totally unbelievable story, and my husband was not stupid. He looked at me with such disappointment and tried to pretend the conversation never happened.

Whenever we were at rehearsals, K_____ and I couldn't keep our hands off of each other. We started to meet up in secret and have sex at his house. K_____ was a lot younger than me and still lived with his parents, so arranging times to have sex took some orchestrating. Sex with K_____ was always crazy good. It was radically different than anything I had with my husband which would last for only ten minutes before bed. Sex with K_____ was marathon sessions. K_____ was a pretty heavy drug user and we would always get high before sex. It would be hours of lovemaking every time we did it. I couldn't get enough.

One time when I took a shower at home, I left my phone on the table face down. When I came back for it, the phone was face up. I knew by then that my husband was onto me. He made a few comments about me being on my phone all of time so after that I put a passcode on it. I knew that he wouldn't ask me for the code because he was too proud to admit that he was checking up on me. My husband always thought of himself as intellectually superior. I knew that he wouldn't give up so easily, though.

The day of reckoning came when my husband hacked my Facebook account on the computer. K_____ and I talked on Facebook regularly, so the messages revealed everything that we'd been doing up until that point. Even though I was caught red-handed, I still couldn't admit that I'd been cheating. I kept telling my husband that K_____ and I were just friends; he was over-reacting. My husband showed me several things that I'd said to K_____ that proved I was lying, but I had an explanation for everything that he pointed out. I started to get exhausted by my own lies and couldn't take it anymore. I'd been unhappy in the marriage for far too long so I finally told my husband that I wanted a divorce.

"You're going to leave me for a community college undergrad?" he asked. K_____ was on the seven-year community college degree plan. Based on my husband's standards as a community college instructor, K_____ was a loser. It just added insult to injury. My husband couldn't understand why I would pick a 23-year-old actor over him.

"I'm not leaving you for K_____. I'm leaving you because I don't love you anymore." There were real issues in our marriage that had been eating at me for a long time. My husband was really controlling about money. My paychecks were direct deposited, but I always had to ask permission if I wanted to spend any of that money. Before I graduated with my master's degree, I had school fees. They were going to hold my degree if I didn't pay the $50. Even then I had to ask him if I could pay for that, and he told me to wait a couple months.

My marital sex life was nothing to look forward to. It was just another obligation. When I kissed K_____ for the first time on stage there was this electricity that came with it. I forgot that true intimacy was this intense, phys-

ical pleasure. We'd been lacking those romantic moments in our marriage. I was eager to explore those feelings again. I denied myself that pleasure partially because I'd gained about 20 pounds during my graduate program. My lack of confidence in my physical appearance affected the outlook on my life. I began to doubt my academic career.

When I first started cheating on him, I thought it would only be for duration of the play, but in the back of my mind it might have been for revenge. It was a motivation that I was not cognitively aware of at the time, but my actions showed that I had absolutely no regard for my husband's feelings. Once my husband caught me cheating, all of these complaints came out and there was no taking them back. Despite his protests, I ended the marriage.

Being in that musical made me realize how stagnant and oppressive my marriage had become. When it came to my marital problems, I probably should've developed some better coping skills. Cheating was a selfish way of ending that relationship. However, it was the best thing that I have ever done as far as my life trajectory and my career. Ending that marriage allowed me to have the freedom to explore who I am and who I wanted to be.

I honestly don't think about my ex-husband often. Getting out of that marriage opened up so many really wonderful possibilities and opportunities in my life. I have a wonderful partner right now who is incredibly supportive in everything that I need. There's no reason why a woman shouldn't have all of her needs met. Sometimes we need to take an unfavorable path to get what we deserve.

Evelyn

"Right person, wrong time."

We were both already married when we met at a wedding. We had general conversation which turned into email conversations because he lives in another state. We talked so much about what we were missing from our spouses. L_____ married because it was expected of him. They had a bad dating relationship, but he took her back because he felt that she would be a good mom, he knew her, and he didn't want to go out and start all over again. I guess I didn't marry for the best reasons either. I thought I was marrying for love, but now I think I was marrying to get out of my parents' house. We've been married for 19 years. We have two young kids.

I think about leaving, but I've invested so much time, and I couldn't afford to live by myself without an additional income. My husband is always gone for work-related events. One time, he went on a business trip, and I was unable to reach him for 36 hours which is unusual. He said that his phone

wasn't working which I know is not the case because other people said they talked to him. I think my husband had an affair, but I can't prove it. I always felt like I was not as important to him. L_____, though, makes me feel much more important.

Our extramarital affair became physical about six months after we met. In the beginning, we saw each other three to four times a year. The sex was good, much better than what I got at home. L_____ always called me his soul-mate. He says we connected in such a way that had we met each other prior to our relationships, we could potentially be together, but the way it stands now he's not leaving his wife because they have a child together. I was the person that was intended to be in his life, but I just came in at a different stage—right person, wrong time. I never wanted him to leave his wife for me. L_____ is my best friend; we can talk about anything.

If we lived in the same city, our spouses would've found out about us. We wouldn't have been able to hide it as well as we've done. We almost got caught once. My husband was checking my phone and saw text messages between us. He copied the number and called but never had the opportunity to actually speak to L_____. He asked me about it. I told him it was someone that I had met at a wedding and that we were just communicating with each other. He wasn't okay with that. He told me to stop. Every time the phone would ring or I would have a message indicator, my husband would want to know who I was talking to. Obviously, I didn't stop, but we were more careful. I deleted messages and erased L_____'s number.

L_____'s wife has her suspicions too. I've actually met her on two uncomfortable occasions. At one event, she came over, sat next to me, and engaged me in conversation about what was going on with her relationship. He wasn't responding to her the way that she wanted him to. I just felt so uncomfortable and guilty knowing that I was the other person that he was responding to more than her. I had just seen him 12 hours before. We're not friends so maybe she was testing me. I just tried to steer the conversation in a different direction. Then there was that time, we were on a trip, and his wife called and said that the child was sick. I felt guilty because he wasn't there like he would've been if it wasn't for us going on our trip together.

For the past three years, L_____ and I talk on the phone more than any-thing or email or text, and we'll see each other only once a year. The sex now is not what it used to be because it's not new anymore, and L_____'s become complacent. Plus, it's becoming a lot to try to make the trips to see each other. There are 3000 miles between us. It's been seven years since I started seeing L_____. We might be coming to an end. I think I'm a point in my life where I just tolerate people that I've had in my life for so long. I love my husband and L_____, but I'm not in love with either of them.

I've learned about myself with this affair. I don't regret it because each

person that you meet you learn from. I learned who I am as a person and what I will or won't tolerate. I won't tolerate when a person is unnecessarily indifferent to me, meaning that if I'm giving you all of my attention and you're acting as if it doesn't matter, I won't tolerate that. I will walk away. I'm getting myself to a point where I can walk away from my marriage by getting everything that I need lined up. This affair helped me realize what's best for me.

Nicole

"Once you have an affair people think of you as
the kind of person that can have an affair."

M____ and I were like two peas in a pod. We understood each other in a way that made us extremely compatible. We were both into chess competitions in high school and that's where we met, so when we got married, we understood each other's drive and determination. For the first two weeks back after our honeymoon, we didn't take a single day off. We had the work ethic to be entrepreneurs. Even before we got married, we did business together and worked hard to become successful. We both worked ten to 12 hours a day pretty regularly and the work schedule was what started our marital problems.

M____ worked from, like, eight in the morning till 11 o'clock at night. I felt ignored and neglected. Our business was still growing so when I got pregnant he put a lot of pressure on me to have an abortion. I was anti-abortion, but I did it to appease him. I became depressed. Based on how much we loved each other, I couldn't understand why he wouldn't want to keep the baby. I didn't know how to communicate with him at the time, so we fought a lot. I felt emotionally abandoned.

I had a lot of anger toward him when he was absent and also impotent. M____ started to go bald and had to take Propecia to treat it. He'd been taking it for eight months and the medication just flat-lined his sex drive. It was such a huge shift for me because he had always enjoyed sex. Even with all of the fighting, we always managed to have a decent sex life. Prior to him being impotent we had sex at least two times a week. The distance between us became greater once we moved to the city. I didn't know anyone and M____ would travel quite often for work. I had no idea how to talk to him about things. When he was home, he was extremely critical of me. I could never make him happy. We barely talked.

When you're having marital problems, you don't feel like you have anyone to talk to. When M____ and I moved, all we had was each other. His

parents were bad alcoholics and they fell on some really hard times. They used to have a lot of money but lost it all through drinking and gambling. They were both on a drinking binge, living in a shady motel, and dealing with mental health issues. After his mom attempted suicide, he said to me, "We have the money to take care of them. They're older now. Why don't we just move them down here?" That was a decision that was hard for me because his mother was very verbally abusive.

I knew in my mind that we couldn't provide the care that they needed, but M_____ felt confident that he could help even though his parents didn't think that they had a problem with alcohol. There were issues from the moment they moved in with us. If we gave them money, they would take the money and go gambling. It was always stressful to manage them, but the worst part of it was every time that my husband would travel, I would be alone with them for most of the time. When my husband was gone, my mother-in-law would become verbally abusive towards me. She would just say horrible things to me, things that should never be said to anybody.

One time she told me, "You know you're losing your looks. I don't know why M_____ is with you. You're really not that smart." She would attack me about the furniture and say, "You made my son have this ugly furniture in this house, but you can't even provide for us. It's your fault that we're poor." She was treating me like I was subjecting M_____ to a life that she didn't see fit for him, but the truth was she was really unhappy. I think she was jealous of my life.

When we moved, I enrolled in a graduate program, but I didn't make any friends there so there was no one to talk to about my home life. There was a socioeconomic barrier between me and other people. One of my classmates said to me that they thought I grew up with a silver spoon in my mouth, but that's untrue because I grew up poor. I had one person who friended me. He wasn't in my program, but he pursued me aggressively. Usually I don't get too close to guys if I sense they like me. However, this new friend gave me the positive attention I'd been craving, and I couldn't ignore him.

We started hanging out while M_____ was at work and started an affair. I never ever, ever, ever on planet Earth wanted to have an affair. The actual physical affair wasn't very long, but sex with him became very important for me. I was having withdrawals from having sex with this guy because I had such incredibly high need for it. I am a sexual girl, but I also had such a high need to connect because at the time I felt completely alone. I think once you have an affair people think of you as the kind of person that can have an affair. I never thought that I would ever have one, and even though I was completely against infidelity, this affair was the thing that filled that empty void. In my mind, the world was divided among people who cheat on their spouses and people who don't. I never, ever considered myself to be someone on the less righteous side of that divide.

I completely hated myself. I actually felt like I was dying on the inside. I didn't want to divorce him because that would be violating what I valued, but I was having an affair so I felt like I was committing suicide in a way. After we were done with the physical affair, we continued an emotional affair for several months. He was also married, but it was a marriage that was just awful because his wife cheated on him too. He didn't believe in divorce either so both of us were trying to work stuff out in our failing marriages. We both felt terrible with what we had done, so after a few months we decided that we needed to break and commit to working on our marriages.

When I ended the affair completely, I didn't tell my husband about it for almost a year. I knew that once I told him our marriage would be over. When we moved back to our hometown we were getting along wonderfully, but then I started to feel guilty. Here was this wonderful man who's loving me and being good to me, but I felt like it was all under the false impression of who I was when I had, in fact, failed him and his trust. I wanted to be loved in truth and not loved for his image of me. I wanted to be the woman that had never failed him, but I wasn't. When I finally told him what happened, it wounded him and he never recovered. He tried really hard to forgive me because he wanted to do the right thing and not give up. He just wasn't able to so he divorced me three years after I confessed to the affair.

I was the only girl that M____ had ever dated. In the time that we've been apart he's dated other people and had some realizations about what I had to put up with in our marriage. When we were married, I cleaned the whole house, did the landscaping, took care of our dogs, did the grocery shopping, and everything thing else that he needed. He just worked. I worked too and did all of the things that were needed for the house. I was also supposed to maintain everything else we had going on, and all he had to do was dictate how things needed to be done to accommodate his particular tastes. He was so used to his mother pampering him that he never considered how much went into taking care of him.

For so long I thought that he only saw me as this bitchy wife because all I did was yell and lose my temper. Instead of seeing my pain, he saw a bitch. The truth was we just didn't communicate as we should have. We knowingly steered away from problematic things because we didn't want to have to have hard conversations. I should have honored my own limits. The affair was a symptom of something much bigger. We had lost a lot of trust and communication with one another. I was trying to have power over our lives, but I can't control anything a person does. All I can do is say how I feel and remove myself when it feels bad.

We're still divorced, but M____ and I decided to give things another chance. I remember praying to God about it because I realized that underneath it all, it's not about the marriage. This is about me and God. My relationship

with M____ is the heritage that God prepared for me, and it's not over. When M____ left me, I lost my whole world, but even though I still love him I can't treat him like the center of my world anymore. I used to look at M____ like an idol but I don't look at my ex-husband like that anymore. Instead of idolizing M_____, I look at him as the person that I'm going to go through my life with.

Taj

"A part of me wanted to be caught so that it would
force my husband to deal with our issues."

Somewhere in our marriage I became completely invisible. I wanted affirmation from my husband that I was worth a second marriage and that I was better than his ex-wife. I never felt that I would ever be smart enough to be on the same level as either of them. Some of that inadequacy had to do with the fact that there's a huge age difference between us. My husband was a teacher to me in every way even when we had sex. I wanted to be submissive, and at first, I loved that control from him, but at some point, it became condescending. Whenever he introduced us to other people sometimes I felt like more of a daughter than his wife.

I was receiving several promotions at work but despite my accomplishments my husband reminded me that his ex-wife used to make more money than me. I hated the comparisons. I was determined to have a career that surpassed hers. He and I worked for the same company which increased some of that pressure. As I climbed through the ranks at work, my peers would be right there congratulating me. My husband, on the other hand, would be right there to bring me down as soon as I got home.

I had this tunnel vision to prove to my husband that I was a worthy equal. Both of us were career driven which should've brought us together, but it only created the competitiveness that later turned into resentment. We couldn't have a conversation without yelling so I urged for us to get professional help. "I've got stuff to do," he'd say. "You just need to grow up and deal with your own issues." The option for divorce wasn't a solution at the time because a part of me didn't have to the heart to put him through it again. His first divorce was messy and horrendous.

His ex's pursuit of full custody resulted in a strained relationship with their son. I didn't want our two sons to go through that. Their dad was a good man who loved his kids. He strove to provide everything for our family. There wasn't anything that our children needed to ask for because they had a father that provided everything. My husband didn't know his father so he

gave that extra attention to his sons. Even if I remarried, I didn't want to subject my boys to another male figure. My husband was a hero that my children looked up to. I wanted to keep that intact.

I was searching for a newness I wasn't getting from my marriage. I had a good-looking coworker named N_____ who was three years younger than me. There would be times when I would have to lead projects, and he would be my assistant. He was positive, vibrant, and everything I said was fascinating to him. It was strengthening for me to be around him.

N_____ and I had a cat-and-mouse type of flirtation for four months. He was good at keeping his affection under the radar, but I was longing to be more intimate with him. I had that fluttering feeling whenever I was around him like I was back in high school. However, I knew that he would never make the first move because I was senior to him in the company. I had to be the aggressor and pursue him, so I went all in with my intention knowing that we couldn't be any more than an affair.

N_____ and I started sleeping together and developed such an intimate bond for almost two years. Out of any man that's ever worked with me, he respected me the most. It was nice to be intimate with a man who wasn't trying to bring me down. He's trusted my leadership and authority 1000 percent. My husband and I didn't have the same work hours, so it was always easy to arrange times to see N_____.

One of the rules that I had for him was whenever I was with my husband, I was with my husband. He wasn't allowed to call me or text me during those times. N_____ lived close by so it was possible for my husband to run into us. Some people saw me with him, but it didn't make me retreat from the relationship. A part of me wanted to be caught so that it would force my husband to deal with our issues. My husband was spreading himself all over the place and only giving me thirds or fourths of his attention. He was negligent in our marriage. Finding out about me and N_____ would force him to see that.

During the worst moments of our relationship, it took everything in me to not retaliate and tell my husband that I fucked another man right under his nose. To my surprise, however, my husband revealed to me that he knew the whole time. He was drunk when he said to me, "You know I've never cheated on you, but I know you've cheated on me." The confession took me aback. I didn't know what he was going to say next. "I know what you've been doing, Taj, and I forgive you if it's over."

Right after that I told N_____ that it was time for him to let me go work on my marriage. At first, he provided some resistance, but then I reminded him that I was never going to leave my family. N_____ wanted to have a family for himself, and I wouldn't have been able to give that to him. It was selfish of me to not let him pursue that dream. I told him, "You can't play around with me. I need to concentrate on my family, and you need to focus

on getting a wife." It was actually a relief for me to finally leave that relationship. I wanted to give my family and career my complete focus.

I still work with N_____, but I've grown past the affair and just think of him as one of the fellas. From outside appearances, you'd never you know that he and I ever slept together. Once in awhile, he'll still confide in me about his family. I would consider him to be a friend rather than a coworker. When he was starting to talk to other women, he would try to brag about those conquests to me. I finally had to say to him, "You know what? That's what you have your boys for. I don't want talk about that with you." I don't know if that was some game he was playing to keep me thinking about him.

Me and N____ were never intimate again, and I have not had another affair. My husband and I have been together for 15 years and that's because I chose to look at our relationship differently. Love doesn't dwindle, but you have to nurture it continually. People lose that need to nurture their love when they get married. When you marry your partner, you have to love them like you did when you first met them. That takes some work. You continually have to think of how you can keep your love alive. Remembering the qualities that made me fall in love with my husband again, I regret giving 110 percent of my love to another man for two years.

Sofia

"I wish I felt guilty about how good that sex felt."

I went through with my wedding because people treat you differently when you're married. I wanted all of the grown-up accolades that come with that. Plus, it was an excuse to have a fantastic party. When I met my husband, I fell genuinely in love with him. At the time, marriage was the right fit for us, and we've grown emotionally as a couple. It's made me feel like a woman in all of its traditional aspects, but there were some sexually progressive ideas in my personality that made marriage a difficult adjustment for me. An open marriage was what I wanted, but I didn't have the confidence to ask for that. I've always found physical monogamy challenging. So near the end of my first year of marriage, I had an affair.

O_____ was a friend from college. We were close friends back then but we never slept together. Through the years, we kept in touch through Facebook. We also ran in the same writing and poetry circles. "We should hangout," he said casually. "Maybe go to a reading together." I was game and confessed that I still had a sweatshirt that belonged to him from college. "Now we really have to see each other again," he said. "I've been missing that sweatshirt."

The next time we saw each other was with mutual friends from college.

We all had a great time drinking and sharing stories from the old days. O_____ got really touchy with me. I wasn't having much sex with my husband during this time, and O_____ could tell I was getting turned on. When he invited me back to his apartment, I accepted the invitation without hesitation. As soon as we went inside he started taking off my clothes. I didn't even have to say anything. It was pretty clear what I wanted.

O_____ and I had sex throughout the whole summer because of my teaching job. The free time in the summer made it convenient for me to have another boyfriend without a single suspicion. My husband and I have the type of marriage where we both go out with friends of the opposite sex. I've never been the type of wife that had to check in. I would just go out.

I wish I felt guilty about how good that sex felt. The naughtiness of it was enticing because it was my first time ever having an affair. I know that the sex felt good because it was "wrong," and everything about that made me feel like a bad girl. It was the best sex of my life. Every moment with O_____ during that time was a blast.

At some point, I think my husband started to get suspicious. He became needy and clingy and for the first time started to ask me where I was going. We've never talked about our social media, but all of sudden he was asking me about certain men. We were in the car when my husband said to me, "I know what you've been up to. We need to talk about your Facebook." At the moment, I thought it was going to be another false accusation related to some random like on a picture. He took another deep breath and said, "Sofia, I know everything. I know about you and O_____." It turns out he was on my computer earlier that day and my Facebook account was open. O_____ sent me a message asking about meeting up. That message prompted my husband to look through my whole message history.

When I tried to explain myself, my husband started yelling and screaming. There was nothing I could do so I fessed up to the truth. The news wrecked him which surprised me because, based on his easy-going demeanor, I thought he would just sort of acquiesce to an open marriage. Divorce wouldn't have been his go-to solution. His parents have been married for 40 years and mine were married for almost 20 years before my mom passed away. We both came from "intact families with stable marriages," so he didn't want to make a hasty decision. He agreed not to tell anyone until we made a final decision together. If people knew about the affair, I think the judgment would be racially gendered. My husband is Jewish and I'm African American. There was this overwhelming feeling that the blame would be misplaced on me.

We engaged in a lot yelling during those next couple of months. My husband delivered many drunken tirades towards me. The yelling got so bad I thought the neighbors would call the police. One time he got so drunk and ridiculous, I left him at the bar. While I was storming out, I realized that I

didn't bring my credit card. I couldn't check into a hotel or stay with my friends or our parents. Everyone would know that my husband was drunk, screaming at me because I had an affair. There was literally nowhere I could go at that moment because I was the woman who cheated on her husband nine months into her marriage. Everyone we knew would take my husband's side, so I went to a park where I felt safe and I stayed in my car until sun came up.

If my husband were in better physical shape, I think it would've prevented me from straying. He's got that husbandly dad bod. I'm in really good physical shape, and when I look at him, I'm just kind of like, "Eh." His appearance was a huge bone of contention and when it came up he said, "So if I had a six-pack you wouldn't have had the affair?" I didn't know how to answer that because he and O_____ are actually quite similar. They're both Jewish, politically progressive, and artsy. My husband is a lot older than me. O_____ is three years younger, vibrant, and much more overtly sexual. My husband, on the other hand, is reserved.

When you're first married, your sex life cools down quickly. I became disinterested in sex almost right away. The affair forced both of us to talk about these issues openly. I was finally able to explain my difficulty with monogamy. My husband entertained the idea of having an open relationship despite the fact that I knew that wasn't what he wanted. I allowed him to carry on his own Internet flirtations just to see if he could commit to the idea. He had a few coffee dates with a couple of his ex-girlfriends, but I don't think that he ever had sex with them. It wasn't my place to demand that he stay faithful. After that phase was done, he was adamant that he didn't want to be with anyone else. He told me that he wanted to work through our problems and found it in his heart to forgive me.

We worked through forgiveness for the next six months. We're still married now; it took a lot of hard work. At the root of our marriage, my husband and I are really good friends. Spending more time together definitely healed a lot of things. We also share the same values and political ideas. Seeing how hurt he was clued me into how much he loved me because most guys wouldn't forgive their wife for cheating. I'm definitely happier now being married, even with a sex life that I'm not particularly thrilled with. I still wish that I could have an open physical marriage, but I'm just going to try really hard to remain faithful to him.

Rosa

"To be honest, I'm not sure who my son's father is."

I dated P____ before I met my husband Q____. After I met my husband, I dated both men at the same time. Q____ was really sweet when we first

started dating. He wined and dined and just spoiled me rotten. I became completely enamored with him. When it was time for me to decide which man I wanted, I chose Q___. I was faithful to our marriage for the first four years. I don't know what changed, but I wasn't being satisfied sexually and the marriage had trouble.

Instead of dealing with the issues, I sought gratification outside of the marriage and went back to P____ who was my first love. I had an arrangement that made it convenient for me to see both men. With my husband, I was always able to come and go as I pleased. At the beginning of our marriage, he wasn't a demanding man. If I wanted to go to dinner with P____, it wasn't a problem. I could come home whenever I wanted. P___ also had his own life, and he had a friend that he was seeing off and on.

Despite what was going on in our lives, I could never stop seeing P____. Just hearing his voice on the phone got me so excited. It made my heart flutter just thinking about him. I wanted to be with him night and day. Whenever I was with him, I was able to block out everything in my marriage. I was in a different world, a different place, which made me feel good. P____ worshipped me. I had the best sex ever with him. I wish I could bottle it and still have it here. Sexually, I have not found any other man that can make me feel the way P____ made me feel.

I was not planning on having children. Even though Q____ wanted a family, I told him no from the very beginning. When I had my son, it was a gift from God. I was on the pill when I got pregnant. We don't know how he crept up. I was 13 weeks pregnant and didn't know it. The nurse had to hand me my ultrasound so that I could finally believe it.

To be honest, I'm not sure who my son's father is. I was with both P____ and my husband. I did not have a DNA test to see who was the biological father. Q___'s name is on the birth certificate as his father and I'd rather keep it that way. As of right now, my son looks identical to me. If you put a wig on him, we could pass for twins. When P___ found out I was pregnant, he wanted me to leave my marriage and bring myself and my son to live with him. I didn't want to do that to my husband. I wasn't going to take Q____ away from the baby.

Even though I loved P_____, it was impossible for me to marry him. I had my own issues. I didn't think that I was good enough for him. He was head of personnel for his company and loved to play golf. He would go out on the golf course and take the "white boys' money," as he called it. He worked really hard and socialized with an upper-class crowd. P___ was a gentleman. I felt that I wasn't up to his standards.

P____ and I stopped seeing each other because the AIDS epidemic was prevalent and, of course, we weren't using any protection. He was showing signs of illness and I told him that I had to make sure that I was there for my

son. Unbeknownst to me, P____ was diagnosed with terminal lung cancer. During our very last date before our break-up, he wanted me to go back to his apartment with him. I said, "No, I can't do that. You won't tell me if you have AIDS and I have to be here for my son. I can't risk getting sick and dying and leaving my son here without me." During that date, he was extremely frail. I had no idea that he was in the process of going through extensive chemotherapy.

After that he backed off and didn't pressure me to be with him. When it was my son's birthday, I called P_____ to invite him to his party. At first, I tried him at his house and then I called him at work. He secretary told me that he was home ill, so I just assumed he was home with a cold. When I finally got a hold of him on his cell phone, he told me over the phone that he had terminal cancer and that he only had a short time to live. A family friend told me that P____ would be doing one final farewell trip to see his sons, but I don't think he even told them that he was ill. He just went to see them. I figured I'd give him his time to take care of his family and I'd talk to him when he got back.

A few weeks went by and I tried to call P____ at his house. When it went to the answering machine, it wasn't his voice on the greeting. I thought I dialed the wrong number or maybe he changed it because he moved. It turns out that the voice on the machine was P____'s son. He called my mom's home to tell me that P____ passed away. I never got the opportunity to say goodbye to him. I don't think he wanted me to see him in that condition. The other lady in his life took care of him until he went into hospice.

Q___'s anger issues got worse after P___ died. I don't know if it was coincidence or revenge because he found out about my long-term affair. He became verbally abusive to our son and would chastise him and call him names. For years everyone had to walk on eggshells around Q_____ because you never knew when he would snap. Eventually, I just had enough and filed for divorce. He moved in our basement during that time, and I was here when the sheriff came in and brought him the summons. I think he was shocked when he finally got the papers because I threatened divorce for the past 15 years.

Q___ had his own health issues and died from pancreatic cancer. When I found out about the diagnosis, he only had six months left. I believe he willed himself to live to see my son finish high school, but he was too ill and wasn't able to see him walk across the stage. After graduation I made sure that my son went to the hospital and took his diploma so that his dad could see it.

The death of both of these men will stay with me for the rest of my life. I wasted 25 years of my life unhappily married. I wonder if it would have been a happier time if I was married to P_____ instead.

Jennifer

"There's something about that feeling of sleeping with someone new
that I just can't seem to recreate in any other aspect of my life."

I always knew that I was capable of cheating. If I'm attracted to someone, I'm ready to sleep with them despite the consequences. Sleeping with one person over and over again doesn't excite me because you lose that nervous tension of sleeping with someone for the first time. I love having new sexual partners. Even though we don't know each other's bodies yet, the unknown of what's going to happen next is what excites me. I don't care if they don't know what I like in bed because I can't wait for them to show me something new. You don't get that in a marriage. When you're comfortable with someone you lose everything that is titillating about sex.

My boss and I always flirted at work. I couldn't help myself. He was attractive and charismatic. I secretly wanted to sleep with him because of the way he stirred up the women in our office. I'm sure it made my coworkers jealous when he gave me special attention. One night he called me drunk and asked for a ride home. My fiancé at the time was having dinner with his family so I was able to sneak out of the house and pick up my boss from the bar. When we got to his house, he invited me inside and we started having sex. It was a surreal experience because my boss had a reputation for only dating beautiful women. He could've had any woman he wanted, and he chose me. I couldn't say no.

I never told anyone about that encounter because I was still engaged. I was only 20 years old, but I figured that getting married was the right thing to do because I'd already been with my boyfriend for two years. I wasn't ready for marriage, but my family was Catholic and they would've disapproved of me moving in with him. I started to have serious thoughts about backing out of our wedding, but everything was already planned and paid for. If I called the wedding off, we would be throwing all of this money away. I didn't want to hurt anyone so I convinced myself that I could make it work.

As soon as we got married, my husband became clingy. He wanted to hang out with me all of the time. I felt trapped. Luckily, I was still in college, so I was able to have some time to pursue my academic interests. When I started writing for the school newspaper, I became close with another writer named R____. He was funny and intelligent and struck up a friendship quickly. I had to attend a journalism conference in another state, and R_____ was assigned to come with me. I enjoyed being in a new city and having all of that alone time with him. After a week of getting drunk and heavy flirting, we had sex in his hotel room before we had to fly home.

When I got back from the conference, R____ and I continued having an affair. It was hard to keep that secret from my husband because all I wanted to do was talk to R_____. Plus, my husband was so clingy it was hard to pry away. I couldn't just tell him that I was staying the night at a friend's house. I used that lie with my parents as a high school student; it seemed silly to try the same line as an adult married woman. Instead I used the school newspaper as a way to get out of the house. I told my husband I was out reporting. He was incredibly supportive of me. I don't think he ever suspected anything.

There was nothing wrong with my husband, but I had been thinking about divorcing him ever since we got married. He was one of the nicest guys I'd ever known, and my family loved him. If I told him about the affair, it would've devastated him. My relationship with R_____ made me realize I couldn't continue being married to him. I never told my husband that I cheated on him, but I divorced him three months after the conference.

I broke up with R_____ because I knew my family wouldn't accept him if they knew his role in my divorce. I was always worried about what my family thought of me. I didn't want them to think I was a bad woman. When men cheat, people tend to excuse it a little bit more. Even when it's the man's fault, you hear reasons why the woman is to blame. People will say things like, "Well she stopped sleeping with him" or "You know how men are; they have a high sex drive." Women are often encouraged to forgive a man that cheats, but if a woman cheats, she's ostracized from her community.

After I got divorced, I just started to feel like a terrible person for cheating in my marriage. That guilt lasted for two years even after I broke up with R_____. I also felt guilty because the divorce disappointed my very Catholic family. They couldn't understand why I would leave my ex-husband because he was such a nice guy. I've made up reasons that have nothing to do with infidelity. If they knew I cheated on him, they would have disowned me. It was about a year and a half after my divorce before I started dating someone else. I wasn't ready to tell my family or friends because I didn't want them to think I was a slut for getting divorced and dating someone right away. They like my boyfriend now, but they don't treat him with the same affection as my ex-husband. It bothers me, but I can't let my family's opinion define every aspect of my personal life.

When I started graduate school my guilt about my divorce started to subside. Meeting older students and hearing their relationship stories helped me broaden my perspective about relationships. When I first met my now-best friend in graduate school, she shared that she cheated on her boyfriends. We've had many open conversations about it. She made me feel like I wasn't alone anymore. Talking openly about my affairs was freeing. She never judged me and that helped me stop feeling guilty about it.

My boyfriend and I are monogamous. I've never physically cheated on

him, but I've indulged in some inappropriate conversations with other men. It's the most that I can do right now, because even if I wanted to cheat on my boyfriend, I wouldn't have the chance because he's around me all of the time. I would absolutely love to have sex with other people, but my boyfriend would not be into that at all. He would break up with me. All the men that I've ever dated are always the ones that want to be super exclusive.

Maybe if I tried to do more exciting things in my everyday life, I wouldn't feel the need to only to find excitement in sexual relationships. There's something about that feeling of sleeping with someone new that I just can't seem to recreate in any other aspect of my life. I love the possibility of having sex with a new person. I love flirting and initiating a relationship with someone I'm attracted to. There's just something like that feeling that keeps me alive.

Ayn
"It was the craziest four months sleeping with the both
of them without either of them knowing."

I've always had male attention from guys who were trying to pursue me. I've always used that to my advantage. There's a saying that says you teach people how to treat you. Throughout my whole life, men taught me that I could treat them poorly. If they allow me to walk all over them, then that's what I was going to do. I like to test the men in my relationships and exploit their vulnerabilities. I don't like taking no for an answer. If I want something, I know I can get it because I'm pretty and smart. Once these guys are smitten, I'm able to get away with murder. I've been very manipulative with my relationships where I make men stay with me out of guilt.

My mom taught me how to bully men because she bullies my dad. She emotionally abuses my father. It's made me lose respect for him, and it's unfortunate because my father is one of the most talented men I know. He built our house, our furniture, and, in many respects, was even more domestic than my mother. My father would be the one to cook dinner, cut our hair, and make our clothes. He did everything and still worked a 9-to-5 job. My dad was like Superman, but my mom would still yell and bitch at him.

I know that her behavior is due to post-traumatic stress from the war. My mom saw her dad killed in front of her. All of her siblings died, and she was imprisoned in the concentration camps during the Cambodian genocide. She and my dad were able to escape to a refugee camp in Thailand. Right after I was born, we came to the United States on a refugee visa. They struggled to learn English and to adjust to a foreign country. It was hard for my dad to find work so he took up a bunch of odd jobs, painted houses, and fixed

cars. No matter what my father did to make ends meet, my mother was never happy.

My mom claims that there was no love between them. The marriage was more out of convenience. My dad apparently has another family somewhere in Cambodia and initially lied about that to my mom. I remember my mom always accused my dad of cheating. He'd come home from work and she'd be like, "You're ten minutes late. Who were you having sex with?" She holds my dad hostage in their marriage with guilt. That's why he deals with her abuse. My mom was determined to push my dad until he finally left her, but he never left and to me that's love. You push and you push and you treat someone as horribly as you can, and if they stay, then they have to love you.

S_____ was a guy I'd met at school. For eight months we were exclusive, and it was a good relationship. We even flew out to Oregon to meet his family. When we got home from the trip, I started to pick fights with him. We'd just hit our six-month mark. The relationship was getting serious, and I was getting restless. I told him that I didn't feel we were intellectually compatible. I complained that he was too simple-minded and didn't pursue anything intellectually worthwhile. He took all of my criticisms in stride and did his best to improve on these things, but all I could do was fixate on every flaw he had and find ways to get mad over nothing. There was one night he went out with his friends for a beer, and I was mad that he didn't take care of me while I was sick, so I texted my ex-boyfriend T_____.

T_____ and I have an extensive history with one another. We've known each other since we were 14 years old. I treated him like crap from the beginning. I knew that I could get away with stuff because I was gorgeous. I took advantage of the fact that he was so in love with me. I almost wanted to punish him for dating me because of my looks so I'd boss him around and demean him for a couple of months and then I'd break up with him for no reason. He could've kicked me to the curb at any moment, but we grew up in the Mormon church so we were already planning on marriage. When we lost our virginity together, he bought me a ring and got a tattoo of my name.

I've always had T_____ on call whenever I was in between relationships. We developed this codependency in high school. For years we've been on and off and because I always need T_____ to want me. When I was mad at S____ for being out with his friends, I decided to go to T_____'s house to have sex. After I was done hooking up with T_____, I came back to S_____'s place to be with him when he got home.

During the next few months I started having a relationship with the both of them. I'd create drama with one of them so that I could have an excuse to sleep with the other. It was the craziest four months sleeping with the both of them without either of them knowing. I didn't have any remorse for anything that I was doing. I wasn't in love with either of them.

Finally, I told T_____ that I'd been having sex with someone else for the last few months. He sat down and just looked at the wall, then asked me, "How long has this been going on?"

"Three or four months."

"Why would you do that to me?"

"Because you deserve it," I said.

"I've never cheated on you. I've never done anything like that to you." I watched T_____ walk out of my apartment and sob in his car. Even at that point, I still didn't feel any remorse for hurting him because T_____ never once showed me that he truly loved me. My relationship with him was the root of all of my insecurity issues.

I was self-conscious about my looks when I was with T_____. In high school while we were at a party, I pushed him and then he slapped me in front of his friends. After that he kicked me out and we didn't talk for a couple of weeks. Instead of looking at our unhealthy relationship patterns, I was certain he slapped me because I wasn't pretty enough. It's such a twisted way of thinking, but T____ was so obsessed with pretty girls with big boobs. He would often make jokes about my chest, so to get him back I went and I got my boobs done. That's why I felt like he deserved everything that I did to him. T_____ was the one who forced me to get my boobs done.

When I told S____ his reaction was completely different. He just looked at me and asked, "Did you have sex with the both of us on the same day?"

"Sometimes," I said.

"I never want to see you again." S___ made good on that promise. Once he walked out of my apartment, we never spoke again. He was the longest relationship I'd ever had, and if I could do it all over again I would've told him sooner. It wasn't fair for these two to not be informed of the truth. I was oppressing another person by eradicating their choices.

Up until that point S____ and T_____ were the only two people I'd ever slept with, and I knew there was a lot more I wanted to explore. I don't believe that you ever show your significant other or another adult unconditional love because it makes way for perverse things to enter into your life. There are no boundaries with unconditional love, which should only be reserved for children and healthy attachments. Unconditional love erases all boundaries and boundaries are what you need to have a healthy relationship.

I've decided to go to therapy this year because I don't like the way that I treat men. I've treated them the same way all of my life without any concern for the consequences. I need to get my mother's habits out of my system or else they'll haunt me for the rest of my life. The things that I've done have left me a lot of guilt. Cruelty is not how I want to treat the man I end up marrying or who's going to be the father to my kids.

Fiona

"When I had a good closeness with a guy,
I had sex with him just to keep him around."

I think I would call myself a love addict. I've never felt good about myself so therefore I've required a lot of love, attention, and acceptance. I'm also very much a caregiver so I wanted to take care of everybody. I needed to feel connected. It was a void in me that was never enough. I met U___ in college. He was someone who'd gone back to school later in life. I was 20 and he was 30. I liked that he was someone who knew more than me. I felt special that someone with more experience would want to be with me. He was also a reformed bad boy. I've always been intrigued by rebellious guys which have caused a lot of my issues. I liked that U____ was still a bad boy at heart, but in addition to that he was also reformed and responsible.

Although I wanted a relationship with him, he never wanted anything serious with me. He just wanted sex and companionship but not the relationship itself. Because he never wanted to commit to me, I treated him like the guy on the side. I've cheated on multiple people with U____. During all of that time, I wanted U____ to love me and that's why I kept him in my life for nine years. I grew to love him because we spent a lot of time together.

When I met my current fiancé V___, I was still seeing U____ as well as dating other people. V____ was a very loving and attentive boyfriend, but we didn't always have the best communication. I was able to have so many affairs because I was living at my parents' house, but when issues came up at my parents' house, I needed to leave right away. I had nowhere to go so I moved in with V___. I still had my relationship with U___, and I didn't want to end that. On top of that, things were getting complicated because I was juggling two other boyfriends at the same time. I was trying to figure out how I could still cheat and be in my relationship with V___.

V____ was good about helping me with financial stability, but I didn't feel fulfilled in my relationship so I was always looking for somebody better than him. In my quest for a better man I realized that the guys I was finding were actually worse. I was attracting chaos into my life, and the men I've slept with reflected what was going on inside of me.

I've had sex with multiple people behind V____'s back. Sometimes I liked the sex and sometimes I didn't. Mostly I just did it because I wanted to talk to someone and be held. When I had a good closeness with a guy I had sex with him just to keep him around. I was with a guy for a year who was sexually abusive towards me but tried to disguise it as BDSM. If he caused me pain, it actually excited him more. He wouldn't hold me in bed or touch me the whole night. He would only touch me when he wanted to have sex.

It was a matter of time before V____ knew I was cheating on him because my behavior changed while I was living with him. When I was with V___, I cheated on him with seven other guys. These different affairs were causing a lot of trauma in my life, and I was exhausted by all of the madness. I decided to come clean so that I wouldn't have it on my conscience anymore. I broke up with V____ and I told him that I needed space to figure things out.

When I moved out, I started going to therapy and was diagnosed as a love addict. I started going to sex/love addiction meetings. I was consistently going to meetings and doing well in my recovery until I met a new guy. I fell head over heels for him and decided that I was solely going to be with him. I had only known him two weeks and he turned out to be a heroin addict. Being with him was awful and traumatic. For one horrible night he held me hostage for hours while smoking heroin in front of me. He turned into this awful monster and was just completely abusive, not physically, but just verbally for hours and hours. I was scared for my life so I just curled up in a fetal position and cried. After that incident, I broke it off with him and eventually made my way back to V____.

I went back to therapy and my therapist encouraged me to tell V____ everything. "You were held hostage against your will. This is serious trauma that you've been through. You need to come clean and tell V___ what happened." When I told V____ everything he was angry but also realized how lucky I was that I wasn't hurt. He was committed to staying with me and helping me with my issues. I still wanted him in my life because he's always been my best friend. When things have gotten bad, he's the one person I can count on. Even if we didn't get back together, I still wanted our closeness. V___ started going to therapy to understand my struggles and told me he was going to stick by me under one condition. He said, "If you ever do it again, that's it. It's over. I'm leaving, and we'll be done."

I couldn't hold my promise. I had one last night with the heroin addict. The heroin addict was the first guy I was ever actually physically attracted to that was pure infatuation. He was the most gorgeous guy I'd ever been with. I couldn't refuse him. He could've been a Calvin Klein model. He had this way of charming me, and when he told me that I was the woman of his dreams, I figured that one more night couldn't hurt. He told me he finished rehab and wanted to make amends.

When I saw him, I found out that he had been kicked out of rehab and was on a binge. He'd been high on meth for three days and was coming down. I have never been around serious drug addicts, so when he started doing all these weird things like twitching and sweating, it started to weird me out. Luckily, I was able to leave him without being held hostage again.

When I came home to V____ I told him that I relapsed and hooked up with heroin addict. We both realized that his initial ultimatum was an empty

threat and that I had a larger problem with addiction. He told me I needed to be more vigilant with my treatment. As we've remained together, we've had to work on building our trust again. Every time someone that I've slept with contacts me, I always show him the message. When someone on Facebook friend requests me, I show him. I tell him everything so he knows what's going on with me. That's been part of the rebuilding and therapy.

This time around, I've ended all of my side relationships which included U____. I've read that love addicts can have healthy relationships, and I'm committed to developing that with V_____. I think there is a part of him that fears I will cheat again, but we don't talk about it like I am going to do it. Hopefully, I can stop that compulsive behavior before it gets to that point. One time I asked him why he doesn't go through my phone or emails and he said, "What would it change? You're going to do what you're going to do. I can go through your stuff. I can spy on you. I can stalk you. In the end is it going to make you not do it?" He's right to say that to me because the temptation is always going to be there. I can't say that I'll never do it again, but I can say that every day I'm going to work towards being faithful.

Tracy

"I was trying my best to not cheat on this boyfriend, but there's something about my personality that just loves to push boundaries."

Working in restaurants fuels this real sexual tension. Servers, by nature, have to be likable so that customers give tips. Flirting comes with the job, and you're around all of these young, attractive people. Because we're moving in close quarters, it's not uncommon to touch one another and develop these attractions. It's this intense work experience for six hours a day. I was totally 100 percent completely immersed in being a server and no one could understand except for my coworkers.

The fast-paced environment of a restaurant helped me cope with my relationship problems. I was in a long-term relationship with a guy that wasn't in love with me so I began flirting with one of my coworkers at the restaurant. My coworker was married but only for citizenship reasons. His wife never suspected anything because she knew her husband was a big flirt. If she caught us touching each other at work, at most she'd give me a dirty look. One time he slapped my butt right before she walked in to pick him up.

There was one night my coworker and I worked the closing shift. It was almost 2 a.m. and we were both filthy from the dinner rush. My coworker asked me if I wanted to go over to his place and wash up. His wife was out of town,

and I didn't want to go home. I figured a hot shower wouldn't hurt anyone, but we ended up having sex. I didn't tell my partner.

The first time we hooked up was really bizarre because we weren't drinking. That was a big deal for me. Most of my intimate behaviors were initiated by alcohol. It made me completely cognizant and aware of my behavior. Knowing that it was wrong was a thrill. The sex wasn't that great, but I was addicted to the danger of being caught. It became like a drug.

I was also punishing my boyfriend for not loving me. There was one night that my boyfriend cooked dinner for me, his sister, and some mutual friends. While they were at the house waiting for me, I was at a bar with my coworker. I know that my boyfriend was trying to make it look like he and I were doing good. He was putting on a show for his sister; I didn't want to show up for it. My coworker was happy to stay out with me for as long as I wanted, so we got drunk and then hooked up at his apartment.

I was still completely smashed when I finally returned home. I brought some other friends my boyfriend didn't know, and it was just this weird, awkward, horrible day. We broke up soon after that. I ended up telling him about my coworker a few months after our break-up when we were drinking together. The admission came out by accident. I regretted it the moment I said it. We weren't together anymore, but I could tell that I just broke his heart.

After confessing to my ex-boyfriend about my infidelity, I decided to change jobs and started working at a new restaurant. Once I got comfortable, I began dating someone else almost immediately. Getting into relationships quickly has always been a pattern for me. It's no surprise that this guy was the bartender at the restaurant where I worked, but he wasn't a server like my last restaurant boyfriend, so I thought that this was a significant change.

In the beginning, it was a fun relationship. He gave me a lot of freedom to be myself. He wasn't threatened by my flirty nature and didn't ask any questions about certain guys who were texting me. When we got a year into our relationship, I started having feelings for and crushes on random people. I wasn't actually interested in being in a relationship with anyone other than my new boyfriend, but I was getting attention from new people, so I fed off of that excitement.

I'm also not someone that gets validation through one-night stands. There's a prolonged excitement that I'm addicted to. I like the endless possibilities of admiring multiple people. I knew that things were getting out of control when I started to have a crush on his cousin. I would get excited whenever his cousin came to the house or arrived at a party. His cousin started to respond to my flirting and that's when I knew that I had to stop. I was trying my best to not cheat on this boyfriend, but there's something about my personality that just loves to push boundaries.

I wasn't loyal to my second boyfriend. When he couldn't come with me

to my friend's wedding, I cheated on him and slept with the best man. I was caught up in the excitement of that beautiful wedding and the best man was front and center the whole weekend. He was good about rallying the troops and getting everyone together. The whole experience was almost like summer camp. Something about his leadership drew me to him. He was funny, charismatic, and had a strong spirituality. There was just something exciting and fun about him.

I broke up with my boyfriend the day I got back from the wedding. It was a really sudden and sad break-up. I don't think he had any idea that it was coming. He was a really good guy but I just wasn't in love with him. Perhaps that's why I cheated on him. I didn't feel any remorse about that wedding infidelity. Perhaps it was because he and I jumped into a relationship quickly and there wasn't enough time for me to develop that type of bond.

I don't think I have a fear of commitment. I have romantic fantasies about getting married and having kids like everyone else, but I'm just addicted to having crushes. Chasing a crush's attention is exciting to me especially when I have those feelings reciprocated. It's a part of me that likes being wanted and being loved. It's why I get into relationships so quickly but it's a pattern of behavior that's caused a lot of pain.

After that break-up there was a shift that happened for me. I realized that I have this horrible pattern of infidelity. That last break-up was a game changer. I never wanted to cheat again, but there's something about these crushes that I don't want to give up. If I were to actually work through these relationships instead of destroying them, maybe I wouldn't have these attractions to random people. I've cheated on all my exes, and even though I say that I want to settle down with someone, I don't know if I have it in me to do that.

Cree

"That convention was a complete vacation from my life.
I didn't want it to stop."

I'd been with my fiancé for two and a half years when I traveled east to a business convention. Out of the group of the ladies I was traveling with, I was the only one in a committed relationship. I was acting funny style about it because I didn't want to be around a bunch of women that just wanted to chase boys, so I told them that maybe I should get my own room because I wouldn't feel comfortable being around all of their single shenanigans. I was actually kind of bitchy about it because I had elevated myself to a particular moral status because I was engaged. I was fine with being alone in the hotel

room while they hooked up with other guys. I planned to go out with the girls at night and then come back to the hotel so they could all have their fun.

During our first night, we all went to a convention party together. The party itself was quite a sight to see. I've never seen so many young, professional, black people in one place in my life. It was like an intellectual meat market for the brilliant and single. The convention party was just wall to wall men. I was sitting next to my friend who was single and very on the prowl. We saw this guy and my friend said, "Ooh, look how cute he is." I looked over and saw that he was cute, but I didn't think anything of it.

Then he walked by us and said, "Well, hello."

My friend was like, "Hi."

He looked over at my friend and said, "Oh, hi. I'm sorry. I don't mean to be rude, but I was saying hello to your friend."

"Me?" I said.

"Yeah, I'd like to get your name." We started chatting. During the whole time, I had my ring on and throughout the conversation I mentioned that I had a fiancé. He asked me a few questions about our wedding plans, and then casually turned the conversation into a networking prospect and asked for my number. He was local in the area so he said, "Oh, I could take you girls out. We can get a boat."

"That'd be great. You have my number. Let's go out when you're free." All of my girlfriends were squealing, "Oh my God. He's so cute! I can't believe he's gonna take us on a boat."

"I know," I told them. "That guy was cool. I'd like to talk to him again."

"No, play it cool," they said. "You'll look desperate if you try to find him again." Then I got up to get a drink at the bar. All of a sudden, he was right next to me. "I was looking for you. I want to continue our conversation."

I laughed and said, "That's funny that you should say that because I want to continue our conversation too."

"You know the boys told me not to come back."

"Yeah, my friends told me the same." We talked a little bit more, but then the night ended and that was it. When I went back to the hotel that night, I didn't think he was going to call the next day, but he called early in the morning. I had convention things to do all day so I said, "Well, you know we're going to a club later tonight if you want to meet up." I didn't think he was going to show up to the club, but he came by himself and we danced all night long. If you saw us you would have thought we were together because we only hung out with each other.

Then the next night he asked me if he could he take me on a date. That gave me a little bit of anxiety because I hadn't been on a date in a long time, but the date was magical from the beginning. I wore my favorite dress. I could tell by the look on his face that I looked good. He took me to this amazing

restaurant and then gave me a sightseeing tour all around the city. When it got late, we hung out at a hookah lounge. As we were leaving he said, "Oh, let's go this back way." As I followed him, he pushed me on this wall and kissed me. I knew I wasn't supposed to be kissing him, but I didn't care at that moment. The only thought going through my mind was, "Well, should I go back to the hotel? Do I go back to his house?"

I liked this guy because he was my foray into being with a bad boy. He'd been to prison for selling drugs, but by the time I'd met him he'd completely rehabilitated himself and became a business entrepreneur. He was also hot with a voice like DMX. I am this geeky grad student, like, nerdy and kind of a square, so it was closest I came to dating a roughneck and that was fun for me. I ended up going back to his house, and we hung out that whole night. As we were having sex, I wasn't thinking about my fiancé or what would happen if he found out. It was a great date that ended with great sex.

The next morning, I didn't feel any guilt. I don't know if I was going on adrenaline or delusion, but I spent the next eight days booed up with him, like, completely booed up. He was my convention boyfriend. The cool thing about it was that he got along with my girls. He took us all with him for two nights, so they loved him. Till this day they still ask about him. There was a code of secrecy between my closest girlfriends and me during that trip. They were completely cool with it and probably liked him more than my fiancé.

Even though he was the one I was primarily seeing, there were so many attractive people at this convention that we decided to date other people. All of my friends knew what I was doing because I wasn't hiding from them. They were like, "What's going on?" I'd tell them that I was going out with this guy or that guy tonight. They just wanted to make sure that I was safe.

It was a surreal week. I'd never done anything like that, not to that extent where it was like, "I am like clearly cheating! Cheating, cheating, cheating!" Even though I was going on other dates with men at the conference, I still slept with my convention boo every night. There would be certain nights where my fiancé would call. I don't remember how I hedged it off. We had a few arguments because he felt I wasn't calling him enough on that trip. I tried to call him just enough to ward off suspicion, but I wasn't as vigilant about calling as I could've been. That convention was a complete vacation from my life. I didn't want it to stop.

When I got home from the trip, I had to find a way to snap back into my normal self. For a second, I was in a better mood because I'd been swept off my feet for ten days. My fiancé was a bit clingy when I got home, but I could put up with a little more of the bullshit because everything that hadn't been fulfilled in my romantic life was fulfilled at that conference. Me and the guy from the convention were talking a lot and had scheduled a trip to see each other again, but I started getting nervous because I returned to normal

life with my fiancé. I wasn't feeling right about it. I started to feel guilty about everything I'd done but didn't want to cancel because we'd spent months planning the trip.

I made it out to see him, but I decided to stay with my sister instead. He was really upset when I told him that I wasn't going to stay with him. "I am engaged," I said to him. "I can't act like I don't belong to somebody else."

"For real? That's how you're going to do this?"

"It's wrong. I have to stop."

"How are you going to be in my city and not see me?"

"I can't have another boyfriend in another city. We're just going to have to approach this trip as friends."

He took a deep breath and said, "Just give me one night and I promise whatever you decide to do when you leave, I'll respect it and leave you alone." It was an agreement that I could live with, so I ended up spending one night with him, and it was so much fun.

When I try to figure this out why it happened, I don't have a clear answer. It's not like I was miserable with my fiancé. I didn't go to that convention looking to cheat on my fiancé. I think it was just serendipity. Those ten days changed me because I was able to explore a different side of myself and challenge my belief systems. I got to be with a man who was different from anyone I'd ever known, who allowed me to be with other men while also having the best time with him. I don't think I'll ever have an experience like that ever again.

He honored the agreement and let me have my space. We never got together even when things with my fiancé didn't work out. He flew down to see me once and we had one business dinner, but we've only remained friends. "Remember when you were convention girlfriend?" he said. We laughed about it, but that's all that it was. We had an extraordinary moment for a short amount of time and he'll always have a special place in my heart.

Understanding the Unfaithful

No woman would cheat without an opportunity to do so. Opportunity or the availability of willing partners, most often found through work, school or online, is a requirement for infidelity. A common theory of infidelity is that people take advantage of these opportunities and cheat because they are either pushed or pulled into a relationship with an extradyadic partner.

Pushes are characterized by dissatisfaction whereas pulls are marked by desire. Peggy Vaughan, author of *The Monogamy Myth*, lists pushes as "desire to escape or find relief from a painful relationship; boredom; desire to fill gaps in an existing relationship; desire to punish one's partner; need to prove one's

attractiveness or worth; desire for more attention or other unmet needs." Pulls are "attraction (sex, companionship, admiration); power, novelty; excitement, risk, or challenge; curiosity; enhanced self-image; falling in love."[4] When thought of as a continuum, the push and pull theory provides a useful structure for understanding these women's motivations.

On the push extreme of the binary are the women who want to punish their partners. In fact, Assata and Sue used the word revenge. Typically, revenge affairs are enacted in response to a partner's infidelity, but faithful partners can enact other violations that warrant negative reciprocity. The previous section addressed intimate partner violations that accompanied infidelity. For several of the women who cheated on their partners, experiencing violations led to infidelity.

Assata's partner was emotionally abusive to the extent that his family queried why she stayed with him. His put-downs diminished her self-esteem. His attempts to embarrass her in public and control her interactions with others were signs of social aggression. This "push" created Assata's "need to be a winner, to win," which is how she justifies being unfaithful. Sue describes her husband's financial aggression of withholding financial resources that she felt were rightfully hers. Perel notes that under the constraints of the emotional torments such as those described above, "infidelity may be an expression of self-preservation and self-determination."[5]

Neither woman intended for her partner to find out. Assata is a "monogamous infidel"—an unfaithful partner who withdraws because she cannot be in two concurrent relationships.[6] After Assata cheated, she ended her relationship and continues to keep her secret. Sue denied her affair initially, but once she confessed, a litany of complaints emerged, and she knew she wanted a divorce. Relational violations pushed the women to have sex with someone else but, perhaps more importantly, it pushed them towards a version of themselves self-aware enough to terminate their unsatisfactory relationships.

Assata and Sue's actions can be interpreted as more selfish than malicious, but when combined with the ways that Ayn punished her two boyfriends and Tracy punished the first boyfriend in her narrative, there may be an emergent personality characteristic among women who cheat that aligns with the Dark Triad. The Dark Triad personality traits of narcissism, Machiavellianism, and psychopathy have been associated with infidelity. The theory cannot be fully applied here because the women were not asked about their traits. However, because of the intentional way these women used infidelity without remorse, at least in the moment and/or upon partner discovery, they behaved in a very deliberate, "maximally advantageous," Machiavellian way.

Jones and Weiser identify Machiavellianism as a unique predictor of infidelity among women because "Machiavellianism as a strategic trait is most beneficial for committing malevolent acts in a calculated way that maximizes

selfish benefits."[7] As mentioned in this section introduction, women who cheat on their partners face unique consequences. Women higher in Machiavellianism traits will have accepted these risks and fully calculated their potential rewards which, in the cases of Assata, Sue, Ayn, and Tracy, were to punish their partners and terminate the relationships.

Taj never says she wanted to punish or get revenge on her husband, but her "push" included gaps and unmet needs in the marriage. Her "pull" towards her lover for two years was a newness and respect that she was lacking. Taj is a paradigmatic example of how pushes can lead to an affair and pulls can sustain it. Evelyn was also unhappy with her husband and found new happiness with another man for seven years. At the time of the interview, it seems her newness has become commonplace and is perhaps creating another push. Rosa's triangle relationship finally ended with both partners' deaths. Similar to Taj and Evelyn, she was pushed towards an affair by a desire to escape trouble in her marriage and pulled by great sex with her first love.

Taj, Evelyn, and Rosa are the only mothers and the only wives with sustained infidelity partners. Sims and Meana outline three "forces dragging down sexual desire" for wives. They are (1) institutionalization of relationships, (2) overfamiliarity, and (3) desexualized roles.[8] Taj had been married for 15 years, Evelyn for 19, and Rosa for 25. When that length of time passes between two people, the relationship often enters a rut. A wife and mother may come to be seen as those roles, not an individual with her own passions and desires that, in these instances, pulled her away from her husband and towards a lover.

On the pull extreme of the binary, there are women like Sofia, Tracy, Jennifer, Fiona, and Cree who have permissive attitudes towards sex with multiple partners. Sofia is nonmonogamous. Unfortunately, she is married to a monogamous man. Tracy says, "There's something about my personality that just loves to push boundaries." She is addicted to "prolonged excitement" and "the endless possibilities of admiring multiple people." Jennifer is in love with beginnings and admits, "If I'm attracted to someone, I'm ready to sleep with them despite the consequences." Fiona is a self-professed love addict looking to fill a void. At the conclusion of their narratives, they each assert that they hope to be faithful in the future, but the underlying doubt is undeniable. They are driven by attraction, novelty, excitement, and curiosity—all prominent pull characteristics.

Specifically, Fiona and Cree mention the appeal of a bad boy who differentiates them from the good girls they are expected to be and the bad girls they would like to be. The men who were addicted to drugs and had been to prison were an intoxicating "pathway to risk, danger, and the defiant energy of transgression."[9] Perel uses this phrase to describe affairs in general, but this tripartite cocktail is applicable to and amplified by women looking to

escape social expectations. Women who have done everything "right"—getting engaged and married, earing degrees, and being faithful—sometimes use affairs to indulge in something incredibly pleasurable, exciting, and "wrong."

The Dark Triad psychopathy trait characterizes "individuals [who] may pursue sex irrespective of consequences, relationship context, or outcome."[10] Again, it is impossible to assign this trait to these women without further study, but opportunity, personality, and attitudes toward infidelity are infidelity predictors. While some personalities may be more prone to infidelity than others, we must not pathologize women's affairs. Sims and Mena assert, "We have long associated the link between sexual excitement and novelty to men's sexual desire, but rarely do we associate it to women's desire."[11] Sometimes the pull simply is desire. Because it is so rarely recognized, women who act on their desires should be acknowledged for doing so.

It is important to remember that desire is not synonymous with love. The majority of these stories are not about love. Taj, Nicole, and Frances are definitely in love with their primary partners, but they had to cheat to fully realize it. Evelyn says she loves both men but isn't in love with either of them. Rosa loved her lover but not enough to leave her husband or confirm her son's paternity. No one notes falling in love with an affair partner. The women who were pushed either used the affair as justification for leaving their primary relationship or they used the affair to rebuild their primary relationship. The women who were pulled embodied a *ludus* love style that was very noncommittal and playful. Although they sometimes left their primary partner, no one with a pull orientation left their partner for someone new or remained with an affair partner for an extended period of time.

Irrespective of their position on the push/pull continuum, these experiences embody "affair utility." Affair utility describes the usefulness of an affair to help a woman execute important decisions about her relational and personal life. Affair utility does not abate the pain these women may have caused their partners. It does, however, emphasize how women make choices about who they want to be with and who they want to be after an extradyadic relationship. Perel suggests, "Sometimes when we seek the gaze of another, it isn't our partner we are turning away from, but the person we have become. We are not looking for another lover so much as another version of ourselves."[12]

Sometimes these relationships mend. Sometimes they end. Sometimes women like Ayn and Fiona seek therapy because they want to change their behaviors. Sometimes unapologetic women like Cree embrace their ability to accept pleasure whenever and wherever they encounter it. Sections one and two demonstrate the devastation that can arise from an affair. This section appreciates the decision-making process that emerges from an affair.

I Was the Other Woman

Mistresses get a bad rap. According to Raven in this section, "Many people think of a mistress as a brutal woman who's coming in and kicking everybody's puppy and little children, taking this marriage, throwing it away, being heartless and cold, and being the bitch." The section challenges Raven's description of the Other Woman as scapegoat. Instead, it humanizes Other Women beyond the stereotypes of ultimate temptresses and home-wrecking whores. To be clear, this section is not meant to celebrate Other Woman behavior but to understand the contexts in which it occurs.

Contextualization begins by adopting Laurel Richardson's use of Other Woman with capital letters instead of mistress "to wrest [the label] from its stigmatized context, and to remind the reader continuously that these women are not just 'others' ... they are a distinct social group worthy of analysis."[1] Other Women are defined as women who are "the third party to a primary romantic relationship."[2] Reputable research on the Other Woman is impossible without Richardson's seminal work *The New Other Woman*.

At the time of the interview, these Other Women's ages ranged from 22 to 46 with an average age of 33. Sheva declined to offer an age or a racial identification. Eight self-identify as black; four as white. Ten self-identify as heterosexual whereas two identify as bisexual and one as heteroflexible. All of the core narratives, with the exception of Denise, are about heterosexual relational triads. Five participants earned professional or graduate degrees, four graduated from college, and four attended some college.

Of course, these 13 women are not representative of all Other Women, but they are a diverse sample. Four are mothers. One of the mothers was also married. An additional woman was in a relationship at the time that she became an Other Woman. Several of them were Other Women when they were young and learning about love and exciting sex for the first time. The

diversity of this sample reflects the diversity of experiences when exploring how and why women become Other Women.

Sasha

"It started with explicit text messaging that detailed
all of the things that he wanted to do to me."

I was young when my dad cheated on my mom with a family friend. Our families were really close. We were over at their house all the time. I knew something was up and was trying to tell my mom for some time. Finally, the woman came to my mom and confessed to the affair, but it was devastating for her because they were good friends. It didn't come out until a year after they had ended it. My mom was clear that if he messed up again, he was out of there. He wanted to be in his marriage. He wanted to be around, so he agreed. The effects of my dad's infidelity are deeply ingrained. I thought about it a lot when I was in my own situation with a married man.

I was in a pilot film program during my last year of high school. It was such a great year because it was my first time working in film. It was through this program that I started to become close with the director who truly believed in my potential. He would come in once a week, but there was definitely something between us the from the moment we met. I was attracted to him as an older teacher even though he was married with two kids. I've always been attracted to older guys, but I liked that as a teacher he had a thriving program, a film production company, and was successful in many areas.

I had a major teacher crush to the point that I hung onto his every word. It was this immense admiration because he was this older leader figure who gave me a lot of confidence in what I was doing. Everyone loved him, and I know other girls kind of had a crush on him. He was never inappropriate while I was in high school. I always wanted him to come into the classroom, get his opinion, or just anything to get him close to me. In the spring of my senior year, we worked on this big production together at school. It was next level in terms of production value and set design. A production of this caliber hadn't been done before at our school, and I was in charge of leading it. He gave me the confidence to pull it off. All of the extra time that we had together brought us closer, and that's when his guidance became flirtation.

I went to a community college in my hometown so I was around during the next high school film festival. I helped with costuming for it, but I mainly helped because he was there. There were a couple of events in the next year that he invited me to. Looking back on it, I was the only alumni he'd invite.

He then asked me to be the director for the next film festival. During the next six months from summer to the film festival, our work together dramatically evolved into something inappropriate.

It started with explicit text messaging that detailed all of the things that he wanted to do to me. I usually don't like to text message with boys because they can pretty much say whatever they want, but it was for this exact reason that I started to get bold with my teacher. There were things that we would never say to each other in person, but we felt free to say them in text messages. He was totally consumed and obsessive. He would leave me sexy poems and notes on my car and drive by my house just to park in front. One time he drove into a tree outside of my house and my dad said, "Wow, I wonder what happened? Why was he even here? You know him, right?" My teacher and I lied to make it seem like it was just coincidence that he was there.

During our banquet for our film festival he got up in front of everyone and thanked me publicly for all of my hard work. He expressed accolades and praise for all of my achievements, and he shared with the room that he completely believed in my future. I was totally enamored because he was doing this in front of everybody. My parents were there. My mom said later, "That was kind of weird that he was going on about you. It made it seem like you were the only one that did something for the film festival." There was an uncomfortable silence between us. She gave me a look like she wanted to ask me something, but she wasn't ready to ask it yet.

Earlier in high school my mom used to say to me, "Be careful. Men are weak when it comes to sex. You're strong. So be careful how you use your beauty and strength. Women have that power to say no." It was all beyond her control. I was completely overwhelmed by the emotions associated with this relationship. It was very emotional, anxiety driven, paralyzing, and thrilling at the same time.

I was finally getting the attention that I'd been wanting and now I had confirmation that he'd been attracted to me the whole time. I was wrapped up in the fact that he chose me over his wife. For me there was a sense of pride in that. I had met her on random occasions but did not have a relationship with her. She was rarely around for his film events, so they obviously did not have a strong marriage at the time. They were both incredibly intelligent and driven people. Their marriage was filled with a lot of individualism, but it wasn't balanced. He told me that he and his wife weren't having sex and that he was looking for someone else.

I think for men an affair is more about sex and for women it's more about the emotional intensity. I was not the most sexually experienced person when we were seeing each other, so we never had sex. We didn't technically have oral sex either, but we had oral sex with clothes on. The extent of our physical relationship was kissing and touching. I never felt I was going to be raped,

because he wasn't violent or forceful with me. He was always trying to make things more romantic. He used to tell me, "I can touch you all day, but I won't because you're too nice." He never tried to take off my clothes or get into my pants. He just liked to caress me and give me the romance he wasn't getting at home with his wife.

My teacher usually listened to me when I wanted to pump the brakes sexually, but over time he pushed the boundaries if he saw an opportunity. There was a time where I tried on some clothes in front of him, and he pulled out his penis. I told him, "Whoa, put that back." If I hadn't stopped it, I think he would've tried to pursue sexual intercourse with me. Once while we were messing around he came all over me. The whole time we were sitting in the back of his car, and even though there were teenagers outside watching us that didn't prompt him to stop. He just did it without thinking. Afterwards I had to wear a jacket over my clothes while I sat in class for two hours. I started to feel like he didn't give a shit about me.

My lack of experience and need for validation was an advantage for him. Instead of working out his problems with his wife, he would make me feel good about myself so that he could get what he wanted from me. When I found out that his wife was pregnant, I knew that he lied about their level of intimacy. To get me to stay, he started to tell me how much he loved me, and I realized just how manipulative he was. I told him he was coward. "How could you be doing this to your family?" I said to him. I did not feel in love with him. We did not have a ton in common. I was dealing with someone in his mid–30s and I had just got done with high school. It started to become creepy so I tried to break it off, but sometimes I would need the attention and then I would text him just to get it.

During this time, I was lying to my family and friends about my where-abouts. I would ignore calls from my parents. If they asked where I was, I said down the street. "No, you're not," my mom would say. "Where are you?" I finally told my mom about everything that had been going on. She said to me, "You need to break it off. If you don't break it off, I'm going to tell your dad. Do you want me to call his wife? Break it off now."

She told my dad anyway and my dad pulled out my phone records. I'm a kid still so they're still paying for my cell phone bill. My parents got a full scope of just how much my teacher and I were talking. Thank God he wasn't able to see any of the actual text messages because they were disgusting. He was only able to see the amount of the text messages at all hours of the day and night. That night we blocked his number and I was no longer a kid being taken advantage of by her teacher. I didn't want anything to do with him, but at the same time I was distraught about losing his friendship. He was the only male giving me positive male attention. Losing that support was an adjustment I hadn't prepared for. Whenever I would get emotional about it

my parents would say, "Sasha, why are you crying? You don't have to make this into a big deal." My dad was coming from more of a protective angle; he just wanted it to go away. He just told me to forget about the whole thing and use mind over matter.

I'm very lucky that my parents had been through something similar. They gave me a lot of grace and never treated me like I should be ashamed of what happened. At the time, I didn't want to see my teacher's validation as inappropriate because I've always wanted to be older and hang out with older people. He was a successful man that made me feel we were on the same level, but this isn't a story of two equals. I was taken advantage of. I acknowledge that I was an equal participant. I was driving the affair just as much as he was. However, I didn't make a vow to anybody. I did not have a husband. I did not have children. I was the younger person—his student. I was just this little girl that he made feel like a woman.

He'll still try to get in touch with me. Recently he told my brother that he had a ticket for me for this year's film festival and that he was going to present me with an award. When I checked out the film festival website, I saw I'm in a lot of the pictures. Even though we don't talk, he's always trying subtle ways to get to me. He was always so good at walking this fine line.

Lita

"I think regret is a stupid emotion, so I never
regret the things that I have done."

There was a person in the group of friends I hung out with who was married, and I started to just sort of get a vibe from them that they might have been interested in me. This was a very good-looking person and a really nice person I'd socialized with on a lot of occasions. At one point, I started to think that it might be something I needed to talk to my friends about. I confessed to my best friend that I had crush on this person who was significantly older. I think he was 32; I was 19. She told me that he and his wife had an open marriage, so I just kind of stored it away in the back of my head. I didn't really choose to pursue it. I just kind of hung around and was going to see what happened.

A lot of people in that group were polyamorous so they would have multiple partners. The way a lot of them would do it is they'd have a primary relationship, whether it was a marriage or a dating long-term situation, and then they'd have other boyfriends or girlfriends. That was the way I was introduced to it. After just a couple months of this kind of infatuation thing—we didn't really flirt or anything—he asked if I wanted to have a chat. We used

to play board games and stuff a lot in that social circle so I thought, "Hmm, well, that could either mean he wants to talk to me about a game or it could be what I think it is." And it was what I thought it was. He said that he and his wife had an open kind of situation and that if I wanted to pursue a casual dating relationship with him, that was something he was open to, something he would like to pursue. I don't really remember exactly what I said, but I told him I was interested, basically. So we hung around kind of casually for a while.

I guess the rule with them was that you could have another partner in a more physical sense. Casual sex was okay, but you weren't really supposed to get emotionally attached, which brings its own whole slew of issues. I was very inexperienced at that point. I wasn't a virgin, but I was just very shy and moved very slowly in relationships. We kissed a lot at first. After a couple weeks, he said he developed really deep feelings for me really fast and told me he loved me. I, being 19, was like, "Wow! Somebody loves me—how nice!" So I let myself fall deeper into that feeling as well. He was definitely big in my romantic development. He was the first person I really loved and thought that I could be with on a long-term basis.

We both got tested before we were ever even naked together just to make sure that neither of us had anything. After about a month or so we did other things, but we didn't have sex until like three or four months into it. I was on birth control and always insisted on protection. After we started sleeping together, he told me that he was no longer sharing a bed with her. I don't know for sure if that was true, but I believed at the time that we had an exclusive sexual relationship.

By that point, we were telling each other that we loved each other. Since there were deep feelings involved, it wasn't just casual sex, it was lovemaking, and that was out of the realm of what should have been happening. It was obvious to both of us that it wasn't the casual thing that their open marriage entailed. His wife didn't want children, but I did, and he said he wanted them with me. We had "I want to marry you" feelings. He decided that he wanted to leave his wife and be with me instead. I haven't ever really been someone who's drawn to the polyamorous lifestyle. In my mind, we wanted to establish ourselves as a couple and as a committed relationship.

This went on for two years. He did actually move out of her house. He lived by himself for a while, and I would visit. We were essentially dating— we just weren't telling anyone that we were dating because, according to the group, everyone knew they were separated but had not started divorce proceedings. He'd act like we were together and then we weren't. He changed his mind about children. In my imagining of my future, there's always children. I stayed because I had strong feelings for him. At one point, though, I asked him if he wanted to make this an actual relationship. Basically, he said that

he couldn't and that he wouldn't tell people about us. Finally, I put my foot down and said, "I can't do that anymore. You need to tell people about us, or I'm going to get out." So I got out of it. At the end of that school year, which was my last year in college, I went away to a job in another state. I heard from my best friend after probably two or three weeks that he moved to City E with his wife and that they were together and everything's just fine. I was so devastated that I hung up on my best friend.

He would say things like, "Even if we don't work out, there's no one else for me," blah, blah, blah, "I'm never going to get back with her." All the things that I feel like people say but they never really leave the wife. It's not exactly that I thought my situation was different, because I'm kind of a scientifically-minded person. In my mind, he had declared his feelings to me, had taken steps to get out of the marriage, was physically living in another place. It seemed to me like that was progress. That it wasn't just empty promises. It was actual action. When the emotional back and forth started, that obviously made me feel used and led on because it was like, "Okay, well, you're out of the situation in a physical sense. Is there a reason why you want to keep me a secret?" That always felt super sucky. I'm never going to let that happen to me again. When I found out that they were together, it was just really hard because I felt completely lied to. It made me question whether any of the affection that he showed me was real or whether I was just his 20-year-old plaything. The bitter side of me wonders if he was just bored and looking for a conquest or something.

I always felt really bad for his wife because I don't know if she was ever told the extent. She obviously knew he wasn't living there. She knew they were separated, but I don't know if she ever knew that he was "serious" about me, or whether she felt betrayed because she and I weren't really ever friends. She usually hung out with a different crowd while he and I hung out with the same crowd. There wasn't ever a time to talk to her because they were living apart, and I wasn't exactly going to go to her and say, "I'm sorry I stole your husband." By the time it ended, I was 21 years old. I didn't want to get beaten up by a woman who was twice my size!

What I experienced was love as I understood it. I felt a lot of affection, a lot of attachment and loyalty. I was willing to compromise and make decisions with him factored into them. People fall in love with who they think somebody is. It's so hard to say what's true and what is just the illusion you're projecting on a person. I don't know how much of his intention was genuine. I definitely loved the person that I knew him to be. Even though now I do question whether his feelings were genuine, that doesn't diminish the experience that I had. Since this guy, I learned that love doesn't have to be that sense of struggle at all times that we see in a lot of movies and books and everything. In fact, if it is a struggle, you're probably not in the right relationship.

And that doesn't demean the feelings that you experience. You can still be in love with somebody and realize it's not a good idea to be with them because the circumstances are too difficult.

If a situation that you put a lot of energy into blows up in your face, you do kind of feel like it was wasted even though that's not the case. I mean, you learn from everything that happens, but I definitely felt emotionally a little bit wrecked. It sucks to feel not valued, and I felt like I had a lot to offer. I felt like I was a really good partner, and I didn't get anything in return for that, but I think regret is a stupid emotion, so I never regret the things that I have done. I have only learned from them and tried not to make those same mistakes again. I feel gentle towards my younger self. Not like, "Oh, you dumb ass," like, "You made this big mistake." It's more like, "You were 19, you were kind of pulled around a little bit, you hadn't had a lot of experience, it's not a bad thing that this happened." I don't know if I'd want to change it. I'm the person that I am because that happened.

Elle
"Did I just accidentally become someone's mistress?"

If you're an attractive woman in the music business, there's going to come a day when your boss will hit on you. Point blank. Unless they're gay, they're going to try you. You could either stop things right there and let him know that this is a professional relationship or carry on and keep your mouth shut. As a woman who works in the music industry, I've had to learn how to stand my ground. I was 17 years old when someone in the industry hit on me. He was a label executive. One night while we were out celebrating, he kissed me. I pushed him off and didn't put much on it. I figured he was drunk and found me attractive. I was the pretty girl at the party so he took the opportunity to try.

W_____ was incredibly handsome. Actually, he was fine. However, I wanted respect and longevity in this business so after that incident I told him, "I respect you and all that, but I don't plan on doing that with you." The confrontation didn't disrupt our rapport. When there was downtime at work, we had a lot of time to get to know each other. We got each other's humor and understood each other's personality. When he broke up with his fiancée, he confided in me a lot and asked for advice. Whenever I gave him my opinion he knew I was coming from a good place. W____ liked my perspective even though he was way older than me.

At the time, his ex-fiancée hated me. The moment W____ hired me as his marketing coordinator she assumed it was because we were sleeping

together. She tried to use me against him and asked me to follow him and spy. She also demanded that I call her and report his whereabouts. I intimidated her because I was younger, and because she just had a kid, her body wasn't on point. Before their break-up, his fiancée complained all the time that she needed plastic surgery and Louboutins. To me she was a complete bitch because she was new money. People with new money do not know how to act. She just loved the idea of having a slave and treated me like I was the help.

It was around that time he started comparing me to her and began to develop an emotional attraction. He would often say, "I'm here for you. If you need anything, just tell me. I want to help you. If you can't afford something, I'll buy it for you." Sometimes we'd see a movie or do really chill stuff in the daytime. I wouldn't feel guilty about it because it wasn't a date to me. Dates happen at night. However, he was older and seasoned in his game. W_____ knew what he was doing.

He started to show more affection towards me. At first it was little touches here and there, but then he wanted me to hang out in his bed and cuddle. I told him that we shouldn't. He assured me that it would be okay because we're just friends, but I had to back off because that was more relationship-type stuff. Coincidentally, I had to start working with him more because we were developing new projects. I had to be around him 24/7, and with all of this additional time together, I started catching feelings for him. I couldn't resist it anymore. After six months of working with him, I became his girlfriend.

W_____ and I connected on every level. Our feelings for each other were very strong in a short amount of time. He was way more sexually experienced had done a lot of stuff with women while he was on the road. I've never been with multiple people, but I don't have many inhibitions when it came to sex so W_____ was able to be very free with me. I had an ex that told me, "If you have any thoughts outside of missionary sex, you're a hoe." I never believed that for one second. I am the type of person that's outside of sex. I'm addicted to experiences. When W_____ and I started sleeping with each other, he was able to do things that he couldn't do with any other female. He didn't have to worry about me getting mad if he suggested something freaky. We were able to be wild, and it was amazing. I'm grateful for that time because once I do get married and have kids, I feel like I am not going to be curious about anything. W_____ has already fulfilled everything I wanted to do.

We were out of town somewhere. He was outside on the balcony, but I had to get him for something that had to do with work. I tried to get his attention. When I walked closer to him he gave me a hand gesture to be quiet. I saw on his tablet screen that he was Skyping with his supposed ex-fiancée. I walked out from the room, and from that day forward I asked myself, "Did I just accidentally become someone's mistress?" W_____ had children so I

understood that when it came to family things he had to step back and be a father, but then he would go on these nice, lavish family trips and invite her. This made me suspect that they were back together even though he would tell me that he couldn't stand her. That's when I heard through the grapevine that the two of them were married. Someone close to him told me that he only married her because he didn't want to be a baby daddy. It looked better for him to be a husband.

Once I found out they were married, I honestly still wanted him so we continued our relationship for a long time. However, after a while, it became too much because I was on the losing end of the battle. Whenever he told me he had to Skype with the kids he was really Skyping with his wife. If he and I were together his phone would be ringing off the hook because she needed to know where he was at all times. It would confuse me because he would say that he loved me, but his actions showed his loyalties were else-where.

That whole dynamic put me on the sideline looking stupid. When we were working together he was always attentive and all about me, but when it came down to having to deal with family, he went back to being someone else's man. I felt like I was taking somebody's husband and father away. I just had too much confidence in myself to do that. I wanted somebody that was down for me. I had too much self-esteem to have another woman's sloppy seconds. I told him, "You have to pick one of us."

W____ said to me, "I want you to quit your job and be my girlfriend." He asked me four times to do that, and I told him no every time.

"You basically want to keep both of us in your life. I can't do that. You need to be alone."

"Okay, if you're not going to date me then I'm going to date someone else. I mean, you could still work for me, but I'm just going to do my own thing." I still worked for him even when he started dating other women. I was aware of everything that he was doing. I knew when he was buying these women gifts, ordering limos, and making restaurant reservations. I had eyes and ears around the whole company, and he still trusted me with all of his business. It was hard for me emotionally, but for some reason I was able to completely separate the emotions and business. I'm still able to handle stuff even if I feel a certain way.

W____ eventually met someone else and started keeping her as the side woman. He broke up with his wife because the new girl wouldn't tolerate not having him to herself. He chose the new girl over his family and I kept myself out of his romantic life. I quit him cold turkey.

Despite my inner principles, I can still feel that connection between us, and I know that he still loves me too. We really did fall in love. Even now when he sees me he'll ignore his girlfriend just to talk to me. The second time that

happened she asked him, "Do you want to be with her because why am I even here?" Everybody could see how he would light up when I came around. It's just unfortunate because he and I were a perfect match. He was one of the best guys I've had in my life. I've never had chemistry like that with anyone else. Everything with him was amazing and worth it. I believe that we probably will end up dating eventually. We were just that compatible. As of right now, he has to get his stuff together and figure out what he wants. It just felt so right but the timing was all wrong.

Barbara
"I knew that playing hard to get made him want me more."

I was 22 working at a fast food restaurant as my part-time job while I was in school. Eventually I got promoted to management, so I took time off of school and worked full-time. I was immediately attracted to our new store manager. He wasn't physically attractive but there was something about his personality that drew me to him even though he was married with a kid. He was flirtatious and charming but also very vocal about the love that he had for his wife. I pushed my emotions and feelings back in my mind, but I didn't try to extinguish them. Instead of expressing my attraction to him, I tried to see him as a brother instead.

We worked well together. He didn't show any indication that he was attracted to me. I started working on myself by running and eating healthier. When I lost a significant amount of weight, I was feeling more confident and that's when he started to notice me. His flirting started to have a very serious undercurrent to it. Every time I would come into work his eyes wandered towards me. He had these wonderful blue eyes and intense stares. We would make eye contact across the restaurant at one another quite often. I was always looking for him and knew where he was in proximity to me. I did my best to push back at his advances, but I secretly liked it. I knew that playing hard to get made him want me more. I remember as clear as day when he said to me, "What if I told that you could have it?"

"I can't have you," I said to him. "You don't belong to me. This isn't something that can happen." By that time, he and his wife had two children and they seemed happy in their marriage. I was torn emotionally because I had developed these feelings for him and now the man that I'd been attracted to offered me exactly what I wanted from him. At that point, I had fallen in love with him or at least what I understood love to be at that time. There was something about him that just sent me in a whirl. When he wasn't at work, I would be in a bad mood and then once he showed up my day would be ten times better.

We started making plans to see each other privately. His wife frequently went out of town with their kids to visit family. The first time I went to his house we both awkwardly sat on the couch. I was a virgin. I had never done anything. I'd had my first kiss with a boy probably three months prior to me going over to his house. I'd never had oral sex, seen a man naked, or revealed my naked body to another person. We awkwardly sat on the couch for a little bit. Then he just led me through what we were going to do next. He talked me through oral sex and carried me to their bedroom. We had sex for the first time in the bed that he shared with his wife. Sex was painful and bloody during our first time. After we did it, I just stood there completely naked. I didn't feel ashamed but just very vulnerable because I was standing in that room with no clothes on. Then he broke the ice and said, "I can't believe that we just did that."

"I have to tell you something," I said to him. "I'm in love with you."

"I forgot to tell you that I feel the same way about you," he said, "but I'm not leaving my wife for you."

"I know. You don't need to do that. I just like being here with you." He was very careful about not saying "I love you" back to me. I didn't need for him to say it back because having just the physical part of him was better than not having anything at all. It was probably at least two weeks before I wanted to have sex with him again because our first time hurt so bad. He told me that I would learn to enjoy sex and he was right. The second time there was next to no pain. Then maybe two or three times after that I had my first orgasm with him.

I didn't know what I was doing so I naively let him do what he wanted to do with me. He was controlling in the bedroom, and I was a virgin so that fed his ego. I never used birth control; we never used a condom. The first time we ever had sex he said, "There is going to be nothing between you and me the first time we do it." Every time we had sex he would always pull out so I never got pregnant.

I was never worried about my sexual health, but because of his flirtatiousness I was worried that he was with other girls. We were attached but not exclusive, which led to really awful mind games with one another. During our two years of seeing one another I would try to sleep with other people to get over him. When he would find out that I had slept with someone else, he would immediately want to know if his penis was bigger or if the guys were better partners. He used to tell me that he would always be the standard when it came to me sleeping with other men. I wanted him to be jealous, but he claimed that he could always have me when he wanted it so he was never jealous of some other guy stealing me from him.

After a while, he was taking me for granted, and I was pretty depressed. I would get so excited for him to come over to see me. We would maybe have

sex for ten, 15 minutes total then he would leave me empty again. When his wife was giving birth to his third child it sent me into a reeling depression because I had to come into work to cover him so he could be with his family. I remember getting home and just crying after work. The further this affair went the more I started to pull away from the church. I was burnt-out from working a lot because the restaurant was open 24 hours. My shifts were midnight to day shifts. I was trying to go back to school at the same time, but then I would just sleep through class. I failed a whole semester of classes trying maintain this secret affair while working and going to school at the same time.

My concerned friends told me, "You need to quit your job or transfer. You need to get away from him because this is not going to end well." I didn't take that advice because I just didn't want to not be around him. Finally, I just couldn't take it anymore. I walked into work and quit. After I had given him my keys and uniform, I said to him, "I can't do this anymore. I can't be in love with you and also be empty inside. This isn't enough for me."

"You don't have to quit," he said. "Do you hate me or something?"

"That's the problem. I don't hate you. I'm too attached to you and this is why I want to leave."

"Well, don't quit your job because of a boy—I mean don't quit because of a man."

I was like, "No, you had it right. You're a boy. I'm quitting my job because of a boy." I was confidently trying to vocalize how I was hurting in this whole process. I missed college. I missed having a life because I didn't have one anymore. After I quit that job, I joined a smaller community within our church. I started an art project in a local trailer park for kids that lived there. There was something about that experience that helped me out of this horrible depression. It took almost three years to feel like myself again.

Those were some of the hardest two years of my life, being in love with someone who didn't love me in return. I would say that today I have a love for him, but I am no longer in love with him. I don't have feelings of bitterness or hate about what happened. I wrote him a letter at one point and I asked him to be faithful to his wife, but to tell you the truth I wouldn't take back the experience.

I'm not ashamed of the things that I wanted with him because they were what I desired in that relationship. I wanted love and that's nothing to be ashamed of. It's shaped the woman that I am today as much as I don't want to admit that. I don't want to give him that credit. I learned the value of being able to express love. I thought somehow our love was always somehow connected to sex, but I wanted someone to hold my hand in public or to sit down and have dinner. I wanted to have an intimate conversation with someone who loved me. There is something so much better about being able to touch

someone's face and to look them in the eye and to feel those emotions recip-
rocated. I never had that with him.

Brenda

"I don't like how I feel about what I'm doing to her."

I was introduced to him by a friend of a friend. He was a couple of years
older than me—very charming, very nice, and very cool. We went to a concert
one night and he brushed up against me in a way that told me he didn't intend
to let go. We went out afterward to McDonald's and as we were placing our
order the cashier said to us, "Aw, how long have you two been together?" I
told her that we weren't together, and that became a running joke throughout
the night.

The next day I called him to tell him that I had so much fun and I thanked
him for inviting me to the concert. The next week he called and asked me to
meet up for drinks. When we met up I definitely felt something between us
although it wasn't defined for me yet. We had a very casual friendship; we
started to talk on the phone regularly. I had a feeling that maybe he was dat-
ing a few people or had a steady girlfriend but I didn't think he was married
until his wife called me one day and asked if we could meet up. I was curious
so I met up with her. She asked me to answer her questions truthfully. "What's
the nature of your and X_____'s relationship?"

"We're friends," I said to her.

"I heard you guys talk on the phone the other morning."

"Well, we went out for drinks the night before. He just called to make
sure I got home okay."

"It's inappropriate for him to be talking to another woman on the phone
especially that early on a Saturday," she said.

"We do that with our friends. I know your husband through a mutual
friend. We were all out together. I'm sure that he called her too." I felt I was
honest and that I didn't have anything to hide at the time. Our meeting lasted
for a few hours, and I didn't hear from her after that. When he came over I
told him, "I'm just gonna back off because clearly we can't even really be
friends."

"I'm really sorry that you had to go through that. She's been a bit jeal-
ous."

"I can't blame her for being upset."

I backed off but then we found ourselves in another group setting. There
was something about that night because all of a sudden something started to
brew. The way we engaged with each other was more intimate than before. He

gave me his full attention, and I loved it. I'm not proud of how that night went down because I had agreed to back off after finding out he was married, but honestly, I didn't want the night to end and neither did he. When he finally kissed me, I had no hesitation about kissing him back. "Do you want to come over?" he asked. "My wife is out of town." I gave in and said yes. From there we started our relationship.

It was physical, emotional, and everything in between. I fell head over heels for this man. I still love him to this day. It was not a situation where I started sleeping with him and then found out he was married. Before we had sex, I knew what I was doing to his wife. I was on the pill because I was worried about getting pregnant, but I didn't use any other protection because he wasn't sleeping with anyone else but his wife. I was dating other people at the same time, but everyone else paled in comparison to him. He was everything I'd envisioned in a partner for me, and I had become the person that he thought he was meant to be with. He wasn't ready to leave her, and I understood that.

He was there for me emotionally when my father passed away. He was a social worker and thought I should talk to someone. "I'm fine," I said to him.

"I know you are, but who do you talk to about your dad?"

"Nobody."

"You have insurance, right?" I nodded my head. "Then you can have free sessions here with me." I came to his office and talked to him about my dad and it was the best thing that I've ever done. I was finally able to release my grief. That opened me up and allowed me to say things without being so hard on myself. In a way, talking about my grief relieved the other feelings that were constantly in my mind. I put a lot of guilt on myself about my relationship with X____, but he reminded me he was the one that was married and that he was the one in a commitment. Our therapy sessions about my dad's passing helped me come to terms with our affair.

When we were together, we rarely ever talked about her. I never asked him to leave her because I knew that he wasn't ready. He would sometimes talk to me about his frustrations with their marriage, but never mentioned any worries about her infidelity. They didn't have the same physical chemistry that we had. She didn't understand him the way that I did. According to him she had had issues growing up with male figures in her life and that bled into their relationship. I would offer suggestions on what he could do to be a better husband. He would laugh and say, "Well, not having you here would be the first step to becoming a better husband."

He had a work phone and a personal phone. His wife had access to his personal phone, but he locked his work phone because he's a social worker with sensitive information in it. Since she was never checking his work phone that was where he always called me from. I worked graveyard at the time so after I was done with my shift I would see him during his lunch break. We

wouldn't necessarily be intimate all the time. We would actually do stuff together and not just be meeting in hotel rooms. However, looking back I realize that he was very messy. He didn't do that pick-me-up-down-the-street-type stuff. We could've easily been caught because with us there was no sneaking or snooping around. Anyone could've seen us when we were out.

There was one night we were supposed to meet up, but then he called to cancel. He told me that he had to go pick her up from the airport. His wife had to leave her hometown vacation earlier than expected because of a health emergency. When I asked him what was going on he told me that she had a miscarriage. Once he gave me the news I started to cry. I couldn't carry on this love I had for him. It was too much; I told him I had to end this. "I can't do this with you anymore," I said to him. "You're trying to start a family. I don't like how I feel about what I'm doing to her."

It was hard at first because his way of coping with the miscarriage was to talk to me. My way of coping with the guilt of this affair was not talking to him. "You have to stop calling me right now until I can get through this." He eventually agreed to my requests and backed off. I should've been mad at him for not being forthcoming about their family plans, but he was always honest with me if I asked questions about their marriage. This was just a situation where I didn't ask the right questions so that's how I got blindsided. His wife eventually got pregnant for real, but I didn't stick around. I moved to another state.

I still talk to him and always will. He recently told me that his wife was expecting baby number two, and I sincerely congratulated him. The only reason why we're not together is that I'm in a different state now. Our relationship was genuine, and even though we're just friends now we still tell each other that we love one another. We want to have each other in our lives, but we know that it cannot be at the capacity that it once was. I feel like one day we will reconnect, and we will be an old couple swinging on a bench somewhere. I've accepted that this is what happened, and I've allowed myself to be okay with it. I've had wonderful experiences since my relationship with X____. I don't regret having met him or having him as a friend because we were there for each other through all kinds of things. I can find a wonderful mate, but the connection I had with X____ is like none other I've ever experienced. I honestly believe that he is my soulmate; we just didn't meet each other at the right time.

Sadie

"I think he wanted me to be envious of his wife's life."

I was planning to move, and my brother-in-law said, "Oh, my frat brother lives there with his wife. You remember him? The one that works for the NBA?

Maybe you guys can connect." His frat brother's name was Y_____. I remember him flirting with me at the wedding, but I didn't pay much attention to it at the time. My brother-in-law's suggestion was very innocent on his part. I thought Y____ and his wife would show me around for a good time. Truth be told, I never really got to know Y_____'s wife, but I was in a romantic relationship with Y_____ for five years.

Once my brother-in-law connected us, Y____ and I started texting each other frequently. I had just moved to a new city. It was nice to have a friend. Y____ had to travel a lot for work. He offered to fly me out to wherever he was. At first, the meetings were not sexual. Whenever I'd meet him we would spend the time shopping and eat at nice restaurants. It just never really crossed my mind that his wife would take issue with what he was doing. I thought that she was okay with her husband having a female friend.

One time he invited me over to his beach house when his wife was out of town. I didn't think that much of it because I thought we were going to talk about a website that he wanted me to build. He picked me up in his wife's new Range Rover. He told me I had to ride in the backseat during the day because he didn't want to stir up rumors in his neighborhood. He ran within a circle of professional athletes who all fool around on their wives. He knew how to lay low. He assured me that I could ride in the front seat once it was nighttime.

Y____ and his wife lived in a beautiful house. Looking back on it, I think he wanted me to be envious of his wife's life. He wanted to show me what he could offer me if I agreed to be romantically involved. I was still under the impression that he and I had a working relationship before anything else. I've dated coaches in the NBA. I've dated athletes. Y____ was a fresh new athlete in the game and that was enticing to me. He was very well connected and would refer people to me. I specialized in visual design and if he needed something done for his business he'd come to me. I was working on my own entrepreneurial ventures, so he was definitely helpful and resourceful in that area.

Y_____ was very good looking but not in a conventional kind of way. He was an athlete with very chiseled features like Billy Dee Williams or Denzel. He was beautiful to me, and I liked how he felt seriously about things. I was attracted to his mind. He and I could talk to each other about anything. We could talk about religion and politics. I miss that about him. I miss how passionate he was about life.

Whenever he was out of town, he would just buy me a flight. On one of the trips, he took me to really nice restaurant. Then when he took me back to my hotel, it just happened. We started a physical affair. He bought me jewelry and trips. Sometimes he would give me some cash, but he wasn't a sugar daddy in the sense that he was paying my bills.

I was like a drug for him. He was addicted to the excitement of it all. There was a thrill in the risk of getting caught, but in the end, it eventually turned into a control thing. He was bored in his marriage, and I was that added spark in his life. Our sex life was pretty good, but I always had to have sex drunk. Being drunk helped numb my guilt because I always felt guilty about being with him.

He said that I was his first time cheating on his wife, but I don't believe him. One time I heard him trying to talk to another woman on my voicemail, but I never confronted him about it. I wouldn't spy or do any research because I didn't care enough about it to look. I just hoped that his wife was healthy and that he was using protection with the other women he was sleeping with. Y____ and I didn't use protection. I didn't want anyone to catch an STI, but everything that I did with him was risky. I wasn't on birth control. In fact, I've never been on it. If we had sex without protection I would just take the morning after pill.

His wife was on his tail, though. She hired a private investigator to follow him around so she found out about me. I started to get these phone calls at 4 a.m. from blocked IDs. One day he called me from his private jet to tell me that we had to chill. I told Y___ that it would be best to just end things for good. I was seeing someone seriously and wanted to give that relationship my full attention. He got upset and hung up on me.

I lied because I was looking for a way out. For five years, I had been living this secret life that wasn't good. My family knew I was dating, but no one knew that I was seeing a married man. I was living this double life and no one who was close to me knew that I was someone's mistress. I was another person. Till this day absolutely no one knows about my relationship with Y____. The whole thing was weighing on my conscience and sometimes I wonder if karma is punishing me because I'm still single. When I stepped back and looked at the whole picture, I realized it wasn't right. I wasn't happy with myself at that point in my life, and that's how I got caught up in all of this. He was getting the last laugh, and I got nothing. If I had to take a wild guess he's probably still cheating on his wife.

Raven

"If we're going to do this, it's only your wife and me."

I moved to the South to start a new university job. A string of complicated relationships promptly ensued. I had been celibate for three years. The loneliness had gotten to me, and I was just so ready to have sex or at least be in a friends-with-benefits situation. I was desperate for attention so I went

on a black dating site. I met a guy who told me he was separated from his wife. Being kind of free and open during that time in my life, I was able to tolerate that he was only somewhat available. I figured their relationship was ending so it was okay for me to date him.

Our conversations became serious and we started making plans to have sex at my house. We agreed that we were going to have dinner first. When the day came, I waited at the restaurant and he never showed up. He texted me and said that he had to go to the hospital. I didn't make a further issue out of it. What could I do? He had to go to the hospital. A couple days later while I was out at lunch with another friend he texted me, "Don't ever text me again, I'm going back to my wife. She's the only one who supports me. She has been with me at the hospital the entire time."

I didn't know I was the one that was supposed to rush to the hospital that night. I was a bit confused about the resentment. I texted him back anyway. "Okay, fine. That's great that you're working things out with your wife." The ending of that devastated me because he was the first guy I met in the new city. I thought we had a genuine connection.

I started dating another guy, and for a few months it was going well. We were hooking up regularly, and I was certain that we were moving towards a real relationship. It was the day before he was going out of the country, and he wanted to see me. I suggested that we go to the movies and have dinner and drinks afterward. As I was getting ready to go, I felt compelled to go to his Facebook page. Perhaps there was some anxiety about him leaving town and certain suspicions were coming up. After doing some snooping, I found out that he was engaged to some woman in South America. I called him. "So you're engaged but you want to come to kick it with me?" We had made all of these future plans together. My dating life at that point had become frustrating. I'm smart, intelligent, and a published professor. I'd been career driven for the past ten years. Was this why I was having a hard time meeting someone, even if it was just for sex?

Then I met another guy at a party for a mutual friend. We were heavily flirting. I liked him, and, for once in my life, I was going to be daring. I gave him my phone number just to see what would happen. The next day while I was out to brunch I got a text from him. "Oh, by the way—I'm married," he said.

I texted him back. "Is it wrong for us to be talking?"

"No, I don't think so," he said. "We should meet up."

"That sounds like trouble. I'm not going to do this," I said. I didn't want that kind of trouble in my life, but there was something that drew me to him. It's not that he's powerful because he's not. He's younger than I am and in a profession where he'll never make a lot of money. However, I loved his drive, competitiveness, and the way he looked at me. He courted me like a true

gentleman. When we first met, he brought me flowers. I've never had a guy bring me flowers before. He was very charming and conscientious. Sex was good—fun and pleasurable. We definitely knew how to turn each other on. We had a really good sexual relationship, but I think it was because there was a certain level of intimacy. It wasn't just about the sex. We both caught feelings which was unexpected for both of us.

We really didn't go out that often. It was never a public relationship. Our relationship consisted of text messages. He'd send me early morning texts which always made my day. There would be check-in phone calls in the middle of the day, and he'd bring flowers when he came over. All of the nice things that he did for me never really happened in my other relationships. The trade-off was we could not go out in public and hold hands.

After a while I started to notice that he wanted to change me. I started to see that he wanted to control me the way he couldn't control his wife. He could be brutal with his comments saying such things like, "You're too fat and you're not pretty. I don't like this natural hair. Go get a weave. You need to dress yourself up because in this city, nobody's going to be ever attracted to anyone like you."

He completely messed with my mind to the point where I felt like I was just an unlovable, unfuckable shlub. For a long time, I felt that I wasn't worth loving, but despite his comments, he still wanted me, and I wasn't willing to let go of our connection. He didn't have anyone else in his life that he was close to. I'd seen him and his wife together once. I noticed they didn't have an intimate body language between them. It was like how a brother treats a sister or how a friend treats a friend. He told me a lot of stuff that a guy friend would tell a girl friend. His wife wasn't supportive, and I thought I could help with that. I thought he had so much potential, but I don't think he could see that within himself.

My attachment to him was growing and I couldn't control it. I remember showing a picture of him to a friend and realized that I would have given anything to have him right there with me right then. I was thinking very selfishly and felt entitled. I felt I deserved this man and for once in my life I didn't care about the consequences. He was the guy that I wanted so I was going to have him. I was very bratty about it and didn't respect what he had with his wife.

I found out later that he had many mistresses, and I was only just one of them. His wife knew but mostly turned a blind eye to everything. If he was going back to his old college for homecoming, she knew he was going to see other women. I knew that he slept with all of these other women and told him that he needed to slow down. He then said to me, "I would only be with you, if that's what you wanted."

"If we're going to do this," I said to him. "It's only your wife and me." He

honored that agreement. It was a very weird relationship. We had this push-and-pull dynamic. I would be invested in trying to help him with his issues, but then it would get too much for me and I would pull away. For so many years, he was trying to keep up the façade of a happy household. When his wife found out about me she told him to cut it off and he did. It felt like a karate chop to the neck because I lost not just a friend but also my lover. That's the consequence of falling in love with somebody who pledged their undying love and fidelity to someone else. I know I can do better than finding a married man.

Many people think of a mistress as a brutal woman who's coming in and kicking everybody's puppy and little children, taking this marriage, throwing it away, being heartless and cold, and being the bitch. No. Many of the women that I know who've had affairs didn't intend to wreck a home; they just felt a special connection to the man they loved. They brought something to that person's life. I was with a married man. I'm not going out waving a flag and being proud of that, but it makes me empathetic towards other women who are in these situations as well.

It also makes me empathetic towards wives. Husbands need to take ownership of their vows. Their relationships were broken before they got to me. I didn't have anything to do with the initial wrecking of it, but I participated in this affair and enjoyed it. I thoroughly enjoyed it. I'm an intellectual. Intellectuals don't do love, but this affair was an experience that made me vulnerable and appreciative to have love.

Xeena

"I was doing my best friend."

As his friend, I've been through a couple of relationships with Z_____. I was his friend when he was the hoe man. I was his friend when he was the freaky man. I was even there for him when he tried to settle down with one of his church friends and took her on vacation. She ended up filing an order of protection against him during that vacation, and he was banned from the resort. I had been his friend for ten years when he married. I've been friends with him through thick and thin.

Naturally, when he started having marital trouble, he turned to me for emotional support. Z____ and I come from a strict fundamentalist background; we were both ministers. At first, his wife appeared to be great. To me she was someone who was good for him because she was from our church and was willing to follow him. When they started to have troubles, she wasn't always supportive. In all the times I've watched Z_____ preach I've only seen her

once. Also, her favorite show was *Snapped*, so I'm not surprised that she got bold once Z____ started displaying some weird behavior.

His wife had some suspicions that he was cheating because she found a receipt in the trash that she didn't recognize. She called his pastor and told him that Z____ was cheating and drinking. Drinking is strictly forbidden in our church, and because of his wife's actions, Z____ was forbidden from participating in any church activities for six months. This was crucial since Z___ had been a minister for his church for the past ten years.

After his pastor gave him the news, he texted, wondering where I was. When I asked him what happened, he was like, "I have to tell you. This is the straw that broke the camel's back. I don't feel safe around her. Can we hang out?" I agreed to have some alone time with him so we went out and got drunk. I was in a fragmented relationship with a man that Z____ knew about so we both needed to let out some steam.

The alcohol and the privacy broke down the barriers of our friendship, and that's when we knew there was more of an emotional connection than before. The night progressed from innocent flirting to heavy petting and caressing, but when we kissed, I got a sudden feeling of regret. I felt like I was a cheater and that crossed that line. That's when I started to question why was I doing this. Ironically, the cheating and the drinking his wife accused him of when he wasn't doing it, he was now doing with me.

The feeling was too overwhelming so I ran home. I knew that what we did wasn't good. Men never leave their wives, and Z____ confirmed that point when we finally talked about it. He was like, "I want to be very clear. I'm not looking for a relationship. I really just want us to remain friends and strengthen our friendship." I agreed with him and thought that keeping our friendship was the best thing for us.

I asked him. "Honestly, Z_____, have you done this before?"

"No," he said. "Because I never felt safe around anybody else but you. You've been just my friend, and you haven't judged me, but it's a possibility that we could sleep together someday. Are you okay with that?"

"Yeah," I said. "As long as we can remain friends."

We had our first sexual encounter on Veterans Day. The whole time he kept asking me, "Are you really okay with this? Are you going to flip out on me? Are you not going to be my friend?" When I confirmed that everything would be okay after this he went on to say things like, "I can't believe you're giving me things that I can't even get at home."

Sex with Z____ was great. I'll just say it was probably the best experience I've had because I was doing my best friend, and he knew what to do. It was like he knew things about me that I didn't think he ever paid attention to. Just the mere fact that he knew that I enjoyed foreplay and he knew how to heighten the anticipation that leads up to sex made it incredible. For him, pleasing me

was like baking a cake or preparing a meal, whereas my other partner did not fulfill that for me. He just wasn't into doing what I liked.

After our sexual encounter, Z_____ would send me flirt daggers like five days a week. Every morning he'd text messages like, "Did you go get your sexy in today? Did you get your swag on at the gym?" He actually was a part of my inspiration about my health because he found out he was diabetic and started to feel his mortality. He's a spin class instructor so he encouraged me to keep going to the gym. He is the type of person where outward appearance is very important. I'm learning more and more and more that he's very vain and has insecurities about getting old. He's 50. He doesn't like wearing glasses because it makes him appear older. He also keeps his head and beard shaved because he doesn't want to expose the gray.

Then he became distant with our communication. Before we started having sex, if we went two weeks without talking to each other that was okay with me. However, going for more than two weeks without any communication seemed a little insensitive. We talked through it and he was like, "I'm busy working. It's nothing personal toward you. I just have a lot going on." When we would see each other, it became more than just sex for me. When he started performing oral sex on me, I didn't like it. For me, when you begin to perform those kinds of acts on someone you go into a whole other level. I don't think that people do that just for the heck of it. There has to be some kind of emotional connection when it comes to oral sex and I told him, "We can't do this anymore. We need to build our friendship into an actual friendship."

"Do you want a relationship? I can't give that to you."

"No," I told him. "I don't want to go to a hotel with you anymore. I don't want to go to your house."

"If I've hurt you, I didn't mean to. I know I need to figure out what I'm going to do with my marriage." It wasn't that he hurt me, I just didn't want to carry on the sexual affair because I didn't want my integrity to be violated. When you're a minister, people will question your integrity if you're cheating on your wife. He agreed with the moral implications, but he was still unable to let go. "But I like your company," he said. "I like your insight and your friendship. I don't want that to stop." I felt the same way about him. I loved his perspective. We had a lot of great dates, and he gave me so much trust and support. I wanted to keep the friendship intact, so I decided to do different activities like going to church and worshipping together. We would watch each other preach during service and that became a stronger bond than an actual sexual relationship.

When I look back, I didn't see myself as a mistress. I think I was more of an emotional whore. If we had kept having sex and there was no other kind of emotional investment, then I think that I would have been a mistress.

I started to develop an emotional attachment to him that was separate from our friendship. I wanted more of his heart, but I knew that he couldn't give me that as long as he was married.

Often times what happens in sexual affairs is that the two people having it usually split up. It'll eventually go bad because somebody ends up going crazy. Z_____ and I have actually really strengthened our relationship, and since then he's become even more supportive as a friend. He's also decided to work out his issues with his wife. I'm still with my boyfriend, but I emotionally moved away from Z_____. My boyfriend knows that Z____ and I are friends, but he doesn't know the extent. Z_____ and I have had some indescribable successes, and we continue to celebrate those things together. He wants me there for his success; I want him there for mine. We continue to be there for each other because we're really great friends and we have that bond because of our affair.

I think that you should keep your sin in the sphere in which it's in. I don't think it would help anyone if I came clean and told all of the people involved. I stopped because I was aware of what I'd done. During my private time with my faith, I know that there's going to be grace that's going to be provided for me, and I think that's what's most important to me than anything.

Sheva

"If all of us are in the same bed together,
everybody needs to know what's going on."

He was the picture-perfect person to marry, but that picture changed into a nightmare. I met him at a law event. I spotted this handsome attorney from across the room. He was wearing a pin that was similar to one that I have, so I went over and struck up a conversation with him. We instantly hit it off and upon me walking away we accidentally brushed faces and kissed. That was a sign to me that, my God, this must be the one.

Of course, I gave him my number. I thought that maybe he'd call in a few weeks, but he called the next day and we connected the following weekend. I've always been in committed relationships, but I put pressure on those men and that made them run away so with A_____ I wanted to play it safe. I was dating other men while I was with A_____. We were not in an open relationship in my eyes, but I liked having attention from other men. I treated A_____ as my one true partner, and there was never a moment that he didn't have my love or attention. He didn't know about any of my other dating episodes because I was hoping our relationship would grow toward marriage. I didn't want to spoil it by telling him that I was dating other men.

It was the day before Mother's Day and six years into our relationship. I wanted to see him before I spent the rest of the day with my two kids. I called him 12 times and he didn't answer. My kids were eager to take me to a movie so I left him alone. Our movie was sold out so we decided to catch the next show. When we walked away from the ticket window, I saw my boyfriend with another woman. My kids know him so they immediately asked me, "Mommy, isn't that your boyfriend?" I tried to play it off because I was too embarrassed to explain the truth. The two of them were walking hand in hand, smiling and as they were walking. He didn't acknowledge me.

Two weeks later, I finally got the nerve to ask him about the lady. He confessed that she was his girlfriend of eight years. During the whole time we'd been together, I had no clue that he had another girlfriend. I snooped through his computer and found her contact information. I decided to reach out to her via email because I was hurt and hoped she would give her perspective, but she never replied. I'd been intimate with this gentleman for so many years, and I wasn't sure if she was having unprotected sex with him as well. As far as I was concerned, if all of us are in the same bed together, everybody needs to know what's going on.

I probably should've just walked away as soon as I saw her because every time he's not available I'm thinking, "Oh, well, it's because he's with her." Even though A_____'s girlfriend and I are black women, the two of us had completely different skin tones. It's reinforced some stereotypes that impact my self-image. I'm a darker-skinned, caramel-colored sister with short and processed hair. The other sister is light-skinned sister with very long hair that's wavy, curly, and natural. His other girlfriend has the physical standards of what a man in his profession would want as his wife.

Based on my looks, I've been pigeonholed as the type of girlfriend that swings off the chandeliers in the bedroom but is not good enough to showcase or adorn in public. He's never said anything to make me feel less than her but being with both of us is a nonverbal statement of where he's at. She has a master's and a Ph.D. I'm still working towards getting my bachelor's degree. I was never invited as his date to the law parties or the Urban League events which were the black-tie and ball-gown events. He and I would do other things on the social level that would just be like in-the-hood-type things. We would go to 'round the way bars or clubs with mutual friends, but nowhere where his colleagues or fellow attorneys would be. There's a certain standard regarding what is considered the trophy girlfriend, and I know that he doesn't see me that way.

Don't get me wrong. A_____ has his own issues. He's an alcoholic and his father had a long history of infidelity. A_____ has a bunch of half-siblings so he saw his father's infidelity throughout his adolescence. A_____ grew up thinking that this was okay to do. I don't blame him, but at the same time I

wish he would've been honest early on. He doesn't see himself as a cheater but rather as a man who loves two women. That's the reason why he's kept the charade for so long.

It's just hard to wean myself away from him because I love him. It doesn't stop us from being seen in public or traveling together. We've hung out with groups of mutual friends so they see him as Sheva's boyfriend, not the other woman's boyfriend. All of the people who are close to me know about A_____. They think that I should just walk away without looking back. It's easy for outsiders to tell me just to leave, but I'm still going through the process of healing; it's an ongoing battle. Since I found out about his other girlfriend, I make him wear a condom every time. He won't leave her because he has an undying commitment based on their history together. We're still in an intimate relationship now.

I would say this has been a tremendous learning experience for me. No woman should have to go through the pain that I have gone through. Women need to know that if there is an unfaithful man in your life, you need to set some boundaries, ultimatums, as well as some long- and short-term goals. I think that's where I went wrong with my relationship. I should've been more transparent with him early on and told him my true intentions to get married. We, as women, need to give pressure to men, because if they succumb to the pressure that means that they love you. If they run away and reject the pressure that means it's time for you to move on. If you're a woman who wants to stay in a situation like mine then I think you need to make sure that you're getting out of it what you want. If you're not getting out of it what you want, then it's time to leave.

Denise

"If you are in so many different relationships with people who aren't yours to be in a relationship with, it's never going to work."

I've always considered myself a pretty sound decision-maker. When I met my ex-fiancé, I was ready to move forward in life and be in a relationship so we got together right away. I realized that he was perfect for me because he was so much older and had his own home. He was looking for one woman, and as long as I met his needs I didn't have to worry about him cheating on me.

During our relationship, I was deployed overseas for some time, and when I came back I found out that he had cheated. Not only did he cheat, but he cheated with someone that came to our engagement dinner. This was a woman who made me feel uncomfortable and uneasy around her from the

start. I warned her back then to stay away from my fiancé. She came to my home and told me that she slept with him in the bed that we shared.

When I decided to leave him, I found out I was pregnant. I didn't want to work it out with him so I was alone during all of my prenatal appointments at the army base. I was hurting a lot because some really bad things happened to me overseas and I was recovering from that. It was difficult to readjust and it would have been good to have my fiancé's support. He was a person that was supposed to love me and have my back. He allowed this female to disrespect me, so I moved on from that situation and had our daughter.

After having my daughter and my completing my military duty, I met a female who we'll call B_____. We started out as friends. We had interests in the same type of things—music, food, and clothes—so we talked a lot. Both of us felt an undeniable attraction to one another and we started to date. Things moved slowly at first. I was only 22 and my family knew about my sexuality, but I wasn't public with it. B_____ couldn't hold my hand on the street or wrap her arms around me. When we went out to eat, she found it difficult not to stare at me. I wouldn't stare at her. I wouldn't give her a lot of eye contact. I was still a little reserved about my sexuality. Come to find out, we were both holding back.

We were together for five months before I found out she had this other relationship. I couldn't understand why I couldn't call her. We worked at the same place of employment so I would see her daily. Every morning we would have breakfast together. I would also see her at least on Saturday. I had my own life so if I didn't see her on the weekends it didn't matter because I had other things to do. When we started to get serious, her distance had me wondering what was going on. I felt this during the second or third month so I asked her, "Hey, why can't I call you at your other number?"

"What do you mean?" she said.

"Whenever I'm on the phone with you, I hear a phone ringing."

"I have two phones."

"So when you can't pick up this phone, why don't I have the other phone number?"

"My friend's mother lives with me."

"How come you've never told me this?"

"You've never really asked me about my life before." What she said was true. I didn't ask, and she didn't answer. She didn't volunteer information so that's what led to her keeping secrets. I didn't believe the story about a friend's mother. I knew then that she was involved with someone. Eventually she admitted that she was living with her girlfriend and her son who she adopted as her own. Her relationship wasn't working out, but she wasn't interested in leaving her.

I started to put B_____ in a different category in my mind. She wasn't

relationship material, but she was someone who I could hang out with and be around without the thought of commitment. It was supposed to be a simple arrangement that actually didn't work at all. We started to get more and more serious. There wasn't a time that she didn't answer my phone calls. There wasn't a time that if I said, "I want you here now" she wasn't at my house. We lived approximately a mile and a half away from one another, so seeing her was never an issue.

With a lot of perseverance, I finally convinced B____ to give me her home phone number. She thought she set the ground rules, but eventually I always got what I wanted. I couldn't get a hold of her on this one particular day so I called her at home. A young lady picked up. "Who the hell is this?" I asked.

"This is B_____'s girlfriend. You must be the Other Woman." In my mind it was chess game on. I just played her. I became a friend to appease the situation. When I phoned, I didn't want hostility. I wanted to speak to B_____ when I wanted to speak to B_____ so I manipulated the situation in order to be able to do that. It worked for a long while. I will say maybe four years into the game this chick thought she and I were cool, but then it got really ugly.

B_____ got on my case for calling her home number because it showed a lack of respect for the other young lady, but to tell you the truth, I really didn't care. B_____ knew that if I wanted to talk to her she would get on that phone. If I wanted to be with her, I'd tell her to come to my house. When I was finished with B____, I sent her home and she complied. In some weird way, I felt I had control. It didn't matter to me. It wasn't important that I didn't have her all to myself because I had her when I wanted her or so she allowed me to think.

B_____'s girlfriend started to get more threatened, so I didn't have as much access to B_____ as I usually had. To this day, I think that woman hates my guts. She will call me just to harass me. When I moved to another state, she found my phone number and one time she called me every ten minutes for like two or three hours through the middle of the night. I had to be to work the very next morning for a big meeting. I left B_____ a message. "I just want to let you know that I called the police on your girlfriend. I will press harassment charges against her if you don't do something about it."

B_____ immediately called me back and said, "If the cops get involved we'll never speak again. That's a violation. That's my stepson's mother." She stuck up for her and that violated my trust. Around that time, I also went through a really difficult custody battle for my daughter. I expressed to B_____ that I needed her more than ever, and she didn't respond the way I would've liked.

Sometimes things aren't done the way you want them done. I can deal

with that as long as I know that person has my best interests at heart, but the moment that's not the case, I shut down completely. As someone who stays in relationships with people who belong to other people, loyalty is very important to me. I didn't feel like B_____ had my best interests in mind anymore. It was easy for me to disconnect from her, and we didn't talk for three years after that. My relationship with B_____ was a crazy, mixed up, deranged, and confusing situation. We hurt other people. Even when we just tried to hurt each other, we've hurt other people more. I don't really understand it. Perhaps that has to do with some unresolved trauma during my time in the military.

As someone in active service when you miss death by a heartbeat, by two steps, by three turns of a wheel, your adrenaline pumps in a different kind of way. When someone in your unit has your back, it's a whole other set of emotions that come attached to that person. Male and females and that's what we are in the military. You ask any soldier, "Are you a woman or a man?" They'll tell you they are male or a female after they tell you they're a soldier, a Marine, a Navy Seal, a navy warrior. They don't tell you if they are a man or a woman because it comes with a whole other set of responsibility. It's much better to kill the woman in you during battle because you won't survive.

During one of my breaks with B_____, I became really close with an officer who used to be in my unit. When we became reacquainted again we started working out together. As we got closer, he confessed that he had dreams about my body. We became very connected on so many different levels including sexually. When you're in the military you can't have too many different hormones in your system, so I opted out of taking birth control. We practiced coitus interruptus. Low and behold, I got pregnant. His wife was going through artificial insemination so she and I were pregnant at the same time. It was very easy for me to make a decision about the pregnancy. There was no way I could have his child. I had to move on. It's painful for me the recount this story because of the way it ended.

After that I moved into a new apartment where I got friendly with the owner. He was a really nice guy and a police officer. He was impressed with my military background. Three months after I moved in, he wanted to sell the building. He needed a model apartment so he would come to find out if my apartment had everything that it needed. He'd come to the apartment a lot to see about me. I was still young, and I was by myself so he would always come to the apartment to visit and check in on me. My aspiration at that time was to purchase a building also. Because he owned our building, he was giving me a lot of advice and telling me how to get into real estate ownership and how to maintain my credit. He was pretty good at just advising me.

At first it was just an admiration, so it wasn't an issue for me that he was married. He liked me for the fact that as young as I was, I was on top of my

business. There was a naturally-drawn attraction because both of us had been in the armed services. I'm military. I love guns; I love weapons. It turns me on to see an attractive man with a weapon. I loved that he was into physical fitness. He had a great physique and demeanor. All of that was attractive to me. I was just really excited to be around him. I loved hearing his stories. He started coming to my apartment more frequently because the realtor wanted to see the building. He was coming around so often that I made him a separate set of keys. He came by one evening while I was in the shower. When I walked out of the shower he was standing in my doorway. It was a little freaky but a turn-on at the same time. We had sex that night, and he and I started a relationship from there.

Whenever we went out, I always wondered how he was always cool being seen with me in public. He would often hold my hand and wrap his arms around me. He showed me PDA without any regard for his marriage. One day I called his house about my water heater and his wife answered the phone. I told her that I was one of the tenants and that I needed my water heater to be fixed. She was polite to me. She gave him the phone. When he found out it was me, he was turned on by the fact that I called his house. That was exciting to him so he came to my house that afternoon. I hadn't seen him in a couple of days, and as soon as I got home from work the first thing he said was, "You called my house?" He smiled and threw his arms around me. Not only was my water heater fixed immediately, but things got hot and heavy for the rest of the night.

His wife never had any idea about us, and at the time there was no remorse on my end. There was no feeling of "Hey, this is somebody else's mate." It never occurred to me that these things were wrong. I just did it. I slept with him. I met with him behind her back and he stayed at my house. I wasn't married to her. He was the one married to her, so he had to own his faithfulness to her and not me. I wasn't in love with him because I knew it couldn't be anything. It couldn't be anything other than sex and conversation. That was it; that's all it was. I was young. That was enough for me. That lasted for about as long as I lived in the building, but after I got transferred to another job, we just lost touch.

After my affair with the building owner, I went on vacation to the Caribbean so I could engage in some much-needed hedonism. I wanted to get all the wild that was left in me out of my system. I met a couple named C and D. They were married but C____ was experimenting with women. Her husband was accepting of it so all of us were together as a threesome throughout the whole trip. After our trip, they invited me to their house. I took leave, flew out to see them, and stayed for almost a month. It was a weird and crazy experience living with this married couple, but I'm actually glad I had it. It allowed me to get all of my sexual issues out of the way.

B_____ has been in the background of all of these relationships. We have been on and off for about 12 years. We'll always link back up after each relationship. Then we'll see each other for about six months and then go cold. She rarely changed her phone number, and when she did, she made sure to reach out to me. I know it's odd. If you were to ask her why she and I are not together she would say that it's my fault because I have commitment issues, but she's wrong. I don't fear commitment. I fear disappointment. Commitment and disappointment go hand in hand. Those two concepts are pretty much one story to me. We could've been more, but she constantly disappointed me over the years.

Right now she's in a committed relationship with a woman that she's been with for three years. I'll say that we've seen each other less in the past three years, but despite her engagement to another woman, we've still connected. If she wanted to have it just the two of us forever, I'd probably say no. That would mean I'd have her all to myself, and I've never had her like that, so I wouldn't know how to act after six months. I think we would probably fight a lot because I'm used to having her around for such a short time. She'll always be more than just a friend because she's the only person that I can't BS. I'm a runner so she's quick to say, "You're running again. Why won't you stand and take responsibility for this? Address this head on and stop running from it."

I've tried to stop running. As I've gotten older, I've become more remorseful for the things that I've done. I have to be held accountable for my actions. If you are in so many different relationships with people who aren't yours to be in a relationship with, it's never going to work. You can't have something that does not belong to you. Someone else is missing that man or someone else is missing that woman. That time spent with you is absentee time from their kids and their spouse. I had to understand that nothing good was ever going happen to me as long as I was pushing bad into the world. I was putting pain on another woman regardless of whether she was good enough for her partner. I'm ready to be a contributing factor to a successful relationship. We have a responsibility to one another to make sure we are doing our part not to cause unnecessary heartache.

Ferris

"We often have sex in the same bed that they sleep in."

I was walking down the street. This guy says, "Come into the strip club." I had never been to a strip club in my life, but I went inside, saw Taboo, and was hooked. I was young when I met Taboo so I wasn't very experienced when

it came to sex. Once we started hooking up regularly, it was like a drug to me. I lusted after him because he was an Adonis. He was gorgeous. Six feet, four inches, 230 pounds. He was the bomb. I started to associate the sex with love but being with a gorgeous stripper came with drama.

Another dancer named Mercury told me my Adonis was married. I said to him, "Nope, you're just lying to me. I don't believe it." I was really naïve. I honestly thought Taboo was going to be faithful to me even though I'd never seen his house during the four years we'd been together. We'd always meet at a hotel or my cousin's house. I would rent my friend's apartment just to have sex because I was living with my parents at the time. The effort was always worth it, and when it came to his faults, I was so quick to forget them. He stood me up on my 21st birthday and I cried and cried, but when I saw him days later it was like I had completely forgotten the whole thing.

When I told Taboo what Mercury said, he replied, "He's just telling you that so he can have you for himself." Taboo was the type of guy who always knew what to say to get me to stay. Whenever he called me, I came. Every time he told me that he loved me I hung onto every word. I was just happy to be with this man. I didn't care what it took to see him.

One time we were at the club and he told me to wait outside. While I was waiting by the door, this woman walked up to me and said, "Excuse me." I started looking around like, "I know this woman is not talking to me." I ignored her, but then she tapped me on the shoulder.

I turned around and said, "Oh, are you talking to me?"

"Yes. Are you seeing Taboo?" she asked.

"Yeah, I'm his girlfriend."

"Well, so am I." I didn't know what to say. I was so devastated. I never had any woman confront me like that especially not over Taboo. She was unattractive too, so I assume that whatever he had going with this woman was all about sex. I bought 20 drinks that night to get my mind off of it. When I left the club, Taboo came outside and pulled me out of the cab, "Don't leave! Don't leave!" he pleaded. I let him pull me out and take me home. Then we did whatever we did, and everything was okay. Sex always fixed things between us.

During the fourth year of our relationship, he accidentally left his pager at my house. I did what everybody else does. I went through it. I wrote down all of the numbers on his pager and called every single one of them. There was one number that belonged to E____. Turns out, she was his wife and the number I called was their house number. I then realized that Mercury was right all along. I had no choice but to explain who I was. She was completely shocked and had no clue that her husband had been cheating on her. E____ was pregnant with their first child so it broke me to tell her all of these things. I asked her, "He never came home. It didn't occur to you that he was cheating?"

"Nope," she said. "I had no idea. All of those nights, I just thought he was working."

"Well, for four years he's been sleeping with me and everybody in this city," I said. Even after talking to his wife, I was still sleeping with this man. When he found out that I spoke to his wife, he slapped me in the face and broke my window. He didn't like that I was trying to wreck his home. He wasn't the hitting type, but when it came to protecting his home he was like most men—he would protect it all costs.

I tried to leave him after he hit me. When he came to my house and begged me to forgive him, we had sex and forgot about the whole thing. It was hard not to forgive him when he used sex to make me stay with him. There was never a time that I would not sleep with this man. The sex was incredible and still to this day nothing ever compares to that. I had sex with him everywhere, in the park, in the back of a car, in the bathroom of the club, in my friend's house, you name it, wherever we could have sex that's where we would have it. He was 12 inches of love. We measured it when it was fully erect.

But once his infidelity got out of control, I just couldn't do it anymore. During the end of our relationship I was at a strip show with him. When he dropped me off at my house I saw that there was a girl in another car following him. I couldn't believe that he actually had another female who he was going to spend the night with. It was humiliating that he brought this other woman to my house and had to nerve to flaunt her in my face. That's when I knew it was over. It was because of him that I never found a real relationship. I was always comparing everybody to him. They had to be gorgeous like him. I would try to have sex with other people, but they were never as good in bed. Taboo ruined everything for me.

The man I sought out after Taboo wasn't gorgeous, wasn't tall, and there was no 12 inches. My daughter's father was just a regular married guy I had a baby with. It's so sad because I've never been promiscuous until after Taboo. I'm really lucky I didn't get pregnant with Taboo's baby. After I had my daughter, I was celibate for seven years, then we moved to a bigger city with all types of men of different races. I'm African American and there was a time where African American women only dated African American men, but when I moved to a new city I was like, "Wow, new meat!"

The guy that I'm seeing now is different from the other men I've been with. F____ is definitely not someone that I pictured myself with. He's not a legal citizen; he barely speaks English. He's ten years younger than me and also has like the teeniest penis ever, but even though his penis is small, he does everything else sexually and makes it fun. For me it's not the size of the ship that matters, it's the motion of the ocean. He came on to me at his daughter's birthday party, and it was unbelievable because it was totally out of the blue.

After that, he showed up at my house and then we just started doing it. The only downside is that he's my friend's boyfriend. I've been sleeping with him for the last two and a half years. I'm going to hell for it, and I know it.

With Taboo it was always about sex and I think that messed things up for me because we didn't have intimacy. However, with this guy, even with his broken English, he knows how to make me feel loved. When we laugh and we talk it's as if no one else can touch us. I love the way he holds my hand and how he kisses me. I've never experienced something like that even when I was with my male dancer. I'm the first person he's ever cheated on his girl-friend with. I'm really sad because she is my friend, but we can't control our-selves whenever we're together. She's told me that she's certain he would never cheat on her, and if he did, she'd kill him. It's the worst form of deception because I'll act like a good friend to her, but I've had sex with her boyfriend so many times right under her nose. We often have sex in the same bed that they sleep in, and if she's upstairs sleeping we'll have sex in their garage instead.

My friend used to ask me to help drive F____ around if she couldn't do it. She thought I was the best friend in the world for being so helpful, but to me she was so stupid. Even though you should have a certain level of trust in your friends, why would you leave a woman with your boyfriend for that amount of time? If I had to take F____ somewhere we'd stop by my house first and have sex there. If I had to take him to their house then we'd be having sex before she got home. I purposely made myself available for anything she needed to accommodate him.

I was in this class and my Internet wasn't working at home. My friend invited me to stay at their house. While his girlfriend and kids were asleep, we would have sex downstairs, and anytime she'd leave the house, we'd be screwing the moment she left. It's not something that I'm proud of, and after a while I had this impulse to stop doing this to her. While I was still living there sometimes I'd go to their bedroom to wake her up. If he saw me first he'd look at me like, "Why are you waking her up?" I just felt bad because if she weren't awake then F____ and I would use that opportunity to have sex all morning. She would usually go back to sleep and tell the both of us to hang out without her.

I wonder if she just pretended like she didn't know what was going on because she had a baby by his brother. F____ has been in a relationship with my friend for the past 12 years. They have three children together, but their oldest child is fathered by his brother whom she was cheating with for two years. I think on some level I'm his revenge and they both know it. That's probably why no one is putting a stop to my and F____'s affair.

The closest that she came to confronting me was when F_____ had 90 missed calls from her. When she couldn't get a hold of him, his mom called his phone 20 more times. I don't know why he was avoiding her. He looked

at his phone and then over to me and said, "Let's go and tell her right now. I'm going to leave her and be with you." I couldn't do it. It was like somebody put cement blocks on my feet because there was no way I would be able to tell her that I'd been sleeping with him.

When I dropped him off at home, she was at the front of the house waiting. "I knew it," she said. "I saw you two driving together from down the street."

I couldn't help but lie. "It's not what you think. Calm down. It's not...."

"Get the fuck out of here," she said. "Don't you ever come to my house." She cursed me out, and I let her have her moment. I let her have it because he should have answered his phone. As he let himself out of my car to go into their house she said to him, "Oh, you go with her." He just went into the garage and pulled out a chair and sat in it. He wasn't going anywhere. The truth was neither of them were ever going to leave each other. Without her he doesn't even have a pot to piss in, and he's helping her raise their three children. I'm not the one that he can run to because he's not even a legal citizen. She takes care of him. I can't do that. I can't financially take care of F____ because I have a child to support.

After that night, we cooled off for a couple of months. It killed him for us to be apart for that long. Once in a while he'll still entertain the idea of leaving her for me, but like I said, I don't think he'll ever do it. Every relationship that I've ever been in has always been the same. Sometimes I wonder if I ever really got over Taboo. Maybe that's why I'm in the situation I'm in now. I see on social media Taboo's moved on, and it's sad that I never really did. I just wasn't worthy of being relationship material to him. I always thought better about myself because I was an attractive girl, but Taboo destroyed all of that.

When I look at my Mexican (I call him "my Mexican"), I wish that we could wake up in each other's arms. As much as I've slept with him, I've never slept with him and woke up in the same bed. Sometimes he'll say to me, "If only I met you first. You'd be the one." I believe him, and it's horrible knowing that after we do what we do I have to take him home to his girlfriend. I know women equate sex with love and that's what happened with me in both situations.

Adriana

"Even now as I allow myself to rehash the memories of having sex
with him, I still feel that throbbing and aching need for him."

My marriage with my husband has a tide that ebbs and flows. There are times where it's really good and secure, and then there are other times when

I desire more. What's missing is communication, connection, and, at times, intimacy. I had a two-year-old son when we first met, so when I got pregnant again, I did not want to have a second child out of wedlock. We got married when I was 26. For the most part, it was a good relationship for 20 years.

When my youngest child left home, I was going through empty nest syndrome. I decided that it was time to work on myself so I started exercising and eating better. Once I started losing weight, I started to feel more attractive and confident. People began to pick up on my new energy including a coworker.

I had known G____ for about three years. He was the most gorgeous man I'd ever seen. Most women have a particular type that they are attracted to. Funny enough, my husband is not that type. G____ was the quintessential guy that I'd always been attracted to and was eight years my junior. He was tall and in shape with dark brown skin and a gorgeous smile.

We worked together on a couple of projects and then we developed more of a personal relationship. He'd send me friendly emails and visit my office just to check in to catch up. When he would go on trips for work he would always bring me back trinkets. I never saw him outside of work. We never spent any personal time together, but then one day out of the blue he gave me a hug and he kissed me on the neck. We'd always kept our relationship professional and at arm's length, but that kiss opened the door into this fantasy that I couldn't stop.

It was flattering that this young guy was coming on to me, so I wanted to sleep with him at least once to settle the curiosity. He invited me to his house while his wife was out of the country. We had sex in their bedroom, and it was the most mind-blowing experience of my life. G____ was a phenomenal lover.

Our physical attraction was instant, intermediate, and magnetic. He consumed me all at once. Sex with him was just fabulous. In fact, it was batshit crazy. There were times that I thought about this man every moment of the day. At this point, I'm 46 years old, but I felt my body revert to 22. Even now as I allow myself to rehash the memories of having sex with him, I still feel that throbbing and aching need for him. I was addicted to him. I physically craved this man like a drug. He brought out this adventurous and sexual side of me that had been buried. I even went out and got a body piercing. These were things that I felt were inappropriate for a wife and mother. Having sex with G____ integrated these two identities.

We were having sex in our offices. That kind of risk was crazy within itself, but the danger of being caught heightened the excitement of it all. I was still having sex with my husband at this time. Our sex life was actually more active than ever. I was certainly a better wife because I was happy and pleasant. I stayed excited with just the thought of being with my coworker. It was almost like I took my brain out of my head and set it on the shelf.

I was definitely doing some soul-searching during that affair. I was not prepared to leave my marriage. G_____ was on his second marriage and the two of them were raising children, so he wasn't trying to leave his family for me. My husband doesn't know about the infidelity, but unfortunately my coworker's wife knows. I think she probably found email correspondences between him and me, but I don't know for sure. It was a joint decision to end it because G____ and his wife were moving to another state. If I had let this affair go on further his wife could have potentially destroyed me. I never wanted to be the other woman and here I was choosing to put myself in that situation.

For my job, I have to process military files and G_____'s wife's paperwork came across my desk. I give her a lot of credit because she brought me her papers in person even though she knew I was sleeping with her husband. During the whole process, I tried to be very professional. As she was leaving, she stood at the doorway and said to me, "I hope you enjoyed fucking my husband." I didn't say anything back. I just returned her look and watched her leave. The few weeks before they left were very stressful. I didn't know who she was going to tell about the affair. When they finally left it was a relief because not a single person in my office has asked me about my relationship with G_____.

This experience reconnected me back to my spiritual self, and I pray daily for his marriage. I hope that they were able to work through any damage that I caused. It was never my intent to become a damaging factor in his marriage. I regret that his wife found out because I potentially destroyed another woman's home. I could sit here and say, "Well, if she were doing everything she was supposed to do, he wouldn't be in the streets with me," but that's not the truth. She is a good woman who loves and adores her husband. No matter how deeply I desired him, we shouldn't have been together. I had the potential to destroy relationships and in the end that's not worth it.

Tru

"If someone came to me with a crust of bread,
I would've treated it like a gourmet meal."

I was always faithful to my husband, but we had kind of a sexless marriage which caused me a borderline nervous breakdown at one point. I was very depressed so I went to lots of different shrinks, tried different cocktails of medications, but nothing worked. I was still unhappy. A friend of mine told me to watch this television series (it was new at the time) called *True Blood*.

"Oh God, vampires?" I said. "Really? You want me to watch vampires? I do not have the patience for this. This sounds really silly."

"Watch it. It'll make you feel better," my friend said. "It's campy. It'll take your mind off your problems." I started watching the show and became obsessed like a 13-year-old. I felt something between the two main characters. Their romance was unlike anything I'd ever seen. I didn't know that the actors were falling in love in real life, and to me that was a very sexy courtship. There was a poignant sex scene that really grabbed me. It was when the two main characters finally came together and consummated their relationship. All of that tension that had built up during the season was finally rewarded. I lost it. I started crying. I was inconsolable and hyperventilating. I thought my husband was going to come in and institutionalize me because I was crying so hard. I was missing that passion with him, and after watching that sex scene all the answers fell into place. I realized I wasn't in love with my husband, and I never was.

I was starving for attention with such sad desperation. If someone came to me with a crust of bread, I would've treated it like a gourmet meal. I had never been with men that were interested in my sexual pleasure. I finally decided to divorce my husband and explore my own sexual fantasies ... on social media. I started having cybersex. I chatted with strangers and indulged my interests. Twitter is a hotbed of inappropriate flirtation.

There were these role-play scenarios that turned me on, and I would often tweet with the Anglophiles. An Anglophile is someone who really loves anything to do with England and old England like Henry VIII. I loved imagining someone talking dirty in a proper British accent and undressing me in my opulent Tudor ball gown. Then I met someone I started instant messaging quite frequently. When he showed me pictures of himself, I was struck by how handsome he was. Our conversations were incredibly hot, steamy, intimate, and romantic. I would get love letters and all of this attention from this guy. It was nothing that I had ever experienced and that's how I became involved with H_____.

H_____ was married. I should've stopped talking to him, but there was something about him that had such a powerful, lustful draw. Everyone told me, "He's married. This is going nowhere. What about the wife?" None of it mattered. I had to have that crust of bread! When I decided that I was going to meet him, I called a private investigator who owed me a favor. I said to him, "Look, I'm about to meet this guy who I met online. I want to make sure it's right." I gave the private investigator all of the information and once everything checked out, I flew to meet H_____.

We met in the lobby of a hotel and as soon as we locked eyes I just knew that I had made the right decision. I'd always had body image issues and H_____ was very patient with me. It was the first time I ever had enjoyable

sex. It wasn't just enjoyable physically, but sensually and emotionally as well. We had a lot of sex, a lot of different adventures in different places, but when we started to fall in love it became a lot more complicated and a lot less exciting. I would try to see other men during my divorce, and it would bother him. It excited me that it bothered him, and I would rub it in his face that he was still married so I could do whatever I wanted.

I thought I would have felt tremendous guilt and empathy for his wife. Instead I felt nothing and that disappointed me. I kept saying to my therapist, "Why don't I feel bad? I think it's awful that I don't feel bad." He and his wife were Republican Christians and their sexual issues had been brewing for a while. Based on what H____ told me, his wife was a devoted mother and a lovely woman, but their relationship was not something tenable for him anymore. There was a point where he was considering a move to another state for a job opportunity, and I said to him, "Before you uproot that woman from her life, you better tell her you're not in this marriage anymore." He wouldn't do it so then I said, "Forget about me. There's no way I'm following you across the country but do her a favor. Free her so that she can find someone who will make her happy."

One day I texted him something and I got a reply back saying, "Who is this?" He never changed my name on his phone even though I told him a million times that she was bound to find out about us.

"I don't care if she sees it," he said.

"I kind of care if she sees it," I told him. "And if you don't care, then leave her." After that his wife had a hunch that he was cheating, and she found all of our emails. Afterward H____ left me a 15-second voicemail message saying that our relationship was over.

A year later he started contacting me again to tell me he was separating from his wife. "I know I owe you a lot," he'd say. "I want to be with you. Let's just try again." He would always write me these flowery, narcissistic emails and because of my self-esteem issues I always bought into it. After a while, it became part of his bag of tricks, and as soon as I agreed to give him another chance he said to me, "But my wife can't know because she'll flip out."

"Well, that doesn't sound like you two are splitting up," I said.

"No, no, we are. Don't worry. I'm in therapy now." He had never been in therapy before, so that gave me some hope that things this time would be different. He also told me he was diagnosed with MS and made me afraid that he didn't have much longer to live.

"I will be with you during this time," I said to him. "It doesn't matter to me that you have MS. I love you and we'll conquer it together."

A year later he later he was still living with his wife and kids because he couldn't afford to move out yet. His wife had struck up a new friendship with another man, and he was getting a little irritated with that. I said, "You know,

you should be happy. When I left my husband, I was over the moon when he found somebody. Why is this not making you thrilled?"

They were both playing games with each other and it seemed like neither of them could let go. He called me and said, "I sat down and had coffee with her. She told me I could go ahead and date whoever I want, but if I end up dating you, she would take the kids and poison their minds against you. She said she would make our lives hell."

"I'm not doing this," I said to him. "I deserve to be with somebody who will fight for me. If you loved me, you'd fight for me. So goodbye."

Two weeks later, he forwarded an email from her where she wrote, "Tru published an erotica story about you online." It was a story about me and H_____'s relationship that described our sex life in graphic detail. I have my own writing career. I felt that I didn't need his permission to publish it. His wife sent out a link to the story to his family and friends. He pleaded with me, "You owe me nothing, but please, for the sake of my kids, please take these stories offline. I have secondary MS and they are giving me ten years to live. For the sake of these kids, please take it offline." Reading that just pissed the fuck out of me. There's no way I was going to take that stuff off. It was my work and my story.

Reading his wife's email to him made me feel better. She wrote a gorgeous, eloquent letter taking her life back. The empowerment of it inspired me. She said to him, "I'm not obligated to stay with you because you have MS. It's horrible that you do, but I'm not going to do this anymore. I tried to make our marriage work. You have embarrassed and shamed me. You have done deviant things with this woman, and I am going to start a relationship with someone else. I deserve happiness and I'm moving on."

After that whole email debacle, I allowed myself to finally be free of him. The only regret I have is that since my relationship with H____, I've held myself back from emotionally connecting with anyone else. I have lots of sex with other people, but I was emotionally tethered to this man who, at the end of the day, didn't love me. That kind of history is getting in the way of me moving forward. That's a little painful because I thought he saw me the way I had always wanted my ex-husband to see me.

When I think about those two years with H_____, I honestly think that it could have been any other woman. There was nothing special about me. It was a perfect storm of circumstances. This affair changed the direction of my life. I became an erotica writer with a popular website. I'm now a sex coach and a sexuality educator. I'm helping women discover that sensual part of themselves. I do not feel guilty about the affair. The guilt would have kept me from learning from the whole experience. I think more women need to talk about their sexuality and their sexual journey without judging themselves. My relationship with H____ was my journey, and I had to live it out. No one

can tell me what I can or cannot do with my life. Every woman should live this way.

Understanding the Other Woman

Other Women exist in the liminal space between disempowerment and empowerment. Disempowered representations of Other Women depict them as expendable and extraneous to a core relationship. At the time of the interviews, only Sheva and Ferris were still in less-than-ideal Other Woman relationships. Sheva was wary of the sexual health dangers of sharing her partner with another woman. Ferris feared her friend's reaction when she finally confirmed the truth.

Another aspect of disempowerment is deception. During many beginnings, the facts available to Other Women were either unknown or unclear. Was he secretly married? Were he and his partner really separated? Is he really planning to leave her? Did he still love her? Are they still having sex? Did they share the same definition for their open relationship? Other Women sometimes described feelings of regret and hurt especially when they discovered that "the competition is not with the wife, but with the other 'other women.' Plural."[3] This was the case with Elle, Sadie, Raven, and a young Ferris.

These narratives, however, suggest there are also empowering experiences available to the Other Woman. The epicenter of that empowerment is the feminist concept of agency—the ability to make decisions unconstrained by the expectations of others and unconstrained by material conditions. While Other Women are necessarily constrained by the nature of their infidelity triad, this section highlights key agential moments surrounding selfishness, pleasure, and personal growth that facilitate empowerment.

Selfishness is a recurring characteristic of Other Women reflected among these narratives. Raven is transparent about her selfishness when she says, "He was the guy that I wanted so I was going to have him. I was very bratty about it and didn't respect what he had with his wife." Denise's nonchalant declaration "He was the one married to her, so he had to own his faithfulness to her and not me" continues along the same vain. Ferris's brashness about having sex with her friend's boyfriend "in the same bed that they sleep in" confirms there is a level of selfishness inherent in an Other Woman's conscious decision to remain in a relationship with someone who is simultaneously maintaining a committed relationship with an initial partner.

In *Cheating on the Sisterhood*, Rosewarne notes, "While a single woman's disregard for the betrayed partner may be selfish, the affair is rarely pursued as a direct assault. By pursing one's self-interests through infidelity, arguably some feminist goals can be achieved, albeit with a cost."[4] Selfish Other Women

pursue a feminist goal of self-empowerment via agency by finally putting their needs first. Within the confines of a traditional, compulsory, heterosexual coupledom, gendered expectations for women do not sanction selfishness. Instead, women are supposed to nurture and behave selflessly toward their partners and children. Because Other Women exist outside the constraints of these traditional relationships, they can more easily shirk these expectations.

Selfishness, then, is not an attempt at mate poaching or "knowingly luring an individual away from an exclusive relationship."[5] In fact, all of these relationships, with the exception of Denise's relationship with B___, were initiated by the infidelity partner. Accepting an infidelity partner's advances is an internal recognition of and determination to fulfill previously unmet desires. Raven, Denise, and Ferris were all devastatingly disappointed when what they perceived to be "genuine connections" with previous partners turned out to be utter betrayals. Their selfishness in Other Woman relationships appear to be a reaction to pain caused by a quondam partner's selfishness.

Other Women further enacted the feminist goal of agency by choosing to be Other Women out of a desire to meet their needs for emotional and sexual pleasure. Emotional pleasure derives from attention. Raven and Tru describe themselves as desperate for attention. Denise toyed with B____ because she coveted her attention. Sasha relished in receiving public praise and attention from her married man. The women describe the pleasure they received from being someone else's focus even if that focus was temporary.

While Sasha's mediated experience is unique among this sample, explicit, bold, consumed, and obsessive online communication is common. The online disinhibition effect describes conversations people would normally not have in face-to-face interactions. Several factors may lead to disinhibition, but in the case of this relationship between a married much older man and his former student, they created an intrapsychic world "shaped partly by how the person actually presents him or herself via text communication, but also by one's internal representational system based on personal expectations, wishes, and needs."[6] Her online presence was his escape. His online presence was the attention she wanted. Via text, they created a fantasy world "separate and apart from the demands and responsibilities of the real world"[7] which minimized their age difference, ignored the inappropriate nature of the relationship, intensified their online disinhibitions, and increased the excitement and emotional pleasure generated from their interactions.

Love is another emotional pleasure. Eight of the 13 women described their experience as love. While reflecting on the demise of their triangular relationships, several women are unapologetic about falling in love. Barbara declares, "I wanted love and that's nothing to be ashamed of." Elle proclaims,

"Despite my inner principles, I can still feel that connection between us, and I know that he still loves me too. We really did fall in love." Brenda reaffirms, "I still love him to this day." Raven acknowledges that she didn't "do love," but her affair helped her to become vulnerable to and appreciate love. Perhaps the love noted here is not solely regulated to their lovers, but, as Richardson suggests, with pleasurable memories of the affair.[8]

For the majority of these women, love intensified incredibly pleasurable sex. Perhaps Adriana is clearest when she describes sex with her lover as "the most mind-blowing experience of my life." Xeena notes the heightened sexual pleasure of "doing my best friend" who was sexually attentive in ways her boyfriend was not. Sasha and Barbara were virgins when they met married men who guided them into the world of sexual intimacy. Lita, Elle, and a young Ferris were admittedly inexperienced and appreciated a sexual freedom with their lovers that they had never experienced before.

The asymmetrical affair of a financially stable, sexually proficient, married man offers a young, sexually inexperienced woman a wealth of pleasurable experiences for which she often develops an insatiable desire. And for older women, a sexually proficient man who may be younger and less financially secure still offers a sexually stagnated professional woman a wealth of pleasurable experiences for which she often develops an insatiable desire.

Ferris rightly identifies the dangers of equating love with sex, but the sex should not be underestimated. Richardson writes, "In a relationship with a married man, because it is outside the bonds of convention [the Other Woman] can *experiment* and *practice* new definitions of her sexual self. Such a relationship gives her both time and freedom to redefine herself."[9] In a society where women's sexual pleasure is subordinated to men's, it is very important for these women to have experienced it at all. Prioritizing desire irrespective of the potential outcome exemplifies a form of self-determination. This access, freedom, redefinition, and self-determination adhere to the feminist principle of agency.

The final agential principle that facilitates empowerment for Other Women is personal growth. The personal growth model "suggests that individuals engage in extramarital behaviors to enhance their sense of self."[10] Again, none of these women are poachers who intentionally found a committed person to boost their self-esteem, but they frequently prioritize essential lessons learned over regret. Sheva admits, "I would say this has been a tremendous learning experience for me," and she encourages Other Women to prioritize their personal needs when making their relationship decisions. Neither Lita nor Barbara would change their Other Woman experiences because they shaped them into the women they are today.

Sadie, on the other hand, did express regret, but not because of social expectations or even guilt. Sadie's personal growth was realizing she was in

her situation because she was not happy with herself. Tru described being in a state of "sad desperation" before the affair that changed the direction of her life. Her sexual awakening led to a career as an erotica writer, sex coach, and sexuality educator. While Denise and Adriana express regret for the people they hurt, they simultaneously articulate essential lessons learned and project positivity into their relational futures.

In essence, disappointment leads to self-discovery. Personal growth can be an unexpected result of enduring a less-than-ideal relationship. The Other Woman experiences recounted within this section are never entirely negative. The women discover how they desire to be loved, how they want to have sex, and how to determine when a relationship is no longer fulfilling their needs, among many other personalized lessons. Across the varied experiences of these Other Women, they, and perhaps we as readers, are unified in our increased self-awareness about the empowering lessons that can be learned from a stereotypically disempowering experience.

We Cheated on Each Other; It's Complicated

A romantic relationship is greater than the sum of the people involved. Relationships are their own entities that come into being when two people unite themselves, their histories, their perceptions of each other's histories, their present situations, their interpretations of each other's present situations, their visions for the future, and their assumptions about their partner's visions for the future. Compound this with the addition of one or more extradyadic sexual relationships with other individuals' past, present, and future perceptions, and "it's complicated" is the vaguest most accurate description there is.

The eight women in this section lived it's complicated relationships where both partners had sex with an extradyadic partner at least once. At the time of the interview, the average age was 43. The youngest was 21; the oldest was 64. Four identify as white, two as Latina, one as black, and one as biracial white and Latina. Six self-identify as heterosexual, one as lesbian, and one as bisexual although all participants shared stories from heterosexual relationships. One's highest education level was trade school. The youngest two were still attending college, two graduated from college, and three earned professional or graduate degrees.

At the time of the interview, Ishtar, Julie, Anne, and Melanie were still in their primary relationships whereas Florence, Symone, Lindsay, and Jane were not. This section notes the complications than can arise from infidelity experiences when both partners have partners. It also draws attention to women's decision-making strategies—to end or mend—relationships that get complicated.

Ishtar

"My husband confessed that he had a lot of fantasies
about me being with other men."

I had a brief flirtation with someone that I had known since elementary school. It was sort of like unfinished business and didn't really mean anything. I told my husband about it since we tell each other everything, but he seemed more interested than mad. It really took the guilt out of it. I felt comfortable explaining the incident. Then my husband asked me, "Do you think you could have a sexual relationship with him? We should try being open with other people." At first, I thought it was weird; he must have been joking. Then my husband confessed that he had a lot of fantasies about me being with other men. I couldn't understand why this was attractive to him. I assumed he wanted to have an affair and leave me, but as we further discussed his fantasies, he was basically telling me that he wanted me to have sexual relationships outside of our marriage.

Throughout my whole life, cheating was very familiar to me. I had cheated on every boyfriend that I ever had before my husband. It was something that I deemed as bad behavior in a relationship, so when my husband proposed this arrangement I was definitely intrigued. My husband and I have pretty different education levels. I would define myself as sort of a pointy-headed, intellectual-type person. I'm really cerebral. I live in my head. I love the world of ideas. My husband is much more practical and hands-on.

These things that he suddenly expressed that he needed were deep-seated in his thoughts. I wanted to hear him out. He sacrificed a lot for our family to not work and take care of our child. I asked myself, "What does it cost me to try this? If I don't like it, I don't have to do it again." We started to explore that part of his needs. I started sleeping with other men, and our marriage has never been the same since.

One of my first extramarital relationships was someone that I met on Facebook. I knew that he was married with three children when our relationship started. I had actually fallen in love with him, but I started to feel really guilty about his wife and kids. I could just imagine how hurt she would be if she knew, and that made me sad and not as happy with the relationship as I had been.

My marriage was solid because I was being honest with my husband. He knew everything that was going on between me and this guy, whereas the guy I was seeing was lying to his family. I broke it off with the Facebook guy after discussing the dilemma with my husband. Till this day this guy will try to call me because wants to have phone sex or start sexting again. I'm always

polite and will engage in some real brief talk. Although there can't be any intimacy with him, I'll still look at his Facebook but never write anything on his wall.

I'm religious but I don't condemn people for how they love each other. To me love comes in a really a big spectrum because the more you try to define it, the harder it gets. But not everyone feels this way. Somebody at my church got up in front of our congregation and announced that she was in a polyamorous relationship. This started a real controversy. There were people who actually quit the congregation over it. There was a summit to discuss what to do and they arranged for different couples to meet with each other. I was assigned to a couple that I didn't know very well. I met with the husband first, because his wife had to tend to their sick child. The whole thing was silly to me, and I told the husband that this polyamory thing wasn't hurting anyone. If you're an adult, you're free to make your own decisions. The husband expressed the same concern. "My wife and I have a different private life than others," he said.

My husband and I developed a friendship with this couple. Everyone wanted to experiment, so we became swingers with them. At times, they were a little bit too far out there for us. They were into every single fetish you could think of. If you could name it, this couple was into it. Their lifestyle was really dangerous because they were into bondage/BDSM play parties. They invited us to go to a bondage workshop in another state, but my husband and I weren't into that. The four of us would meet up for sex quite frequently. It was a nice friendship until the husband started falling for me. His wife started to feel the same way about my husband, but the feeling wasn't mutual. My husband and I were fine having casual sex with them, either together or separately, but not interested in engaging in a four-way marriage.

You really have to talk when you live the kind of alternative lifestyle that we live. Your communication has to be really strong. I think our marriage is better than most because we don't have anything in the closet to hide. We have a few rules for our arrangement. There can't be any physical relationship with another person outside of our marriage without discussing it first. For a while my husband had a girlfriend. I knew about her, but her husband didn't know about their relationship. Based on previous experiences, I know that dynamic just doesn't work because there's dishonesty in it. He crossed an unspoken boundary by bringing her to our house without me knowing. I felt really violated by that. Now we both know that our house is off limits unless permission is sought and given. However, I will never give that permission to him because this house is my heart and my space. You don't come into my space without me being involved.

One of the perks of this arrangement is that I've given my husband my last damn blow job. There are some things I now outsource to other women

so that my husband can remain satisfied. I'm not interested in oral sex anymore so if my husband wants to do that he can find a girlfriend. The longer we've been together and the more honest we are with each other, it seems like our love and sexual life becomes more complicated. I don't know why. I guess we've dropped a lot of restrictions about things. Sometimes it works and sometimes we have to talk through it.

I was a prude before we got married, but I've loosened up over the years. Our first date was on my 23rd birthday and I'm about to be 45. We've been together for a really long time so I trust him. I'm going to be with this man until one of us dies. We have the same values and we've built a good life together. I want to preserve that so when these side things come up, and they seem like a potential threat, I'm really committed to putting us back on track so that our relationship continues.

Julie

"You can't have a girlfriend and a wife."

My husband J_____ has been an alcoholic for basically our entire marriage. Some years were heavier than others. This year he was back to drinking again. We weren't necessarily arguing, but we certainly weren't close. We got married a month after our high school graduation and have never been without each other since. We've always been a couple with clear directives. We planned on two kids. We had them. We wanted a house. We bought it. In my eyes, everything was chugging along the path that you're supposed to follow as a grown up until last Christmas.

At a family holiday gathering, J_____ had been receiving text messages that he said were work-related. He was sort of feigning irritation at being texted about work on a weekend at Christmastime. On the way home that day, he apologized for being distracted recently.

"I'm sorry I haven't been myself," he said.

"I hadn't noticed that you weren't yourself. I know you're focused on your promotion. Is that what's distracting you?"

"No, no, that's not it," he said, so I let it go.

The next morning something possessed me to look at his phone, and when I did, it was pretty clear that something was going on with a woman coworker. There were messages that said things along the lines of "I love you. I miss you. I can't wait to see you." In an instant, my world crashed. I never, ever would have predicted. I didn't see it coming. If there were clues, I missed them. I sat and stewed on it for a good couple of hours.

When he woke up, I put the kids down for a nap, approached him, and said, "You have a lot more to apologize for than being grouchy, don't you?"

"What are you talking about?"

"There's a lot more going on with your coworker than just friendship, isn't there?"

He knew he was caught instantly, was quiet for a minute, and just sort of meekly said, "I'm sorry."

"Are you in love with her?"

"Yes, I am."

"Do you still love me?"

"I'm not sure."

"Have you been physical with her?"

"No, not at all. It's not like that. We just talk."

We had a very lengthy conversation, and at some point, I just became overwhelmed, went to my sister's house, told her what was going on, and processed everything. Money was tight, and we weren't sure how he was going to be able to afford to leave. We were barely making the mortgage payment as it was, and how each of us was going to afford a rent deposit for two new apartments was beyond me. I'd leave and stay at my sister's house, and he'd leave for a night and then come back. Finally, on Christmas Day, he came back and said he had decided it was time to go. He needed to leave, and it was over. I told him, "You can stay on the couch until the tax return comes, and when it does then you can use that to move."

On New Year's Eve, he decided to spend the night with a friend. Before he left, I kissed him to see if I would feel anything, sort of this one last kiss kind of thing. It was empty. Later that night, the emptiness grew emptier. I got a text message from J_____ that said, "You know, I wish you hadn't done that."

I texted J_____ back. "Well, I'm glad I did because that told me what I needed to know. It's over, forget it."

A week or so went by and we were still cohabiting, getting along, being civil. Then one day he suggested, "We should sleep with each other. I mean, we should do it just for the fun of it. You know? Just to get it out. We're horny," he pressed. "And let's just, you know, just do this just for the hell of it."

I looked at him and then back at our bed. I hadn't decided if I was horny or not. As he threw me on the bed, I closed my eyes. "Here we go," I said to myself. "No strings attached." All of a sudden it was a lot more fun and exciting than it had been for a while. After two nights of guiltless roommate sex, I dropped him off for a work trip. When he was out of town, I checked his phone records and saw that immediately upon me dropping him off, he had been on the phone with her. I recognized the number. I thought, "This is ridiculous. I've been played." I sent J_____ a message. "I went through our

phone records. You're playing the both of us. You can't have a girlfriend and a wife."

When he finally arrived at his hotel room, he called me. "You're right, Julie. I've been ridiculous," he admitted. "I'm going to end it. I'm going to go see her, and I'm going to end it." By the time he returned home, however, he still wanted to be friends with her. "Friends?" I said. "How can you be friends?"

"Because she's important to me, and I don't want to hurt her, but it's over. Okay?"

"You want to be friends with someone you cheated on me with."

"I've told you many times, Julie. I never slept with her. I just needed someone to talk to."

"Okay. I don't like it, but okay. I'll live with it."

Throughout all of this, he swore to me over and over and over again that there had never been anything physical, despite their text messages saying otherwise. He'd always maintained that their relationship never went that far physically; he never slept with M_____. Then M_____ contacted me online. "By the way, I'm not the only one," she wrote. "He's been with other women too. I just thought you should know."

I asked M_____ if we could talk over the phone, and when we talked she hashed out the details of their affair. M_____ was young, jailbait young. She told me she had just, just turned 18. She still lived with her parents, and she would sneak J_____ into her bedroom like they were high schoolers. As she described their numerous sexual trysts, I remind her that J_____ claimed that he never slept with her.

"How do you want me to prove it to you?" she asked.

I asked her what he looked like naked and what his favorite sexual positions were. She described them in accurate detail. M_____ also told me that she had been inside of our house. As I sat on our bed sheets, I wondered how many times M_____ was in them.

When J_____ got home from work, I confronted him.

"I know that you lied to me," I said to him. "You slept with M_____."

He continued to deny it, but as I described what M_____ told me, he hung his head and sighed, "I'm sorry." I had to decide if it was worth staying with him knowing what I knew, or if I was going to end it. At the time, I was still fairly religious and believed that he was my soulmate, that he was the one decided for me. I was working part-time and had two small kids that were still not even in school yet. I was terrified of starting over and supporting myself financially and emotionally. I decided that it was worth it to stick it out and deal with it.

If J_____ never cheated on me, I probably would not have even considered cheating on him. I didn't set out to hurt him the way he had hurt me, but the door was opened for me to have an affair because of it having been

done to me. Earlier in October, I ran into old coworker named Q_____. I had previously felt a physical attraction to him, but it hadn't ever gone anywhere. I started texting with him mostly, then talked on the phone every once in a while. I would set up meetings with Q_____ that were meant to appear to be accidental run-ins in public places. My idea was that if I ever was caught with Q_____—well, I just ran into him. In my mind, I was good at being in an affair. Because unlike J_____, I deleted messages and made sure that my phone records were clear. Anytime I talked to Q_____ on the phone it was from my office instead of from my cell.

Eventually, we saw each other "accidentally" on a regular basis. I fell in love with Q_____ and slept with him around the same time I'd confronted J_____ about sex with M_____, but unlike me, Q_____ wasn't ready to leave his marriage. Although his marriage was on the rocks, and it wasn't romantic anymore, the two were cohabitating for the sake of the kids. I didn't feel like I was a mistress because he wasn't in an actual romantic relationship, but I'm sure this is what every married guy who's screwing around says.

In January, I went out of town for a weekend with my girlfriends to clear my head. Before I left, I met Q_____ in a motel, had some fun, and then went off on my merry way. When I came back, the first thing that J_____ said was, "Oh, I've missed you so much." I didn't reciprocate the feelings. After seeing Q_____ for a few weeks, I was finally ready to tell J_____ that I was leaving him for good.

"You being away made me realize how much I want to make this work. I'm dedicated to putting things back together."

"Oh, well, that's too bad," I told him. "Because I realized that I really didn't miss you, and I don't really want to do this anymore."

"I'll stop," he pleaded. "I'll be better for you."

I sighed. "No, really—you've said that enough times. It's time, and I'm just done." That was the first time those words had come out of my mouth. They stunned me just as much as they stunned him.

He looked me up and down. "You've been out quite a bit in these past few weeks."

"I've been spending more time with girlfriends."

"Girlfriends? Which ones?"

I summoned every cell in my body to lie with a straight face. "J_____, stop. There's no one else," I told him.

"You're lying," he said. "Out of all of the people in your life, I'd be the one to know if there was someone else."

As anxious as I was about watching him fall apart, a part of me just wanted to see it. I was done as I could be with J_____, and I just didn't care what the consequences were anymore. So I told him, "You're right. There's someone else."

"Did you fuck him?" he asked.

I looked at the hole in my bedroom wall from J_____ throwing a shoe at it and saying it should have been my head. I didn't want things to escalate.

"I'm going to ask you one last time," he said. "Did you fuck him?"

"Yeah, I slept with him," I admitted. "But only once. It was a month ago."

"I think it was more recent than that."

"No, it wasn't." I couldn't figure out what the hell J_____ was talking about. Had he been following me? Did he place a GPS device on my car? As I was retracing all of my steps from the past two weeks, he grabbed a box that he had hidden in the closet. He dropped it in front of me.

"I ordered a semen detection kit. I swabbed your underwear for residual semen," he said. "The test results came back yesterday. Whatever was in your underwear—it isn't mine."

I was in shock. There was no way J____ would go this far. Part of me was insulted that he found it in my character to be capable of cheating, so I kept the denial going. "I slept with you a week ago, are you sure it's not yours? You ordered this test from the Internet. It can't be right."

"Semen lingers in the female body for three to five days," he said. "We haven't had sex for ten days. Just fess up to it, Julie. Admit that I'm not the only one who fucked up."

Of course, J_____ wanted me to end it with Q_____ and rededicate myself to him. I needed some time to think, so I went and stayed with my brother for a week and shuffled the kids back and forth. The back and forth was a logistical mess. I finally decided that I wanted to go home. If we were going to split up, he was going to leave, not me, because everything is in my name. I made more money than he did, and I wasn't going to uproot the kids and make them live somewhere else. I agreed not to see Q_____ anymore and per J_____'s request, attend marriage counseling. We started dating each other, but I still wanted to be separate. I wanted some space and the experience of being independent. Because we married so young, I had never lived on my own.

I am the last person anyone would suspect of having an affair with a married man, or one who'd likely to stay with a man who cheated on me, but J_____ and I are miraculously still together. The odds of a marriage surviving two infidelities was impossible, but after 18 years of being together, after serious counseling and therapy sessions, I think we're as happy as we're ever going to be.

When people ask me what I've learned, I tell them if these infidelities can happen to me, they can happen to anybody. When you're having an affair, you can get caught up in how fabulous this other person is and everything they are that your spouse is not. You fantasize about this beautiful life with your lover without realizing that they too have their flaws. I don't think there

is a step by step. I think it takes time. It just takes a long time, and just know if you're going to cheat on your husband, tread lightly, and wear a panty liner.

Anne
"Basically, we had an open marriage, I just didn't know it."

I was so naïve when I found out about my husband's first affair. We'd been married ten years, and I had absolutely no idea that he was seeing another woman for over a year. It totally devastated me. I can't even describe the way you feel when you find out your husband has cheated. I felt like the ugliest in the world because the man who was supposed to love me and be attracted to me more than anybody else in the world threw me in the gutter.

I tried to get over it. Since we were young, I figured the cheating was a phase. We just needed to get it out of our system. I met an incredibly attractive man during an out-of-town conference. We sat next to each other at dinner and talked all night long. As we continued on the dance floor he pulled me close and said, "I would like to spend the night with you." I was giddy and flattered. I had a revenge affair with him that night. It was a way for me to disassociate from the pain, and, for once, not feel like the ugly wife deceived by her husband.

The sex wasn't even the best part of my affair. His validation meant much more. When I told him that my husband had cheated on me he said, "Your husband is an idiot. You're beautiful." He was a great conversationalist. We talked about everything under the sun, and that's what attracted me to him. He was an intellectual with a Ph.D. He was into handwriting analysis and wanted desperately for me to send him a letter so he could analyze my handwriting. That flattered me to no end because with my husband I always felt like a little Stepford wife that was just there to give him sex. My husband really didn't care who I was. In fact, my husband didn't care who I was sleeping with. When I returned home from the conference, I told him everything. He said to me, "Well, I'd rather have a sexy wife that has a fling once in a while than somebody who is passionless."

I met up with my guy from the conference for a "same time, next year" for several years before we eventually stopped talking. I told my husband every time I flew out to see him, and he'd say to me, "Oh, that's okay. Just tell me all about it when you get back. I think that's sexy." At the time, I thought that having that those extra relationships helped our marriage, that it put a little spice back into it. When I told my therapist about our arrangement, he looked at me and said, "Anne, what does that tell you?" I didn't know what

he meant by the question, so he repeated himself. "Think about it. What does that tell you?"

Then a light bulb went on in my head. That response meant "It's all good, Anne." My affair relieved his guilt so he could keep sleeping with other women. Sometimes you're stricken over the head and you wonder how you were so stupid and naïve, but that's how it's always been with my husband. I was in the dark until I was forced to see him for who he was. When I confronted him, he confessed to 13 affairs. Basically, we had an open marriage, I just didn't know it.

Throughout the years, I've looked at that portion of our marriage as a young, stupid, and crazy time. He came clean, we ended our affairs, decided to start over, and agreed that marriage should be between two people. For the next few decades, we lived a comfortable life. We were secure financially. There was no reason for me to suspect anything until one night while we were at the grocery store, I noticed an empty Christmas gift bag in the back of his trunk. I picked it up, and it had a gift card with his name on it. Naturally I was curious, so I asked him who the gift was from because often his staff members would give him little gifts. It was a very innocent question but then he turned to me with this rage that came out of nowhere. He went ballistic as if there were an IED in that bag. "I have no idea who gave me that gift. Don't ask me who gave it to me because I don't know!"

"I just thought it was from your secretary," I said. "She gave us some pretty Christmas trinkets last year. Did you give anything back?"

"I have no idea. Just shut up." When we got on the road he proceeded to have all kinds of road rage. It was unlike my husband to have this sort of reaction to my questions. It made me suspicious when we got home, so I got the gift bag out of the trunk and looked at it again. I realized that there was nothing odd about it. It was a nice gift bag so I took it in the house and saved it to use for next year.

Then the next day he came up to me and said, "Oh, I remember who gave me the gift. It's from the Christmas party. The staff gave me a golf video game." He was excited to show me the video game and spent a good ten minutes explaining how it worked.

"Why couldn't you remember that yesterday?" I asked.

"I just thought of it right now. I didn't mean to get mad. I'm sorry." By that time my wheels were turning. If a wife suspects her husband is having an affair, she is 85 percent correct. I thought, "Shit, I hope I'm in the 15 percent."

"I think there's something that you're hiding from me. You got so angry. Are you sure there isn't something you want to tell me?"

"We're not going through this again. I told you I would never cheat on you again. What can I do to convince you that I'm not having an affair?" he said.

"Well, let's check your phone record after dinner."

"Oh, well, I don't have a phone log. I delete everything from my phone and you won't see it. I just like to keep the memory empty."

"We can check your records on the computer," I said.

Then my husband all of a sudden turned from a pretty tech-savvy person to completely clueless. "I don't know how to get onto my account," he said. "In fact, I can't remember my Sprint username or password." I stayed on the site until I found the current log activity. There were 23 calls to a number in a nearby town. By the look on his face, he knew that was the smoking gun. That's when he confessed everything.

He was having an affair with a coworker and been doing so for the past ten years. I downloaded the phone records from the last three years or five years and saw that he called her when we were in Canada for our 30th anniversary. We stayed in a beautiful resort which I thought it was one of the most romantic trips we'd ever had. It had been hard for me because during those last five years my husband and I stopped having sex. I thought it was because he didn't want me anymore.

"I'm on all these medications," he'd say. "I just can't get it up anymore." I was very sympathetic because he had a heart condition. It had been hard for him to adjust to all of the new medications so I asked him, "Does it frustrate you not to be sexually active?"

"I feel relieved," he said. "I know you get tired. I don't want to bother you." It turns out his lack of sexual drive for me was a result of him spending all of that energy having sex with someone else. He and his mistress saw each other two to three times a week, sometimes four. All of this time, he'd been lying to me when he promised to remain faithful.

Initially, he told me that their affair had only been going on for the past two years, but then I found out it was actually a decade. I was looking around his office and found a flight itinerary with both their names on it that was dated ten years prior. It was a trip to City F to celebrate their anniversary. It killed me to imagine him taking her out to eat with flowers and bottled wine and so they could toast the first night that they committed adultery.

I'd known this woman. I honestly didn't think anything of it because she wasn't very attractive. She was his right-hand man, so to speak, and pretty much took over the department at his work, so much so that he could just sit back and let her run things. This woman was a subordinate that made him look good. He'd always talked about her in a friendly way, but I never suspected a romantic connection, although when our son had an art show and she came to show support, I thought it was a little strange that she was there.

My husband tried to downplay the affair. "This wasn't the great love story that you think it is," he said. "I was with her because she was convenient.

She's not even that good in bed." He gained companionship from her. She was his golf partner for ten years. That's an activity that doesn't interest me at all. Talk about a man's top needs; she was pretty much meeting the first two: recreational companionship and sex.

I handed him the phone and told him it was time to make a choice. He picked up the phone and told his girlfriend of ten years, "I have some bad news; my wife found out." After that he hung up the phone and put his head down on the table. "I want to die," he sobbed. "I've hurt both the women I love." The fact that he could love another woman as much as he loved me twisted the knife that he just stabbed in my back.

I started to fall apart. I didn't know how to cope with his infidelity again. I wanted to leave, but I didn't. How did I leave a man that I'd been with for half of my life? It's like a tragedy that you've gotten over and then you realize you have to go back to this horrible place. I just remember rocking back and forth and saying, "I can't do this. I cannot do this again." I dropped to my knees and screamed in hysterics.

I was afraid I was going to die from the pain so I just stuffed it. I felt bipolar trying to navigate my husband's infidelity. One day I was totally in love and passionately having sex then the next day I just wanted to die. I've wondered if my husband was ever going to change. Was this the best that it was ever going to be? I weighed the pros and cons. No matter how I saw it, there was no situation where I was going to live blissfully ever after. I bargained with the fact that financially it would be better if we stayed together. He's the man that I've loved for the past 35 years. We had enough good times to make this work. Despite his attachment to that woman, he chose me over her.

Eventually, we worked through our issues. A part of him has been gone out to lunch for ten years and finally now we're back together again. We started a frenzied two years of just incredible and amazing sex. It's bittersweet because sometimes after we have great sex all the pain comes back. When you're in the greatest pain you can have the greatest pleasure at the same time. We wasted a whole decade on not communicating about sex and assuming the other was impotent. It's very nice to know that even as you enter your 50s and 60s your sex life can be ten times better than it was in your 20s. That's been a good thing that's come out of all this.

Melanie

"I want to try to love myself more so that I'm strong enough to leave him."

When I was 17 years old I started hooking up with a longtime crush named K_____. He was the cutest boy in our high school, and he'd always

make time to talk to me. I'd get that butterfly feeling whenever he'd sit next to me in class, but he was someone who always had a girlfriend. He actually still had a girlfriend when we started hooking up, but I wanted to be with him for so long that it didn't matter. When his girlfriend found out about me, she threatened to contact the police. K____ was 18 at the time. She told him that if he didn't stop talking to me she'd report him for statutory rape.

On my 18th birthday I received a message from K_____. I was happy to hear from him. He said he regretted that he let his girlfriend come between us. We confessed that our feelings for each other were still there, but K_____ was still with the same girlfriend. They had an apartment together. She dropped him off at work every day, so despite his complaints about her, the two of them appeared to be in a serious relationship.

One day he told me to get dressed because he wanted to take me on a date. He ordered tickets for us to go to the aquarium. The aquarium was my favorite place. I was touched that he remembered. We had a blast spending the whole day together. It was one of the most romantic experiences I'd ever had. No one in my life has ever been that thoughtful. I never wanted to be without him again.

K____ and I started sleeping with each other again behind his girlfriend's back. I know that it was wrong, but I truly felt that she had robbed something from me. He wanted to be with me before and she threatened to put him in jail so I'd go away. I was 18 now so there was nothing that was going to stop me from being with him. Yes, I knew that he was still with her. I was a part of that infidelity but I'm not so much responsible for it. If he really wanted to be with her, he would have stayed faithful.

Eventually they broke up and he started staying at my house more often. He didn't ask me to be his girlfriend, but just to make sure I had his heart, I wanted to be better than his ex-girlfriend. Every day I cooked, cleaned, and washed everything in the house before he got home. I wanted to be there to provide his every need so I stopped hanging out with my friends and getting into trouble. Before I was with him, I used to smoke weed, but he didn't like that so I stopped. I went from being a wild teenager without boundaries to this very ladylike and dutiful girlfriend.

I had an ex-boyfriend that lived in our apartment building. For some reason, my mom wanted me to drop off an Avon catalog to him. I had not seen my ex-boyfriend for a few years so I was nervous about doing this for her. I walked over to his apartment and knocked on the door. He was surprised to see me but didn't hesitate to invite me inside. We were both out of high school now; I was happy to see that he was doing well. "You look good," he said. There was something about the way he looked at me. He had such admiration for me at that moment, it turned me on. I grabbed his face and kissed him. Once we started messing around, I couldn't stop. We had sex in his living room.

After we were done, I started to feel a lot of guilt about it because K_____ was texting me the whole time I was there. The entire visit was only 30 minutes and I could've just left without doing something so stupid. I called K_____ right away, told him that I messed up, and said we needed to talk. He wanted me to tell him what was wrong over the phone, but I insisted on telling him in person because he had anger issues.

At first, he was hysterical. He was yelling and throwing things and then, all of a sudden, he completely shut down. He wouldn't say a single thing for an hour. It was just this quiet rage that was even scarier. When he was finally ready to talk he said, "I don't want to hear an explanation. I just want to move on and forget about the whole thing."

"I'm so sorry," I said. "I'll never do it again." I felt extremely horrible. I messed up our whole relationship in 30 minutes. I just wanted to make everything right again. I hugged him and said, "K____, I love you. I swear."

"I'm good," he said. Then he walked away, and we didn't talk about for the rest of the night.

We tried to move on after that and even decided to have a baby, but for years he held my cheating incident over my head. "How do I know we're going to work?" he'd say. "What if you're just trying to fuck somebody." K____ was certain I was dressing sexy for another man even though I was six months pregnant and working as a security guard. There wasn't much I could do to look sexy in that uniform. At most I'd be wearing jeans and a long shirt to go to school after work, but even that sent him into a spiral. "Why are you getting dressed up? Are you trying to find somebody else?" I always tried to dress in a way that wouldn't send him into a jealous rage, but his insecurity was constant.

When my daughter was born, I did my best to make our family work. In addition to taking care of our baby, I would do my best to cater to him after he got home work. One night I fixed K_____ a plate while he went to lay down on my couch. My phone was disconnected, and I needed to call my best friend to pick up a bottle warmer. When I picked up his phone, I discovered a text conversation with a woman.

"I miss you," the first message said. "I don't know how your mom feels about me sleeping with you while you're still sleeping with your baby momma."

He replied back, "It's okay. My mom doesn't even like her. Trust me, she hates her. We're not serious. It's not even like that." I grabbed his phone, ran across the street to a restaurant, and locked myself in a bathroom stall. I tried over and over again to unlock his phone because I wanted to see more of their conversation. When I finally figured it out the password, I went through the whole conversation. Not only was he downplaying our relationship, but he had a video of this woman giving him oral sex. There were also several naked pictures of her and the two of them in bed. My whole world had just

shattered. I was so heartbroken. I could've locked myself in that bathroom all night.

Once I went through all of the messages, I called the girl from the bathroom stall. She claimed that she didn't know that we were together and that they'd been seeing each other for the past seven years. They weren't a couple, but according to her she was his best friend. She'd been in his life constantly ever since he was sleeping with me and living with the first girlfriend. He met her on Facebook. He never added her publicly as a friend but that's where he met her.

She claimed to be his friend, but I never heard about her. As I was talking to her, I recalled a trip to Target when he was looking for a Hello Kitty iPhone case. When I asked him who it was for he said, "Oh, that's for my friend at work. She's a nursing student." He left it at that, and I never followed up, but then I realized that it was for her.

When K____ woke up from his nap, he found out I was at the restaurant and started banging on the stall door. "Give me my phone back!" The restaurant manager came into the bathroom to kick us out, so I pushed the stall door open and ran back to my house. Then I grabbed my daughter who was wearing nothing but a diaper and walked over to my mother's house.

While I was at my mother's, he kept calling me, saying that he wanted to work things out, but I know it's because he didn't want to lose our daughter.

"Melanie, I swear that it's over," he said. "I told her that I need to make sacrifices for my family."

"So you're not doing this for me?" I said. "You don't want me back because you love me."

"I do love you, but you did this to me first. I took you back, so give me another chance." We got back together because I wanted to try to forgive him or at least forget the whole incident. It was hard because I became very fixated on the other woman. She wasn't even prettier than me, but she was virgin at the time they first had sex and that turned him on.

I don't know what it is about K_____. He's the type of guy that can get a girl to do everything he wants. They'll cook for him, buy his clothes, take him places, and just try their hardest to please him. He's the type that always needs a woman to take care of him, but this other woman didn't do any wifey stuff for him. She was a nursing major just like me, but she didn't like to cook or clean. To him, I'm just this maid that he gets to have sex with whenever he feels like it. He doesn't even have to pay car insurance to go to work or provide financially for our daughter. He doesn't even have to watch her.

"How can you say that you love her?" I asked. "She's never even picked up a plate to cook for you! I'm the mother of your child. I gave you my life!"

"She understands me. She's my best friend." He told me that they talked

at night about feelings that he couldn't discuss with me. He felt like this woman was perfect, but even though she was perfect, he didn't want to be with her.

He still kept seeing her even though she gave him chlamydia. When I contracted it, he tried to say it was because I had cheated on him. He was right, I did cheat on him, but since my last test I only had HPV but was clean for everything else. I never understood how I went from being clean to having chlamydia. I don't want to end up with a disease from the father of my child. I would rather he beat my ass every day instead of having sex with all of these women who don't do half of what I do for him. That emotional pain is so much stronger.

I could no longer accept being the girl that was doing everything at home and some other girlfriend came over when I wasn't there. These two were messing around on the bed that I bought and eating the food that I purchased. Whatever they had to enjoy in our home came out of my money. It killed me to know that his mom knew about their relationship and never once told him to stop. I confronted her about it. "Why didn't you say anything to him?"

She said, "He told me that you guys weren't together."

"You see him driving my car to work. We have a baby together. He's at my house five days of the week."

"He told me you guys broke up."

"Even if we did break up, why wouldn't you think that we were trying to work things out?"

"I don't understand why you're tripping," she said.

"Seriously? You're going to sit here and act like if your man was fucking somebody else at their mom's house after you just had a baby, you would just let it go? Like it's nothing? After you've helped that them pay for stuff?"

"I didn't even know it was like that."

That's when I got really upset and I said, "You're going to tell me that your grown-ass, almost-30-year-old son is going to bring a bitch over to your house and they're going to be lying naked under the covers but they're not fucking?" I was yelling these things to his mother when he walked towards me and hit me square in the jaw. During our fights before, he would push me, grab me hard, and tell me to calm down, but he never hit me like he was trying to fight me. This time, he punched me multiple times. I knew it was something different. He claimed that he thought I was going to hit his mom, but honestly, I think he just wanted to hit me and me yelling at his mom was the perfect excuse.

The neighbors called the police. When they took K___ into custody, I walked out into the yard. His ten-year-old neighbor saw my face bleeding and said, "Oh my God, he hit you because you found out about the big lady that comes over when you're not here." I ended up getting five stitches on my

face, and he went to jail for a week. I went from breastfeeding my daughter to losing my milk supply because I was so stressed out. I switched her to formula because I was on antidepressants. I pressed charges out of spite and K_____ received five years' probation.

When K_____ got out of jail, we found out that I was pregnant again and he proposed. He told me I was the only person that deserved his last name. It made me hopeful that he was serious about being together this time. Maybe the time in jail made him realize what he had with me. However, K_____ would still not acknowledge that we were together even though he proposed. We've always functioned as a married couple but to this day he will not claim me as his girlfriend. During a fight, he confessed that he proposed so that I would get an abortion—as if he had made me happy enough to propose to me, then I would make him happy by terminating my second pregnancy. He said it was my fault that he had to pay the $5,000 for his legal fees and that his record was messed up because I pressed charges against him. Despite our issues, there was no way I was going to abort my baby.

We're not married but still together. I wonder if he's just been using me all of these years. It makes me suspicious that he's constantly on his phone. When we're together, he'll walk away all of a sudden to smoke a cigarette but only after his phone rings. He'll never answer his phone in front of me. It just hurts because now that he's going to college, he's talking about getting his own car. I'm building this man for another girl. Whatever he accomplishes is going to be because of me. All these things he did to improve his life have been my ideas, and I had to take his abuse in order for him to do it.

I want to try to love myself more so that I'm strong enough to leave him. When I'm ready, I'm going to tell him that he needs to pack his bags and give me my car. I've set a date for when I'm going to tell him all of this and that date is coming right around the corner. I mean, he doesn't kiss me. He hasn't kissed me really in over a year. He doesn't hug me or hold me at night. Even when I do dress up he doesn't say, "Oh, you look pretty." For him it's just, "Oh, can you bring me this or can you can you do me a solid…."

We're more friends, like a brother and sister relationship. I can't live like this forever. It's not healthy for me to be worrying about whether or not he went to work or if he drove my car to another girl's house. I have two girls to worry about, and I haven't even finished my nursing program. I need to move forward in improving my life and the lives of my two daughters. He needs to spend the rest of his life learning how to take care of himself. Being with him has caused me a tremendous amount of pain. It's not worth it to be with someone who can't even acknowledge that you're in a relationship.

Florence

"Being unfaithful helped me get free."

Six or seven years ago I met my son's father N___. I was working as an assistant and training him. It was kind of like love at first sight. We started dating shortly after and then transitioned into a committed relationship. Our love was very passionate; we were with each other all the time. N____ expressed that he wanted more children and was committed to having a family with me. After going through a really bad break-up before meeting him, I was relieved to have finally found a relationship that made me feel happy and secure.

I was on the pill, but I wanted to have a baby so I stopped my birth control even though I knew it wasn't right not to tell N___. He had a seven-year-old son from a previous relationship, and we had talked about having kids so I didn't think he would be upset if we started our family now. Everything changed when I became pregnant. My happy story, my happy relationship was no longer. All of sudden he didn't want to have children. "I want an abortion," he said. "I never wanted to have that kind of a long-term relationship with you. You trapped me into this." Having an abortion was out of the question for me. Despite his anger about my pregnancy, I knew that his love for me remained. After I gave him some time, he came around and apologized for the terrible things that were said. We decided to stay together and work it through.

As my pregnancy progressed, N____ started to have a crisis about being a father for the second time and kept reminding me that he didn't want to have the baby. His other son's mother was always in the picture which caused a lot of fights. She would text him to see if we were still together and was apparently waiting for the right time to be in his life again. When she tried to attack me, saying I was trying to be a stepmom to her son, he never defended me but would only try to calm her down.

He withdrew his support the moment I began my prenatal care. Only a month before my son was born did he buy two or three outfits for the baby. I wanted him to be that excited father, but not once did he ever go with me to doctor's visits or ultrasounds. I never had that. To this day, I still resent him for it, but I didn't want to be a single mother and, in my mind, N___ was still my son's father. I wasn't going to take a father away from my baby.

I was in the hospital for three days because of my C-section and N___ was surprisingly helpful. After watching our son come into the world, he had this sudden paternal instinct. I thought maybe our relationship was going to change because he bonded with our son. Whenever our son cried to be fed

or changed, N____ took over as I recovered. I thought that maybe things were going to change. N___ even asked me if I wanted to get married but my first response was no. I suffered so much hurt during my pregnancy, I didn't want to be committed. I felt that marriage was a once-in-a-lifetime thing and you should be very sure before you commit to marriage.

However, my love for him was unlike anyone that I've ever loved before. He was the father of my child. I didn't see myself with anyone else. We were living with my parents at the time and marriage would be the perfect reason to move out and start over. Two or three months later I said to J___, "You know, I stayed with you through the emotional nightmare of my pregnancy. I think we should get married and move out of here."

"I don't want to get married anymore," he said. "We fight too much. It's not a good time."

At the time we were fighting a lot because N____ wanted to spend more time doing what I call "single activities." I felt like there was never any time for my son or me because he would go to work and then to the gym. He'd come home eventually just to eat and sleep. This was the same pattern every day except for weekends when he drove to see his other child. I felt like I didn't have a relationship with him anymore.

It was as if he was still committed to his first family. Only recently did he start giving me $20 a week for our son, but every weekend he was spending more money on his other kid. Whenever it came to spending time with our son he always said, "I don't have time" or "I'm broke." If I ever asked for money for diapers it was always, "I don't have money." He wasn't financially stepping up as a father, but I didn't want to take him for child support because I still loved him.

Once I saw nude pictures of other son's mother on his phone, I told him, "I found these pictures and I am ready to leave." I was so angry, but N___ was very smart and played reverse psychology on me. He made me feel guilty for looking through his phone, and I practically begged him not to leave me. Looking back, I knew I should have made my way out, but I was trapped in this relationship because I thought this is the way a relationship had to be. I believed things were going to be different. I believed N___ every time he said he was going to change. There were times I felt like I was forced to have sex, not rape because it was still consensual, but I felt like I still had to do it to keep him around.

It was two and half years in my relationship with N___ when I became unfaithful. N____ moved out when my son was four months old. Even though we were still together, the abandonment devastated me. My girlfriends kept telling me that I could do better, and for the first time I started to listen. Before that my son's father was everything to me. If anybody looked at me or tried to talk to me I would always be like, "No, I'm in a committed relationship

with my son's father." It was always that way for two and a half years until my girlfriends made me open my eyes and see that I didn't have to live this way. I could be loved by someone else.

After N_____ moved out, I allowed myself to flirt and meet other men, and that's when I met someone else through work who gave me that attention I wanted. I didn't love him, but he made me feel like there was hope for something else. I was unfaithful for two months and never told N___. Even though we were no longer living together, I still did my duties as a mother and a girlfriend. I figured if I could get away with cheating that one time I could probably still keep going and N_____ would never suspect.

I then reconnected with an old friend from high school through social media. He was my first puppy love, and when we met up I felt that connection that I lacked with N___. When I wanted to spend time with this friend, I would drop my son at N___'s and tell him that I was going out with the girls. For a while I got caught up in my dating life and started to neglect my son, but this guy was giving me everything that I lacked in my relationship. Two months into dating this guy, I said enough is enough and broke up with N___. Being unfaithful helped me get free. It actually took me to feel a connection with someone else to be unfaithful and to realize that I could be happy too.

I didn't continue dating that guy because I needed to find myself. I had to admit that I hadn't been happy in a very long time. Trying to find love from other people when I didn't love myself was not going to work. You can't be in a committed relationship if you don't love yourself. I don't justify cheating or lying, but I was a solid support to N____ throughout our entire relationship. For years he said that he was going to change; every time I believed him and just allowed him to get worse and worse and worse. So now it's all about my son and me. I'm back in school and eventually I want to get my Ph.D. I can't say I'm 100 percent free of N___ because he is the father of my son, and if it weren't for him, I wouldn't love motherhood as I do now. However, as long as N___'s in the picture, there's that small reminder of the hard time I had when I was with him. I never told him I was unfaithful. That secret never got out of me. To this day he doesn't know.

Symone

"Overall, I was as faithful as I could be."

I got married at 17 for the sake of not being in my mother's house anymore, and I also really wanted to have children. I wanted to give the love that I never had to my own children. My husband was older and had been married and divorced before meeting me. He was very dominating. When he became

infertile because of a medical issue, he couldn't give me children. Since there was no point in being with him, I left. After that I met the person that I thought was mine forever. I loved him beyond reality. He could do no wrong.

O____ gave me children so I'm forever grateful to him, but he also had children with his wife. I was certain that O_____ was going to leave his wife and three kids for me, but for years he rotated between two lives. He would spend weekends with me and stay at my place until he had to go to work. Then every night after work he would go home to his wife.

We started having issues when he started seeing other women. There were nights when he was supposed to be with me and he never came home. I saw a monkey bite on his neck. The woman who gave him the hickey was a university professor. It was a slap in the face because our long-term goal was for him to graduate with a degree, but while he was in school he was making time to see other women. He used to complain that he didn't have any money to buy clothes, but one day after seeing her, he came home with these new dress shoes. He strutted around the house to make sure that I saw them. When I saw him make out with that professor in front of our house, it hurt me. God, it hurt me.

The second relationship that he had was an out-of-body experience. I had a friend who was a white lesbian that didn't live far from us. Her partner just had gallbladder surgery, so I went by to check on her and show her my baby girl. It was dark outside, and my car was parked on the street. As I started walking down the steps leaving my friend's house, I saw a car that looked like O____'s. The car turned around in the little cul-de-sac and parked exactly in front of my girlfriend's house. I told my friend to hold my baby so that I could check the car out. Any other time, I would have been carrying a gun in my purse. I walked up to the car and saw this dark-skinned woman sitting in the passenger seat. O____ popped his head out. He let the window down. "What's up?" I said.

"I don't know what you're talking about."

I pointed at the woman. "You need to tell me what this is."

The lady interrupted and said, "If I can just get out the car...."

"No, bitch," I said to her, "you just sit right there while I talk to you two."

"I really don't want to be involved."

"Did you know he already got a wife and three kids? I'm not the wife, by the way, but we have two kids. Are you the next one in line? Are you trying to be the number three?"

She looked down at the ground. "I just want to get out of the car."

"Your best bet is to get your ass out the car now and don't ever get back in," I said. "Also, you are both very lucky that I don't have my gun right now. Otherwise, there'd be two dead whores up in this car."

When we got home, he was trying to make love to me. I didn't even want

to touch him. He tried his sweet talk, but I just wanted to kill him. I thought about leaving him, but here I was with two children. I couldn't just jump up and leave. I was stuck between a rock in a hard place. I had a good job, but I just started school. I didn't want to disrupt my children's stability. They were very, very young. I wanted my children to have their daddy, but then, on the other hand, his other kids didn't have their daddy. I was enduring all of this for my children because I wanted children all of my life. However, I didn't want my children to be by different men. I wanted them to be by the same person.

Sometimes he even brought his other family into my home. When his wife and his daughter were having issues, he brought her to me to take care of. She was about ten or 11 and hated us. At that point, her dad was living with me, so she hated my children because they had their daddy and she didn't. She was extremely jealous of the relationship that her dad and our daughter had. She'd do little things like steal money from me, take my watch or anything she could get her hands on. I would cash my paycheck and then put it under my pillow. While I slept, his daughter would use that opportunity to slip her hand up under my pillow and take the money. It was a horrible situation. I should not have put up with the daughter living with us, but I did because I loved the man. To this day, the daughter has major drug issues because of how her father raised her. She wanted to be daddy's girl and she wasn't.

There were moments when I wanted to have a normal family. I've got one cousin who's been married 50 years. They never had sex with anybody but themselves, just the two of them. They raised perfect kids, had a house-keeper, were both educated and successful. Every time I'd threaten to leave he'd say to me, "No man's ever going to accept you having kids by somebody else." I believed him. I was very gullible. When I look back on it, I know that it was stupid. I know that it was a bad situation.

When things were rough with O____, sometimes I stayed with a girl-friend whose brother was in jail for dealing drugs. I got close to her and her parents. I would ride with them to see him, and we'd just hold conversation. He said he knew my kids' dad. When I asked O____ if they knew each other, he confirmed they worked together back in the day and then said some derogatory things about him.

When he got out, in my psychic sense, I knew the exact date. I called his mom's house and the first thing she said was, "How did you know?" Her son was home. She invited me to dinner so I packed up the kids and went. Nothing happened. He knew that I was in this relationship with the kids' dad. He said, "If there's anything you want or need, just let me know or let my mother know, and I'll take care of it." I thought about it, but this was somebody who was only ever going to be a drug dealer. I wasn't going to bring my children into that.

Somehow O_____ found out where I was and confronted me when I walked in the door.

"I heard you was up in L_____'s house. You took my babies over there to visit."

"And? You went home to your wife too, didn't you? I can say nothing happened. Like I don't really think there's nothing going on between you and your wife. You all sleep in the same bed. I know what happens when you're in my bed." He got an attitude about that. He thought that would cover him because I had done something wrong.

We decided to move south with our two kids and his daughter, but his feelings of love toward me had not improved, so I started seeing someone. I had an extremely sexual relationship with a guy from around the way. It was wonderful, wonderful sex. He was the first person that ever made total, 1000 percent, head-to-toe love to me, more than what my ex-husband or children's father had ever done or was capable of doing. It was just beyond reality. We had this understanding that we were a wonderful thing but not a permanent thing.

O____ also had a relationship with this white woman when we moved. She was married and really loved him. I found out that he had her in my bed. The two of them would have sex on my furniture while I was gone with the kids. When I confronted him about it his response was, "You know I can't be by myself." I had tolerated his nonsense for too long. It was just not healthy for the children and me. I left him and his daughter and took my kids to live with my brother.

Once my brother saw my children he just took them and held them to his heart. He didn't have kids so he gave all of his love to mine. I don't know what I would have done had he not been there to hold them and embrace them. My mother, on the other hand, was bitching, moaning, and complaining the whole time. She couldn't understand why I would leave him because she thought the world of him. My relationship with my mother was the most dysfunctional relationship of my life. I was forever trying to please her. She thought it was terrible that those two were not with their father. O____ and my mother were incredibly close. When I left him she said, "You need to take those kids back to their daddy."

"Their daddy doesn't want them," I said to her. Earlier in our relationship O____ would go to my mother's house in the morning and have coffee if I was working nights. She just fell in love with him throughout the eight years we were together. The two of them remained close even after I left him. My mother herself had been an adulteress; so was her sister. I came from a family that consisted of mistresses. For us it was accepted to have a boyfriend on the side. The women in our family were doing it so that made it okay, but it really wasn't. Only the wives got the benefits of being the wife. There were times

that I thought about having relationships, but, honestly, in those eight years, I never met anyone that I wanted to be with, anybody that made me have serious thoughts. Overall, I was as faithful as I could be. It was always the love that I had for him and for the potential of having a family. That was my need.

O____ and I were not so different. I wasn't a happy child. I was sexually abused and never recovered from any of that. When I was growing up, I watched other people develop closeness in their relationships but that was not my experience. I did not feel that love from them and that was probably something that I continued to seek throughout my lifetime. So I understand what O_____ learned from his childhood. He was simply not capable of loving someone because he hated his mother. He projected all of his anger for his mother into our relationship. When you come out of a relationship that's not nurturing, you can't give that out to the world. I truly believe he didn't know how to take love when it was given to him.

After eight years with this man I walked away because I had been psychologically abused. I was degraded and I couldn't make it work no matter what I did. Today, I still feel that anger, but the love that I had for him is not anything you can compare to. For so long I wanted to protect myself from the public knowing that I made a damn fool out of myself. Men have the option to be cheaters and women don't. To all of the women who are in a similar situation, you don't need a man at your breakfast table, or in your bed, or in your shower to feel important. Your self-respect is more important than having a man in your life.

Lindsay

"Two weeks after that, we told our spouses what we had done, left our marriages, and have been together ever since."

We had already moved in together, so we were definitely supposedly monogamous. Maybe he was drunk and had sex in a car or whatever. I was hurt by the affair, but we stayed together. We got married. Maybe five or six years later, we moved into a new place. As I was moving his stuff, I discovered some paternity paperwork in a satchel that showed he had a child I never knew about as the result of his affair. Of course, I was distraught, and I asked him, "Why did you keep this from me? I'm really much more hurt by the fact that you kept it from me than the fact that you did it particularly considering we weren't even married at the time." What really hurt was the fact that he kept it from me all that time. He apologized profusely, but I thought there was something wrong with him, that he didn't trust me or himself. Not only

did he have a shitty character for lying, but how could he be such a coward that he would let this kid grow up thinking that his father doesn't care about him? I lost a lot of respect for him. I wanted him to go to therapy, but he refused.

I just kind of buried it but we started to drift apart. I spent more and more time outside the house doing my thing, which at that time was playing music. I was gone all the time. My friend P_____ and I met in music class and we started commuting together. Once a week, for two years we were driving to and from this class together just getting to know each other and talking. We were bluegrass musicians at the time and one thing that you do a lot when you're a bluegrass musician is go to these jams which are public music social engagement things. We were both kind of new to the scene, so we would go together because we were shy. Eventually we started two bands together. Our lives were really entwined.

One morning about two years after I discovered the kid thing, I was sitting at the kitchen table. I looked at him and his neck was covered in hickeys.

"What the hell?"

"Oh, I'm so sorry," he said. "I was out last night, got really drunk, and ended up making out with this girl" who we both knew. I lost it. The thing is, if you're going to cheat on somebody, be discreet. You can tell when somebody is giving you a hickey and he had like ten! It was so clearly an attack on me; he wanted me to see it.

"How could you do this again?" I kept asking him over and over, "Why did you let this happen? Do you understand? Do you actually get how bad it hurts when you do this?"

"I don't know. I guess I don't really know because it's never really happened to me."

"Well, I'm going to get you back." I literally said that. "I'm going to get you back."

From that point on I knew I was going to cheat on him, I just had to find someone to do it with. I started trolling through Craigslist ads. It was ridiculous. I was in a state. It was surreal. I started dressing up, going out on the town with my friends. P_____ was literally my best friend. He was probably the last person who I ever would have thought that I would hook up with. If you lined all my male friends up, he would have been dead last of somebody that I was attracted to. He was like this owlish guy, really dorky, not ever putting out any flirtatious energy at all. He never led on at all that he was interested in me. There were tons of other guys that I would've gladly hooked up with.

This one night we had band practice and we all ended up getting really, really drunk, and then he and I were the last ones to leave the bar. We started

dancing and then all of a sudden in an instant, like I have never felt before, we fell madly in love. Nothing happened that night, but two weeks later, I saw P_____ again and we had sex for the first time, about two weeks after that, we told our spouses what we had done, left our marriages, and have been together ever since. We got married and have a kid. Everything is hunky-dory. Well, now it is.

When I initially told my husband that I was falling in love with P_____ and I had sex with him, he said, "Look, you have been out every single night for the past couple of months. You're addled. You're not sleeping. You're not eating. You're crazy. You need to take some time and get your head together. Take the car, take as much money as you need, and go wherever you want. Just chill for as long as it takes for you to get clarity." I thought that was pretty cool so I took the car and went to the coast for a couple of days. I stopped drinking so I could be clear about what I was doing.

That little amount of time between realizing we were in love and leaving our marriages was like this insane game of chicken. It was more me than P_____ because he was Mr. Brave. He knew he was going to leave, but with me I was a little bit like, "Jesus Christ, is this guy going to leave for me? I'm only going to leave if he's going to leave." About four or five days after my trip, I went out with some friends and had a glass of wine. All it took it was that little bit of liquid courage. I didn't even know I was going to do it, but I came back and said, "I'm leaving." I stuck all of my stuff in a bag, not all of it but enough stuff into a big backpack, and I left. Maybe three to four weeks after I left we met in a coffee shop for breakfast. I told him I wanted a divorce and he played it off like he thought it was the best thing too, but I know that he didn't want to get divorced. He didn't want me to leave. He's really, really complex. I think he's kind of a fucked up person but I know that he loved me, and I know that he was devastated that it ended and that he caused it.

Then maybe a year after I left, I got this email from this crazy, literally insane girl who my husband and I both knew. She was a bartender at a bar we used to go to. She said, "I just wanted to let you know that your husband was cheating on you this whole time with me." It seemed like the kid transgression and then the later transgression with the hickies on the neck were isolated incidents, but this girl said there had been others. I forwarded the email to my husband and asked, "Is this true?" He emailed back and said, "She's crazy. The last time I saw her I had to call the police because she was attacking me in front of the house." I thought, "That's interesting, but you didn't say it's not true." Saying somebody is crazy is not the same thing as saying they are lying. I don't know what to believe. It's weird to have been in a relationship with somebody and they are so guarded with their life that you don't even know what's true and what's not. I didn't want to be with somebody like that. That's crazy.

Even though P____ knew that he wanted to eventually marry me, it wasn't something that we could jump right into. His wife was pissed. She hated me. My husband never saw it coming. Our families were absolutely enraged. His family basically almost disowned him. His two sisters and his parents wouldn't talk to him for a year. My parents were a lot more accepting because I had a closer relationship with them, but it was horrible. They must have felt we were imbeciles. None of our friends thought it would work out. They thought we were acting really impetuously, we were just infatuated, and we were throwing away our marriages without even trying to save them. I can understand why they would think that.

The divorces were clean as can be. Neither of us had lawyers. We both did the do-it-yourself kind. P____ voluntarily split everything in half with his wife, and she walked away. With my marriage, I bent over backwards to make sure that I didn't take anything even though legally I could've split everything in half with him. I felt guilty and bad about leaving him so I walked away from everything. I mean everything. I didn't take one single cent from him. We had property; I turned over the deed to him. I had anger towards him especially after I got the email, but never ever, ever, ever, ever to the level that I would want to drag him through a messy divorce proceeding. My anger with him then as now is very much tempered or softened by an extreme, extreme empathy for the guy. I feel bad that he fucked up the one relationship that I think he really wanted to hold on to.

I feel very sad that I can't have an honest-to-God conversation with my ex where he tells me everything and we figure out what the problems were. We never fought. If he was mad at me about something, I never knew it. He never said anything. I've learned that if the relationship is messed up, it's not the cheating that is the issue, it's the underlying problems. We never had real deep and meaningful conversations about the problems in our relationship whatever those were and whoever was responsible.

I don't know to what extent he cheated on me to this day. It was definitely more than once, at least twice, maybe even more, I don't know. But I definitely don't regret having been with him because I think it was a great relationship in a lot of ways, and it was probably what we both needed. I certainly don't regret leaving. We would've eventually broken up, but it would've taken a lot longer. It would've been a slow, awful process.

I would tell a woman in my situation to ask herself if she wants to be out of her current relationship if she couldn't be with her new guy. If the answer is no, then I guess proceed with caution. You might find yourself with nothing in the end and maybe that's okay if your relationship is so unsatisfying and you know on some level that there is no way to repair it. For me, I would've gotten to that point with my husband where I knew there was no way to repair it, but I wasn't there yet. The only reason that I wanted out was

because I fell in love with somebody else. If I hadn't fallen in love with somebody else, I know the relationship would've ended; it just would've taken longer.

Jane
"We each had an affair that we talked about with each other."

My husband Ron and I each at the same time fell in love with other people. It started with a group of us who all rode dirt bikes together, like five couples. I was attracted to this guy, Sal, who was dating Vanessa. Ron and Sal were good friends. Tanya and Ulysses also rode with us. Tanya was my best friend. I was really liking Sal, so I started seeing him and telling Tanya about us. Tanya said the same thing was happening to her because she was attracted to Ron. She offered to play up to Ron and get him to feel about her the way Sal and I felt and then Ron would understand. So Ron and Tanya fell in love. Sal and I fell in love. We each had an affair that we talked about with each other. Ron and I would lay in bed and talk about how much I really cared about Sal and how much Ron really cared about Tanya. Of all the couples, we were the only ones that had a child and we wanted to stay together for him.

Ron owned his own business. I'd always worked with him, done all the bookkeeping and stuff, but when I had my kid, I decided I wanted to be a full-time mom. So we hired Tanya and that's how she and Ron started working together. So when Sal and his girlfriend took a road trip, I went to see my sister, so that left Ron and Tanya alone. When I came home, I told Ron, "Okay, now that I've been away from the whole situation, we have a child, and we need to stay together." Then he said, "Oh, gosh, you know, that's nice, but I've been here with Tanya all this time, so I think I need some time to get away from it all and figure out what I want to do." He moved into our motorhome and in two hours Tanya had moved in with him. Tanya left her husband to be with Ron. When Sal and Vanessa came home, he and I had an affair for like a year.

Even though I had the thing with Sal, I really didn't want to lose Ron. I went through hell for two years after that. I'd go to lunch with Tanya and I'd say, "I hate your guts." Then we'd have some wine and end up hugging and kissing and agreeing we'd never use my son as a weapon. Then I finally couldn't deal anymore. I was single because my husband left me for Tanya so I made Sal choose between me and Vanessa. He wouldn't leave Vanessa because her 16-year-old son had just committed suicide. He felt responsible for her, which meant I was on my own. Sal stayed with Vanessa for four more years. Ron and Tanya got married, and I went to their wedding. Vanessa wanted to marry Sal, but he never wanted to. I hadn't seen him in four years when

he randomly asked me to lunch. At lunch, Sal told me Vanessa left and then we got together and stayed together for the next eight years. We had never fallen out of love with each other.

Ron, Tanya, Sal, myself, and my son all spent all the holidays together. Because Sal and Ron were good friends, when my son spent weekends with his dad, he always saw Sal even when Sal was exclusively seeing Vanessa. Sal and my son are very close. Sal asked me to marry him, but I declined. We're not together any more, but we are all still friends. Ron and Tanya stayed together for ten years, then they got divorced. Ron married his third wife Suzy. They were married for 15 years, and we're kind of friends with her, but not as much. Tanya had been with somebody else for a while, but when Ron divorced Suzy, they starting dating again!

People ask how we stayed friends through that whole affair thing, but it was a commitment to my son. I think I was more the injured party, but I was so committed to never hurting my son whatever it cost me. The four of us can spend a whole weekend together and be fine because back when he was two, we made the commitment that that's how it's going to be. My son is 39 now and not married. He says it's all our fault.

Understanding "It's Complicated" Infidelity

The investment model helps understand the decision-making strategies of women in relationships where both partners have sex with other partners. Rusbult and colleagues' investment model suggests that partners are motivated to maintain a relationship when their satisfaction is high, the number of quality alternative partners is low, and investment (tangible and intangible resources) is high. The tangible and intangible resources that comprise the investment portion of the tripartite investment model might include money, shared property, children, number of years together, emotional connection, plans for the future, and so on.

According to Rusbult, "the investment model is based on several principles of interdependence theory, and assumes that individuals are in general motivated to maximize rewards while minimizing costs."[1] A common misconception is that people remain in their relationships because their satisfaction is high—rewards outweigh costs. However, people often remain in relationships as the costs increase. The greatest predictor of relationship outcomes is actually commitment which consists of all three criteria—satisfaction, alternatives, and investment—combined. That said, it is important to distinguish among the types of commitment.[2]

Personal commitment occurs when a woman is committed because she wants to be in the relationship. She is either attracted to her partner, her relationship, and/or both. Moral commitment occurs when a woman commits for a higher good, e.g., religious beliefs prohibiting divorce or obligations to providing a nuclear family for the children. Structural commitment occurs when a woman feels like she has to remain in the relationship because of certain constraints. She would lose too much of her economic, emotional, or time investments if she left or she is afraid she will not find another relationship better than the one she has. These fears along with social pressures to remain coupled are all constraints.

Ishtar is personally very committed to her relationship. Her relational satisfaction is high. She describes a positive relationship with her husband. They consented to sexual relationships outside of their marriage, and despite encountering an alternative partner that she developed deep feelings for, Ishtar expressed no desire to leave her husband. Her investment remains high because they have known each other for 22 years, are married, share a child, and have "built a good life together."

All of that being true, they still had to negotiate boundaries with her role as an Other Woman, their limits with other swingers, and his indiscretion of bringing another woman into their house. She admits that the longer they are together, the more complicated their love and sex life becomes, and she expresses the ultimate commitment: "I'm going to be with this man until one of us dies." Her personal commitment inspires the prosocial relational maintenance of "talking through it" when issues arise. In this, Ishtar differs from the other women in the section.

Julie and Anne, for example, confess to being shocked when they discovered their husbands' affair(s). The relational defection that infidelity communicates reasonably reduced their relational satisfaction and required a re-evaluation of their commitment. They married young and shared years of history with and emotional connection to their husbands. There were children to think about as well as dealing with the financial constraints of leaving. When their investments were high and their satisfaction was low, they pursued alternatives. Anne calls hers a revenge affair. Julie explains, "The door was opened for me to have an affair because of it having been done to me." Perel describes Julie's rationale as "corrective cheating."[3]

In both instances, intentional infidelity that communicates a message is identified by Tafoya and Spitzberg as communicative infidelity or CI.[4] Revenge is the CI component most applicable to these narratives because cheaters may rationalize and justify their infidelity if they are seeking revenge. Dillow et al. conducted a study to determine whether infidelity victims are likely to rationalize a cheating partner's behavior if they do so out of revenge. Study results show "it is not surprising that participants did not view any of the

motives for CI commission as acceptable when their partner was the transgressor."[5] Interestingly, the husbands who cheated first understood their wives' CI revenge responses albeit for different reasons. Anne's husband seemed to want an excuse to continue his behavior whereas Julie's husband wanted to "put things back together."

Although Julie considered leaving her husband for her alternative, she decided to stay for the sake of her finances, family, and faith. Moral combined with structural commitment was sufficient. Anne never had plans to leave. Although her husband's alternatives were high for much of their marriage, her alternatives were low. Because her investment was high, she remained committed for personal and structural reasons. Perhaps it was also her husband's structural commitment that urged him to finally chose is wife over his long-term Other Woman. Sometimes intentional infidelity sends a wake-up call to a partner that may elevate the relationship to new heights. Research theorizes that negative relational maintenance behaviors like infidelity can restore equity in some relationships as it appears to have done for Julie and Anne.[6]

Lindsay shares similar circumstances with Julie and Anne. She was a wife whose husband cheated which lead to her revenge affair. Her husband also seemed to acquiesce to her CI and asked her to think carefully about her desires before making a final decision about their relationship. Lindsay chose to leave her husband for her alternative partner because he likely possessed perceived partner uniqueness (PPU), the quality of being a superior alternative that no one else would match.[7] Although Lindsay faced backlash from their families, her investments were much lower than other women in this section. Absent children or financial constraints, she could afford to leave.

PPU also shaped Symone's decisions about her relationship with O_____. Throughout her narrative, she recounts the incomparable love she felt for her children's father even after their break-up. PPU likely explains why she tolerated his serial affairs as long as she did and was able to reconcile his infidelity with the painful lessons learned from his mother during his childhood. In addition to her low satisfaction, Symone's alternatives were also low because she believed her children's father when he told her "no man's ever going to accept you having kids by somebody else." Even when the emotional and financial commitment seemed to be strong from her drug dealer and the sex was amazing with her other partner, neither could meet O____'s PPU. Additionally, Symone's investment in her children was incredibly high as she described her great need for children.

Florence's desire for a child and a traditional family kept her with her son's father but once attraction and opportunity aligned she realized that she could attract high quality alternatives. Being unfaithful freed her from an unsatisfactory relationship. Because her infidelity remained a secret, it carried

no interpersonal message to her son's father but her intrapersonal message of positive self-esteem and worthiness were received loudly and clearly.

Attraction and opportunity also aligned for Melanie and Jane. While neither of their relationships ultimately worked out to their satisfaction, both made key moral investment decisions based on their children. Melanie tries to work things out for her daughters' sake despite his alternative and her decreasing satisfaction. Consistent with Dillow et al.'s research, despite Melanie's boyfriend's claim that "you did this to me first. I took you back, so give me another chance," Melanie could not accept revenge as a justifiable CI. Jane and her friends were able to remain friends throughout years of partner swapping because they avoided sending negative CI to each other. Their affairs were not intentional. They simply fell in and out of love with each other yet remained invested in and thus committed to the well-being of "their" son who ironically now blames them for his choice not to marry.

The commonality for all women in it's complicated relationships is that they are presented with the opportunity to make choices about their commitment to their relationships. The less elegant phrase "presented with the opportunity to make choices" acknowledges others' prior choices to which women in it's complicated relationships must also respond. Four of the women in this section committed to their relationships for personal, moral, and structural reasons and stayed. Others decided to leave despite their investments of time, money, love, and children. Neither decision is an easy one because, well, it's complicated.

I've Experienced Multiple Aspects of Infidelity in Multiple Relationships

For some women, infidelity is a singular occurrence. For others, infidelity recurs throughout their lifetimes. The women in this section have experienced multiple types of infidelities in multiple relationships. They philosophize about the whys and hows of their infidelities as well as those committed against them. They integrate their infidelity experiences and explain how each one shaped them as a person and a partner.

At the time of the interview, the average age of these seven women was 41. The youngest was 28; the oldest was 55. Thumbalina declined to state her age. They all describe themselves as black and heterosexual with the exception of Coco who self-identifies as bisexual and Sandra who is a white lesbian and also the youngest. Two attended college, one graduated from college, and four received professional or graduate degrees. Only Coco remained in her primary relationship.

Unlike the it's complicated narratives from the previous section where the infidelities were initiated within or were a response to a single relationship, these narratives span multiple relationships. Each experience shaped who the narrator would become in her next experience. While these women are complex and sometimes contradictory, their stories are unique because they offer continuity through multiple experiences of infidelity behaviors that denotes how infidelity can configure and reconfigure an individual's outlook on romantic relationships.

Sandra

"I knew logically in my mind that it was absurd
to be talking to my girlfriend's lover."

It was six months into our relationship when I moved in with A____. I had just started graduate school. When Thanksgiving came around, I made plans to go home to see my family. I told her that she was welcome to accompany me, but she wanted to stay behind and earn some extra money. Then she suddenly changed her plans. Her mother made a last-minute decision to fly up to spend Thanksgiving break with her. I was relieved that she wouldn't be at home alone. I was feeling guilty that she might have a microwave Lean Cuisine for Thanksgiving dinner. They were going to take a road trip only a couple of hours away. She warned me that she might have bad reception while on the road. I told her it was fine. All I asked was that she stayed in touch with me whenever she had the chance.

I was disappointed that I didn't hear much from her during the break. I received a few text messages, but not once did we speak on the phone. Nonetheless, I was eager to hear about her adventure when I got back. Upon first impression, she looked happy and refreshed. She was eager to tell me all of the details including her mother's flight complications and frustrations with the airline. From there the drive was beautiful and serene, although she didn't have any pictures because they were on her mother's phone. She even told me what kind of car her mother rented and what color it was. I had no suspicions at all until I asked her the name of their hotel and she couldn't remember.

A____ had an impeccable memory. I pressed her a little more because I thought it was strange that she couldn't recall where she stayed. She explained that her mom made reservations somewhere off the beaten path. A____ was the type that could remember what she had for breakfast a week ago. Surely, she was capable of at least remembering the name of the hotel. I started to spiral into this paranoid thinking that I tried to suppress. I started to doubt that we were in an exclusive relationship.

When Christmas came around, I again told her that she was welcome to come with me to visit my family. She declined because she was going to stay behind and work. I told her that it would mean a lot to me if she came this time, but she was insistent that she'd rather work through the holiday. At the time, she worked at a nursing home and it would be double the pay for Christmas. She assured me that we would spend New Year's Eve together, but I was uneasy about leaving her behind.

After a few days of being with my family, I got a message from this girl

named L_____ online. I didn't recognize the name, but the subject line read "URGENT PLEASE READ." The message said: "I don't know what's going on between you and A____, but I'm starting to have suspicions that she's been lying to me. She told me that you two are roommates and you're living there temporarily until you could figure out somewhere else to live but based on some of the pictures she has, I suspect that you two are more than that. I've been having a long-distance relationship with A____ for a year and half now. We spent Thanksgiving together at your apartment which we'd been planning for a long time. I was there all week and we had sex in your bed. To prove that I'm not lying I can provide letters and pictures to confirm...."

I imagine that once L_____ found out that A____ had been lying, a fight ensued and that's what prompted her to reach out to me. A_____ had been telling L_____ that our relationship was once romantic, and because it didn't work out, the cohabiting situation was getting awkward. She even complained that her back hurt because I made her sleep on the couch while I slept in our bed. I forwarded the message to A_____ and told her that I wanted her to be out of the apartment by the time I got home. From there, everything in my life unraveled. I thought I understood what it meant to have a healthy long-term relationship with a woman, but I underestimated the kind of pain that A____ was capable of causing. We were supposed to spend the rest of our lives together; we even decided on the names of our future adopted children.

A____ complied with my request and moved into a motel in a depressing part of downtown. I was left alone in our apartment to sort out our things. My older sister visited me shortly after my break-up and was disgusted that a lot of my ex-girlfriend's stuff was still there. She called A____ and said, "You better fucking come and pick up your shit. I'm throwing it outside." In hindsight that was a cowardly move to let my sister handle that severing of ties.

Even though I was angry with A_____, I felt an enormous amount of guilt for kicking her out. A____ would tell me all of these details about how horrible her life was. I was starting to question my motives and actions. Perhaps I overreacted to the infidelity. It felt unfair to put her in that position. I sincerely didn't want her to suffer, but I was so jarred by the change in my relationship that I became really impulsive.

For example, I was reading L_____'s message over and over again to a point where it became obsessive. I sent L_____ questions about their affair. I needed clarity on the situation and L_____ was surprisingly supportive and sympathetic. L_____ was very charming and extremely creative. The more I talked to her, I realized that she had an amazing mind. Her talent as a writer and an artist was unbelievable. A_____ had fallen short of her potential. She

had gotten a degree but hadn't really done anything with it. I had this superiority complex over her because of my high-achieving academic career.

L____, on the other hand, was very passionate about her art; we could talk on the same level. She was interested in my work in a way that A_____ had never been. I knew logically in my mind that it was absurd to be talking to my girlfriend's lover. She was an integral part of my heartbreak, but we were also two women duped by the same person. We were both angry and needed the support. I started to look forward to our conversations. There was a certain level of intellect and charisma that I'd been missing from A_____, and L_____'s intellectual perspective helped with my healing for a short time.

When L_____ confessed that she'd developed feelings for me, I didn't even think about what to do next. I decided to drive the whole night to see her. It took me 18 hours to get there. Once we were finally together, we had a sexual chemistry that was unlike anything I'd ever had. I could tell that there was something so toxic about what we were doing, but I couldn't pull myself away from it. I knew that it would hurt A_____ but I had such righteous anger and was so indignant that I didn't really think about her feelings. I was so hell-bent on only looking at it from my perspective because it was so convenient for me to do so.

Despite my self-righteousness, my love for L____ was not without its complications. Her demons took over our relationship from the moment it started. She was a big-time drug addict. Not only was she addicted to Oxycontin and Oxycodone, but she was also transitioning from female to male. I was supportive throughout this process. If she had any moments of frailty or poor judgment, I forgave her because of the transition.

I'm not sure how I finished graduate school when all this was happening. When L____ was using drugs, she was just so emotionally and mentally unstable. She would feign injuries to try to get prescription painkillers. We'd be driving all over the state going to different emergency rooms sometimes until 6 in the morning. If the doctors didn't believe her, I would be the one to fake an injury so she could get the medicine.

I'm certain that L____ had borderline personality disorder. She could be sweet and kind one minute and then verbally and physically abusive the next. It was just such an awful relationship and I blamed all of it on A_____. I blamed her for putting me in this unhealthy relationship because blaming her was more convenient than blaming myself. Her infidelity was the chain of all these really terrible things that happened.

I now hated the both of them. I couldn't understand what A____ saw in this human being. She disrupted our goals by introducing this woman into our lives. A_____ became the receptacle for my frustration and failures. She was the perfect person to blame for everything I'd done wrong

because none of these things would have happened if she hadn't cheated on me.

It took me three years to end my relationship with L_____. After our break-up, my ability to be in a monogamous relationship was completely tarnished. I met a woman named E____ who was a fellow graduate student. She had all of the qualities that I really liked in women—intelligent, interesting, and creative. We started a long-distance relationship that felt safer to me because it wasn't exclusive. She allowed me to date other people.

E_____ was the most accommodating out of all of my girlfriends. Unlike A_____, she was eager to visit me in my hometown for about a week. We were really intimate with each other. It felt like any beginning of a relationship which is always positive and intoxicating. I enjoyed being around her so we made plans to meet again. I told E_____ that when I started my Ph.D. program, she could come with me.

I agreed to be in a relationship with her but protested it at the same time. I didn't want to answer to her. I liked the sexual tension that the distance created, but I needed my freedom to sleep with other people. When E____ went home, I met another girl in the town and started sleeping with her. I got physically intimate with her pretty quickly, and I didn't tell E____ about it. As far as she knew I was busy because of X, Y, and Z that were all related to school. Through mutual friends, E_____ eventually found out about the relationship and was completely heartbroken by it.

I was so beaten down emotionally by L____ and A_____. I hated myself for being complicit with that. E_____ was offering a better version of what I had, but I wasn't ready for it. It was a mutual decision to break up. She's in another relationship now, but sometimes she'll text me after she's been drinking. The last text she sent said, "I'll always love you even though you broke my heart. I would let you hurt me again if I had the opportunity." I missed her and proposed that we meet somewhere.

I told her, "We don't have to be in a committed relationship. Let's just hang out and sleep together with no strings attached." She never took me up on it.

Of course, I realize in hindsight that I was maybe not the best partner. I've dated women all around the United States because I chose to pursue an academic career. To me whatever they're doing is not as important as what I'm doing. I'm a little bit selfish and opportunistic when it comes to women. I need to just be more explicit with myself about that. Not only has it stopped me from really getting into relationships, but I'm unable to trust any women that I date. I don't know how I got to the point where I was with someone so horribly wrong for me. It's turned me off to monogamy completely. Sometimes I think I want to be monogamous someday, but I know if I were forced into a monogamous relationship right now, I'd probably cheat again.

Thumbalina

"It wasn't as hard as I thought to be honest with myself about myself."

I thought I was deeply in love with this man. We talked about getting married. I was between 22 and 24. We were talking about having a life together. There seemed to be a building of a foundation happening, but for some reason I felt that there was a problem in our relationship. I asked. He wouldn't give me any answers, and things got strained. I felt like it was just me going through changes and maybe not giving myself space to figure out what I was doing that was causing my own discomfort.

Until one night, I just had this overwhelming feeling that he was doing something that was hurtful in terms of our relationship. I knew at least one woman that he had dated because she had been a friend of mine, or was still a friend of mine, but had become a distant friend of mine. She was almost ten years older than me. I knew her in grammar school and met him much later. So between 1 and 1:30 in the morning, I got in my car. I drove to her house, and I saw his car. I sat there in my car. After about an hour, I decided I had to do one of two things: confront them or let it go. In the midst of making that decision, a thought came to me.

"What the hell are you doing? Why are you, in the middle of the damn night, sitting in front of some other woman's house to see whether or not a man comes out? Who are you? Do you need anybody that badly? You're the idiot sitting out here in the middle of the damn night in a car by yourself waiting on somebody, and what are they doing? Whatever they're doing! You are not nowhere in their psyche or in their sphere of conversation—99.999 percent you ain't entered their minds. So what are you doing making a fool out of yourself? And for what? A man that obviously does not feel about you the way you feel about him, so here's the choice you've got to make: stay or go?"

I started my car went home, laughing all the way, thinking, "I can't believe you're just that silly." At that moment, I knew that there was nobody, and I hoped I would never allow myself to believe that there was anybody, that important to me that I would risk my safety and sanity to prove what? What I already knew is that they were a shit, and that I could be that infantile to believe that I had something to do with it. I didn't have anything to do with it. It wasn't me. It was him and the choices he made, and that's what I told him later. I said, "I know what you're doing. I know who you're doing it with, and no, I'm not going to have a fit, go crazy. I just want to know why."

"Because I wanted to," he said. Just like that.

"Okay," I said. "You know what? You just aren't that important. You made

your choice. I've made mine." It wasn't as hard as I thought to be honest with myself about myself. I was doing something so innately ignorant in the truest definition of that word that I didn't recognize me.

Why do people, particularly women, readily accept that we've done something wrong because our partner made a decision to be with someone else? It's not about what we did or didn't do. What we said or didn't say. It is about them and what they chose to do, irrespective of how we feel or whatever the relationship is that we believe we're in with them and that they believe that they're in with us.

I learned to let go of guilt, sorrow, shame, and blame that was focused on me, because there wasn't any. I didn't do anything. Life's too short to be unhappy about decisions you made. I didn't make the decision he made, so why am I unhappy? Because things aren't going the way that I wish them to? Well, in the course of a day, how many things go ass backwards that you wish hadn't? This is just one more.

If a man is waiting for me to say it's wonderful that we need to chat every day, and I need to check in every night, and I need to see him every week, he is looking at the wrong person. If he's away on business or even pleasure and I'm not in his presence, if he's waiting for a phone call from me to check or ask what he's doing or who he's with, then he's not looking for me. What he does when he's not with me is what he does. I can't control it, so why am I going to worry about it? The most I can do is ask him to be faithful in the physical sense in terms of my health. That's it. That's all I can ask. I have to take care of my emotional well-being. That isn't something that I can give over to somebody else.

It was a learning experience. Periodically men would want this reassurance that I'm into them, that I want to know what's happening with them, and then I would see myself sitting in that car outside that house and think, "I don't think so. If that's what you need, you're looking at the wrong person. I'm not 22 anymore—been long past that. If you need somebody to check on you, you need to find that woman because she doesn't live here. I have a life. I have things to do. I have thoughts. I have so much more going on than just focusing on what you're doing because you're not sitting next to me." I think that's a problem that a lot of people have. If you're not sitting next to them, they've got issues.

My other infidelity experience happened in my mid–20s. It bothered me, initially, because it happened with my best friend's husband. I felt really bad about it for a while, and when I say a while, maybe a few years, and then I woke up and went, "Shit happens."

Strangely enough I've been a part of a threesome more times than I care to remember. It's not always moved into the sexual realm, but threesome nonetheless. My best friend and I were extremely close. She was like a sister that

I didn't have. She and I hung out a lot, and when she got married, we still hung out. He got into some trouble and had to go away. So we were even closer. Because of problems with her family, I was her lifeline. When he came back, we continued to be a threesome, and it was even closer. Part of the problem was, unfortunately at that time, I was an experimenter of substances that weren't necessarily legal. They'd married and they'd separated for some reason. I really don't remember why. I was supposed to meet her at his apartment. At least that's what he told me. We were meeting because we were taking care of some business and she needed my help. I got over there—we were sitting, talking, drinking wine, and smoking a joint as we normally did, and I got completely stoned. I mean, I was stoned out of my gourd.

The next thing I knew, we're making love, and it's like, "Oh shit." When I come to myself, I was like, "What the hell?" He said, "I don't know what you're upset about. Do you really think Z_____ would mind?"

"This ain't about Z_____." I said. "This is about me. I mind. I mind that I'm in this predicament. You ought to mind. This is not who I am, at least I didn't believe me to be this."

It was hurtful. I felt like I betrayed myself, betrayed her, and the relationship that had grown from high school up until that point because she was a high school friend from freshman year all the way through and we were adults now. She had a baby. I had finished college. We were both working. We were viable human beings, and to have gone through all the stuff I went through with her from high school to that moment, it was like I had torn asunder the very fabric of our existence. The fact that she didn't know wasn't the most important thing. It was what I had done and how I felt about what I had done. I asked myself, "How the hell could you put yourself in that situation? You have enough sense—you have enough presence of mind—you have enough gifts to know better, to have seen this coming. You chose not to see it for whatever reason, and now look at this garbage that's strewn before you."

That's how I felt. I was like, "I don't believe I did this." He finally told her in a fit of rage about whatever they were arguing about. She confronted me, and I told her, "Yes, it happened and the most I can do is say I'm sorry, but that doesn't change it, and I know that. So we're not going to be friends anymore? Okay, then we're not going to be friends anymore. If you think I'm going to beg and plead with you, there's nothing to beg and plead for. You're either going to forgive me or you're not. You're either going to understand or you're not." It was her decision, not mine. It was one of the most painful things that I have ever done, and I lived for a while with the regret, because our friendship finally did falter and fall apart.

There was a protagonist and an antagonist. It was a divine tragedy. I look back at it now and know this was waiting to happen. As I look back, I saw

the trajectory of our threesome leading there. If I had stopped and really examined the things that happened, I would have known this is the direction that he was moving. He had to hurt her. He had to try to break her, and I was the one thing that he could use to put that dagger in her heart. That's not to give myself importance as a person, but I was the pivotal figure who was the lynchpin between her, her family, and him.

I was the one that kept things together for a really long time. I was the one her parents talked to about them. I kept things okay. When she refused to see her parents, I called them, I talked to them, or they called me. When they needed to see that things were okay, I was the one that picked them up and took them to her. I was the one that would take their grandchild over to see them when she wouldn't go. I understood the role I played. I didn't understand how he felt about the role that I played. It wasn't a role that I asked for. I played that role because I loved her. I loved her family. I loved the child that they had. She was my friend, and whenever friends are in trouble, no matter what kind of trouble it is, you step into the breach. You do whatever's needed. I didn't realize that was a threat. I didn't realize that would cause jealousy on his part. She wasn't my lover; she was my friend.

I understood and I didn't understand how it happened. I should have known better. He'd played tricks on me before. Tricks that, strangely enough, she was a part of. There was that time he tricked me with what I thought was coke that wasn't and had that really bad trip; she knew. Then I was like, "Okay, you know what? I don't feel sorry anymore. I'm not going to blame me anymore. I'm not going to feel shame anymore. I'm not going to beat myself up anymore." There are too many times when I watched her do shit that was not necessarily kind to me and for me. When I started making the puzzle truly visible for myself, I went, "Okay, it doesn't absolve me, but it explains what I never wanted to see."

I take responsibility for my being there and for what subsequently happened, but I'm not the only person responsible. I'm not the only person that's screwed up. That doesn't absolve me. That doesn't make me better. That doesn't make me worse. When I look at infidelity, there's more than one person involved. The person that participates is just as culpable as the person that initiates. It's no different than any other action that requires consent or dissent. You either say yes or you say no.

We like to think of infidelity only in a sexual sense. It goes beyond that. When we view infidelity as sex, we do ourselves and those people that we care about and invest time, energy and emotions in a great disservice. When we white-lie our way through relationships and accept things that are abhorrent to us because we say we love them or we want the relationship to work, that, to me, is an infidelity.

The infidelity was beyond the sex. It was of the mind and of the heart,

the very essence of where people live. That's when it becomes a deep-seated wound that is difficult to forgive. But I don't regret it anymore. I look at it for what it was. It was that moment in time that the confluence of events brought to fruition. Needless to say, me and drugs took a big vacation, for a really, really, really, long, long, long, long time. That experience taught me, because I was in my mid–20s, that if you don't give time for reflection and learn self-awareness, you will be caught in those moments.

Antoinette

"Every time a man professed his love for me, it turned out to be a lie."

I married my high school sweetheart when I was 21 years old. We started having issues six years into the marriage due to financial problems. He made some bad investments. I had to help out with the bills. My husband was a daddy's boy who depended on his father for everything. He couldn't make a decision without running to him and asking for money. He wasn't an actual man at the time. Instead of getting another job, my husband suggested that we ask some of my coworkers to loan us some money.

I decided to ask a coworker I was close with. We both worked in the hospitality industry which sometimes required long evenings together. He and I talked a lot; he knew that things were financially tight at home. There'd be times I'd ask him if could I borrow a couple of dollars to pay bills, and he'd give it to me without any hesitation. That's how our relationship started. I saw that he was independent. That's where that romantic spark came from. At that time, I didn't understand that my husband was wrong for sending me out to borrow money. He left a window open for somebody else to come into my heart because he wasn't man enough to take care of his wife.

My coworker was also married but we had a bond that couldn't keep us apart. Instead of giving me money whenever I needed it, he eventually put me on a weekly allowance. My husband and I had been together throughout high school and college, but he never made me feel like a woman. We were under such financial restraint that we weren't able to have any new experiences. Whenever my coworker took me to new places it was like a whole 'nother world. It was my first introduction to a real man who knew how to take care of his woman. My coworker got another job but we continued with our relationship. Things were great with him for five years, but I had two little kids to tend to. Not only was I taking my attention away from them, but I was taking my coworker away from his own family, and it was time for me to fix my marriage. I got another job in another state so I packed my family up and left.

Those first 90 days after we moved, it was like someone died. My husband thought I was depressed because I was homesick, but it was because I missed my coworker and I wished that I was with him. After a few months at my new job one of my male coworkers approached me to start a friendship. What started out as lunch slowly progressed into an extramarital affair. Things weren't getting better in my marriage, so I was less secretive about this affair. Even though my husband found out that I was cheating on him with W____, he stayed with me for three more months. Then finally I said to him, "I can't do this. I don't love you anymore." I moved out, got my own place with my children, and exclusively dated W____.

When we started dating, I had my place and W___ lived with his sister. I would come over to his place only when the sister wasn't there. If I were at his place, I wouldn't stay long because something about it didn't feel right to me. I knew that was probably my woman's senses going off, but I didn't know how to read them at the time. One day I arrived at his house and the woman who I thought was his sister was in the driveway. I'd never had a conversation with her until she told me that she was actually his girlfriend.

I was like, "Wait a minute, I've been dating him for the last year."

"Yeah, I've seen you," she said. "But he told me you were a cousin." She told me she got suspicious when he started spending more time away from home. She'd ask if she could talk to me so that she could get to know his cousin, but then he'd tell her that I was busy and would make all kinds of excuses. His girlfriend worked from 7 in the evening to 7 in the morning. It was easy for him to pull this off because we had completely different work schedules.

After that girlfriend kicked him out, he begged for me to give him a second chance. I let him move in with me and we did our best to move on from that incident. Soon after we got engaged and we eventually bought a house together. We no longer worked together and my new job required me to travel a lot. My children always stayed with their father when I traveled, so while we were gone, he had women coming to the house without me knowing. I had no idea they were coming until it all blew up. He was doing the same thing me that he did to his ex-girlfriend.

When I discovered what he was doing, he swore that he didn't have another girlfriend. These girls were just there for a fun time. To make it up to me, he took me to the mall and bought me a couple of dresses. As we were walking out of the store, I went to look for something in my purse, and when I looked up, he just disappeared. I went outside to look for him and there was a lady standing next to him. I looked at her and she looked at me. Both of us looked at him. Then we looked at each other again.

"Do you know him?" she asked.

"Yeah, I know him," I said. "Do you know him?"

"That's my fiancé."

Once we got to talking, I found out that W___ told her the same stuff that he used to tell his ex-girlfriend. He said he lived with his sister and her two kids, and that's why this girlfriend was never able to come over.

W___ started to yell at me. "Stop talking to her! Get in the car!" He opened the passenger door of my car.

I said, "No, I'm not going anywhere." He turned to the other woman and said, "Fine, you get in the car!"

"Wait a minute, that's my car," I said. "No one is going to get in there except for me." But W___ had already gotten in and slammed his door. As we drove home, he tried to convince me that this was all my fault.

"You should have never started digging," he said.

"I didn't dig. I didn't snoop. Your ass got caught," I said. A few weeks later another woman came to the door and asked for him. She looked at me up and down and said, "Well, I guess you must be his sister."

I said, "His sister? I'm not his sister. I'm his fiancée."

Then she said, "You can't be. I'm his fiancée." When I found out about the first "sister," he begged and begged for me to not break up with him. I still loved him and just couldn't wrap my mind around him doing something that stupid to me. When I found out about the woman at the mall, he became very abusive. He placed terror and fear in my heart because he'd threatened several times to kill me. He tried to make me drink Clorox until I fought him off. Then he put sugar in my gas tank so I wouldn't leave. A week later he tried to get me fired from my job. When the third woman came to the door, I couldn't take it anymore and finally devised a plan to leave, but it wasn't that easy. I had to call a police officer help me move out. I found a case worker that was able to help me find new place, and I was able to turn my whole life around.

Leaving my husband for that monster was probably the worst mistake I've ever made. In order to cope with my past, I started to date married men. It was easier to be with married men. I knew how to play the game. They're looking for somebody to provide sex, boost their ego, and for a woman to not emasculate them. Most of these men were treated badly at home so they were kinda weak, and I knew that. There's a safety shield for myself when I'm with a married man.

Since W___, I've had about six affairs with married men. I was even with a married man who left his wife for me. He and I were dating for a while and he was probably the only person I've ever really loved in my whole life. Then he started cheating and that was it. Out of all of my break-ups this one probably hurt the most because he left his wife for me. Every time a man professed his love for me, it turned out to be a lie.

Each man presented a promise of fidelity, but based on what I've been through, I can no longer accept those promises. I don't have to deal with the

consequences of their lies. I'm done with that life. I don't want to be anybody's mistress only seeing my guy before or after Christmas and before or after Valentine's Day. I hate that as a mistress I was part of bringing that kind of pain to another woman. As far as my own pain, there is no way that I can give my heart to another man ever again. I've been through too much to repeat those mistakes.

Coco

"Sex is sex. I just liked the pleasure of it.
You're not supposed to feel bad about it."

We're not married, but I consider him my partner. We've raised a blended family with two of my children and five of his. He's reliable in providing security for me, but when it comes to passion it's like oil and vinegar. There's no chemistry. I'm a bisexual woman with a high sex drive, and my partner doesn't indulge me in those needs. No matter how many times I tell him what I want in bed, it just doesn't register. It's led me to sleep with other people. I know it's wrong, but I've never really tied sex to emotions. I've always felt that sex is sex. I just liked the pleasure of it. It's like getting a massage. You're not supposed to feel bad about it. When you have sex outside of your relationship you don't have to think of it as it being a lie. It's strictly for pleasure; it's a normal thing that you just do.

One night I convinced one of my guy friends to go with me to a gay bar. I wasn't sexually attracted to him so I didn't think it would be a big deal. He wasn't entirely comfortable at first because there were a lot of men checking him out. The night started to change once women started hitting on me. He got turned on watching me make out with a few girls in front of him. It was his first time watching two girls live, and when we got home he started having sex with me on the couch.

That night at the gay club rekindled my interest in women. Before my boyfriend, I had a girlfriend for four years. She knew that I liked men. She even confronted the guy I was seeing on the side. She said to him, "Hey, you know, this cool, but every now and then I need a little bit of her so back off." At first, she acted like she was okay with me having the both of them, but then she confessed that she didn't like the idea him touching me. I didn't like to be held down by her, so we parted ways. Then I ran into her again after eight years of not seeing each other. We started hanging out on a regular basis and our old emotions started to come back. During one meet-up we started kissing and making out and then we were completely naked. We had an amazing sex session, so much so that she still won't stop calling me.

I don't feel guilty about my infidelities. I probably step out of my relationship at least once a year. Before meeting my partner, I was happy single. I was seeing several people at the same time. He wasn't going to stay with me if I continued with that. "Look, I'm a monogamous person," he said. "I don't believe in all of this sleeping around. If you're going to see me you've got to stop seeing people." I still dated other people even though he asked me not to. I've had multiple partners throughout our whole relationship.

It's not that I don't sympathize with the pain of infidelity. I understand it very well. I used to be head over heels for a guy who cheated on me. His name was B_____ and he changed my life. I had known B_____ since I was a little girl. I never had any interest in him. I was like a little sister to him. We kept in touch through letters while he was in jail. One day he said to me, "When I get out, I'm going to take you out to dinner. We'll go have some drinks."

When he came to my doorstep I was like, "Oh my God! You've changed." B____ was skinny throughout his whole life. He was now about 6'4" and a solid 200 pounds.

"I'm out of jail," he announced. "Let's go get that drink." I've always had this sexual fantasy of sleeping with a man straight out of jail because I knew he'd be hungry for it. Now that fantasy was at my door, I was so turned on I couldn't think straight. I was seeing lucky stars and blooming clovers. He was fine and the sex was off the chain, just incredible. He was everything I could ever want and then some.

I was a promiscuous teenager before B____, but when I was with him, I didn't want to be with anyone else. I was still grieving at that time, so I didn't think about why we were getting so close so fast. When he came into my life, I had inherited some money from my mom's death. B____ didn't have to work because I supported him. All we cared about was just having a good time. I paid for all of our adventures.

For his birthday, I took him to a brothel and bought him a woman. "Pick any one you want," I said.

He looked at me and said, "This is one hell of a birthday present."

I know B____ was taking advantage of me, but I was so in love with him I didn't care. He was the only person I've ever wanted to marry. I didn't want us to end.

We were living with each other for a year when we started a business together. I looked at our phone bill and noticed that this one number kept showing up. B____ claimed that the phone number was tied to the business; it was a woman who needed extensive work on her house. We had a construction company so it was normal for him to see clients and there was never anything for me to suspect. However, this number appeared multiple times in a day, so that made me doubt that he was telling the truth.

I decided to do a courtesy call to the phone number. When I called, a woman answered and I said, "Hi, I'm with Expert Construction and I wanted to check the status of our service."

"It's been great," she said.

"Has B____ been in contact with you to follow up?" Even though I knew the answer to this, I wanted to see what this woman was going to say.

"Yes, I talk to B____ quite often," she said. "In fact, he's my boyfriend."

"He's your who?"

"He's my man," she said.

"Okay, is he there right now?"

"Yeah, he's right here right next to me."

She handed him the phone and I said to him, "So you're laying there right next to her, huh?"

"I'll explain later."

"Whatever," I said. "Your stuff will be on the front lawn. You better hurry up because you know we live in a bad neighborhood. Your shit will be gone in seconds."

I wasn't in a place to leave him. I took him back and tried to forgive him, but every time he'd leave, I'd accuse him of going over to the woman's house. He swore to me that their relationship was over, but then I found her driver's license in his car.

I kicked him out for real that time, but I wasn't mentally stable. I drove to his grandparents' house with my two little kids in the car. When I arrived at their house, I put chocolate bars in all the cars' gas tanks to mess up the engines. Then I took my can of gasoline and poured it all around the house. After I was done, I called B____ and said, "If you're not going to be with me then I'm going to kill your grandparents. I'm going to blow up the house."

My kids looked at me from the back seat and said, "Mom, you're acting like a crazy lady. He's not going to come for you." All of a sudden, I just snapped back into reality. It dawned on me that I was being insane.

I turned to the back seat. "You're right," I said to them. "Let's leave before the police come." Afterwards I called him and said, "I'm sorry. I totally lost it. Enjoy your life." He never called me back. I haven't seen him since.

I fell into a deep depression after that break-up. It got so bad that I checked myself into a 72-hour hospital suicide watch. I was lucky that B____ didn't call the police and put me in jail for the rest of my life. I had this money from my mother, and I wasn't doing anything useful with it. I wasn't progressing my life in a way that would make her proud. I was spending money on a bum that couldn't be faithful to me. I paid for all of our good times and I was burdened with a lot of guilt for using my mom's money for that.

B____ is the reason why I can never be with one guy. After him I went back to sleeping with multiple people, and I've never been interested in marrying

anyone since. I like to be free. There's a lot of pain that had to happen for me to realize that. You should never put your all into a person. You should not let somebody define who you are. After my mom's death, I didn't keep my self-worth and value. I gave one person so much. Once he left, I fell into pieces. I think every woman has had her crazy moment of sitting in front of a grandma's house. I'm so glad my children talked some sense into me, because at that moment, I could've lost everything.

My boyfriend knows my past, so he knows my true nature even though I don't tell him about every person I've slept with. He doesn't satisfy me sexually so I find satisfaction on my own terms. People may think I don't love him because of what I do, but I'm not going anywhere. I'm not planning on leaving him for someone else. After 12 years, we're at a point in our relationship where I don't have to cheat on him all of the time, but when I do it doesn't mean things have to end.

Ava

"I've been unfaithful due to the fact that I feel
like it's already going to get done to me."

I was a mistress before I got married. I was 17, 18 working at a hardware store. This man would come in all the time and flirt with me, so finally I decided to go on a date with him. I found out he was married, but that didn't stop me from going out with him. I was never able to go to his house, or call him late, or anything like that, but I was faithful to him at the time. We had a sexual relationship, and I knew that he had a wife at home. I felt like it was okay. As long as the attention that I wanted was given to me at the time that he was able to, I was cool. It lasted about seven, eight months.

I felt bad about his wife. I never met her or anything like that, but if I ever ran into her, I would have respected her and not said anything. I felt bad about it, but that didn't stop me. I was in this mind frame of getting taken care of. Growing up, my dad spoiled me, so I felt like every man after my dad had to spoil me. My father instilled in my head that a man is supposed to take care of his woman. I don't think that he meant it in that type of way, but at that time, I took it as I'm supposed to be spoiled. Anything that I wanted, my man was supposed to give to me. My daddy said it. That's how my mentality was.

The guy that had a wife spoiled me with anything that I wanted. I could say random stuff like I want a purple panda-eater and he would try to find me a purple panda-eater. It wasn't even the material things. It didn't matter what it was, he was willing to get it for me. I liked that. That's the reason why

I was okay being a mistress. I think that's the reason why I was okay being cheated on because my husband treated me like that too; anything that I wanted, I could get.

I got married when I was 19. It wasn't love; it was me being rebellious against my strict parents. I wasn't able to talk to boys on the phone until I was 15. I wasn't able to have a boyfriend until I was 16. I snuck out a lot due to the fact that they were so strict. I felt like, "I'm out of high school. I need to go ahead and do something that you'll probably be upset about." He was one of my friend's uncle's best friends. I knew him all my life. We dated for about four or five months before I up and got married to a man 16 years older than me. I just felt like that was the thing that I was supposed to do at the time. When we got married, everything was perfectly fine. He would cater to me. He made me feel like I was special. I was not in love with him when we married, but I fell in love with my husband because I felt like he spoiled me. I was faithful.

Between six and eight months after the wedding, when he knew that I wasn't going anywhere, he started cheating. People would come over to my house when I wasn't there. I would find phone numbers. They would actually call.

"Can I to talk to C____?"

"Who are you?"

"Oh, you know, I'm such and such, he told me about you."

There were some that were like really blunt with it. "Oh, he's told me about you. You're his wife, and he said he's never going to leave you." They're really calling my phone telling me this.

This one time, I was at my parents' house, and I didn't have my car with me because I got dropped off. I called him to come pick me up, and he didn't answer his cell phone. I kept calling his cell phone, calling the house phone. Finally, I guess he got up and left or something so the girl picked up my phone, and she was like, "Hello?"

"Is C____ there?"

"He's out. Who is this?"

"This is his wife."

"Oh, you got the wrong number," and she hung up on me. She's in my house!

People would call my phone and tell me that my husband was messing with them and he would tell them, "This is just who I am. I'm not leaving my wife, and she is not leaving me." He was controlling in the mind frame of "I have her, I can do whatever I want to."

Every time I found out he cheated, I would leave and go back to my parents' house. My mom would say leave him. She would tell me I didn't have to stay in a relationship like that, leave him. My dad didn't know. I hid

everything so in my dad's eyes he was still a good guy. My dad told me to go back home. In our family, we don't divorce, we actually stay in marriages. He didn't know the severity of our problems.

My husband would call me at my parents,' sweet talk me and try to buy me something. At that time I felt like, "Oh, okay, he's going to change." I always felt like he was going to change back then until I realized he was never going to change, because for a few times he would stop, and I wouldn't see any females. They wouldn't call me or anything like that, so I would think, "Oh yeah, he's changed," and then once I'm back in the house and living with him, then he would go back to the same old ways. His females were steady. They basically stayed around. There were probably eight or nine that I knew of for sure.

I can't say that I was always calm. One night I went over there wild, broke stuff, and everything. I wasn't the quiet type always. There was times that I was just like, "Man, I can't." I'd just throw my hands up. There's nothing that I can do, but a lot of times I showed him my other side. He didn't have a problem hitting me back. He wouldn't just restrain me, he would hit me back.

We stayed together for four years. The reason why we stayed together for so long was because my grandparents celebrated 50th wedding anniversaries on both sides of my family. My parents were married forever, so I felt like I had to stay in a marriage even though he was being unfaithful. Eventually, I gave up because I couldn't take it anymore. It was constant. The last straw was actually really weird.

It was New Year's Eve and my sister worked for the radio station so she gave us VIP tickets to the club. They were worth $100 each. We decided instead of going to a club that night, we should go to dinner. We agreed to sell the tickets for $60 a piece. A bunch of guys kept passing the car. It looked like they would've paid $100 for the tickets because the VIP was probably sold out, but this one girl with a short miniskirt came by, and he sold both tickets for $30 total. That one hurt. So instead of going to dinner, I suggested we go to church. While we were at church, he had this look on his face like he just didn't want to be there. He looked evil to me. No lie. He looked like the devil in church that night. That was my wake-up call. "Ava, he's not going to be right." After we left church, I had him drop me off at my parents' house and we didn't talk for two years after that; I started my divorce.

After my divorce, I still to this day have my trust issues. Being so young at 19 in a relationship with an unfaithful husband, I started not trusting anyone. When I get into a relationship, I turn into Inspector Gadget because I don't want to be hurt anymore. In relationships after him, I've been unfaithful due to the fact that I feel like it's already going to get done to me, so I beat him to the punch basically.

For example, I was dating a local DJ and he had a lot of women that threw themselves at him. I would go to the clubs with him and women would blatantly come up and ask him to go home with them. I don't know if they knew who I was. I think they just assumed that I was just another groupie hanging around. They didn't know that he was my boyfriend. I automatically assumed that all these women were trying to sleep with him, and if he's doing it, then I'm doing it too.

I would have a guy on the side. If I didn't hear from my boyfriend, I would call him and we would go places. At first, it was more just someone's attention and being able to go somewhere that I wasn't able to go with my boyfriend. Then we got closer and closer, flirting, then having sex, so that's how that situation worked. I didn't have any proof that my boyfriend was cheating, but with my track record with my ex-husband, I felt like he probably was. So to beat him to the punch, I did it myself too.

Then I got caught. I'd see my guy on the side randomly. He wasn't my steady boyfriend. It was random, different times in the day. We were like, "Well I'm free, let's go somewhere," but he wanted more. Because my boyfriend was a local DJ, everybody knew him. My side dude knew somebody that knew my boyfriend. He asked this guy if they could go over to my boyfriend's house to pick up a mix CD. They go over there and my side dude called me and put me on speaker phone. Usually I don't fall for something like that, but I didn't know he was over at my boyfriend's house and he was like, "Hey, Ava, what you doing?"

"Nothing."

"Well, you going to come see me tonight?" And he kept on saying a bunch of sexual things that we normally don't talk about.

"What's wrong with you?"

"I've just been thinking about you."

We were still on speaker phone and I was like, "Yeah, I'll come see you tonight. I'll talk to you later."

When I got off the phone, my boyfriend was like, "Was that Ava?" And he was like, "Yeah," trying to play it off like he didn't know that me and the DJ was dating and he said, "Well, that's my girlfriend. I've been messing with her forever." A few minutes later my boyfriend called and was like, "How could you be fucking him?" and goes off on me. My side dude told on me basically because I wouldn't give him the same type of treatment that I was giving my boyfriend. He wanted to be my boyfriend, I guess. If I knew something like that was coming, I would have stopped talking to the guy because I actually did like my boyfriend.

Me and the DJ worked it out. Not right away, though. At first, he played games. He'd call me, ask me to come over. I'd get all the way to his house, knock on the door, and he wouldn't answer. A lot of that happened. He was hurt. I

knew he was hurt, so we took a break for a few months but then he forgave me. We were together for two years before he moved out of the city. I never did anything sexual with anybody, but I would flirt or talk to people on the phone but nothing crossing the line of something sexual. I never had any evidence that he was hiding anything from me. The DJ proved to me that no matter what, even after I did something, he cared about me so much that he didn't step out on me. We're not saying that we're together since he's been gone, but we still talk on a regular basis. We talk about whether there's a chance that we will build a future in the future. I hope so. I know he's a good person, and I know that he loves me.

If I had a time machine, I would've never cheated on the DJ due to the fact that I never had any proof of him doing anything on the side on me. In fact, if I could revisit all of the infidelities, I would change things. Being in a relationship as a wife having a husband cheating on her, I would have never been a mistress with anybody because I know how that feels now. And then with my ex-husband, I wouldn't stick around as long as I did because he hurt me; he scarred me for a long time due to the fact that still, to this day, I do have trust issues.

My story is the complete opposite of women who have daddy issues or trust issues because their father wasn't around. Before my mom passed, my parents would have been married for 34 years. My dad worked and provided for the family. My mom didn't have to work. She only worked because she was bored. My dad was always faithful to my mom, but my mom wasn't always faithful to him.

My mom was an outgoing person. My dad was a homebody, a nerd. He just would rather stay at home, so she ended up just going places herself. When I would go places with my mom, I would always see this random man, and they would have a quick conversation. It wasn't like they knew each other, just a friendly conversation. I never thought they would actually be seeing each other, but it was always the same man. I've seen him around since I was like 14, 15.

Three or four months after my mom passed, I was driving her truck and the guy that I would randomly see with her was honking at me, asking, "Miss Ava, can I talk to you?" He knew my name, and I remembered him so I didn't think that it was strange. I pulled into a parking lot, he pulled in behind me, I got out of the car, and he was like, "I'm sorry about your mom passing. Do you know who I am?"

"No, not really. I've seen you around, but I don't know who you are."

"Me and your mom had a relationship for over 15 years," he said. "No disrespect to your dad, but I loved your mom." He told me how they met. My mom was out at a club and his best friend dared him to pull the "most beautiful woman there." He pointed out my mom, asked her to dance, and she agreed.

They danced then my mom sent him a drink. At the end of the night, she told him, "It was nice meeting you, but I'm married. Have a good night."

He said that after the club, he was driving to drop his friend off and then going back home. He stopped at the light, looked over, and my mom was in the car next to him. He felt like that was destiny. He thought he was never going to see her again but then there they were at the same light. That's how they started talking, and they exchanged numbers. He said my mom was hesitant at first but then after a while they would randomly say, "Well, I'm going to be at this place. If you're going out, I'll be here" and they would see each other like that until they ended up making dates with each other.

I was surprised, but I wasn't too surprised when I found out. I had seen that man randomly, and it was always suspicious. I don't know if my dad knew. If he did, he wouldn't say anything. For me, it was also kind of a relief. I knew something about my mom that she didn't share with me, but it made me feel closer to her even though she was gone. It made me relate to her a little bit more because I have cheated on someone. I'm not saying that made me feel good, but it made me feel like my mom was human.

Ebony

"There was a lot of pain in my childhood and I've indulged in a lot of personal pleasures to hide that pain."

My parents got divorced when I was 13 because my father was cheating on my mother with a woman from our neighborhood. I felt like my dad was cheating on me too. I was daddy's baby girl. Whatever I wanted, he gave it to me. Once the news of his cheating got around town, my mom told him it was time for him to choose. My father left us for his mistress.

Being at home became unbearable after my dad left. As soon as I graduated high school, I married my first husband at 19 years old. He took on the role of my father right away by being a generous provider. He gave me everything I wanted and rarely ever said no. Then one day I came home and saw him in his car with another woman. Whoever it was ducked her head down. To this day, he won't tell me who that woman was. I speculate that it's because she knew me. All of his mistresses knew me because he was screwing every woman within a ten-mile radius. I decided to leave him because I wasn't going to stay with a cheating man like my father. I was never going to let a man hurt me like that again. I was gonna do them before they did me.

My divorce was still pending when I met my second husband at a club. When D____ came up and asked me to dance we hit it off right away. There was an instant chemistry that kept us dancing together all night long. D____

was insistent that I give him my phone number before I left. I made it clear to him that I was going through a divorce and if he wanted to keep talking it couldn't be anything serious. He thought about it for a moment. "Okay, that works for me," he said. From there we talked every day. We couldn't get enough of each other. Four months later we started living together.

When I got pregnant, D____ and I were incredibly happy. Even though I didn't want to be tied down, the pregnancy created a sense of hope for the both of us. D____ stuck by my side throughout the whole pregnancy. I carried the baby to full term, but sadly my baby girl passed away during labor. The pain was unbearable and D_____ was the only person who knew what I was going through. The tragedy brought us together so when D_____ proposed to me, I said yes.

I should've been happily married, but I was still grieving my child. I could've focused my energy on raising my husband's daughter from another relationship, but after I lost the baby, my mental health was unstable. I started to rebel within my marriage. I decided that I was going to do whatever I wanted and didn't care about the consequences. I went back to being wild and having fun, going out to clubs, and doing party drugs with friends. During that time, I connected with an old friend from childhood named Y_____ who was always in and out of jail.

When Y_____ was released from prison, I invited him to hang out with me. Being around him distracted me from my grief. D____ was a constant reminder of the baby we lost. Y_____, on the other hand, had an energy that made me feel young again. I started to invite Y_____ over more often since my husband worked the graveyard shift. One night after going out we went back to my house and the next thing you know we started messing around. He took off his pants, and oh my goodness, he had a real big one. His penis was so big I was afraid of it. We had sex in the bed my husband and I shared, and from there everything about my married life changed.

Even though I cheated on my husband, I still was on the lookout for his possible infidelity. I had known men to cheat since I was a little girl, so I would've been naïve to think that D_____ would never do it to me. One day, I checked the phone bill and there was a number calling our house every day. It was strange because each time this number called the house the duration was never over two minutes. I had stopped seeing Y____ so I knew it wasn't him. I asked my husband about it, but he claimed he didn't know who it was so I called the number. When a woman answered she said to me, "I'm not sleeping with your husband. We're just good friends."

"You've been calling my house every day," I said to her.

"I was suicidal. D_____ has been a good friend. It's easy for me to talk to him."

"It's inappropriate for you to be talking to him this much."

"Well, how come men and women can't be friends?"

"You have medical insurance. If you're suicidal you need to go to a hospital because my husband is not your personal therapist. I don't understand why you're only suicidal when I'm at work. You ain't never been suicidal when I'm home. I don't want your number on my phone bill anymore."

When I confronted my husband about their friendship, he said to me, "Well, there ain't nothing going on with us. Stop trying to say this is an affair."

I made him look up the word affair in the dictionary. "Affair has three meanings," I said. "Business, sexual, and communication. Out of those three meanings we know for sure that you have two of 'em. We know for sure that this is a business affair because you guys work together. We know for sure that it is a communication affair because you talk to her every day. Now what we don't know is whether this was sexual or not, but from what I know about this 'friendship' you got two out of the three based on what's in the dictionary, so I would say you had an affair."

"Well, get over it. We have this house. We have a family. Get over it."

"Wrong answer. We need to go to counseling."

"Ain't no white man gonna tell me what to do," he said. I wanted to go to counseling, so we could put everything on the table. Perhaps if we admitted we were cheating we could start all over and still have the family that we built together. If D____ hadn't had an infidelity yet I was certain that it was only a matter of time, so I continued to see other men behind his back.

I started to explore Internet dating. My niece introduced me to a website. I learned that you could meet different types of men at your own convenience without having to spend a bunch of money going out to clubs. My screen name was F_____, and I talked to every man in the chat room.

I met a guy online named G_____ who had been separated from his wife for a year and a half. At the time, I wasn't interested in finding a new sexual partner because my husband and I stayed sexually active. That was the only area in my marriage that wasn't a problem. In fact, since the miscarriage and my stint with Y_____, I carried two pregnancies to term and had two boys. As parents, D____ and I had a family connection, but G_____ and I had a really good mental connection. We talked every single day on the phone. I had an alarm clock set to call him as soon as my husband left for work. Every day we talked from three to seven in the morning, then I'd start getting ready for work.

Conveniently my mom was having a class reunion in his city, and I convinced her to go. It was a perfect excuse since I was going to be with my mom. I was excited to meet G_____ because I couldn't wait for him to see me looking my best. I'd lost all this weight from working out every day. I'd also grown my hair out. It was so long, it was flowing down my back.

When my mom and I got off the plane, G_____ arrived with a big bouquet

of roses that he handed to my mother. I couldn't kiss him in front of my mother even though she knew I was there to meet him. She was aware that me and D_____ were having problems, but she didn't discourage me from exploring this new relationship. She took the flowers and left me alone with G_____ while she went to her class reunion.

Even though we booked a room together, I was insistent that I couldn't have sex with him. G_____ assured me that everything would be okay and every night he held me all night long and not once did he let me go. Those five days I learned how a woman was supposed to be treated. Even though we never had sex just as I requested, I cried like a baby when it was time to get on that plane and go home.

I continued to see G_____ every couple of months. I was clearly unhappy in my marriage as I found reasons to stay late at work. Sometimes I would go to the gym, work out three and four hours a day because I didn't want to go home. After a year of flying back and forth, I finally decided to leave my marriage. I told my husband I was no longer happy, and that I was no longer in love. "It's to the point now where I'm seeing other guys," I said. "I'm woman enough to come to you to tell you that I talk to another man for happiness while you're laying in the bed with me every night."

He looked at the floor and said, "I appreciate you being a woman and telling me in person. Give me three months and I'll be out."

When the divorce was finalized, I made a trip to see G____. After all of this time, we'd never once had sex. I told him that I couldn't wait any longer. It was time for us to consummate our relationship.

He sighed, "I can't do that, Ebony."

"Why not? Don't you want to be with me?"

"Yes, but I'm impotent." I'd just left my marriage for a man who was unable to get an erection. This whole time, I thought that he was a stand-up guy that respected my wishes to be abstinent because I was still married. At first, I told him that we would get through that issue. However, when he proposed we move in together that put things into perspective for me. I wasn't trying to commit to another man, especially to someone I couldn't even be intimate with.

When I broke up with G_____, I went back to the chat rooms. I met another guy online about a week later who was about 14 years older than me. M_____ was crazy in love with me. We met in person during a date at IHOP after two months of chatting. He wasn't handsome in person. He had rotten teeth and a rough face. I wasn't physically attracted to him, but we had so much fun. After a few months he begged me to marry him even though he was already married. He swore he would leave her for me, and I said, "I just came out of a marriage and a one-year affair with someone whose dick don't work. I'm not trying to get serious with anyone." Instead of backing away,

M____ continued to buy me gifts and anything I wanted. Throughout our entire relationship I believe he spent at least $40,000 on me. He bought me a little white sports car and every flipping Coach bag that was out. If I wanted something, he bought it before I could even get the request out of my mouth.

During the fifth month of our relationship we started to discuss having sex. I invited him over to my house when the kids were gone. When you're really feeling someone you try new things. I never cooked at home, but I made sure I had dinner ready before he came. I also ran that boy's shower water and had hot towels ready for him when he came out. I loved seeing him naked. M____ looked so good without clothes I'd forget about how ugly he was in the face. I'd give him massages in sexy outfits and with a porno playing in the background. When I was ready to turn him over, I'd turn that porno off and put on some music. Then I would put a blindfold over his eyes so I could give him a tongue massage from the feet up. I finally could have the type of sex that I'd wanted with W____.

A lot times when people have affairs they go their separate ways after having sex, but M____ and I had an actual relationship and talked every single day. He joked that it was difficult to maintain "two wives." Every single solitary Tuesday and Thursday that man was at my house for three years. Like clockwork he'd come to my house right after playing basketball and didn't leave till three in the morning. Twice a year we'd go out of town and every January we'd go to the porno convention. One day I asked while I was giving him head, "Do you even think about your wife?"

"No," he said. "When I'm with you, I'm with you. When I with my wife, I'm with her." It was those types of answers that started driving me crazy because I started falling in love with him. One time he came to my house after an argument with his wife. I had on my black lace nightie and stocked my house with his favorite licorice and oatmeal cookies. As we were getting ready to have sex, we got into an argument. He became so angry he just stormed out of my house which was unlike him. If we ever had an issue, it didn't matter how late it was, we always talked about it until it was fixed. I thought that this was the night I was going to lose him, so I got into the car and went after him in nothing but my lingerie.

I arrived at M____'s house before him so I sat in my car for about an hour and a half. He never showed up so when I finally drove home, I got stopped by the police with my black lace nightie on. The police officer tapped on my window and said, "Ma'am, can you step out the car?"

"No, I cannot," I said to him. I'm crying my eyes out because I'm so embarrassed.

The officer can clearly see that I have no clothes on. I didn't have my shoes, my phone, or my purse with me. I couldn't even give him my driver's

license. After I explained the whole story, he gave me a ticket for a broken light and said, "Thank you, ma'am. Please go straight home."

When I got home, M____ was in front of my house. "Where the hell have you been?" he said.

"I went to your house."

"Are you crazy? Why would you go there? My wife is there!"

"Because I'm not playing with you. I ain't your wife. You don't leave. If you're going to start abandoning me then we need to end our relationship or move forward." We'd already been together for three years, and we still had to hide from people. There was one time were at a restaurant and M____ suddenly walked out because he saw his best friend's wife. I realized that he was still doing everything he could not to lose his marriage. When I started to think about it some more something just hit me. I asked him, "If we were to both die today we'd go straight to hell for everything we'd done. Is this really worth it?"

"What are you talking about?" he said.

I told him, "No more. I can't do this anymore. I want my own man who's just as attentive to me as you are. I would never ask you to leave your wife, but I want what you two have for myself."

M_____ was the love of my life, but ending our relationship was the right thing to do because I couldn't ruin another marriage. I lived with the fact that I left my husband for another man, but I couldn't live with being a home-wrecker. The decision was not easy. I've never recovered. I have not had a relationship since M_____. He was the one that was closest to my heart. After we broke up, I started going back to church.

There's 1000 members in my church, 700 active. I sat in the same seat every single solitary Sunday for two years. During one service, the pastor told us to hug to someone we didn't know. When I turned around, I saw M_____'s wife. I'd seen her in pictures, but not once had I ever seen her at my church. I hugged her without giving it a second thought. I didn't know what she was going through but she began to sob in my arms. I told her, "Don't worry, it's going to be okay. God's going to work it out. God has the answers. We don't always understand what's happening."

She said to me, "I love you, girl. Thank you." As soon as the service ended, I got my keys and my purse, and I was out the door. I could not believe that I was consoling M_____'s wife after all of the things that we did behind her back. Despite my impulse to confess, there was no way I could tell this woman that I was her husband's mistress. After that Sunday, she never came to church again. It's been two years. I know that she was sent there for me by God because I would've gone down that same stupid road of seeing M___ again. I have not had a relationship since him.

There was a lot of pain in my childhood, and I've indulged in a lot of

personal pleasures to hide that pain. The more I think about it, those men were not worth the consequences. I've raised my children on my own. My children no longer have an intact family because of my selfish need to explore personal feelings with other men. If I could do it all over again, I wouldn't have left D___. The whole time I was married, I only thought about my personal feelings and agendas. I never thought about who was truly going to suffer from my bad decisions.

Sherry

"He made sure no other man would ever want me again."

I got married to my first husband on my 20th birthday. When I met him, I was going to college and he accused me of dating one of the guys in my class. To prove how much I loved him, I dropped out of school. Before we got married, I guess you could say I was brainwashed. I thought he really loved me, but if I'd known the signs of abuse there's no way I would've married him. As time went by, my husband became more possessive and jealous so I started cheating on him with J____. He wasn't half as good sexually as my husband was in bed, but we had that psychological connection. I didn't care if we never had sex again but having somebody to talk to was worth the affair to me.

My husband went crazy when he found out about it, so he cheated on me with a teenage girl out of revenge. There were quite a few phone calls in the middle of the night that I knew had something to do with this girl. She used to call my house and made up all kinds of lies about who she was. One time she said she was in the service club in high school and she randomly chose my husband for a survey. Then she got bold and had to nerve to ask me if my husband could take her to a high school dance. Of course, my husband and I fought that night because he tried to say that it was just a dumb girl who found our number from the phone book even though our phone number was not listed.

Every time we made love, this demon would come out of him. You'd think that he would be happy after sex, but he would become angry and start hitting me for no reason. I would wake up to him beating me in my head. Whenever he grabbed my wrist, I would be perspiring so hard out of fear, I could just slip from his grip. One time he woke up in the middle of the night and strangled me because he had a dream that me and his best friend were having sex. I begged him to find somebody else. I was hoping he'd take his anger out on some other woman rather than me.

One day my husband and I were driving down the street and out of nowhere he said to me, "Take me to J___'s house."

I played dumb and said, "J____ who?"

That's when he put the gun to my head and said, "You know who it is, bitch. I'll blow your fucking brains out. Take me to his house." I wasn't about to tell him because at that time J___ was married with children. I wasn't about to involve him and his wife. Whatever problems we had in our marriage had nothing to do with him.

My cousin was the one who spilled the beans about my affair. Her boyfriend suspected that the two of us were off with other men. After her boyfriend hit her, she told him that it was just me cheating and not her. Her boyfriend then told my husband and that's how he found out, but I still denied it.

When I wouldn't tell him the location of J____'s house, we continued to fight until we got home. I ran toward the kitchen and he tackled me. At that time, he weighed 260 pounds. He was a middle linebacker for a semi-pro team when he tackled my 137-pound self. My hand hit a lamp. I rolled over and whacked him with the lamp, then he snatched my clothes off, picked me up, and threw me outside. I ran and got into my car and I'm looking for something to put on 'cause I'm naked. The neighbor across the street was looking. I asked him to please call the police. He stood there looking at me, not making a single move. My husband approached the car. I jumped out, opened a bottle of bleach that was in the backseat, and threw the Clorox in his face. He had no choice but to get the hose and wash his face. That's when I was able to get away.

I went to a friend's house reeking of Clorox. She let me take a shower and gave me one of her dresses to put on. The police were mean and unaccommodating. I wanted to take my car, but they wouldn't let me because my husband told them that I hit him in the head with a lamp. These officers would've shot my husband if they had to deal with what I dealt with that day. No one wanted to believe that I was defending myself.

The police suggested that I stay the night at home and talk to my husband. When I went back to the house, he was asleep. That gave me the opportunity to get my stuff together and get out of there. I bought a one-way ticket to another state and didn't look back. He didn't know where I was for three months.

I met my second husband at a nightclub even though my mother always told us never to date a man that you meet in a nightclub. I thought it would be different because we grew up in the same neighborhood but never knew each other. He confessed that he used to be a crackhead but was nine months clean. I had prayed for a husband I could lean on. This man had so much promise. I thought I finally found a good partner.

It wasn't long before he became abusive as well. One time we got into a fight, and I cut the top of my thumb with a knife defending myself. There's

still a knot on my forehead from where he hit me with an ashtray. I told him, "If you do that shit again you're gon' wake up dead tomorrow." That was the last time he ever hit me and soon after he skipped town. I was relieved to not be in that relationship anymore.

When my husband left, I started to have respiratory problems, and even though I do have asthma the doctors couldn't get my breathing under control so they kept me overnight. The next morning when the doctor came in there were three bumps on my neck. I looked in the mirror and I saw this non-human thing looking back at me. I started to scream. The nurses ran into the room and turned on the light. It turned out that the face was me. I had contracted chicken pox at 40 years old. All of that trauma had taken a toll on my health and my looks to the point where I couldn't recognize myself.

In addition to the chicken pox, I was having all of these crazy symptoms. The doctors kept drawing blood and running tests. They sent me home but called me back a few weeks later for my test results. I went into the office and the doctor told me that I was HIV-positive. He said to me, "I suggest each time you have sex with this character, make him wear a condom because he's giving you HIV, there's no telling what else he's giving you." I told him my husband left, and he said, "I'm glad he did leave because I'm sure he knew he was positive before he left. I'm sure he knew it."

I started to have flashbacks about some of his suspicious behavior. There was a woman in our neighborhood named H____ who was a regular crack user. She had two children I adored, and when she asked if she could use my bike, I'd let her so I could spend some time with her kids. My second husband would snap and say, "Why would you let a crackhead use your bike? You know she's gonna go buy crack with that."

"I don't care what she uses it for."

"People are going to look at us funny if we're associated with her."

I turned to him and asked, "Are you having sex with her?"

"Why are you asking me that?" he said. "You don't need to be asking me that." He was just so adamant about me not loaning her the bicycle. I found out that he was screwing her, so she could've been the one to give it to him. This guy that my sister dated years back has a niece who used to have sex with my husband and was later diagnosed with HIV. I found out later that he had sex with one of my male cousins, so he had all of kinds of issues that were way beyond my control.

I should've paid more attention. When we would fight, he used to say that he made sure no other man would ever want me again. Now, I knew he was talking about HIV. My second ex-husband was wrong, though. I'm on my third marriage right now, so I haven't given up on love. I've spent a lot of my life being in love with men who took their anger out on me but no more. I've changed my life and dedicated it to helping others. My ministry is assisting

and empowering families healing from domestic violence. I help them transition from shelters into society. This is what I'm doing now because I'm still trying to figure out the pain that I've gone through. If my experience was worth anything, I hope that it's used to help other people.

Understanding Multiple Experiences with Infidelity

The colloquialism "Hurt people hurt people" applies to these seven women. This section explores how these women were hurt by secrets and then used secrets to protect themselves and, as a consequence, sometimes hurt others. Hurt is generally defined as personal injury. Humans are most often hurt by people with whom they are interdependent and vulnerable like family members and romantic partners. Personal injury often follows a relational transgression—when one partner violates an explicit or implicit relationship rule. Relational transgressions are inclusive of but not limited to deception, betraying confidence, unfulfilled commitments, failing to privilege the primary relationship, fighting unfairly, and a lack of emotional reciprocity. Infidelity is a paradigmatic relational transgression because it is a couple rule violation in and of itself and also because of its entanglements with other relational transgressions.[1]

Personal injury can likewise occur when one partner exhibits a relational devaluation or behaves in a way that conveys they no longer value the relationship. When one romantic partner senses a "discrepancy between the current quality of [their] relationship and the relational quality that [they] desire" that person perceives a relational devaluation and may experience hurt feelings.[2] Messages that a partner no longer cares about a relationship are devastating because they may mark a shift towards relationship termination. The persistent deception that accompanies sustained infidelity devalues the entire history of a relationship—leaving the hurt party to parse out what was and what was not real with very few recourses. Furthermore, infidelity also sabotages the injured party's plans for the relationship's future.

These women's experiences with relational transgressions and devaluations destabilized their emotional epicenters via a third type of personal injury that undermined their sense of safety and security.[3] Sandra, Antoinette, Coco, Ava, and Ebony were never the same post their initial betrayal experiences. While Thumbalina recovered relatively quickly from her boyfriend's indiscretion, the realization of her best friend's husband's relational transgressions of how he used Thumbalina to hurt his wife embodied personal injury. Personal injury undermines the injured party's self-esteem—leaving

her wondering why she is no longer valued as a partner. It also impacts how she approaches future relationships. A woman who has been personally injured questions herself, the trustworthiness of future partners, and sometimes her ability to be faithful to others.

A study on serial infidelity across relationships indicates "people who engaged in infidelity themselves, knew about a partner's infidelity, or suspected a partner of infidelity had a higher risk of having those same infidelity experiences again in their next romantic relationships."[4] This research is very new, and if Sandra, Antoinette, Ava, and Ebony's narratives are even slightly representative, more work must be done to determine whether women with betrayal experiences are more likely to have cheating experiences. Ebony's assertion "I was gonna do them before they did me" and Ava's nearly identical declaration "I feel like it's already going to get done to me, so beat him to the punch basically" are very likely not anomalies.

Within these stories, personal injury is facilitated through secrets. "Secrecy involves keeping information from people who have a legitimate claim to the information (e.g. the information affects them directly), whereas privacy involves information that others have no right to know."[5] The biggest secret in this section is that Sherry's ex-husband intentionally infected her with HIV. As his wife, she had a right to know about his status as it affected her directly. Subsequent to her diagnosis, if Sherry chose not to tell her friends that she was HIV positive, that would be her private information. Friends who would not be directly impacted do not have a right to know. Sherry's story, like the other sexually transmitted infection stories, are examples of compounded hurt arising from infidelity and its many secrets.

People keep secrets "to protect themselves, protect their relationships, or protect others."[6] Without the other voices we cannot be certain, but based on these women's narratives, we can surmise that their partners kept secrets about their Other Women to at least protect themselves and possibly their relationships. None of them were honestly straightforward and told these women that they no longer wanted to be in a relationship with them. In each instance, they were unrepentant when caught. The hurt that emerged from these relational devaluations was devastating so much so that Sandra, Antoinette, Ava, and Ebony assumed the opposing position and kept their own secrets as Other Women or cheaters or both.

When women were cheaters or Other Women, their secrets protected themselves as they admitted they acted selfishly to meet their personal and/or financial desires. They also protected others. If Sherry had confessed to her first husband about her lover, he would have certainly threatened him if not worse. When Ebony consoled her ex-lover's wife at church, she kept the secret because she knew that telling his wife would not have helped her. As a serial cheater, Coco has no plans to remain sexually faithful to her partner, but she

has no plans to leave him either. Her secrets simultaneously protect her sexual desires and the relationship to which she is committed and invested as well as her partner's feelings because she knows how much telling him would hurt. Unfortunately, secrets are only protective as long as they remain secrets because when the people these women betrayed found out, they were also deeply hurt.

Thumbalina offers a nuanced perspective on secrets when she alludes to the kind of secrets one keeps from the self. Her narrative includes multiple paragraphs of self-talk where she is finally honest with herself about herself. Revealing those secrets allowed her to forgive herself for her mistakes even when the friend she hurt could not forgive her.

All of the women who had been hurt by secrets make decisions about them. Thumbalina decides to do away with secrets by being more honest with herself and to refrain from drugs. Sandra is also honest with herself as she admits that if she entered another relationship in her current headspace that she would cheat again. CoCo decides to keep her secrets because her desire for sex does not interfere with her desire to remain with her partner. Antoinette, Ava, and Ebony initially decided to continue to keep the types of secrets that were kept from them as a longitudinal revenge until they realized how many people they were hurting including themselves. Perhaps, most encouragingly, Sherry decided that no one else's secret was going to keep her from finding love again.

Conclusion:
Infidelity's Secrets

Infidelity is intimately intertwined with secrets. By definition, experiencing or committing infidelity demands "intentional concealment" from one partner toward the other.[1] Of course, there are narratives about brazen cheaters in this book who did not hide their affairs. Their partner and community knew they were consistently unfaithful. Even in those instances, there was still an initial moment of confirmation where the secret sexual liaison was verified by their partner. Fully understanding infidelity's relationship to secrets demands attention to societal and interpersonal contexts as well as interpersonal consequences.

One of the reasons infidelity persists is because sex is kept secret in Western culture. According to Peggy Vaughan, "Very few children get good information about the physical aspects of sex. And almost none of us gets sound information about sexuality and sexual love. As teenagers, we continue this pattern of secrecy by presenting a false image to our parents when we first become sexually active."[2] Secrets surrounding sex are normalized across the life span from myths about where babies come from in childhood, to teenagers who hide their sexual activity from their parents, to adulthood when a married person has an affair and a spouse suspects said affair and fails to directly confront their partner with their suspicions. Vaughan writes, "At all stages of our lives, the primary way we deal with sexual issues is to close our eyes and hope for the best."[3]

This code of secrecy also applies to all of the people—community members, coworkers, friends, and family—who must keep secrets in order for infidelity to thrive. Friends and even therapists often discourage an unfaithful person from divulging the truth: "Never tell. If questioned, deny it. If caught, say as little as possible."[4] In these narratives, only nine women voluntarily

confess. Xeena's perspective, "I don't think it would help anyone if I came clean and told all of the people involved," is widespread.

Outside of communicative infidelity or being caught, they keep their secrets to themselves. Again, Vaughan explains, "the code of secrecy provides a buffer from the world that makes it easier for a person to engage in affairs and to avoid dealing with the consequences, or even to seriously contemplate the consequences."[5] Additionally, there is support for the hypothesis that "individuals with a social network that supports or condones infidelity will have greater infidelity intentions."[6] In this quote, social network refers to close friends and family, but social networks also include social media.

This societal code of secrecy is augmented by technology. Al Cooper identifies accessibility, affordability, and anonymity as Internet infidelity's "triple–A engine" distinguishing factors.[7] Ebony described the ease with which she met men online "at your own convenience without having to spend a bunch of money." She used a screen name to protect her anonymity.

Selective self-presentation is a hallmark of hyperpersonal relationships—online relationships that develop more quickly and more intensely than face to face relationships.[8] Individuals seeking secret relationships may expend considerable cognitive resources on their online persona construction including omitting information and/or outright lying about their relational status because the facts cannot be as easily confirmed. Furthermore, dissatisfied people seeking secondary relationships may bond through increased self-disclosure which is easily facilitated via technology. In the absence of physical presence, online lovers may idealize each other by projecting on to them their desired partner characteristics.[9]

Sasha described how quickly the sexual communication escalated between her and her married man due to these aforementioned factors and the online disinhibition effect that allowed the two of them to create their own fantasy world online. Although not a key feature of these narratives, digital indiscretions like cybersex or sliding in the DMs are commonplace. New technologies continue to facilitate infidelity via a swiping culture with its stream of attractive alternatives, apps that create background sounds to corroborate a lie, disappearing or self-destructing messages, and dating sites for married people.

Not only does technology facilitate infidelity, but it also shapes infidelity behaviors.[10] There is an even darker side to secrets, infidelity, and technology. Social aggression might include an angry partner disseminating information about an individual's unfaithfulness on social networking sites. Whether the information is factual or fabricated, the result is public shame and embarrassment. Vengeful partners can also dox or share someone's personal identifying information online or post revealing pictures on revenge porn sites.

A combination of social, economic, and psychological aggression coex-

isting with infidelity includes sextortion which threatens the online release of sexual images in exchange for cash or cryptocurrency. Had Danielle's employee demanded an economic exchange for her compromising pictures, it would have been an example of sextortion. Psychological aggression also includes Internet of Things manipulation where a tech savvy individual uses an Internet connected device like an Amazon Echo, Google Home, or Nest to secretly monitor and control a partner's home environment. A person who is terrorized in her own home is less likely to readily leave an unfaithful partner as evidenced in Section Two.

However, as much as technology facilitates these destructive behaviors and deception, it also facilitates discovery. Janet describes the extent to which social media snooping can reveal an unfaithful partner's secrets. Email exchanges, browser histories, phone records, mobile payment app transactions, keylogging software, and fitness trackers that show increased activity during odd hours are some of the many ways the race between keeping and revealing secrets online is progressing.

A culture with codes of secrecy surrounding sex and advances in technology that facilitate secret-keeping create a societal container within which three core interpersonal contexts for keeping infidelity secrets thrive. First, secrets bond people. Sometimes the secret is the illicit relationship. Other times the secrets are private information shared within an extradyadic relationship that the primary partner does not know. Exchanging this private information creates intimacy between people. In *The Mistresses' Survival Manual*, Sands argues that the married man's appeal to the Other Woman is self-disclosure. She explains: "The confessions of the married man have such a tremendous impact. There he stands before you, stripped of his defenses. Not suave. Not controlled. Not trying to impress you. He stands before you as a vulnerable creature. He is reaching out to you. He needs your ear to listen. He needs your shoulder for consolation. He needs you to lean on. He is reaching out to you for your understanding and your compassion. In total sincerity and total honesty he is unraveling his essence to you."[11] These confessions certainly connected Xeena and her lover when he sought her comfort after conflict with his wife and they began to bond beyond friendship.

The second interpersonal context is that secrets concretize power. Perel notes that secrets "function as a portal for autonomy and control."[12] A woman who feels oppressed in other aspects of her life can emerge empowered by calling the shots during an affair. Interpersonal power describes one partner's "ability to control the rewards and costs the [other] partner experiences."[13] The person keeping the secret has interpersonal power over the ignorant party. The person with the greater number of quality alternative partners has more interpersonal power than the dependent party who does not want to end the relationship.

Partners who refuse to confirm or express remorse for their infidelities wield power over wives like Marie who was determined to prove what she knew to be true. Other Women like Raven with her last married man and Denise in her lesbian relationship, may have been able to more easily disregard the primary woman because their secret connection empowered them. Couples who revealed their infidelity secrets to each other alternatively wielded interpersonal power by claiming, "I forgave you, so you should forgive me." Sometimes it led to a more balanced equilibrium in Julie's case but not so much in Melanie's experience.

The final interpersonal context for infidelity is secrecy makes infidelity sexy. Morin's erotic equation of "attraction plus obstacles equals excitement" explains how maintaining a relationship secret can be aphrodisiacal.[14] Denise's lover/apartment owner was turned on when she called his house and spoke to his wife. The excitement created by their secret made "things hot and heavy for the rest of the night." Secrets stir passion and are one undeniable reason why some people are drawn and will continue to be drawn to affairs. The 12th-century monk Cappellanus elucidates the relationship between love, secrets, and marriage: "love, in order to pulsate and thump like the heartbeat, must be kept secret. Marriage cannot be kept secret. It is the secrecy of illicit love, that clandestine element, that fans the flames of passion. The intrigue is exciting. There is no intrigue in marriage."[15]

In addition to the societal and interpersonal contexts for infidelity and secrecy, there are four key interpersonal consequences for infidelity's secrets. First, secrets within the primary relationship can damage it beyond repair. It may be an additional humiliating marital event for a woman to discover that her private and personal information has been shared with her partner's other partner. The same secrets that bonded affair partners can create permanent distrust between spouses. Moreover, Vaughan observes, "in marriages where affairs are kept secret, certain topics of discussion are avoided because the deceiving partner fears being discovered and the other is reluctant to appear suspicious. This causes many relationships to be dominated by dishonesty and deception." According to Lusterman, this relational distancing and alienation may "loom even larger than the extramarital sex."[16] Frequently, this loss of privacy and trust is what leads to relationship termination.

Second, compromising a partner's sexual health is a serious interpersonal consequence of infidelity's relationship to secrets. Women were surprised when their absent husbands came home and said, "You need to get yourself checked" or "You need to take these" or found out from their doctors that they had STIs without engaging in sexual activity with anyone other than their partners. Both Sherry and Teah contracted incurable STIs from their husbands that they must manage for the rest of their lives. Sherry's ability to accept her status was greater than Teah's who admitted she was still struggling "walking around

thinking I have this plague." Teah represents the mental strain that accompanies contracting an STI from a spouse. Conley et al.'s research suggests "sexually unfaithful individuals are also more reckless with sexual health, taking fewer STI preventative measures than other risky groups." Furthermore, "STIs may be associated with health risks including cervical cancer, infertility, and HIV."[17]

The third interpersonal consequence extends the conversation on sexual health to include mental health. It is one thing to share a secret. It is another to embody a secret. Other Women embody secrecy via their very existence. Having to ride in the backseat or only sit up front while dark like Sadie is one example of how living as a secret diminishes one's self esteem. Richardson notes, "To keep the relationship a secret, [Other] Women resort to withdrawing (pulling away from her social circles so he becomes her whole life), compartmentalizing (separating each part of her life including him into separate compartments that don't overlap), cloaking (acting if time spent can be justified by larger obligations like work or friendship), and fictionalizing (lying by omission and commission)."[18] Living as a secret can compromise Other Women's interactions with those they love. Although they are not represented in this data, there are also children of infidelity who live as secrets—who may not be able to connect with a parent or half-siblings because they were conceived in secrecy.

In other instances, children are often recruited to keep infidelity secrets on behalf of their parents. Children are a final interpersonal consequence of infidelity. There is a burgeoning body of research on children's responses to parents' affairs. Lusterman explains that "secrecy has a remarkable capacity to undermine family boundaries. When a parent swears a child to secrecy (e.g., 'Don't tell Mom about this'), a hierarchical boundary is violated, because a younger member of the family is told to withhold information from an adult. This requirement may create anxiety about loyalty or tighten a bond with one parent at the expense of the other."[19] This reminds us of the stress children experience when they unwittingly become co-conspirators in a parent's affair because they saw a text message, or ran into a parent at the mall with a secondary partner, or were taken to an affair partner's house.

The six characteristics of family systems theory are a useful frame for incorporating children into discussions of parental infidelity.[20] For example, all families have *hierarchies*. Generally, adults exert decision-making influence over their children. As Lusterman notes, these hierarchies can be upended when a younger family member discovers an older family member's secret infidelity and must decide whether to share this revelation. Ava admitted feeling closer to her mom once she learned about her 15-year affair, but she also chose not to tell her father. Although Ava is now an adult, she still has to decide whether keeping a secret that makes her feel closer to her deceased

mom, even though it might devastate her dad, is the most appropriate pro-
tection for her father.

The distinction between family secrets (to be avoided) and family pri-
vacy (to be respected) is important as it constructs a family's *external bound-
aries* with the outside world. For example, how did Stacey's young children
who were aware of their father's infidelity and their close-in-age half-siblings
describe their family to others? Did they include all their siblings and their
unrelated parent in family drawings for class assignments? Were they con-
cerned about questions that may arise from their teacher or peers? *Internal
boundaries* of who counts as family can also be breached by a child's discovery
of an Other Person who both is and is not part of the family. Janet's boyfriend's
daughter is an example. She was close to Janet but also liked her father's Other
Woman.

Families are *interdependent* so what happens to one family member
impacts all the family members in some way. Weiser and Wiegal's "research
indicates that parental infidelity sends memorable messages to offspring
about the greater acceptability of infidelity, and these communications are
internalized and used to construct offspring's belief systems."[21] Assata, Sasha,
and Ebony support this through their acknowledgments of how their father's
infidelity impacts them. Symone confesses that she "came from a family that
consisted of mistresses." Families exhibit *wholeness* meaning a family per-
sonality is more than the sum of its individual members. Even if every woman
member of Symone's family was not an Other Woman, her perception of her
family's overall personality is permissiveness about sexual secrets.

Families maintain stability through *calibration*. All families are organized
by rules that are established so that the family can ensure consistency. When
these rules are violated, the family must recalibrate by either forming new
rules or re-establishing the old ones. According to Galvin, Bylund, and Brom-
mel, "Change promoting feedback processes enable the system to grow, create,
innovate, and change whereas maintenance feedback processes attempt to
maintain the status quo."[22] Infidelity is a destabilizing event that demands
recalibration. Whether a family opts to maintain the status quo or change and
grow is dependent upon the family.

This decision-making variability among families with similar experi-
ences reflects *equifinality*. Equifinality explains how different families may
achieve the same goal in different ways. Some families survive infidelity through
open communication. Others survive through silence and secrets. Many sur-
vive via a combination of the two. Thorson advises that "the communication
among family members surrounding parental infidelity may be as important
as the event itself."[23]

More research must investigate the intergenerational effects on betrayal
experiences, cheating experiences, and both when it comes not just to women

but their entire families. Asking further research questions about infidelity requires violating the code of secrecy. Violating that code was my goal with the email I sent to friends and family after my personal infidelity experience. Violating that code was my goal in interviewing 110 women about their infidelity experiences. Violating that code was my goal when I selected 57 of those most poignant stories to create this book. The pain and the self-discovery will only become normalized as we discuss it. For the sake of future generations and their experiences with infidelity, we owe it to ourselves, as Thumbalina advised, to be honest with ourselves about ourselves.

Section Notes

Introduction

1. Ebony A. Utley, "When Better Becomes Worse: Black Wives Describe Their Experiences with Infidelity," *Black Women, Gender, and Families* 5, no. 1 (Spring 2011): 66–89.

2. Esther Perel, *The State of Affairs: Rethinking Infidelity* (New York: HarperCollins, 2017), 10.

3. Todd K. Shackelford, David M. Buss, and Kevin Bennett, "Forgiveness or Breakup: Sex Differences in Responses to a Partner's Infidelity," *Cognition and Emotion* 16, no. 2 (2002): 299–307.

4. Bonnie L. Brogdon, April L. Fitzwater, and Lucille C. Johnson, "Differences in Men's and Women's Perception of Infidelity in Varying Situations," *The Osprey Journal of Ideas and Inquiry* 18 (2006). Christine R. Harris, "Psychological Responses to Imagined Infidelity: The Specific Innate Modular View of Jealousy Reconsidered," *Journal of Personality and Social Psychology* 78, no. 6 (2000): 1082–1091.

5. Perel, *The State of Affairs*, 205.

6. Ebony A. Utley, "Rethinking the Other Woman: Exploring Power in Intimate Heterosexual Triangular Relationships," *Women's Studies in Communication* 39, no. 2 (2016): 181.

7. Joshua D. Foster and Tiffany A. Misra, "It Did Not Mean Anything (About Me): Cognitive Dissonance Theory and the Cognitive and Affective Consequences of Romantic Infidelity," *Journal of Social and Personal Relationships* 30, no. 7 (2013): 839.

8. Frank Pittman, *Private Lies: Infidelity and the Betrayal of Intimacy* (New York: W.W. Norton, 1990), 22.

9. Desiree I. Sharpe, Andrew S. Walters, and Matt J. Goren, "Effect of Cheating Experience on Attitudes Toward Infidelity," *Sexuality & Culture* 17 (2013): 645.

10. Michael W. Wiederman and Catherine Hurd, "Extradyadic Involvement During Dating," *Journal of Social and Personal Relationships* 16, no. 2 (1999): 271.

11. Wendy Wang, "Who Cheats More? The Demographics of Infidelity in America," Institute for Family Studies, January 18, 2018, https://ifstudies.org/blog/who-cheats-more-the-demographics-of-cheating-in-america.

Section One

1. Annmarie Cano and K. Daniel O'Leary, "Infidelity and Separations Precipitate Major Depressive Episodes and Symptoms of Nonspecific Depression and Anxiety," *Journal of Consulting and Clinical Psychology* 68, no. 5 (2000): 775.

2. Mark A. Whisman, "Discovery of a Partner Affair and Major Depressive Episode in a Probability Sample of Married or Cohabiting Adults," *Family Process* 55, no. 4 (2016): 719.

3. Walid A. Afifi, Wendy L. Falato, and Judith L. Weiner, "Identity Concerns Following a Severe Relational Transgression: The Role of Discovery Method for the Relational

Outcomes of Infidelity," *Journal of Social and Personal Relationships* 18, no. 2 (2001): 295.

4. Utley, "When Better Becomes Worse," 72.

5. "Sub," Urban Dictionary, accessed January 12, 2019, https://www.urbandictionary.com/define.php?term=Sub.

6. Don-David Lusterman, "Helping Children and Adults Cope with Parental Infidelity," *Journal of Clinical Psychology* 61, no. 11 (2005): 1441.

7. Afifi, Falato, and Weiner, "Identity Concerns," 304.

8. *Ibid.*

9. Osei-Mensah Aborampah, "Black Male-Female Relationships: Some Observations," *Journal of Black Studies* 19, no. 3 (1989): 321.

10. Elaine B. Pinderhughes, "African American Marriage in the 20th Century," *Family Process* 41, no. 2 (2002): 269–282.

11. Robert J. Sternberg, "A Triangular Theory of Love," *Psychological Review* 93, no. 2 (1986): 119–135.

Section Two

1. Maria Yagoda, "The New Breakup Equation: How Long It Will Take to Get Over Your Ex," Broadly, May 22, 2018, https://broadly.vice.com/en_us/article/gykvp3/breakup-equation-time-it-takes-to-get-over-an-ex.

2. Afifi, Falato, and Weiner, "Identity Concerns," 301.

3. *Ibid.*, 303.

4. Courtney Waite Miller and Michael E. Roloff, "When Hurt Continues: Taking Conflict Personally Leads to Rumination, Residual Hurt and Negative Motivations Toward Someone Who Hurt Us," *Communication Quarterly* 62, no. 2 (2014): 195.

5. Shirley P. Glass and Thomas L. Wright, "Reconstructing Marriages after the Trauma of Infidelity," in *Clinical Handbook of Marriage and Couples Interventions*, ed. W. Kim Halford and Howard J. Markman (Hoboken: John Wiley & Sons, 1997), 472.

6. Jack De Stefano and Monica Oala, "Extramarital Affairs: Basic Considerations and Essential Tasks in Clinical Work," *The Family Journal* 16, no. 1 (2008): 14.

7. Dennis C. Ortman, "Post-Infidelity Stress Disorder," *Journal of Psychosocial Nursing* 43, no. 10 (2005): 51.

8. *Ibid.*

9. Perel, *Rethinking Infidelity*, 66.

10. Sandra Metts, "Face and Facework: Implications for the Study of Personal Relationships," in *Handbook of Personal Relationships*, 2d ed., ed. Steve Duck (Hoboken: John Wiley & Sons, 1997), 379.

11. Maureen Outlaw, "No One Type of Intimate Partner Abuse: Exploring Physical and Non-Physical Abuse Among Intimate Partners," *Journal of Family Violence* 24, no. 4 (2009): 264.

12. Matthew J. Breiding et al., *Intimate Partner Violence Surveillance: Uniform Definitions and Recommended Data Elements*, Version 2.0 (Atlanta: Centers for Disease Control and Prevention, 2011): 11.

13. Chris Segrin and Jeanne Flora, "Models of Family Stress and Coping," in *Family Communication*, 2d ed. (New York: Routledge, 2011): 208–210.

Section Three

1. De Stefano and Oala, "Extramarital Affairs," 14.

2. Steven Arnocky et al., "Anticipated Partner Infidelity and Men's Intimate Partner Violence: The Mediating Role of Anxiety," *Evolutionary Behavioral Sciences* 9, no. 3 (2015): 187.

3. Martin Voracek, Tanja Haubner, and Maryann L. Fisher, "Recent Decline in Nonpaternity Rates: A Cross-Temporal Meta-Analysis," *Psychological Reports* 103 (2008): 806.

4. Peggy Vaughan, *The Monogamy Myth: A Personal Handbook for Recovering from Affairs*, 3d ed. (New York: Newmarket Press, 2003), 223–224.

5. Perel, *State of Affairs*, 216.

6. Glass and Wright, "Reconstructing Marriages," 489.

7. Daniel N. Jones and Dana A. Weiser, "Differential Infidelity Patterns Among the Dark Triad," *Personality and Individual Differences* 57 (2014): 22–23.

8. Karen E. Sims and Marta Meana, "Why Did Passion Wane? A Qualitative Study of Married Women's Attributions for

Declines in Sexual Desire," *Journal of Sex & Marital Therapy* 36 (2019): 364.

9. Perel, *State of Affairs*, 25.

10. Jones and Weiser, "Differential Infidelity Patterns Among the Dark Triad," 21.

11. Sims and Mena, "Why Did Passion Wane?" 376.

12. Perel, *State of Affairs*, 156.

Section Four

1. Laurel Richardson, *The New Other Woman: Contemporary Single Women in Affairs with Married Men* (New York: The Free Press, 1985), xii.

2. Dana A. Weiser and Daniel J. Weigel, "Investigating Experiences of the Infidelity Partner: Who Is the 'Other Man/Woman'?" *Personality and Individual Differences* 85 (2015): 176.

3. Richardson, *The New Other Woman*, 30.

4. Lauren Rosewarne, *Cheating on the Sisterhood: Infidelity and Feminism* (Santa Barbara: Praeger, 2009), 74–75.

5. Weiser and Weigel, "Investigating Experiences," 177.

6. John Suler, "The Online Disinhibition Effect," *Cyberpsychology & Behavior* 6, no. 3 (2004): 323.

7. Ibid.

8. Laurel Richardson, "The 'Other Woman': The End of the Long Affair," *Alternative Lifestyles* 26, no. 4 (1979): 402.

9. Richardson, *The New Other Woman*, 43.

10. Michelle M. Jeanfreau, Anthony P. Jurich, and Michael D. Mong, "An Examination of Potential Attractions of Women's Marital Infidelity," *American Journal of Family Therapy* 42 (2014): 16.

Section Five

1. Caryl E. Rusbult, "Commitment and Satisfaction in Romantic Associations: A Test of the Investment Model," *Journal of Experimental Social Psychology* 16 (1980): 173.

2. Michael P. Johnson, "Personal, Moral, and Structural Commitment to Relationships: Experiences of Choice and Constraint," in *Handbook of Interpersonal Commitment and Relationship Stability*, ed. Jeffrey M. Adams and Warren H. Jones (New York: Kluwer Academic/Plenum, 1999), 73–87.

3. Perel, *State of Affairs*, 116.

4. Melissa Ann Tafoya and Brian H. Spitzberg, "The Dark Side of Infidelity: Its Nature, Prevalence, and Communicative Functions," in *The Dark Side of Interpersonal Communication*, 2d ed., ed. Brian H. Spitzberg and William R. Cupach (Mahwah: Lawrence Erlbaum Associates, 2007), 203.

5. Megan R. Dillow et al., "An Experimental Examination of the Effects of Communicative Infidelity Motives on Communication and Relational Outcomes in Romantic Relationships," *Western Journal of Communication* 75, no. 2 (2011): 492.

6. Marianne Dainton and Jamie Gross, "The Use of Negative Behaviors to Maintain Relationships," *Communication Research Reports* 25, no. 3 (2008): 179–191.

7. Dillow et al., "An Experimental Examination," 478.

Section Six

1. Sandra Metts, "Relational Transgressions," in *The Dark Side of Interpersonal Communication*, ed. William R. Cupach and Brian H. Spitzberg (Hillsdale: Lawrence Erlbaum Associates, 1994).

2. Anita Vangelisti, "Hurt Feelings in Family Relationships: Social Pain and Social Interaction," in *The Darker Side of Family Communication: The Harmful, the Morally Suspect, and the Socially Inappropriate*, ed. Loreen N. Olson and Mark A. Fine (New York: Peter Lang, 2016), 139.

3. Phillip R. Shaver et al., "Understanding and Altering Hurt Feelings: An Attachment-Theoretical Perspective on the Generation and Regulation of Emotions," in *Feeling Hurt in Close Relationships*, ed. Anita L. Vangelisti (Cambridge: Cambridge University Press, 2009), 99.

4. Kayla Knopp et al., "Once a Cheater, Always a Cheater? Serial Infidelity Across Subsequent Relationships," *Archives of Sexual Behavior* 46 (2017): 2306.

5. Tamara Afifi, John Caughlin, and Walid Afifi, "The Dark Side (and Light Side) of Avoidance and Secrets," in *The Dark Side*

of Interpersonal Communication, 2d ed., ed. Brian H. Spitzberg and William R. Cupach (Mahwah: Lawrence Erlbaum Associates, 2007), 63.

6. *Ibid.*, 79.

Conclusion

1. Afifi, Caughlin, and Afifi, "The Dark Side," 63.

2. Vaughan, *Monogamy Myth*, 30.

3. *Ibid.*, 31.

4. *Ibid.*, 40.

5. *Ibid.*, 39.

6. Mahalia Jackman, "Understanding the Cheating Heart: What Determines Infidelity Intentions?" *Sexuality & Culture* 19 (2015): 74.

7. Al Cooper, *Sex and the Internet: A Guidebook for Clinicians* (New York: Brunner-Routledge, 2002), 23.

8. Joseph B. Walther, "Computer-Mediated Communication: Impersonal, Interpersonal, and Hyperpersonal Interaction," *Communication Research* 23, no. 1 (1996): 3–43.

9. Perry M. Pauley and Tara M. Emmers-Sommer, "The Impact of Internet Technologies on Primary and Secondary Romantic Relationship Development," *Communication Studies* 58, no. 4 (2007): 423.

10. Ebony A. Utley, "Digital Indiscretions: Infidelity in the Age of Technology," in *Gender, Sex, and Politics: In the Streets and Between the Sheets in the 21st Century*, ed. Shira Tarrant (New York: Routledge, 2015), 155–168.

11. Melissa Sands, *The Mistress' Survival Manual: How to Get or Give Up Your Married Man* (New York: Berkley, 1978), 25.

12. Perel, *State of Affairs*, 25.

13. Denise Haunani Solomon, Leanne K. Knobloch, and Mary Anne Fitzpatrick, "Relational Power, Marital Schema, and Decisions to Withhold Complaints: An Investigation of the Chilling Effect on Confrontation in Marriage," *Communication Studies* 55, no. 1 (2004): 147.

14. Jack Morin, *The Erotic Mind: Unlocking the Inner Sources of Sexual Passion and Fulfillment* (New York: HarperCollins, 1995), 50.

15. Victoria Zackheim, *The Other Woman: Twenty-One Wives, Lovers, and Others Talk Openly About Sex, Deception, Love, and Betrayal* (New York: Warner Books, 2007), 54.

16. Lusterman, "Helping Children and Adults Cope with Parental Infidelity," 1440.

17. Terri D. Conley et al., "Unfaithful Individuals Are Less Likely to Practice Safer Sex Than Openly Nonmonogamous Individuals," *Journal of Sexual Medicine* 9, no 6 (2012): 1563.

18. Richardson, *The New Other Woman*, 70.

19. Lusterman, "Helping Children and Adults Cope with Parental Infidelity," 1441.

20. Lynn H. Turner and Richard West, *Perspectives on Family Communication*, 5th ed. (New York: McGraw Hill, 2018): 66–73.

21. Dana A. Weiser and Daniel J. Weigel, "Exploring Intergenerational Patterns of Infidelity," *Personal Relationships* 24 (2017): 949.

22. Kathleen M. Galvin, Carma L. Bylund, and Bernard J. Brommel, *Family Communication: Cohesion and Change*, 8th ed. (Boston: Allyn and Bacon, 2012): 62.

23. Allison R. Thorson, "Investigating Adult Children's Experiences with Privacy Turbulence Following the Discovery of Parental Infidelity," *Journal of Family Communication* 15, no. 1 (2015): 51.

Bibliography

Aborampah, Osei-Mensah. "Black Male-Female Relationships: Some Observations." *Journal of Black Studies* 19, no. 3 (1989): 320–342.

Afifi, Tamara, John Caughlin, and Walid Afifi. "The Dark Side (and Light Side) of Avoidance and Secrets." In *The Dark Side of Interpersonal Communication*, 2d ed., edited by Brian H. Spitzberg and William R. Cupach, 61–92. Mahwah: Lawrence Erlbaum Associates, 2007.

Afifi, Walid A., Wendy L. Falato, and Judith L. Weiner. "Identity Concerns Following a Severe Relational Transgression: The Role of Discovery Method for the Relational Outcomes of Infidelity." *Journal of Social and Personal Relationships* 18, no. 2 (2001): 291–308.

Arnocky, Steven, Shafik Sunderani, Wendy Gomes, and Tracy Vaillancourt. "Anticipated Partner Infidelity and Men's Intimate Partner Violence: The Mediating Role of Anxiety." *Evolutionary Behavioral Sciences* 9, no. 3 (2015): 186–196.

Blow, Adrian J., and Kelley Hartnett. "Infidelity in Committed Relationships I: A Methodological Review." *Journal of Marital and Family Therapy* 3, no. 2 (2005): 183–216.

Breiding, Matthew J., Kathleen C. Basile, Sharon G. Smith, Michele C. Black, and Reshma Mahendra. *Intimate Partner Violence Surveillance: Uniform Definitions and Recommended Data Elements*, Version 2.0. Atlanta: Centers for Disease Control and Prevention, 2015.

Brogdon, Bonnie L., April L. Fitzwater, and Lucille C. Johnson. "Differences in Men's and Women's Perception of Infidelity in Varying Situations." *The Osprey Journal of Ideas and Inquiry* 18 (2006). http://digitalcommons.unf.edu/ojii_volumes.

Cano, Annmarie, and K. Daniel O'Leary. "Infidelity and Separations Precipitate Major Depressive Episodes and Symptoms of Nonspecific Depression and Anxiety." *Journal of Consulting and Clinical Psychology* 68, no. 5 (2000): 774–781.

Conley, Terri D., Amy C. Moors, Ali Ziegler, and Constantina Karathanasis. "Unfaithful Individuals Are Less Likely to Practice Safer Sex Than Openly Nonmonogamous Individuals." *Journal of Sexual Medicine* 9, no. 6 (2012): 1559–1565.

Cooper, Al. *Sex and the Internet: A Guidebook for Clinicians*. New York: Brunner-Routledge, 2002

Dainton, Marianne, and Jamie Gross. "The Use of Negative Behaviors to Maintain Relationships." *Communication Research Reports* 25, no. 3 (2008): 179–191.

Davies, Alastair P.C., Todd K. Shackelford, and R. Glen Hass. "When a 'Poach' Is Not a Poach: Re-Defining Human Mate Poaching and Re-Estimating Its Frequency." *Archives of Sexual Behavior* 36 (2007): 702–716.

De Stefano, Jack, and Monica Oala. "Extramarital Affairs: Basic Considerations and Essential Tasks in Clinical Work." *The Family Journal* 16, no. 1 (2008): 13–19.

Dillow, Megan R., Colleen C. Malachowski,

Maria Brann, and Keith D. Weber. "An Experimental Examination of the Effects of Communicative Infidelity Motives on Communication and Relational Outcomes in Romantic Relationships." *Western Journal of Communication* 75, no. 2 (2011): 473–499.

Foster, Joshua D., and Tiffany A. Misra. "It Did Not Mean Anything (About Me): Cognitive Dissonance Theory and the Cognitive and Affective Consequences of Romantic Infidelity." *Journal of Social and Personal Relationships* 30, no. 7 (2013): 835–857.

Galvin, Kathleen M., Carma L. Bylund, and Bernard J. Brommel. *Family Communication: Cohesion and Change*, 8th ed. Boston: Allyn and Bacon, 2012.

Glass, Shirley P., and Thomas L. Wright. "Reconstructing Marriages After the Trauma of Infidelity." In *Clinical Handbook of Marriage and Couples Interventions*, edited by W. Kim Halford and Howard J. Markman, 471–507. Hoboken: John Wiley & Sons, 1997.

Haltzman, Scott. *The Secrets of Surviving Infidelity*. Baltimore: Johns Hopkins University Press, 2013.

Harris, Christine R. "Psychological Responses to Imagined Infidelity: The Specific Innate Modular View of Jealousy Reconsidered." *Journal of Personality and Social Psychology* 78, no. 6 (2000): 1082–1091.

Jackman, Mahalia. "Understanding the Cheating Heart: What Determines Infidelity Intentions?" *Sexuality & Culture* 19 (2015): 72–84.

Jeanfreau, Michelle M., Anthony P. Jurich, and Michael D. Mong. "An Examination of Potential Attractions of Women's Marital Infidelity." *American Journal of Family Therapy* 42 (2014): 14–28.

Johnson, Michael P. "Personal, Moral, and Structural Commitment to Relationships: Experiences of Choice and Constraint." In *Handbook of Interpersonal Commitment and Relationship Stability*, edited by Jeffrey M. Adams and Warren H. Jones, 73–87. New York: Kluwer Academic/Plenum, 1999.

Jones, Daniel N., and Dana A. Weiser. "Differential Infidelity Patterns Among the Dark Triad." *Personality and Individual Differences* 57 (2014): 22–23.

Kirshenbaum, Mira. *When Good People Have Affairs: Inside the Hearts & Minds of People in Two Relationships*. New York: St. Martin's Press, 2008.

Knopp, Kayla, Shelby Scott, Lane Ritchie, Galena K. Rhoades, Howard J. Markman, and Scott M. Stanley. "Once a Cheater, Always a Cheater? Serial Infidelity Across Subsequent Relationships." *Archives of Sexual Behavior* 46 (2017): 2301–2311.

Lusterman, Don-David. "Helping Children and Adults Cope with Parental Infidelity." *Journal of Clinical Psychology* 61, no. 11 (2005): 1439–1451.

Metts, Sandra. "Face and Facework: Implications for the Study of Personal Relationships." In *Handbook of Personal Relationships*, 2d ed., edited by Steve Duck, 373–390. Hoboken: John Wiley & Sons, 1997.

_____. "Relational Trangressions." In *The Dark Side of Interpersonal Communication*, edited by William R. Cupach and Brian H. Spitzberg, 217–239. Hillsdale: Lawrence Erlbaum Associates, 1994.

Miller, Courtney Waite, and Michael E. Roloff. "When Hurt Continues: Taking Conflict Personally Leads to Rumination, Residual Hurt and Negative Motivations Toward Someone Who Hurt Us." *Communication Quarterly* 62, no. 2 (2014): 193–213.

Morin, Jack. *The Erotic Mind: Unlocking the Inner Sources of Sexual Passion and Fulfillment*. New York: HarperCollins, 1995.

Nelson, Tammy. *The New Monogamy: Redefining Your Relationship After Infidelity*. Oakland: New Harbinger, 2012.

Ortman, Dennis C. "Post-Infidelity Stress Disorder." *Journal of Psychosocial Nursing* 43 no. 10 (2005): 46–54.

_____. *Transcending Post-Infidelity Stress Disorder: The Six Stages of Healing*. Berkeley: Celestial Arts, 2009.

Outlaw, Maureen. "No One Type of Intimate Partner Abuse: Exploring Physical and Non-Physical Abuse Among Intimate Partners." *Journal of Family Violence* 24, no. 4 (2009): 263–272.

Pauley, Perry M., and Tara M. Emmers-Sommer. "The Impact of Internet Technologies on Primary and Secondary Romantic Relationship Development." *Communication Studies* 58, no. 4 (2007): 411–427.

Perel, Esther. *The State of Affairs: Rethinking Infidelity*. New York: HarperCollins, 2017.

Pinderhughes, Elaine B. "African American Marriage in the 20th Century." *Family Process* 41, no. 2 (2002): 269–282.

Pittman, Frank. *Private Lies: Infidelity and the Betrayal of Intimacy*. New York: W.W. Norton, 1990.

Praver, Frances Cohen. *Daring Wives: Insight into Women's Desires for Extramarital Affairs*. Westport: Praeger, 2006.

Richardson, Laurel. *The New Other Woman: Contemporary Single Women in Affairs with Married Men*. New York: The Free Press, 1985.

_____. "The 'Other Woman': The End of the Long Affair." *Alternative Lifestyles* 26, no. 4 (1979): 397–414.

Rosewarne, Lauren. *Cheating on the Sisterhood: Infidelity and Feminism*. Santa Barbara: Praeger, 2009.

Rusbult, Caryl E. "Commitment and Satisfaction in Romantic Associations: A Test of the Investment Model." *Journal of Experimental Social Psychology* 16 (1980): 172–186.

_____, Christopher R. Agnew, and Ximena B. Arriaga. "The Investment Model of Commitment Processes." In *Handbook of Theories of Social Psychology*, vol. 2, edited by Paul A. M. Van Lange, Arie W. Kruglanski, and E. Tory Higgins, 218–231. Los Angeles: Sage, 2011.

Sands, Melissa. *The Mistress' Survival Manual: How to Get or Give Up Your Married Man*. New York: Berkley, 1978.

Shackelford, Todd K., David M. Buss, and Kevin Bennett. "Forgiveness or Breakup: Sex Differences in Responses to a Partner's Infidelity." *Cognition and Emotion* 16, no.2 (2002): 299–307.

Sharpe, Desiree I., Andrew S. Walters, Matt J. Goren. "Effect of Cheating Experience on Attitudes Toward Infidelity." *Sexuality & Culture* 17 (2013): 643–658.

Shaver, Phillip R., Mario Mikulincer, Shiri Lavy, and Jude Cassidy. "Understanding and Altering Hurt Feelings: An Attachment-Theoretical Perspective on the Generation and Regulation of Emotions." In *Feeling Hurt in Close Relationships*, edited by Anita L. Vangelisti, 92–119. Cambridge: Cambridge University Press, 2009.

Sims, Karen E., and Marta Meana. "Why Did Passion Wane? A Qualitative Study of Married Women's Attributions for Declines in Sexual Desire." *Journal of Sex & Marital Therapy* 36 (2019): 360–380.

Solomon, Denise Haunani, Leanne K. Knobloch, and Mary Anne Fitzpatrick. "Relational Power, Marital Schema, and Decisions to Withhold Complaints: An Investigation of the Chilling Effect on Confrontation in Marriage." *Communication Studies* 55, no. 1 (2004): 146–167.

Sternberg, Robert J. "A Triangular Theory of Love." *Psychological Review* 93, no. 2 (1986): 119–135.

Suler, John. "The Online Disinhibition Effect." *Cyberpsychology & Behavior* 6, no. 3 (2004): 321–326.

Tafoya, Melissa Ann, and Brian H. Spitzberg. "The Dark Side of Infidelity: Its Nature, Prevalence, and Communicative Functions." In *The Dark Side of Interpersonal Communication*, 2d ed., edited by Brian H. Spitzberg and William R. Cupach, 201–241. Mahwah: Lawrence Erlbaum Associates, 2007.

Thorson, Allison R. "Investigating Adult Children's Experiences with Privacy Turbulence Following the Discovery of Parental Infidelity." *Journal of Family Communication* 15, no. 1 (2015): 41–57.

Turner, Lynn H., and Richard West. *Perspectives on Family Communication*, 5th ed. New York: McGraw-Hill, 2018.

Utley, Ebony A. "Digital Indiscretions: Infidelity in the Age of Technology." In *Gender, Sex, and Politics: In the Streets and Between the Sheets in the 21st Century*, edited by Shira Tarrant, 155–168. New York: Routledge, 2015.

_____. "Infidelity's Coexistence with Intimate Partner Violence: An Interpretive Description of Women Who Survived a Partner's Sexual Affair." *Western Journal of Communication* 81, no. 4 (2017): 426–445.

_____. "Rethinking the Other Woman: Exploring Power in Intimate Heterosexual Triangular Relationships." *Women's Studies in Communication* 39, no. 2 (2016): 177–192.

_____. "When Better Becomes Better Worse: Black Wives Describe Their Experiences with Infidelity." *Black Women, Gender, and Families* 5, no. 1 (Spring 2011): 66–89.

Vangelisti, Anita. "Hurt Feelings in Family Relationships: Social Pain and Social Interaction." In *The Darker Side of Family Communication: The Harmful, the Morally Suspect, and the Socially Inappropriate*, edited by Loreen N. Olson and Mark A. Fine, 137–154. New York: Peter Lang, 2016.

Vaughan, Peggy. *The Monogamy Myth: A Personal Handbook for Recovering from Affairs*, 3d ed. New York: Newmarket Press, 2003.

Voracek, Martin, Tanja Haubner, and Maryann L. Fisher. "Recent Decline in Nonpaternity Rates: A Cross-Temporal Meta-Analysis." *Psychological Reports* 103 (2008): 799–811.

Vossler, Andreas. "Internet Infidelity 10 Years On: A Critical Review of the Literature." *The Family Journal: Counseling and Therapy for Couples and Families* 24, no. 4 (2016): 359–366.

Walther, Joseph B. "Computer-Mediated Communication: Impersonal, Interpersonal, and Hyperpersonal Interaction." *Communication Research* 23, no. 1 (1996): 3–43.

Wang, Wendy. "Who Cheats More? The Demographics of Infidelity in America." Institute for Family Studies, January 18, 2018, https://ifstudies.org/blog/who-cheats-more-the-demographics-of-cheating-in-america.

Weiser, Dana A., and Daniel J. Weigel. "Exploring Intergenerational Patterns of Infidelity," *Personal Relationships* 24 (2017): 933–952.

_____, and _____. "Investigating Experiences of the Infidelity Partner: Who Is the 'Other Man/Woman'?" *Personality and Individual Differences* 85 (2015): 176–181.

_____, _____, Camille B. Lalasz, and William P. Evans. "Family Background and Propensity to Engage in Infidelity." *Journal of Family Issues* 38, no. 15 (2017): 2083–2101.

Whisman, Mark A. "Discovery of a Partner Affair and Major Depressive Episode in a Probability Sample of Married or Cohabiting Adults." *Family Process* 55, no. 4 (2016): 713–723.

Wiederman, Michael W., and Catherine Hurd. "Extradyadic Involvement During Dating." *Journal of Social and Personal Relationships* 16, no. 2 (1999): 265–274.

Yagoda Maria. "The New Breakup Equation: How Long It Will Take to Get Over Your Ex." Broadly, May 22, 2018, https://broadly.vice.com/en_us/article/gykvp3/breakup-equation-time-it-takes-to-get-over-an-ex.

Zackheim, Victoria. *The Other Woman: Twenty-One Wives, Lovers, and Others Talk Openly about Sex, Deception, Love, and Betrayal*. New York: Warner Books, 2007.

Online Resources

Affair Recovery:
https://www.affairrecovery.com/
The Betrayed Wives Club:
http://betrayedwivesclub.blogspot.com/
Beyond Affairs Network:
https://beyondaffairs.com/
Dear Peggy: Extramarital Affairs Resource
Center: https://dearpeggy.com/

Infidelity Counseling Network:
http://www.infidelitycounseling
network.org/
Infidelity Recovery Institute:
https://infidelityrecoveryinstitute.com/
Surviving Infidelity:
https://www.survivinginfidelity.com/

Index